D1223940

UNIVERS____ __ WINNIPEG
POR____ ___ BALMORAL
WINNIPEG ___MAN. CANAD__

DISCARDED

DISCARDED

STUDIES IN BRITISH ART

Ref
NC
978
.H28
1975

BOOK ILLUSTRATORS IN EIGHTEENTH-CENTURY ENGLAND

HANNS HAMMELMANN

edited and completed by

T. S. R. BOASE

PUBLISHED FOR THE PAUL MELLON CENTRE
FOR STUDIES IN BRITISH ART (LONDON) LTD BY

YALE UNIVERSITY PRESS
NEW HAVEN AND LONDON
1975

Copyright © 1975 by Yale University.

All rights reserved.

This book may not be reproduced, in whole or in part,
in any form (except by reviewers for the public press),
without written permission from the publishers.

Library of Congress catalog card number: 75-2770

International standard book number: 0–300–01895–9

Designed by John Nicoll and set in Monotype Bembo.

Printed in Great Britain
by W & J Mackay Limited, Chatham

Published in Great Britain, Europe, and Africa by
Yale University Press, Ltd., London.
Distributed in Latin America by Kaiman & Polon, Inc., New York City;
in India by UBS Publishers' Distributors Pvt., Ltd., Delhi;
in Japan by John Weatherhill, Inc., Tokyo.

CONTENTS

LIST OF PLATES

LIST OF ABBREVIATIONS

A.R.A.	Associate of the Royal Academy
B.M.	British Museum (now British Library)
C.U.L.	Cambridge University Library
C.L.	*Country Life*
Del., delin., delin^t	delineavit
Des.	designed
DNB	*Dictionary of National Biography*
Eng.	engraved
F., fec., fec^t	fecit
Front.	frontispiece
Inv.	invenit
JWCI	*Journal of Warburg and Courtauld Institutes*
n.d.	no date given
n.p.	no publisher or printer's name given
Orn.	ornavit
Pls.	plates
R.A.	Royal Academician
S.	signed
Sc., sculp. sculp^t	sculpsit
V. & A.	Victoria and Albert Museum
Vig.	vignette

PUBLISHER'S NOTE

WHEN Hanns Hammelmann died, this book consisted, with some exceptions, of working papers, unprepared for publication. The exceptions concerned those artists about whom Hammelmann had already published articles in *Country Life*, *The Times Literary Supplement* and the *Book Collector*. Dr. T. S. R. Boase, who then undertook to finish off the task, decided that it would not be possible, without a lifetime's work, to bring all the material to the same standard of completeness evinced in the articles already published. Nor did he attempt to alter Hammelmann's necessarily restricted definition of book illustration. Within this framework, however, Dr. Boase completely revised the text, and added the essay on 'Book Illustration in the Eighteenth Century' which precedes it. In April 1974 he too died, with the job not quite complete.

The publishers are grateful to Nicolas Barker (who had previously collaborated with Hammelmann) and to Mrs. Margaret Cawkwell for finally completing the job. The detailed information has been checked, and a standard form has been imposed on each entry as far as the material allows. Errors will no doubt remain and the publishers will be glad to receive additions and corrections which may be incorporated in any subsequent edition.

The publishers would also like to thank the editors of *Country Life*, *The Times Literary Supplement* and the *Book Collector* for generously allowing the reprinting of material which has previously appeared (in a different form) in those journals.

PREFACE

HANNS Hammelmann died on 26 October 1969. A German Rhodes Scholar at Oxford in the thirties, he did not return to Hitler's Germany. During the War, after a short period of internment in the Isle of Man, he worked on monitoring of German broadcasts. The war ended, he took British nationality and was called to the English bar. Law had been his academic subject in which he had a German doctorate and Oxford first-class honours in Jurisprudence. He could probably have had a distinguished career in this profession, but he had strong interests in other directions. He was soon occupied in translating English plays into German, amongst them Bolt's *Man for All Seasons*, and in working on programmes for both English and German broadcasting, particularly a series on the making of operas in collaboration with his friend, Michael Rose. In 1952 his first article on eighteenth-century book illustration appeared in the *Book Collector*. Others followed that established him as an authority in this unexplored field, and that led to him being commissioned by the Paul Mellon Foundation to write a book on the subject. He had worked through the material in the main English libraries, read innumerable catalogues, corresponded with many people of similar interests, and collected a remarkable library of his own, when illness set in. He was still dictating notes on the day of his death in a clinic at Munich.

He was a careful and persistent scholar, tracking down birth registers, wills and any hint that might lead to new information. It was a large and intractable subject, all the more so because the catalogues of the two main sources, the British Museum and the Bodleian Libraries, could not be relied on to state whether or not a volume had plates. He was very conscious that his card index was not, and could not be, complete. He interpreted 'illustration' as meaning 'that the artist's designs are subsidiary to the text and interpreting or commenting on the author's meaning in a different medium.' He excluded from his survey technical works where plates of architecture, archaeology, anatomy or botany were integral to the scheme of the book, though he included some of their allegorical frontispieces. It was the invention of the artist, not his skill as a copyist that concerned him. This is not the book he would have written had time been given him, but the whole basis is his. I have compiled it from his notes, deposited at the Courtauld Institute, adding something to his book-lists, and filling in where some gap seemed evident to me. His own collection of eighteenth-century books had unfortunately to be dispersed after his death, but they had all been noted in his card index. He would, I know, have wished to acknowledge the help he had received from many correspondents, and I can only hope they realize his gratitude to them. One must, however, be named. Dr. Ulrich Middeldorf had long been filing cuttings from book catalogues of English eighteenth-century works, and these he handed over and placed at Hammelmann's disposal.

Hanns was a man of great charm, a very ready and stimulating talker. His formidable powers of concentration could be masked by what seemed on the surface an indolent disposition. He was a sometimes exasperating and always most rewarding friend. Latterly he lived in an old villa, with the Medici arms above the doorway, high on the hills north of Lucca. Only a comparatively rough track led to its decaying splendour: it seemed remote both in time and space. He turned it into a curiously fitting background for his own wide ranging and idiosyncratic personality. He was twice married and owed much to the devotion of both his English and his German wife.

[T.S.R.B.]

BOOK ILLUSTRATION IN THE EIGHTEENTH CENTURY

IN 1677 Jacob Tonson set up a publishing business along with his brother, Richard, at the Judges Head, Chancery Lane. From the first he interested himself in illustrated editions of leading English writers such as Milton and Dryden. One of his earliest illustrated books (1688) was Milton's *Paradise Lost*, of which he had obtained the copyright.[1] For this he turned to a foreign artist, John Baptist Medina, who two years previously had come from Brussels to London. Medina's plates, with their combination of medieval imagery and mannerist elegance, were far superior to anything that English practitioners such as Robert White or John Sturt were producing. Various reasons were bringing foreign artists to London: Frenchmen were being driven out by the Revocation of the Treaty of Nantes; Dutchmen were following their countryman, William III; but, even when France and England were at war, the admitted superiority of the continental designers led to less motivated intercourse. In 1711 Queen Anne commissioned a set of engravings of the Raphael cartoons at Hampton Court, and the Frenchman Nicholas Dorigny, who had made some English contacts in Rome, was invited to carry out the work. He brought with him two of his compatriots, Dupuis and Claude du Bosc, the latter of whom settled in London and became a central figure in the new standards set in engraving. Two other Frenchmen, Simon Gribelin, who had been for some time resident in England and already in 1707 had engraved a set of the cartoons on a smaller scale, and Louis du Guernier also joined Dorigny's team. S. Gribelin's vignettes and plates in the second edition of the Earl of Shaftesbury's *Characteristics* (1714) set a new style in the integration of engraved decoration in books printed by letterpress. Du Bosc and Gribelin were primarily engravers. Du Guernier both designed and engraved. It was again to a Frenchman, François Boitard, that Tonson turned for the designs for his illustrated Shakespeare (1709) and his Beaumont and Fletcher (1711). In the Shakespeare, Michael van der Gucht, who came to London from Antwerp, carried out most of the engraving ,whereas in the Beaumont and Fletcher the engraving was mainly done by Elisha Kirkall, one of the few Englishmen employed by Tonson.

Another Frenchman, Louis Cheron, was commissioned by Tonson in 1720 to illustrate an edition of Milton's *Works*. Cheron had come to England in the 1690s for religious reasons, and was by now an influential figure among the engravers. In October 1720, along with the young and well-to-do John Vanderbank, whose father was a prosperous tapestry weaver at Soho, Cheron set up an academy at St. Martin's Lane 'for the Improvement of Sculptors and Painters by drawing from the Naked'. Nine years previously, in 1711, a group of artists had formed a school in Great Queen Street, with Kneller as president,

[1] Kneller's portrait of Tonson painted for the Kit Kat Club, of which he was secretary, shows him holding a volume of *Paradise Lost*.

and Dorigny as one of the directors. Kneller was replaced by Thornhill in 1716, but there was much dispute amongst the members, and Cheron and Vanderbank's St. Martin's Lane Academy was a secession from their ranks. Thornhill attempted, without much success, to run a private school of his own. On his death in 1734, Hogarth, his son-in-law, came into possession of the fittings of the school, and used them to refound the St. Martin's Lane Academy, which had run into difficulties owing to its treasurer's embezzlement of the subscriptions. This now became the main teaching establishment of painting and the graphic arts, and under Hogarth's influence new ideas were at work. In particular, to try to avoid incessant factional debate, it was agreed that every member should contribute an equal sum to its support, and have an equal right to vote on every question relative to its affairs.[1]

The Milton of 1720 was one of the last works carried out by Jacob Tonson as manager of the firm. He now retired leaving the business in the hands of his nephew, Jacob Tonson II, who was succeeded by his son, Jacob Tonson III, in 1735. The eldest Jacob outlived his nephew, dying in 1736, but seems, inasmuch as the similarity of names permits of certainty, to have lived in the country and not to have been active in the business. Early in the 1730s, however, the firm undertook one of its greatest publishing ventures, an English edition of Bernard Picart's monumental *Religious Ceremonies and Customs of the known World* in seven folio volumes, with the plates newly engraved 'by most of the best hands in Europe' —a labour which seems to have occupied no less than nine years—the executants were once again Du Bosc himself and three French assistants. They arrived, late in 1732 or early in 1733, especially for the purpose: the two brothers Scotin and the son of a Parisian tailor, just turned thirty but with his name still to make, Hubert François Bourguignon, called Gravelot.

Gravelot's period in England, till he returned to France in 1746, marks the dominance of the French rococo style, which in its native book production reached one of its peaks in 1734 with Boucher's illustrations to Molière. Gravelot had been Boucher's pupil; now he was prominent in the St. Martin's Lane Academy, and in the convivial gatherings at the Beefsteak Club. He was a close colleague of Francis Hayman, his junior by nine years, and in his studio had pupils such as Gainsborough and Thomas Major. For Tonson he illustrated Dryden's *Dramatick Works* in 1735, and for Lintot, Tonson's chief rival, Shakespeare's *Works* in 1740. Then in 1743-4 for the Oxford Press he collaborated with Hayman in the Great Hanmer edition of Shakespeare.

The native genius, however, did not give way entirely to the new fashions. John Sturt's famous *Book of Common Prayer* (1717), engraved throughout on 188 silver plates, had a marked influence on the work of his contemporaries. John Pine's frontispiece for the first edition (1719) of *Robinson Crusoe* is a vigorous piece of work showing Crusoe in his skins, and establishing a type that was to be very lasting. The headpieces and vignettes of his Horace (1733-7), like Sturt's *Common Prayer* engraved throughout, left their mark

[1] See Whitley, *Artists and their Friends*, I, 1928 pp. 13–15, 26, 27. For the general life of the Academy see three important articles by Mark Girouard, *CL*, CXXIX, 1966, pp. 58–61, 183–190, and 224–227.

on the decorative equipment of book illustrators for two generations, although they are not illustrations as such. Pine's close friend was William Hogarth, who in 1730 designed an illustration for a play published by John Watts, who had also published *Robinson Crusoe*. Hogarth's main interest, however, was to be in the publication of a series of his own engravings, and he was soon involved in schemes for protecting his output from the piracy of other engravers, of whom Elisha Kirkall was one. In 1735 he secured the passage through Parliament of the Engravers Copyright Act, giving the designers fourteen years copyright, forbidding any engraving to be made without the designer's permission, and laying down a one shilling fine for every copy of a pirated print found in a printseller's possession. In 1767 an amended act extended the copyright to twenty-four years.

The publishers had their own problems of copyright. There was for instance an involved situation over publication of the Bible. The royal patent to print Bibles had been held since 1577 by members of the Barker family and their partners or assignees. In 1709 the remainder of the then existing patent was purchased by John Baskett, whose family held it till 1769, and were entrusted by the Oxford Press with the production of their Bibles. The rights of the two universities to print Bibles were outside the royal patent to the Barker family.[1] Such royal grants of the sole privilege to print a book had been excepted from the abolition of monopolies in 1623 and they lingered on as a confusing element in the eighteenth century, despite the copyright act of 1709 that enacted that the author of a book already printed, or the bookseller who had bought his copy, had the sole right of printing such book for the term of one and twenty years; and that an author of any book not yet published should have the sole liberty of printing it for the term of fourteen years. How far this act was retrospective and how far a common law right survived in books previously assigned to a publisher remained a matter of frequent debate. In 1736 for instance 'Tonson and others' secured judgment in favour of their 'copy' in *Paradise Lost*, assigned to them by Milton in 1667. The act of 1709 did much, however, to limit piracy of books, though Dublin and to a lesser extent Edinburgh remained centres that it was difficult to control.[2]

On the whole publishers tended more and more to combine over the production and marketing of books. In 1722 for instance Tonson assigned to Bernard Lintot a half interest in Steele's *Conscious Lovers* for £70, and previously in 1718 had entered into a partnership agreement with him for the purchase of plays, to last for eighteen months. Lintot (1675–1736), who had an agreement with Pope over the publication of much of his work, was another who made frequent use of Louis Cheron as an illustrator.

Very different were the activities of George Bickham. He and his family were them-

[1] See T. S. R. Boase, *JWCI*, XXVI, 1963, pp. 155–64, and H. Carter, *A History of the Oxford University Press*, 1975, pp. 166–76.

[2] There is a useful summary of this tangled question by Sir Frederick Mackinnon in Appendix II of *The Oxford Companion to English Literature*, 3rd ed., 1946.

The disputes and even dangers of publishing receive lively comment in Pope's *Dunciad*. 'Genial Jacob' (Tonson) and 'lofty Lintot' both appear, and in particular Edmund Curl, who was fined for publishing obscene books and in March 1728 was pilloried at Charing Cross.

selves engravers and designers, and quite ready to adapt earlier plates. The two folio volumes of *The Musical Entertainer* are his most ambitious and notable production, but his speciality was books for the instruction of the young, many of them written by members of the Bellamy family, one of whom, Mrs. Martha Bellamy, ran a young ladies' boarding school. There was some stress on the educational value of illustrations: 'I have known many a Body drawn in to read a Book, merely because they have liked the Pictures; if it had not been for this Reason, I can assure those who condemn them, I should have been as glad as they possibly could be, to have had them omitted. That Additional Charge was not at all necessary in a Work that without it has cost dear enough.'[1]

The range of subjects that attracted illustration was an ever widening one. Editions of single plays, often published while still in performance, generally had a representation of a scene, where no doubt the stage practice influenced the design. Successful novels, such as those of Fielding, Richardson and Smollet, soon appeared in illustrated editions, and the same was true of poems, in particular those of Pope, Gray, and above all Thomson's *Seasons*. The continuous attempt to establish the text of Shakespeare, by Rowe, Pope, Theobald, Hanmer and others, led to constant new editions of his works. The publication in 1715–25 of Colien Campbell's three volumes of *Vitruvius Britannicus* with its architectural plates is the leading example of the numerous fine books on architecture published in the period. The Royal Society's encouragement of scientific publications with technical plates gave an impetus towards closely accurate delineation, particularly in anatomical diagrams. In the second half of the century a more learned turn was given to such publications with Robert Wood's *Ruins of Palmyra* (1753), Stuart and Revett's *Antiquities of Athens* (Vol. I, 1762) and Robert Adam's *Palace of the Emperor Diocletian at Spalatro* (1764). These were stately, noble tomes for the connoisseurs and professional architects. Topographical tours and guide books had a wider public, and more and more moved towards an interest in the picturesque. Thomas Pennant (1726–98) regularly took an artist with him on his tours of Wales and Scotland to illustrate the accounts he wrote of them. Amid a growing popular market for lower grade prints, there was a lively trade in volumes of erotica.

The value of illustration for propaganda purposes was not neglected. Jonas Hanway (1712–86), whose *Journal of Travels and Account of British Trade over the Caspian Sea* (1753) is a finely illustrated book, employed distinguished engravers to provide headpieces for his many pamphlets on behalf of the Marine Society, a charitable body for training boys as seamen.[2] Political caricature flourished, particularly after the election years of 1784, but mainly as single sheets, rather than in illustrated books.

The portrait frontispiece remained an accepted convention, and here in the first half of the century George Vertue (1684–1756) was the great practitioner, and was said to have engraved above 500 heads. These were largely taken from extant portraits, and Vertue was an engraver, who rarely if ever used his own designs. His *Notebooks*, a prime source

[1] Preface to *A Collection of Old Ballads*, 1738, not a Bickham publication, but by Roberts, Leach and Battley. The plates are all unsigned.
[2] See N. M. Distad, 'Jonas Hanway and the Marine Society', *History Today*, XXIII, 1973, pp. 434–40.

of information about art and artists, ensure a grateful memory of him. Allegorical frontis-
pieces provided more scope for individual fancy, and with the coming of the French rococo
style ornamental head- and tailpieces, framing figure scenes, gave much scope for artistic
ingenuity. Hayman, particularly in his charming illustrations to *Fables of the Female Sex*
(1744), introduced a more homely touch of local genre into the French manner, and this
steadily increased in the work of later artists. Samuel Wale brought contemporary realism
to his plates, luridly so in his scenes for the Newgate Calendar, and by the end of the
century Stothard, Corbould and Westall had a new vein of sentimental romanticism.

The medium most generally employed was engraving, 'burinating' on copperplate
(spelt indifferently as one or two words). The term used in the early editions is 'cuts', but
this gradually gives place to 'engravings'. The copperplate wore quickly, and permitted
only of a limited number of good impressions. Blurring on re-use is a frequent feature of
these books, and plates were often re-engraved by other hands. Paul Fourdrinier, another
engraver of French extraction, was much employed in this re-making of designs. Gravure
on copper is, however, a very insufficient description of the process in use. Many artists,
as for instance Anthony Walker, began their work on the plate with some form of etching,
drawing on some acid-resisting coating, and continuing with the burin after the plate had
been immersed in acid and the line bitten. Aquatint, or as it was at first called *acqua forte*,
the use of rosin powder heated on the plate as an acid resister, was a known process,
though rarely used as a sole method of treatment. Gainsborough signs one of his rare
book illustrations as 'fecit acqua forte'. Paul Sandby brought this medium to a new level
of accomplishment. When an engraver signs a plate 'fecit' (f. or fec.) instead of 'sculpsit'
(sc. or sculp.) this can be taken to mean that the burin had been relatively little employed.
Woodcut, until Thomas Bewick at the end of the century, was comparatively little used,
except for cheap popular books, such as the many eighteenth-century editions of *The
Pilgrim's Progress*.[1] Stipple engraving, building up tonal effects with minute dots, worked
in with various roulette tools, was brought to a high finish by Francesco Bartolozzi
(1725–1815), a Florentine who came to England in 1764. Mezzotint, with its lengthy
preparation of the roughened plate, was little employed for book illustration, except for
portrait frontispieces, and was much more a medium for large plates which were in fact
the prime business of many of the more distinguished engravers. Nicholas Dorigny,
Robert Strange and William Woollett, to mention three of the greatest names, had no or
little contact with the book publishers. Colour prints made as yet little impact on the book
trade. In 1719 Christopher Le Blon (1667–1741), a German from Frankfort despite his
French name, came to England and with the patronage of Sir John Guise set up a company
for a three-colour process of printing. He was not, however, successful; the company went
bankrupt, and Le Blon withdrew to Paris. It was not till the 1770s that William Wynne
Ryland and Francesco Bartolozzi adapted the stipple method to colour printing, and soon,
particularly in plates after Angelica Kauffman, had considerable success with it, mainly,

[1] There is a good woodcut frontispiece, 'W. Pennock sculp.' to *Bacchus and Venus: or a select Collection
of near 200 . . . Songs and Catches in Love and Gallantry*, 12mo. 1737 (Bodl. Douce 571).

however, for single plates or series of plates, and it rarely appeared as book illustration, although, at the end of the century, the topographical works of William Gilpin with aquatint plates found many imitators. Rudolf Ackermann, a German who had come to England in 1779 and founded a printsellers business there, was to be the great entrepreneur of coloured aquatints. His *Microcosm of London*, 1802, based on a collaboration between Augustus Pugin and Rowlandson, was to set new standards in plates, completed in colours by a team of workers copying a watercolour by the master-hand.[1]

Meanwhile the St. Martin's Lane Academy, still something of a centre for the designers, was playing its part in discussions as to a Royal Foundation that would raise the status of all artists. Meetings were held at the Turk's Head Tavern in Soho, and at the Foundling Hospital, but unfortunately the two leading spirits, Hayman and Hogarth, could not agree. Eventually a committee was formed in 1760 for a public exhibition of contemporary British art, the first ever held, for the exhibitions at Vauxhall and the Foundling Hospital had been in the hands of a small coterie. The new exhibition was held in the Strand Great Room of the Society of Arts, and was immensely successful. As a result the group that had organized it took the name of the Incorporated Society of Artists, with Hayman as its president. There were, however, disputes and secessions, and it was not till 10 December 1768 that George III signed the charter establishing the Royal Academy.

The new foundation, while including eminent designers such as Hayman, had at first no category of engravers among its members. This could not continue, at a time when the gap between designer and engraver was becoming more marked and when the painters could not afford to alienate the men on whom they depended for reproductions of their works for a wider public. The fact that the leading engraver, Sir Robert Strange, was *persona non grata* for his Jacobite sympathies may have played some part in the delay. In March 1769 a resolution was passed that up to six engravers should be admitted as Associate members and in February 1770 Thomas Major was elected the first engraver A.R.A.

Meanwhile there were many developments in the publishing business, though still there were no clear lines of demarcation between printing, publishing and book selling. Robert Dodsley (1704–64), a popular poet and playwright, set up a publishing business at Tully's Head in Pall Mall in 1735, and soon showed a new enterprise in contacts with authors and commissioning of plates.[2] In Birmingham John Baskerville (1706–75) set new standards in type and paper for the book trade.[3] The firm of John Murray began business in 1768, though not yet in their famous premises at 50 Albermarle Street. Established firms more and more came to control what was known as 'the trade'. In 1777 a deputation

[1] S. T. Prideaux, *Aquatint Engraving*, 1909, is still the clearest account of aquatints in relation to the book trade. Walter Chamberlain, *Etching and Engraving*, 1972, is a useful guide to the techniques. There is a large literature on the subject, but mostly concerned with the production of single prints. For Ackermann see especially Allen Samuels, 'Rudolph Ackermann and *The English Dance of Death*,' *Book Collector*, XXIII, 1974, pp. 371–80.
[2] Ralph Strauss, *Robert Dodsley*, 1910.
[3] J. H. Benton, *John Baskerville, Type Founder and Printer*, 1944.

of them invited Dr. Johnson to write biographical notices for an edition of the English poets from Chaucer onwards.[1] Eventually the plan was curtailed, beginning with Cowley, and the *Prefaces* were published separately. But the enterprise was a challenge to some of the younger men. John Bell (1745–1831) undertook a cheaper edition of *The Poets of Great Britain complete from Chaucer to Churchill*. This eventually ran to 109 18mo volumes. Already in 1774 he had published an edition of Shakespeare with plates by Edward Edwards, where 'We have earnestly consulted correctness, neatness, ornament, utility and cheapness of price.' He followed this with another edition of 1785 with plates by De Loutherbourg, Burney and others, some of them unsigned representations of actors in particular parts; and with *The British Theatre*, a collection of plays by other authors. Bell was a man of great enterprise, founder of the *Morning Post* and also of an illustrated monthly, *La Belle Assemblée*.[2] John Cooke (1731–1808) and his son Charles (1760–1816) were soon exploiting the same market for small cheap editions with their pocket *Hume's History* (19 volumes, 1793–4) and their sixpenny poets. 'How I loved these little sixpenny numbers,' wrote Leigh Hunt, 'containing whole poets. I doted on their size; I doted on their type, on their ornaments, on their wrappers containing lists of other poets, and on the engravings from Kirk.'[3] Not only Kirk provided plates: Corbould, Riley, Stothard, Thurston, Burney, Edwards and many others were employed in Cooke's venture. The periodicals, such as Harrison's *Novelist's Magazine*, also provided openings for this new generation of designers.

This spate of popular literature was based on a steady increase in the reading public, and particularly on a new demand for novels. The first work of fiction, if it can be called so and if one relegates Bunyan's *Pilgrim's Progress* to some other category, to enjoy immediate and lasting popularity was *Robinson Crusoe*, first published in 1719 and from the beginning 'adorned with cuts'. In 1726 came Swift's *Gulliver's Travels*, half satire, half adventure story. These two books established a popular theme, that of dangerous and fantastic travel. More domestic incidents were soon to exercise as great an appeal. In 1740 appeared the first two volumes of Richardson's *Pamela*, followed by Fielding's *Joseph Andrews* in 1742. Before 1750 these had been followed by *Clarissa Harlowe*, *Tom Jones* and Smollett's *Roderick Random*; and with less lasting but considerable contemporary popularity Fielding's sister, Sarah, had entered the field with her *Adventures of David Simple in search of a Faithful Friend*. These ten years may well be said to have changed the reading tastes of England, and speedy translation was to make Richardson's novels as influential on the continent. It was not long before they appeared in illustrated editions, or before other authors hastened to meet this new demand. There are recurrent, but now forgotten, names in this series provided by Cooke and Harrison: Hugh Kelly's *Louisa Mildmay*, Mrs.

[1] *The Works of the English Poets with Prefaces Biographical and Critical* by Samuel Johnson. 8vo, 1779, for 36 publishers including Rivington, Longman, Dodsley, Lowndes, Cadell, Newbery and Murray. Author's portraits, but otherwise no illustration.
[2] See S. Morison, *John Bell*, 1930. The *DNB* gives considerable space to all these publishers.
[3] *Autobiography*, 1860, p. 70.

Haywood's *Betsy Thoughtless* and *Jemmy and Jenny Lessamy*, Robert Paltock's *Peter Wilkins* with its winged race of 'glums' and 'gawries', half *Crusoe*, half *Gulliver*, Dr. Dodd's *The Sisters*, Mrs. Griffiths' *Moral Tales*, Mrs. Charlotte Lennox's *The Female Quixote*, much admired by both Dr. Johnson, who wrote the dedication, and by Jane Austen.

One novel did perhaps as much as all the others to dominate changing fashions. Goldsmith's *The Vicar of Wakefield* was published in 1766 by John and Francis Newbery.[1] Its deceptive simplicity immensely pleased, and it enjoyed wide success both in England and abroad, despite little notice from the critics when it first appeared. Editions rapidly multiplied, and soon were illustrated.[2] Daniel Dodd provided plates for the *Novelist's Magazine* and for an edition published in 1784 by Wenman, but it is Stothard who found the visual counterpart to the book's new brand of sentiment. Author and artist found a common ground of sensitivity.

The illustration of novels, with all the problems of congruent or conflicting views between author and artist, is a wide subject in itself. The eighteenth century has many examples of particularly successful co-operation. The practice continued, with some famous debates, throughout the nineteenth century, and largely ended in the twentieth with the demise of the illustrated monthlies such as the *Strand*, the *Windsor* and *Pearsons*. Its contemporary survival is largely confined to dust covers and paperbacks.

Very different from the popular editions were the undertakings of the leading figures in the engraving trade. John Boydell (1719–1804) was an alderman of the City of London in 1782 and became Lord Mayor in 1790. The export of prints, it was reported in the House of Lords, amounted to some £200,000 per annum. Thomas Macklin (d. 1800) was a less public figure, but also a man of large ideas. Robert Bowyer (1758–1834) was a successful portrait painter who then turned to dealing in prints. These three publishers developed a new line in book illustration by commissioning paintings from leading artists, and exhibiting them in their galleries before publishing them as prints. These were enterprises that promised to be very successful, but were casualties of the Napoleonic wars and all ended in forced sales by the system of lottery. Impressive tomes had, however, been published before that time. The Boydell Shakespeare Gallery opened in 1789 with thirty-four pictures. When the Gallery was sold in 1805 there were 170 items. 'The Dramatic Works of Shakespeare revised by George Steevens' was published in nine folio volumes in 1802, and the following year two elephant folio volumes of plates only were produced.[3] Names such as Reynolds, Barry, Romney, West, Northcote, Opie, Joseph Wright,

[1] The publishers, John and his nephew Francis Newbery, were well known for their children's books. With Goldsmith they had a close and sometimes complicated relationship. John Newbery figures in *The Vicar of Wakefield* (Chapter 18) as 'The philanthropic bookseller in St. Paul's Churchyard, who has written so many little books for children: he called himself their friend, but he was the friend of all mankind.'

[2] John Forster's Essay in his *Life and Times of Oliver Goldsmith*, 1848, remains the best account of the book's impact.

[3] T. S. R. Boase, 'Illustrations of Shakespeare's Plays', *JWCI*, X, 1948, pp. 83–108; and W. M. Merchant, *Shakespeare and the Artist*, Oxford, 1959.

Hoppner, Matthew Peters, Wheatley, and J. C. Ibbetson are not associated with the supply of smaller-scale book illustration. Others such as Fuseli, Hamilton, Smirke, Stothard, Kirk and Westall were often used in producing it, and notices of their work will be found under their names.[1]

Macklin's Poets Gallery in Pall Mall showed a very similar team of artists, with the addition of Gainsborough, Maria Cosway, Henry Bunbury and William Artaud, but the twenty-four engravings, published in six parts between 1788 and 1799, formed a collection of plates not a book. Macklin's other great undertaking, his illustrated Bible, was published in seven folio volumes in 1800. Paintings were commissioned from Reynolds, West, Opie, Fuseli, Kauffman, Hamilton, Hoppner, Smirke and Westall. De Loutherbourg was much in evidence, a new name in this type of production. He figures also in Robert Bowyer's publication (1793–1801) in nine volumes of David Hume's *History of England*. Tresham, Hamilton, Opie, Fuseli, Smirke, Westall, Northcote and Maria Cosway were the other contributors. The paintings were all exhibited in Bowyer's house in Pall Mall. He had struggled to survive 'the impropitious times and circumstances respecting the Fine Arts' and had even secured some special trading privileges from Napoleon, but in the end, in 1807, his collection also had to be dispersed by sale.[2]

If most of these paintings seem today to belong to their period rather than to posterity, the engravings made from them are a striking testimony to English skill, and a justification of the international repute that it enjoyed. The engraver's task was now very different from that of, for instance, Gravelot when he worked on Hayman's Shakespeare drawings, prepared with engraving in view. There had of course been a long tradition of engraving from the paintings of the old masters, and Dorigny's team for the Raphael cartoons must in the early years of the century have developed the intermediate processes between the actual painting and the cutting on the block. This transference was now once more required of the engravers, and those employed by Boydell, Macklin and Bowyer, men such as Earlom, Tomkins, Ryder, Simon, Caldwell, Leney and Thew, often produced works more striking and atmospheric than the paintings on which they were based.

The collapse of the European market was fatal to these large scale schemes, and to the business of high quality single prints of 'history subjects'. The book trade was less affected particularly in works with a special English appeal. In 1801 John Britton (1771–1857) began production of his *Beauties of England and Wales*. There are new names in his team of artists, J. M. W. Turner among them. Britton remained faithful to copperplates, but

1 One man's activities stimulated interest in book illustration, and also complicated its later study. The Rev. James Granger (1723–76) published in 1769 his *Biographical History of England* illustrated with many plates. The habit of 'Grangerizing', adding plates to books, led to the mutilation of volumes to supply gaps in some major work. A notable example is the Huntington Library extra-illustrated set of Shakespeare's plays, begun in 1835 by Thomas Turner of Gloucester. The Boydell 1802 edition is here expanded to 44 volumes, including 3,000 prints and 740 drawings. Robert Bowyer, the print dealer, was another practitioner of Grangerizing and re-bound the Macklin Bible in 45 volumes with the insertion of some 6,000 engravings (now in the Bolton Public Library).
2 T. S. R. Boase, 'Macklin and Bowyer', *JWCI*, XXVI, 1963, pp. 145–77.

already some engravers, Charles Warren and Abraham Raimbach, were experimenting with steel plates so as to have a more durable medium, allowing of a greater number of impressions. It was not till the second decade of the nineteenth century that steel engraving became a practical proposition, but some artists, notably Stothard, were to bridge the change from copper to steel, and see their work reproduced with a new sharpness of line and a certain loss in subtleties of tone.

BOOKS ILLUSTRATED IN ENGLAND IN THE EIGHTEENTH CENTURY BY KNOWN ARTISTS

'ILLUSTRATED' is here taken as meaning 'designed by', and where no further details are given the illustrations are drawn or painted by the artist under whom they appear. The normal form used is 'del.' (*delineavit*) for the drawing from which the plate was engraved, and the alternative term 'inv.' (*invenit*) implies some less direct relationship between designer and engraver, such as the illustration being based on a painting and not specially drawn for engraving. This was particularly common in the case of portrait frontispieces, often based on much earlier paintings. The use of these terms is, however, not all precise. Hayman for instance often signs 'inv. et del.', but in the Hanmer *Shakespeare* of 1744 signs 'inv.' only, though his drawings for Gravelot's engraving are extant. 'Fec.' (*fecit*) is another term used, generally for some process such as aquatint where the gravure was not used and 'sculp.' (*sculpsit* = engraved) would not be appropriate, but at times it seems to cover some inclusive responsibility for the production of the plate. Where the engraver signs the illustration his name is, as far as possible, given. In the earlier part of the century many engravers, such as Gravelot, made their own designs, but gradually the gap between designer and engraver widened. Titles of books are given fairly fully. Sometimes they run to inordinate length, but they suggest the types of subject that attracted illustration. In many cases I have included the address of the publisher or bookseller as of some topographical interest. Plays constantly include in the title the name of the theatre at which they are 'now being performed': in the interest of brevity this full statement has been reduced to the name of the theatre given in brackets. There are several categories of books that were a source of employment and stimulus for engravers, but which are here only represented by a few examples, as the designs for them were on the whole not the work of the genuine illustrators, men who were interpreting imaginative work, but rather the recording of things seen. Chief amongst these categories are technical, particularly anatomical, works; architecture; archaeology, with its reproductions of ancient buildings and works of art; travel and topography, with a steadily increasing list of *Tours* illustrated by landscape views. Portraits, seldom new designs, are also not included, though much used as frontispieces.

In a very large number of illustrated books the designer is not known. A short and very selective list of these anonymous works is given, but they lie outside the present purpose of this work, and any attempt at comprehensiveness would present problems far beyond those of signed prints. With them the problems are great enough: plates were re-used from edition to edition and often recut; one library will have one edition, another a later or earlier one; plates have often been removed; sometimes, particularly with plays, editions of various dates have been republished in a compilation; large collected editions, running to many volumes, of poets, dramatists and novelists became very popular in the

later part of the century, but all too often sets of them are incomplete. There are detached plates and drawings for plates unidentifiable with any book. Groups of artists worked together on some volumes, where amid anonymous products one small vignette may unexpectedly be signed. Few older library catalogues even state whether or not a book is illustrated, far less the artists' names. Survival has been very random. On the shelves of country houses and college libraries there must be many eighteenth-century books that have escaped Dr. Hammelmann's notice and my later, far less exhaustive, researches. I am well aware that there are unfilled gaps, and that some of them may be conspicuous. But at least the trends in illustrations are there, and something of the men who did them, and of the trade for which they worked; and the recurrence of certain unfamiliar titles, obviously in much demand, may send some readers back to explore texts so much appreciated by our ancestors.

Where several artists supplied illustrations for an edition, a cross-reference is given to the artist under whom the particulars of publication are stated.

R.A. (possibly Robert Adam). See under **R**

William ALEXANDER, 1767-1815

The son of a coach-maker in Maidstone, he was apprenticed to William Pars and in 1784 was admitted to the Royal Academy Schools. He was with Lord Macartney's mission in China 1792-4. His drawings were engraved for Sir George Staunton's account of the Chinese embassy, and he also illustrated various other books of travel in China and the Pacific. In 1808 he became the first keeper of prints and drawings in the British Museum.

1798 David Collins, *An Account of the English Colony in New South Wales*. 2 vols. 4to. 'T. Cadell, Jun. & W. Davies'. Views eng. by James Heath [presumably from drawings made on the spot, possibly by the author: a typical example of the re-working of drawings made on travels.] Vol. II has an elaborate front.: Aborigines round a camp fire, 'W. Alexander del., T. Powell sculp.' 4 colour pls. of birds and a wombat by S. J. Neale.

1797 Sir George Staunton, Bart. *An Historical Account of the Embassy to the Emperor of China*. 8vo. 'For John Stockdale.' Front. 'Stothard delt. Grignion sculp.', title-vig. 'Burney delt. Dadley sculpt.', and 25 pls. by various engravers, 10 s. 'Alexander delt.'

David ALLAN, 1744-96

Born at Alloa, near Edinburgh, he studied at the Glasgow Academy, and from 1764 to 1777 was in Rome, where he was chiefly known as a history painter. In 1781 Paul Sandby engraved in aquatint four of Allan's drawings of the Carnival in Rome, and when the latter settled in Edinburgh as director of the Edinburgh Academy of Arts, he devoted some of his time to etching and engraving. His figures typifying *The Seasons* are neo-classical in aim; his aquatints for *The Gentle Shepherd* are genre scenes and not very successful examples of the medium. He also provided designs for several Scottish song books, generally engraved by Paton Thomson. These were frequently republished.

1778 James Thomson, *The Seasons*. 8vo. 'For John Murray, No. 32 Fleet Street.' 4 pls. of pseudo-classical figures. [see also Hamilton.]

1788 Allan Ramsay, *The Gentle Shepherd*. Folio. Reissued 1796 'for Andrew Foulis, Glasgow.' Front.: portrait 'ad viv. del.' and 12 pls. 'invt et aq. fecit.' A drawing for 1 of the pls. is bound into the 1796 ed. in the Hunterian

Library, Glasgow; other drawings are in the National Gallery of Scotland. See *Book Collector*, XVI, 1967, p. 169.

n.d. George Thomson, *A Select Collection of Original Scottish Airs for the Voice*. 2 vols. Folio. 'By T. Preston.' Front. Vol. II eng. P. Thomson.

James ALLEN, *fl.* 1793-1831

He was employed by Cooke on his *Pocket Editions* (1793-4: see under Corbould), but his best work is after 1800. In *Cooke's Novelists* he designed two plates for *Robinson Crusoe*, engraved by Grainger and Satchwell, and one plate for Smollett's *Humphry Clinker*, engraved by Saunders.

Charles ANSELL, *fl.* 1784-95

He was best known for his animal paintings, but also for scenes of contemporary life. He provided some designs for the fifth volume of:

1792-5 *The Bon Ton Magazine; or Microscope of Fashion and Folly*. 5 vols. 8vo. 'By W. Locke, No. 12 Red Lion Street.'

1788-91 *Shakespeare's Plays* [see under Corbould]. 4 pls. eng. Geo. Walker, Goldar, Barlow, Page.

1796 John Baxter, *A New and Impartial History of England*. 'Printed for the Proprietors.' 2 pls. Baxter describes himself as a 'Member of the London Corresponding Society, and one of the Twelve Indicted and Acquitted of High Treason at the Old Bailey'. The *History* was in fact suppressed. (See T. S. R. Boase, *JWCI*, XXVI, 1963, pp. 173-4.)

C.W.B. (probably Copp Warre Bamfylde). See under **C**

John James BARRALET, d. *c.* 1812

Born in Ireland of French descent, he settled first in Dublin and then in London, where he made a name for tinted landscape drawings. In 1795 he emigrated to Philadelphia, where he remained till his death.

1778 *Dramatick Works of Beaumont and Fletcher* [see M. A. Rooker]. 19 pls. by various engravers.

1780 Salomon Gessner, *The Death of Abel, in five books attempted from the German [by Mary Collyer] . . . embellished with an elegant engraving to each book*. 12th ed. 12mo. 'For J. Collyer, No. 7 in White Lion Row, Islington,

by J. Dodsley.' Front., title-vig. and 4 pls. eng. J. Collyer.

Francesco BARTOLOZZI, 1725–1815

Born in Florence, he came to England in 1764 and became one of the early engraver members of the Royal Academy. In collaboration with William Wynne Ryland he popularized the stipple method of engraving, and went on to experiment with colour-printing, though this was mainly used for single plates rather than book illustration. Angelica Kauffman was a keen advocate of the process, and her designs were used for many of the plates. Later Bartolozzi was much patronized by Reynolds. He formed a large studio, and although some of its output was not of a high standard, Thomas Burke (1749–1815) and Peltro William Tomkins (1760–1840) were distinguished practitioners in the colour-print business. Bartolozzi did little designing himself.

Lady Diana BEAUCLERK, 1734–1808

The eldest daughter of the second Duke of Marlborough, she married in 1757 Frederick St. John, second Viscount Bolingbroke. In 1768 she was divorced by act of Parliament, and immediately married Topham Beauclerk, the friend of Dr. Johnson. Her paintings were much praised by Horace Walpole and Reynolds. In book illustration she was twice commissioned by Edwards and Harding, and her plates for Bürger's *Leonora* (which had only a year before had an elaborate illustrated edition from another publisher) are examples of the new taste for romantic subjects. The prominent position given to her name on the title-pages showed that her aristocratic standing was not without publicity value.

1796 Gottfried August Bürger, *Leonora*. [trans. by W. R. Spencer.] *With designs by the Right Honourable Lady Diana Beauclerk.* Folio. 'For J. Edwards and E. and S. Harding, Pall Mall.' Front., 2 headpieces and 2 tailpieces, eng. Bartolozzi. 4 pls. eng. Harding and Birrell.

1797 John Dryden, *Fables ancient and modern. Ornamented with engravings from the pencil of the Right. Hon. Lady Diana Beauclerk.* Folio. 'Printed by T. Bensley for J. Edwards No. 77 and E. Harding No. 98 Pall Mall.' 8 pls. eng. Bartolozzi, Cheesman, W. N. Gardiner and Vanderburg. 8 headpieces eng. Bartolozzi.

Charles BENAZECH, 1767–94

His father, Peter Paul Benazech, was English by birth, but worked mainly in Paris. Charles studied in Rome and was in Paris in the early days of the Revolution. He exhibited at the Academy in 1790 and 1791.

1793 Samuel Richardson, *Clarissa Harlowe* [see under Chalmers]. 1 pl. eng. Charter.

Richard BENTLEY, d. 1782

Son of Dr. Bentley, Master of Trinity College, Cambridge, and friend of Horace Walpole, for whom he made six designs for *Poems by Mr. T. Gray*, published in folio by R. Dodsley in 1753, and engraved by J. S. Müller and C. Grignion. (Plate 22.) These plates are an extraordinary and skilful combination of classical river gods, rococo lightness, and Strawberry Hill Gothic. A letter from Gray to Dodsley of 12 February 1753 states: 'I desire it may be understood . . . that the verses are only subordinate and explanatory to the Drawings.' Gray may have been unnecessarily modest about his part (the text includes 'A Long Story'), but Bentley's designs achieved an instant reputation; they were a turning-point in British decorative art.

Peter BERCHET or BERCHETT, 1659–1720

A Frenchman, employed by William III to paint his palace at Loo in Holland, he then settled in England, living at Marylebone. He was mainly employed in wall and ceiling paintings. An example is at Trinity College, Oxford. See Croft Murray, *Wall Painting*, I, 1962, p. 65.

[1707?] M. H. Bononcini, *The Additionall Songs in the . . . Opera call'd Camilla.* Folio. 'By I. Walsh at the Golden Harp at Ho-boy in Catherine Street.' Title-page: Apollo, 'Berchet inventor, H. Hulsbergh sculpsit'.

n.d. G. F. Handel, *3rd Book Apollo's Feast . . . being a well chosen Collection of Songs and of the latest operas composed by Mr. Handel.* Folio. 'For I. Walsh and I. Hare.' Front. eng. H. Hulsbergh.
Henry Hulsbergh was a Dutchman who settled in England.

Thomas BEWICK, 1753–1828

Born at Eltringham, Northumberland, the son of a tenant collier and farmer, he was apprenticed in 1767 to Ralph Beilby, a Newcastle metal engraver. Put to every kind of work in the shop, he eventually became more skilled than his master in the handling of end-grain engraving on wood. Much of his early work was for chapbooks and children's books pro-

duced by Charnley and Sant of Newcastle. The first sure evidence of his brilliance as a creative 'white-line' engraver of his own designs appears in Sant's *Fables by the Late Mr. Gay*, 1779, and *A Pretty Book of Pictures* of the same year. In 1776 he went to London, where he was much helped by Thomas Hodgson and by Isaac Taylor who urged him to settle there.[1] But after nine months he returned north and was persuaded to join his former master in partnership. In 1790, while continuing to earn his living as a metal engraver—bank notes, door plates, bill heads and arms and initials on silver were his main occupation—Bewick published his *General History of Quadrupeds*. With help on the text from Beilby, he had engraved on wood, mostly in his spare time, 200 figures of animals and 103 vignettes and tail-pieces. In 1797, the first volume (Land Birds) of his celebrated *History of British Birds* was published, to be followed in 1804 by the second volume (Water Birds). For this he engraved 218 figures of birds and 227 vignettes. Beilby assisted again with the text of the first volume, but the break-up of the partnership in 1797 left Bewick to write the descriptions of the Water Birds on his own. In these works Bewick's artistry reaches its highest point. He had many apprentices and was sometimes assisted by them in his major works—his younger brother John (d. 1795), Charlton Nesbit (1775–1838), Luke Clennell (1781–1840) and William Harvey (1796–1866). John Johnson (d. 1797), and in particular, Robert Johnson (1770–96) whom he trained in draughtsmanship and water-colour painting provided a number of subjects for him and coloured a good many of his preliminary drawings. (See David Croal Thomson, *The Water-Colour of Thomas Bewick*, 1930; Reynolds Stone, *Wood Engravings of Thomas Bewick*, 1953; Iain Bain in *Book Collector XXI*, 1972, pp. 95–105.)

1779 John Gay, *Fables by the late Mr. Gay.* 12mo. T. Sant, Newcastle. 79 cuts (12 of them repeated tail-pieces). Several subsequent editions, Newcastle and York.

1779 *A Pretty Book of Pictures for Little Masters and Misses, or, Tommy Trip's History of Beasts and Birds* Square 24mo. T. Sant, Newcastle. 62 cuts.

[1] In an autograph letter of 18 August 1806 (MS. quotation taken from 'a booksellers catalogue') Bewick wrote to Taylor: 'After the slipping away of nearly 29 years . . . it may be supposed I have forgotten you . . . I was then in the hey-day of youth, completely like a wild colt . . . regardless of money-making, heedless of the future.' (He sends him his two volumes of *British Birds*.)

1784 *Select Fables, in three parts. Part I, Fables extracted from Dodsley's; Part II, Fables with Reflections, in prose and verse; Part III, Fables in Verse . . .* 12mo. T. Sant, Newcastle. 142 cuts.

1794 Oliver Goldsmith, *The Poetical Works of Oliver Goldsmith, M.B. complete in one volume. With the Life of the Author.* 12mo. D. Walker, Hereford. 5 'vignettes designed and engraved on wood by T. Bewick'.

1795 Oliver Goldsmith and Thomas Parnell, *Poems by Goldsmith and Parnell.* Royal 4to. W. Bulmer, Shakspeare Printing Office. 13 cuts (8 vigs, 5 pls) des. Richard Westall, Thomas and John Bewick, Robert and John Johnson, and engraved by the two Bewicks.

1796 William Somerville, *The Chace. A Poem.* Royal 4to. W. Bulmer, Shakspeare Printing Office. 13 cuts (all but one designed by John Bewick and engraved by Thomas Bewick; the final tail-piece cut by Charlton Nesbit).

1796 J. B. Le Grand d'Aussy, *Fabliaux or Tales, abridged from French manuscripts of the XIIth and XIIIth centuries by M. Le G[rand] selected and translated into English verse* [by Gregory Lewis Way] . . . 2 vols (Vol. II, 1800). Super Royal 8vo. Sold by R. Faulder, printed by W. Bulmer at the Shakspeare Printing Office. 51 cuts by Thomas and John Bewick, and Charlton Nesbit, for the most part after sketches by G. L. Way.

1796 *The Blossoms of Youth.* 8vo. 'For E. Newbery.' Headpieces des. John Bewick.

1797 John Gay, *The Fables . . . with cuts by T. Bewick of Newcastle.* 12mo. 'Printed by Wilson Spence and Mowman of York.' Front.: Gay's tomb, and 74 head- and tailpieces.
First appeared in 1779 with anonymous cuts by Bewick.

1798 Oliver Goldsmith, *The Vicar of Wakefield. Embellished with woodcuts by T. Bewick.* 8vo. 'For D. Walker, Hereford.'

George BICKHAM, d. 1769

George BICKHAM Junior, d. 1749

The Bickhams, father and son, were very active in the first half of the century, and seem to have built up a considerable business, engraving portraits and works of the Old Masters, producing illustrations

for books and eventually publishing some under their own name. They dealt largely in textbooks for schools, many written by Daniel Bellamy, whose kinswoman, Mrs. Martha Bellamy, ran a young ladies' boarding school; their most ambitious work was *The Musical Entertainer*. Primarily engravers, they also designed some of the prints from books in which they were involved. A variety of abbreviations are used to indicate their part in the work: *d. fec. inv.* and even *des.* They certainly adapted freely the works of other artists, but had some talent in designing of their own. Several other members of the family seem to have been employed. P. Bickham signs the title-page vignette in *The Bee*, and John Bickham compiled the *Fables and Other Short Poems*. A plate in *The Musical Entertainer* is signed 'Frater G. B. jun. sc.' George Bickham senior became a member of the Free Society of Artists in 1763, and in 1767 sold his stock in trade and retired to Richmond.

1723 D. Bellamy, *The Young Ladies Miscellany; or Youth's innocent and rational amusement. . . . Adorned with cuts.* 'Written for the particular diversion and improvement of the Young Ladies of Mrs. Bellamy's school, in Old Boswel-Court, near Temple Bar.' 12mo. 'By E. Say for the author.' Front. eng. Bickham after Cheron; the 2 other pls. are unsigned, and are probably 'invented' by Bickham.

1733 *The Young Clerks Assistant; or, Penmanship made Easy, Instructive but Entertaining, being a Compleat Pocket-Copy-Book curiously Engraved for the practice of Youth in the Art of Writing.* 8vo. 'For Richard Ware.' Front. eng. G. Bickham; pl. eng. Bickham after Cheron.

1733 *The Bee: or, Universal Weekly Pamphlet containing something to hit every Man's Taste and Principles.* 9 vols. 4to. 'By W. Burton for Richard Chandler and Caesar Ward.' Title-page vig.: a beehive, s. 'P. Bickham'.

[1735] John Bickham, *Fables and other short poems collected from the most celebrated English authors. The whole curiously engraved for the practice & amusement of young gentlemen and ladies, in the art of writing.* 3 Pts. 8vo. 'Printed and sold by William and Oliver Dicey at the Printing Office in Bow Church Yard.'

1736 Nathaniel Gifford, *The Tales and Fables of the late Archbishop of Cambray,* [Fénelon], *author of Telemachus, in French and English. Written originally for the Instruction of a Young Prince; And now publish'd for the Use of Schools. With a particular and curious Relation of the Method observed in training up the young Prince, even from Infancy, to Virtue and Learning.* 8vo. 'For John Hawkins and sold by John Osborn [reprinted in 1780].' 28 pls. des. and eng. George Bickham Jnr.
The book is dedicated by Gifford to his 'kinswoman Mrs. Martha Bellamy Governess of the Young Ladies Boarding School at Kingston upon Thames' and contains a full-page advertisement for the school, including fees.

1737–8 *The Musical Entertainer:* engraved by George Bickham Jnr. 2 vols. Folio. Vol. I [issued in fortnightly parts of 4 pls. each, starting 1 March 1737] sold by George Bickham at his house; Vol. II 'T. Cooper, at the Globe, Paternoster Row.' A later issue was in the name of Charles Corbett. Several of the 200 pls. are signed d. or fec. by the Bickhams: 7 are after Gravelot (q.v.), 1 is s. 'Watteau inv.' Many of the pls. are certainly based on earlier works; even Gravelot borrows heavily from Correggio's *Danae*; but as a whole it is a highly stylish production.

1739–40 D. Bellamy and D. Bellamy Jnr., *Miscellanies in Prose and Verse, consisting of dramatick pieces, poems, humorous tales, fables etc.* 2 vols. 12mo. 'For J. Hodges.' Pls. 'inv. et fec.' G. Bickham [some taken from Bellamy's *Young Ladies Miscellany* of 1723].

1740 John Williamson, *The British Angler: or, a pocket companion for gentlemen-fishers, being a new and methodical treatise of the art of angling; comprehending all that is curious and useful in the knowledge of that polite diversion . . . Embellished with copper-plates curiously engraved. The whole compiled from approved Authors of above 30 years of experience.* 12mo. 'For J. Hodges.' Front. 'inv. et sculp.' G. Bickham, and 3 folding pls. of fishes eng. Cole.

1742 George Bickham Jnr., *Deliciae Britannicae; or the Curiosities of Hampton Court and Windsor Castle.* 12mo. 'Printed for T. Cooper and G. Bickham jun.' Portrait of Raphael eng. G. Bickham jnr. and also views of Hampton Court and Windsor Castle in rococo frames; 9 pls. by Gravelot all 'G. Bickham sculpt.'

1743 D. Bellamy Jnr., *Youth's Scripture-Remembrancer or Select Sacred Stories by Way of*

Dialogue. 8vo. 'For J. Robinson, H. Chapelle and J. Leake.' Front. 'G. Bickham fec.'

1747 George Bickham Jnr., *The Oeconomy of Arts; or a Companion for the Ingenious.* 8vo. 'For G. Bickham.' A textbook on drawing, writing and painting with 50 double-page prints.

William BLAKE, 1757–1827

In 1772 the young Blake was apprenticed to the engraver, James Basire (1730–1802), son of Isaac Basire (1704–68), who was much employed as an engraver in the mid-century. James carried on the traditional techniques of copperplate, and it was in this that Blake was trained. His master set him to make drawings of medieval antiquities, particularly in Westminster Abbey for Richard Gough's *Sepulchral Monuments in Great Britain*, and also for *Archaeologia* and *Vetusta Monumenta*. In Basire's studio he met many of the leading engravers, particularly Woollett, and later criticized their atmospheric style as opposed to the 'firm, determinate outline' in which he was trained. After his apprenticeship, he was employed as an engraver by several of the booksellers. In 1779 he made his first engraving after Stothard and for the next few years engraved several of Stothard's designs for, among other works, *The Novelist's Magazine*, plates that include some of Stothard's best work, and certainly owe something to the engraver, as was later to be the case when Blake worked on Flaxman's drawings. He was designing as well as engraving, and in 1789 he printed by his new methods the first of his own works, *The Songs of Innocence*. The illustration of the *Prophetic Books* occupied him till 1798, and in their treatment of the whole page as a unified design, in itself a return to medieval practice, they mark a new departure in book illustration. These works, however, produced in small, hand-coloured numbers, lie outside the main course of the book trade, and have a large literature of their own. They require no further comment here.

See A. G. B. Russell, *The Engravings of William Blake*, 1912; and Charles Ryskamp, *William Blake: Engraver*, 1969.

1780–2 *The Royal Universal Family Bible.* 4to. 'For Fielding and Walker'. 6 pls. eng. Blake, of which one (for part 92) des. by him.

1786 Richard Gough, *Sepulchral Monuments in Great Britain.* Vol. I Pt. I and [1796] Vol. I Pt. II. Folio. 'Printed by J. Nichols for the author.'

A number of the pls. are based on Blake's drawings, and he is probably also the engraver of some bearing Basire's signature.

1786 Thomas Commins, *An Elegy Set to Music.* 'Printed and sold by J. Fentum No. 78, Corner Salisbury St., Strand.' Vig. on cover 'W. Blake delt. et sculpt.'

1789 *Vetusta Monumenta.* Vol. II. Folio. 'J. Nichols, for the Society of Antiquaries.' 7 pls. probably by Blake, s. Basire.

1791 Mary Wollstonecraft, *Original Stories from real life.* 12mo. 'For J. Johnson, No. 72 St. Paul's Church-Yard.' 6 pls. des. and eng. Blake.

1793 John Gay, *Fables . . . embellished with seventy plates.* 8vo. 'For John Stockdale, Piccadilly.' None of the pls. is s. by the designer, but they are free adaptations from the pls. of Kent and Wooton in the ed. of 1727. Those s. 'Blake sc.' are undoubtedly re-des. by him. See G. Keynes, *Book Collector*, XXI, 1972, pp. 59–64.

1796 Gottfried August Bürger, *Leonora*, [trans. by J. F. Miller.] 4to. 'For W. Miller, Old Bond Street.' Front., head- and tailpiece 'Blake inv., Perry sc.'

1797 Edward Young, *The Complaint, and the Consolation; or, Night Thoughts.* Folio. 'Printed by R. Noble for R. Edwards, No. 142 Bond St.' 43 marginal illustrations des. and eng. Blake.

Some of Blake's engravings were after sketches made by travellers, and owe much to his interpretation of them, as for example:

1793 J. Hunter, *An Historical Journal of the Transactions at Port Jackson and Norfolk Island.* 4to. Pl.: a Family of New South Wales, after a drawing by Governor King.

1796 Capt. J. G. Stedman, *Narrative of a five years expedition against the revolted Negroes of Surinam.* 4to. 'For Johnson and Edwards.' 13 pls. eng. Blake, several of them showing the punishments meted out to the slaves. See B. Smith, *European Vision and the South Pacific*, Oxford, 1960, pp. 128–9; D. V. Erdman, 'Blake's Vision of Slavery', *JWCI*, XV, 1952, pp. 242–52.

Nicholas BLAKEY, *fl.* 1749–53

Born in Ireland and died in Paris. He co-operated

in several volumes with Hayman, working in a somewhat similar style. His widow Elisabeth died in 1770.

1749 Bernard Siegfried Albinus, *Tables of the Skeleton and Muscles of the Human Body . . . Translated from the Latin.* Atlas folio. 'For John and Paul Knapton.' Oblong title-piece: dissection scene, 'N. Blakey inv. et del., G. Scotin sculpt.' Other anatomical plates eng. Grignion, Ravenet, Scotin, and L. P. Boitard.

1749 Alexander Pope, *The Dunciad.* 8vo. 'Published by Mr. Warburton, for J. and P. Knapton.' Front. eng. Grignion.

1751 John Brown, *Essays on the Characteristics.* 8vo. 'For C. Davis.' Front. eng. Grignion.

1751 *The Works of Alexander Pope* [see under Hayman]. Front. Vol. III and 23 pls. eng. Grignion.

1753 Jonas Hanway, *An Historical Account of the British Trade over the Caspian Sea* [see under Hayman]. Front. Vol. II, 'Blakey del. Ravenet sculp.'

1753 J. H. Merchant, *The Revolution in Persia* [see under Hayman]. Front. Vol. II, 'Blakey delin., Major sculp.'

François BOITARD, *c.* 1670–*c.* 1717

In a colophon to a book of drawings (on the London market some years ago) Boitard complains that in London 'the poor Painter and Designer' is left 'to die of hunger'. He seems to have been in London in the first decade of the century. He was employed by Tonson to illustrate the works of Beaumont and Fletcher, where six of the prints are signed by him, either *del.* or *inv*. The rest of the plates appear to be also by him, and his hand can again be found in the Tonson edition of Shakespeare of 1709. In both cases Elisha Kirkall was employed as engraver.

1709–10 Shakespeare, *The Works. Adorn'd with cuts. Revis'd and corrected . . . By N. Rowe Esq.* 7 vols. 8vo. 'For Jacob Tonson.' The pls. are unsigned, but many can be attributed to François Boitard on comparison with his signed plates in Tonson's *Beaumont and Fletcher.* (Plate 3).
See Montague Summers, 'The First Illustrated Shakespeare', *Connoisseur*, CII, 1938, pp. 305–9.

1711 Beaumont and Fletcher, *The Works . . . in seven volumes. Adorn'd with cuts.* 8vo. 'For Jacob Tonson at Shakespear's Head over against Catherine Street in the Strand.' Six pls. s. 'F. Boitard delin. or inv.,' several s. 'E. K. [Elishah Kirkall] sculpt.'
See H. A. Hammelmann, 'Shakespeare's First Illustrators', *Notes on British Art*, Paul Mellon Foundation, 1968, N.11, pp. 1–4; reprinted supplement *Apollo*, August 1968.

1712 W. Rose, Rector of East Clandon, Surrey, *The History of Joseph. A Poem in Six Books.* 8vo. Pls. eng. E. Kirkall.

Louis Philippe BOITARD, d. *c.* 1760

Son of François, he settled in England and married an English wife. He was much employed by the book trade, but also drew slightly caricatured scenes of contemporary London life.
See H. A. Hammelmann, *CL*, CXXVI, 1959, pp. 356–7.

1734 William Howell, *Medulla Historiae Anglicanae. The ancient and present state of England . . . Continued by an impartial hand to the death of his late Majesty King George I . . . Ninth edition, illustrated with Sculptures.* 8vo. 'For J. J. and P. Knapton,' et al. Front. eng. E. Kirkall, 12 pls. unsigned except 1 'eng. J. Cole.'

1735 George Lillo, *The London Merchant: or, the history of George Barnwell.* 12mo. 'For John Gray.' Front.: Barnwell and Millwood at place of execution, des. and eng. Boitard. 6th ed. The 1st and 2nd eds. are not illustrated. The pls. were used reversed in 1737 and again in 1743.

1745 [Eliza Haywood] *The Female Spectator.* 4 vols. 8vo. 'By T. Gardner.' Front. Vol. II des. and eng. Boitard. 2nd ed. 1748, 5th 1755, 9th 1771.
See under Bonneau and Wale 1771.

1746 *The Sufferings of John Custos for Free Masonry and for his refusing to turn Roman Catholic in the Inquisition at Lisbon . . . enriched with Sculptures, designed by Mr. Boitard.* 8vo. 'By W. Strahan for the Author.' Portrait of Custos by Boitard, eng. Truche and 3 folding pls. of scenes of torture.

1747 Joseph Spence, *Polymetis: or, an enquiry concerning the agreement between the works of the Roman Poets and the remains of the Ancient Artists.* Folio. 'For A. Dodsley at Tullys Head,

Pall Mall.' Portrait of author after Isaac Whewel eng. G. Vertue. Many engravings of ancient works of art, s. L. P. Boitard sculp.

1749 *The Works of the Most Celebrated Minor Poets.* 2 vols. 8vo. 'For F. Coglan,' Title-vig. and headpieces des. and eng.

1749 [W. Duff], *A New and Full, critical, Biographical and geographical history of Scotland . . . to the present time.* [But it ends in fact in 1577] *By an Impartial Hand.* Folio. 'For the author.' 6 pls. des. and eng.

1749 John Gilbert Cooper, *The Life of Socrates, collected from . . . Xenophon . . . Plato etc.* 8vo. 'For R. Dodsley.' Portrait front. and 5 headpieces 'inv. et sculp.' Boitard.

1751 [Robert Paltock], *The Life and Adventures of Peter Wilkins, a Cornish Man: Relating particularly his Shipwreck near the South Pole, etc.* 2 vols. 8vo. 'For J. Robinson and R. Dodsley.' 6 pls. des. and eng.

1751 [R. O. Cambridge], *The Scribleriad* [see under Gravelot and Wale]. 5 pls. 'L. P. Boitard inv. et sculp.'

1751 Ralph Morris, *A Narrative of the Life and Astonishing Adventures of John Daniel, a Smith at Royston . . . Also a description of a most surprising engine, invented by his son Jacob, on which he flew to the moon. Illustrated with several copper plates by Mr. Boitard.* 12mo. 'For M. Cooper.' Folding pl. of the flying machine and 3 others.

1751 W. Whitehead, *An Hymn to the Nymph of Bristol spring.* 4to. 'For R. Dodsley and sold by M. Cooper.' Title-vig., head- and tailpieces s. Boitard 'sculp.' or in one case 'fecit'.

1752 *The Court of Queen Mab . . . Select Collection of Tales of the Fairies.* 8vo. 'Sold by [Mrs.] M. Cooper in Paternoster Row.' Front. 'L. Boitard sculp', but probably also des. by him.

1753 W. Bingfield, *The Travels and Adventures of William Bingfield, Esq., containing as surprizing a fluctuation of circumstances, both by sea and land as ever befel one man . . . Printed from his own manuscript. With a beautiful frontispiece.* 2 vols. 12mo. 'For E. Withers and R. Baldwin 1753.' Folding front. s. 'Boitard fecit.'

1754 J. Scott, *The Pocket Companion and History of Free-Masons.* 12mo. 'For J. Scott, sold by R.

Baldwin.' Front.: Masons' Meeting, s. 'I. S. [probably J. Scott] inv., L. P. Boitard del.'

1754 Daniel Bellamy, *The Family Preacher: consisting of practical discourses for every Sunday throughout the year.* 2 vols. 8vo. 'By W. Faden for T. Bellamy, Bookseller at Kingston.' Front.: a family listening to the book read by the father, eng. Scotin, repeated in Vol. II.

1755 *The Voice of Truth, An Ode to His Royal Highness the Prince of Wales.* 4to. 'For M. Cooper.' Large title-vig. 'Boitard fecit'.

1758 *The Gentleman's New Memorandum Book . . . Journal, for the Year 1758.* and *The Ladies' New Memorandum Book.* Frontis. Examples of Dodsley's new memorandum books: see Ralph Straus, *Robert Dodsley,* 1910, p. 336.

1767 [E. Young], *The Works of the Author of the Night-Thoughts revised and corrected by himself. A new edition.* 12mo. 'For Millar, Tonson and Many others.' Front. 'L. P. Boitard inv. et sculp.' 2 pls. by Hayman and Wale, both previously used.

1767 James Anderson, revised by John Entick, *The Constitutions of the Antient and Honourable Fraternity of Free and Accepted Masons.* 4to. 'For W. Johnston in Ludgate Street.' Front. 'Boitard delin, B. Cole sculp et dedit.'

Daniel BOND, 1721–1803

He was mainly associated with Birmingham, where he conducted the decorative branch of a manufactory. He obtained the Royal Society of Arts premiums in 1764 and 1765 for landscape.

1764 William Shenstone, *The Works in Verse and Prose . . . With decorations.* 2 vols. 8vo. 'For R. and J. Dodsley.' Front., title-vig., 5 large headpieces and 2 tailpieces, of which only the last is s. 'D. Bond del., C. Grignion sculp.'

Jacob BONNEAU, d. 1786

He was the son of a French engraver, who practised in London. A member of the Incorporated Society of Artists, he exhibited at the Academy between 1770 and 1784. He contributed plates to the fifth edition of *The Female Spectator* (1755) which he signs 'fecit': one after S. Wale 'invt.' (see under Boitard 1745 and Wale 1771). In 1741 according to Sturt he engraved the heads of the *American Buccaneers,* prefixed to their history by

Exquemeling.[1] Sturt calls him 'a very indifferent engraver', but a manuscript note in the Bodley copy (by Douce) describes the Buccaneer plates as 'not badly executed after Fournier's designs' (Daniel Fournier d. *c*.1766).

Thomas BONNOR, *fl.* 1767–1812

He was mainly known as a topographical designer and engraver. He published the *Copper-plate Perspective Itinerary*. Redgrave calls him 'Bonner', but the plates are clearly signed 'Bonnor'.

1767 T. Bridges, *Homer Travestie: Being a new Burlesque Translation. Second edition, improved.* 2 vols. 12mo. 'For S. Hooper'. 2 fronts., 2nd eng. A. Smith.

1773 Henry Fielding, *The History of Tom Jones, a Foundling.* 12mo. 'For W. Strahan et al.' 4 fronts. des. and eng. T. Bonnor.

1791 Rev. J. Collinson, *The History and Antiquities of the County of Somerset.* 4to. 3 vols., 'By R. Cruttwell for C. Dilly, T. Longman et al.' Pls.: churches, gentlemen's seats etc., drawn and eng. T. Bonnor.
This is a fine and characteristic example of the topographical work of the period.

Charles BROOKING, 1723–59

Best known for his marine paintings, some of which were engraved as plates. He does not seem to have been much employed by the book trade, but his early death at the age of thirty-six came when his reputation was beginning to grow.

1755 John Ellis, F.R.S., *An Essay towards the Natural History of the Coralines and other marine productions of the like kind . . .* 4to. 'Printed for the Author by R. and J. Dodsley et al.' Front.: seashore scene, 'Brooking del. and A. Walker sculpt.' Various plans and technical plates.

Mather BROWN, 1761–1831

Born in Boston, he went to Europe about 1780, and settled in London, studying with Benjamin West. He exhibited regularly at the Royal Academy, and painted *Bolingbroke Offering the Crown to Richard II* for the Boydell Gallery.

1788 Shakespeare, *Dramatic Writings* [see under Burney]. There is a drawing in the Hunting-

ton Library for *The Two Gentlemen of Verona* in the format of this edition, but no print of it is known.

William H. BROWN, 1748–1825

In early life he was employed in Russia as a 'gem sculptor'; he then went to Paris, where he was employed at the court of Louis XVI. At the Revolution he came to England. He continued as a gem engraver, but also as an engraver of prints.

Cooke's Pocket Edition of Novels: [see under Corbould] Treyssac de Vergy, *Henrietta.* 1 pl. eng. Hawkins; *Chinese Tales.* 1 pl. eng. Hawkins.

1796 Cooke's *Pocket Edition of English Poets:* [see under Corbould] *Milton.* 1 pl. eng. Strange.

1796 *Cooke's Pocket Edition of Sacred Classics:* [see under Corbould] *Pilgrim's Progress.* 1 pl. eng. C. Warren.

M. BROWNE

1795 [Thomas Day], *The History of Sandford and Merton, a work intended for the use of children.* 3 vols. 12mo. 'For John Stockdale, Piccadilly.' 'M. Browne del., W. Skelton sculp'.

Henry William BUNBURY, 1750–1811

He was an amateur who occasionally exhibited at the Academy. He had something of a reputation for his humorous drawings. He contributed a plate to *Macklin's Poetry Gallery* and his twelve plates for *An Academy for Young Horseman* (1791) were etched by Rowlandson. In 1792 Nicholls published a volume of plates by him illustrating scenes in Shakespeare's plays.

1794 *Angelica's Ladies Library* [see under Kauffman]. Pls.

Michael BURGHERS, ?1653–1727

Born in Holland, he came to England as a boy after the French occupation of part of the Netherlands, and settled in Oxford in 1673. He was much employed at Oxford engraving for the *Oxford Almanack* and views of the colleges, and his plates were frequently re-used.
See H. M. Petter, *The Oxford Almanacks*, 1974, passim.

1718 Joseph Addison, *The Resurrection.* 8vo. 'For E. Curll in Fleet Street Price Sixpence.' Front. 'Fuller pinxit ad Alt. Coll. Magd. Oxon. Delin. M. Burgh, Sculpt. Univ. Oxon.' Isaac Fuller, 1606–72, was much in demand as a wall painter under Charles II; as well as

[1] Alexander Oliver Exquemeling was a Dutch physician, who lived with the buccaneers from 1668 to 1774 and wrote an account of them that enjoyed great popularity in its English translation.

painting the east wall in Magdalen Chapel, he painted similar works at Wadham College and All Souls College.

Hubert François BURGUIGNON. See under GRAVELOT.

Edward Francesco BURNEY, 1760–1848

Burney is one of those artists whom it is all too easy to dismiss in two words. A contemporary of Stothard, Fuseli and Rowlandson, he had some of the qualities of each, without possessing quite enough of any one of them. Though encouraged by no less a man than Sir Joshua Reynolds, he seems never to have overcome his diffidence sufficiently to paint portraits of anyone outside the circle of his large family and his friends. If he achieved, in later life, a certain degree of fame or at least popularity, it was as a provider of those pretty and often rather insipid 'graphic embellishments' which were the real *raison d'être* of the ubiquitous annuals and drawing-room scrap-books that flourished from 1820 onwards, but which could hardly expect to be taken very seriously. As a result, he has found no place at all in the *Dictionary of National Biography*, and where he is mentioned in dictionaries of artists it is usually with condescension. Only in recent years have the big national collections acquired really representative specimens of the best work he could do in watercolours, which enable one to take a fairer view of his achievement.

Born in Worcester in September 1760, Edward Burney was the son of Dr. Burney's brother Richard. What induced his parents to give him 'Francesco' as a second christian name is hard to say, (it may have come from his father's famous tour of Italy) but it is clear that his propensity for painting manifested itself early, for at the age of sixteen we already find him in London taking drawing lessons at the Royal Academy. At this time he presumably lived in St. Martin's Street, in the house of his uncle, already a well-known figure both as composer and historian of music. Despite the harsh treatment he meted out to his own son for a youthful peccadillo as an undergraduate at Oxford, Dr. Burney was a kindly man and he apparently encouraged the young artist. Certainly when Edward was recalled to Worcester he pleaded with his father to allow him to stay and continue his studies and even took him to see his friend Sir Joshua Reynolds. By now 'our Edward', as he is almost invariably called in the letters and diaries of his famous cousin, Fanny Burney, seems to have become almost indispensable in the large family circle in London, not only for the theatricals in which he took an active part, but also as Fanny's confidant and go-between in her first venture into the world of literature. He was entrusted with some of the negotiations which had to be carried on secretely with the publisher Lowndes for her novel *Evelina* and had the pleasure of bringing her the message of acceptance in 1778. *Evelina*, too, provided Edward with the subject for the first of his drawings that appeared before the public. 'Edward has just finished three stained drawings in miniature, designs for Evelina, and most sweet things they are,' writes Fanny's younger sister Charlotte on 10 April 1780.[1] 'My father is so pleased with them that he has shown them to Sir Joshua Reynolds and asked him whether there would be any propriety in putting them into the Exhibition. Sir Joshua highly approved . . . and Mr. Barry has promised to procure a good place for them.' Fanny, too, declared herself 'delighted that we thus show off together', and in the Catalogue of the Twelfth Exhibition at the Royal Academy in 1780 we find E. F. Burney represented with 'three sketches from Evelina' (Numbers 418–420).

Since, barely eighteen months earlier, illustrations for the novel had been commissioned from John Hamilton Mortimer, only one of these designs appears to have been used in printed form (in an edition of 1794). Edward Burney was luckier with his large oil portrait of his cousin Fanny, which was used as a frontispiece to the first and the many subsequent editions of her *Diary and Letters* (1842) and found a permanent home in the National Portrait Gallery. In the pencil and crayon drawing in the Brooklyn Museum Edward caught his charming cousin at a more relaxed moment reading somewhere on a bench in the garden. Though obviously done very early—even allowing for a great deal of idealization the sitter can hardly have been more than 21—it shows already some of Burney's strengths and weaknesses: a sence of grace and elegance, but also a certain indecisiveness of drawing which smacks of the amateur.

During the next twenty years, Burney contributed some seventeen exhibits to the Royal Academy, many of them portraits of family or friends, one of which, a large oil of an elderly lady

[1] See Hemlow, *History of Fanny Burney*, Oxford 1958.

in front of a bust marked 'Honest and Generous' (possibly Dr. Johnson's friend, Mrs. Thrale), has somehow found its way to the Musée Magny at Dijon. In 1784 Edward Burney drew four full-page designs for his uncle's big volume on the Handel commemoration in Westminster Abbey, and on these plates in quarto size he displays for the first time what must be considered his most interesting gift, the ability to organize successfully numerous figures in rather complex settings. While Thomas Stothard was then rapidly gaining fame for his minute drawings of single, or few, figures of timeless charm like those for the poems of the banker-poet Rogers, Burney shows himself at his best in large watercolour compositions of scenes from contemporary life. The *May Day street scene in London* (B.M.), with urchins molesting two ladies and the gentleman raising his stick to defend them, has all the appearance of something observed at first hand with humour and detachment. Even more unexpected from so gentle and amiable an artist is the *Elegant Establishment for Young Ladies* (V. & A.), an almost ferocious satire on the drilling which girls had to undergo at a fashionable school for manners. Together with its companion (also V. & A.), *The Waltz*, and *The Glee Club* from the Mellon Collection, it is proof of an eye for physiognomy and human foibles that would not have shamed Rowlandson.

To judge from the fashions and the detail, these large, crowded satirical pictures are likely to belong to the first or second decade of the new century and this is confirmed by yet another work in this vein, the *Pandean Minstrels in Performance at Vauxhall*, which is known only from the engraving dated 1806. They were still in the artist's possession in 1826, when he allowed, as a special treat, one of his grandchildren to see his drawings, which also included 'a new set of adventures for John Gilpin, which he had written and illustrated himself and which were equal to Hogarth in humour and Cipriani in taste.'[1] This passage seems to suggest that given the 'diffidence of himself, the most unaffected' of which his cousin speaks, Edward was either unable, or too shy even to try, to sell his more ambitious work; despite Fanny's close association with the court, not a single drawing of his has found its way into the Royal collection. It would also explain what induced him to devote his last forty years almost exclusively to book illustration. All we are told is that 'he withdrew

[1] Hemlow, *op. cit.*, p. 443.

early from what may be called the public life of a painter—the competition which is implicit when pictures are exhibited.' Work for the booksellers at any rate offered him the opportunity to earn a sufficient living for a comfortable, retired bachelor existence, the more so since his designs were also often employed as ornaments by craftsmen, as on a silver snuff box by Walter Jackson in the V. and A., which is finely engraved with the figures from his frontispiece for Mallet's poems in Cooke's edition of *Select British Poets* (1798).

Edward Burney had already been represented, with credit, among the numerous artists engaged in embellishing Bell's vast collection of the poets which appeared in the 1780s and 1790s. From then onward he was obviously much in demand for work of this kind. Quite possibly it is his prolific output as an illustrator that has caused his work to be dismissed all too lightly under the simplifying label of 'insipid'. It is true that for a while he sailed in the wake of Cipriani and Angelica Kauffman; at another stage, as in the designs from Milton, he seems to have tried to emulate Fuseli who was then staggering the art world with his self-willed poses. Some of Burney's stylish ladies in their huge hats have something of Fuseli's disconcerting ambiguity. It would not be difficult to select even from his frontispieces and vignettes samples of elegance, neat observation and wit to do Edward Burney greater justice than is generally accorded him.

The high hopes of the family for 'that astonishing lad' Edward, who would one day be as famous a painter as his cousin was a novelist, were never fulfilled. Perhaps, gentle and diffident as he was in the extreme, he remained content simply to be, as Fanny described him, 'amiable, deserving and almost faultless'.

H. A. Hammelmann, *CL*, CXLIII, 1968, 1504–6.

1785 Charles Burney, *An Account of the Musical Performances in Westminster-Abbey and the Pantheon, May . . . and June 1784 . . . In commemoration of Handel.* 4to. 'For the benefit of the Musical Fund, and sold by T. Payne and Son.' Front. eng. Bartolozzi and 2 scenes of the celebrations eng. J. Spilsbury and J. Collyer.
See K. Spence, 'The Great Handel Revival', *CL*, CXXXV, pp. 1482–86.

1785 Harrison's *British Classics*: [see under Stothard] *Spectator*. Pls.

1785–7 *The Novelist's Magazine*: [see under Cor-

bould] XVIII *Arabian Nights.* 2 pls. eng. Walker, Isaac Taylor; XIX *Humphry Clinker.* 4 pls. eng. Heath, Walker, Angus; XX *Pamela.* 10 pls. eng. Heath, Walker, Angus, Birrell; XXI *Adventures of Signior Gaudentio di Lucca.* 2 pls. eng. Walker, Angus; XXII John Shebbeare, *Lydia.* 1 pl. eng. Heath; Mrs Sheridan, *Memoirs of Miss Sidney Bidulph.* 8 pls. eng. Heath, Walker, Birrell. (Plate 38).

1787 James Beattie, *Poems on Several Occasions.* 12mo. Pls. eng. Lawson.

1788 *The Dramatick Writings of Will. Shakspere.* 20 vols. 8vo. 'For and under the Direction of John Bell, British Library, Strand.' Each play has 2 pls., 1 a portrait of an actor in costume, 1 a scene from the play, with the surprising exception of *Timon of Athens* which has 2 pls. of scenes, as well as 1 of an actor in the leading part. *King Lear* has 2 scenes but no actor's portrait. The scenes illustrated by Burney are from *Two Gentlemen of Verona, Taming of The Shrew, All's Well that Ends Well, King John, Henry IV Pt. 2, King Lear* and *Cymbeline*; eng. A. Smith, Hall and Delattre.
Drawings for *King John, King Lear* and *Cymbeline* are in the Huntington Library.

1788–91 *Shakespeare's Plays* [see under Corbould]. 12 pls. eng. Taylor, Thornthwaite, Grignion, Angus, Goldar, Walker, Wooding, Springsguth.

1793 John Gay, *Fables.* 8vo. 'For John Stockdale with 70 Copper Plates designed by Burney and Cotton.' 12 eng. Blake.

1793 [Rev. George Huddesford, M.A.], *Salmagundi; A Miscellaneous Combination of Original Poetry; consisting of illusions of fancy, amatory, elegiac, cynical, epigrammatical and other palatable ingredients.* 8vo. 'By E. Hodson for J. Anderson.' Title-page: lady with fairies making music for her, eng. Heath.

1794 [Fanny Burney], *Evelina.*
1 of the 3 designs for *Evelina* exhibited by E. F. Burney at the Academy in 1780 was used for this edition. See T. C. Duncan Eaves, 'Edward Burney's Illustrations to Evelina', *Modern Language Association of America*, December 1947.

1795 *A Complete Edition of the Poets of Great Britain.* 13 vols. Large 8vo. 'Printed for John and Arthur Arch; and for Bell and J. Mundell and Co., Edinburgh.' Title-vigs. to each vol. s. 'E. T. Burney del. F. Chesham sculpt.'

1791–5 *Bell's British Theatre*: [see under Fuseli] *Rival Queens.* eng. A. Smith; *Comus.* eng. Delattre; *Cato.* eng. Bartolozzi; Richard Cumberland, *Battle of Hastings.* eng. A. Smith; Arthur Murphy, *The Way to keep him.* eng. Leney; Dr. Franklin, *The Earl of Warwick.* eng. Leney; H. Hartson, *The Countess of Salisbury.* eng. Leney; Fenton, *Marianne.* eng. Fittler; Aaron Hill, *Merope.* eng. Leney.

1795 *Views on the Avon.* 4to. 'For Sam. Ireland.' Front.: Muse inspiring Shakespeare, eng. C. Apostool.

1796 John Milton, *Paradise Regained and the Minor Poems.* Longman, Law, et al. 4 pls.

1797 *Cooke's Cheap and Elegant Pocket Library*: [see under Corbould] *Pomfret.* 1 pl. eng. Woodward.

1797 [T. Prattent and M. Denton], *The Virtuoso's Companion and Coin Collector's Guide.* 8vo. 'Published for the Proprietor.'

1797 F. de Salignac de la Mothe Fénelon, *Telemachus.* (This edition has not been traced.)

1797 *Cooke's Select British Classics*: [see under Corbould] C. Johnstone, *Adventures of a Guinea.* 6 pls. eng. Warren and Raimbach. 1 pl. is s. 'J. Burney', but this is probably a misprint.

1798 A. Pope, *Rape of the Lock* [see under Fuseli]. 1 pl. eng. Bartolozzi.

1798 *Cooke's Select British Poets*: [see under Corbould] *Mallet's Poems.* Front. and pl. eng. Heath and Strange.

1800 John Milton, *Paradise Lost.* 8vo. 'For C. Whittingham.'
See M. Peckham, 'Blake, Milton and Edward Burney', *The Princeton University Library Chronicle* XI, 1950, p. 109; M. R. Pointon, *Milton and English Art*, Manchester, 1970, pp. 87–90.

1802 James Thomson, *The Seasons* [see under Hamilton]. Front. eng. J. Collyer.

C.W.B.

Probably Copp Warre Bamfylde, an amateur artist, and 'honorary exhibitor' at the R.A. in the second half of the eighteenth century.

1776 [Richard Graves], *Euphrosyne; or, Amusements on the road of life.* 8vo. 'For J. Dodsley.' Front. 'C.W.B. del., J. Collyer sculpsit.' A tailpiece in the 2nd ed. of 1780, enlarged to 2 volumes, is s. 'C.W.B., eng. C. G[rignion].'

[?1776] [Richard Graves], *Columella; or the Distressed Anchoret, a Tale.* 2 vols. 12mo, 'For J. Dodsley.' 2 fronts. 'C.W.B. del., C. G[rignion] sc.'

Richard Graves, Fellow of All Souls, was rector of Claverton, nr. Bath; Bamfylde resided at Hestercombe in Somerset, so that acquaintance between them is likely enough.

Colen CAMPBELL, d. 1729

The architect of the Palladian style, who published 1717–25 *Vitruvius Britannicus; or the British Architect; containing the plans, elevations, and sections of the regular Buildings, both publick and private, in Great Britain, with a variety of New Designs.* 3 vols. Folio. A new edition with a continuation by John Wolfe and James Gandon was published in 5 vols., 1767–71. This is one of the great and influential examples of eighteenth-century architectural publications.

John CARTER, 1748–1817

He was early trained as an architectural draughtsman, and did many plates for the *Builders' Magazine*. From 1780 he worked for the Society of Antiquaries, of which he became a member. From 1782–4 he published his *Specimens of Ancient Sculpture and Painting* and *Views on Ancient Buildings in England*. He became recognized as the leading authority on the Gothic style, and was a lively controversialist on the subject in the pages of *The Gentleman's Magazine*.

1783 James Mountague, of the Temple, *The Old Baily Chronicle; or, the Malefactors Register* . . . 4 vols. 8vo. 'Printed by Authority for J. Waller.' Front.: The New Sessions House in the Old Bailey, eng. Wm. Watts.

John CARWITHAM, *fl. c.*1723–41

A professional engraver, he was employed by booksellers to engrave the work of other artists, including Bernard Picart, whose style of first etching the plate and finishing it with a burin he copied. His one contribution to decorative art, however, shows an original and inventive talent for illustration, and other work of his may exist among the many unsighted plates of the period.

[1739] *Various kinds of Floor Decoration . . . design'd and engrav'd by John Carwitham.* 4to.

'For John Bowles.' Engraved title and 24 pls. 'I Carwitham Inv. et sc. 1739', showing plans of marble floors (or of painted floor cloths), with the same design repeated in perspective above in scenes classical, theatrical, pastoral or contemporary—in rooms or on terraces, porticos, the stage, etc.

Charles CATTON, 1756–1819

He was the son of the landscape painter of the same name, and was mainly known for his topographical views. In 1804 he emigrated to America, where he died.

1793 John Gay, *Fables.* 8vo. 'For John Stockdale.' With 70 copper engravings des. Burney and Cotton, 12 eng. Blake.

1797 *Cooke's Select British Novelists*: [see under Corbould] *Tristram Shandy.* 1 pl. eng. Warren.

W. A. CHALMERS, *fl.* 1790–98

He exhibited watercolours of architecture and some theatrical pieces. According to Redgrave he died young. He was employed in book illustration for Hogg's *New Novelist's Magazine*.

1793 Mr. Hogg's *New Novelist's Magazine or Ladys and Gentleman's Entertaining Library*: Samuel Richardson, *The History of Sir Charles Grandison.* 2 vols. 8vo. 'For Alex. Hogg at the King's Arms No. 16 Paternoster Row.' 12 pls. eng. Kidd, Goldar, Sparrow; Samuel Richardson, *Clarissa Harlowe*, 1 pl. eng. Thornton.

John Baptiste CHATELAINE (or CHASTE-LAIN), 1710–71

Born in London of French Protestant parents, and for a time held a commission in the French army. His real name was Philippe, Chatelaine being assumed. Later he lived in Chelsea, and worked for Boydell, but according to Redgrave 'his great talents were obscured by his depraved manners and irregularities.'

1736 *The Cupid, A Collection of Love Songs.* 12mo. 'By J. Crichley at Charing Cross for R. Dodsley at Tullys Head in Pall Mall.' Front and 12 pls., 8 s. 'Chatelaine inv. or del.', 2 s. 'G. Scotin inv.', all 'J. Scotin sculp.'

Louis CHERON, 1655–1735

A Calvinist, he came from France to England in 1695 and tried to establish himself as a history painter, carrying out decorative schemes at

Boughton, Burleigh and Chatsworth. According to Strutt he was 'supported by the bounty' of his older sister, Elizabeth (d. 1711), who was also a painter. Later in his career he was mainly employed in book illustration for all the leading publishers. He was prominent in the St. Martin's Lane Academy, and, when it opened in October 1720, he and Vanderbank are said to have engaged female models as an inducement to membership. Strutt describes him as 'of an affable, good-natured temper, very communicative of his art, with a plain open sincerity that made him agreeable and beloved. Very assiduous at the Academy, and by the young people much imitated.'
See Croft-Murray, *Decorative Paintings in England*, I, p. 68.

1715 A. Pope, *The Temple of Fame: A Vision*. 4to. 'For Bernard Lintott.' 2nd ed. The front. 'L. Cheron inv. Sam. Gribelin Junr sculp.' is not in the 1st ed.

1717 *Ovid's Metamorphoses. Translated by the most eminent Hands*. Folio. 'For J. Tonson.' Pls. after du Guernier and Cheron, eng. M. van der Gucht and E. Kirkall. Each pl. was dedicated to some lady of the aristocracy.

1717 James Greenwood, *The Virgin Muse: being a collection of poems from our most celebrated English Poets, designed for the use of Young Gentlemen and Ladies at Schools*. 12mo. 'By T. Varnham, J. Osborne et al.' Front. eng. C. du Bosc.

1718 R. Rapin, *Of Gardens, A Latin Poem . . . English'd by Mr. Gardiner*. 8vo. 'By W. Bower for Bernard Lintott.' Front.: portrait of translator, eng. Vertue after J. Verelst and 4 pls. by Cheron eng. E. Kirkall.

1718 Matthew Prior, *Poems on Several Occasions*. Folio. 'For J. Tonson.' Title-vig. and head- and tailpieces eng. Beauvais.

1719 [Francis Peck?] *Sighs upon the never enough Lamented Death of Queen Anne. By a clergyman of the Church of England*. 8vo. Front.: apotheosis of the Queen.

1720 John Milton, *The Poetical Works*. 4to. 'Printed for Jacob Tonson.' 2 vols.
Tonson had already in 1688 published the 1st illustrated ed. of *Paradise Lost*, with plates by John Baptist Medina (1660–1711) (except 1 by Bernhard Lens), and in 1713 *Paradise Regained*, with plates unsigned but almost

certainly by Medina. The 1720 ed. of *The Works* has 2 portraits eng. Vertue, and 2 title-pages and 18 headpieces, all by Cheron except one by Thornhill; 17 tailpieces also by Cheron. These are eng. G. van der Gucht, Gribelin, Claude du Bosc. See M. R. Pointon, *Milton and English Art*, Manchester 1970.

1720 A. Pope, *Eloisa and Abelard*. 8vo. 'For B. Lintott.' Front. eng. S. Gribelin.

1720 Albius Tibullus, *The Works of . . . translated*, *by Mr. Dart*. 8vo. 'By T. Sharpe for W. Newton et al.' Front., 5 headpieces and 1 tailpiece eng. G. van der Gucht.

1721 Joseph Addison, *Works* [see under Thornhill]. 1 headpiece eng. G. van der Gucht.

1722 Alexander Pope, *An Essay on Criticism. The Seventh edition, corrected*. 8vo. 'For Bernard Lintott at the Cross Keys, between the Temple Gates in Fleet Street.' Front. 'Lud Cheron inv., Sam. Gribelin sculp.'

1722 Alexander Pope, *Ode for Musick on St. Cecilia's Day. The Fourth edition*. 8vo. 'For Bernard Lintott' Front. eng. Simon Gribelin Jnr.

1723 D. Bellamy, *The Young Ladies Miscellany* [see under Bickham]. Front. eng. Bickham.

1723 Racine, *Oeuvres*. 2 vols. 4to. 'For J. Tonson and J. Watts.' Pls. eng. G. van der Gucht and C. du Bosc.

1724–5 Sir Philip Sidney, *Works*. 3 vols. 8vo. 'For E. Taylor et al.' 5 pls. eng. G. van der Gucht and J. Pine. 14th ed.
See also Van der Gucht.

1724–9 Plutarch, *Lives*. Translated from the Greek with Notes Historical and Critical from M. Dacier. 8 vols. 4to. 'For J. Tonson.' Pls. eng. Giles King and G. van der Gucht.

1729 *A Select Collection of Novels* [see under Vanderbank]. 4 pls. eng. G. van der Gucht.

1732 Abbé Vertot, *The History of the Revolutions that happened in the government of the Roman Republic . . . English'd by Mr. Ozell*. 2 vols. 8vo. 'For Knapton et al.' Fronts. to Vol. II eng. G. van der Gucht. 4th ed.

1733 *The Young Clerks Assistant* [see under Bickham]. 1 pl. eng. Bickham.

1748 John Hippesley, *Flora; or, Hob in the well. An opera*. 12mo. 'For W. Feales.' 6th ed. [1st ed.

probably much earlier]. Front.: street scene, eng. G. van der Gucht.

Giovanni Battista CIPRIANI, 1727–85

Born in Florence, he came to London in 1755, after having met Sir William Chambers and Joseph Wilton in Rome. He joined the St. Martin's Lane Academy and was nominated by the King as a member of the Royal Academy in 1768, whose first diploma he designed (and Bartolozzi engraved). He was much employed by publishers, and in conjunction with Bartolozzi produced some distinguished work, enjoying high repute among his contemporaries. He and Bartolozzi were frequently employed together, and after Cipriani's death, Bartolozzi engraved his set of drawings of the Portland Vase and his *Rudiments of Drawing* (1786–92). He married an Englishwoman, and his son, Henry, began his career as an artist, but then joined the army and was eventually knighted.

n.d. C. F. Abel, *Six Concerts pour le Clavecin avec deux Violons et Violoncello, op. XI.* Folio. 'Londres, imprimé pour l'auteur chez Bremner, dans le Strand.' Title-page: figure of Apollo, Cipriani 'inv. et del.', Bartolozzi 'sculp'.

1772 Sir William Chambers, *A Dissertation on Oriental Gardening.* 4to. 'By W. Griffen, Printer to the Royal Academy, Dodsley et al.' Title-page and tailpiece to dedication eng. Bartolozzi.

1772 [William O'Brien], *The Duel.* 8vo. 'For T. Davies.' Headpiece to dedication eng. Bartolozzi and tailpiece unsigned but presumably by Cipriani.

1777 Jonas Hanway, *The commemorative Sacrifice of our Lord's Supper, considered as a preservative against superstitious fears, and immoral practices.* 8vo. 'For Dodsley.' Front.: Christ dines with the Pharisee, unsigned, but according to sheet of explanation eng. Major after Cipriani.

1779 Giovanni Rucellai, *Rosamunda, Tragedia di Messer G.R., Patrizio Fiorentino.* 4to. 'Londra da Torchio di Moore in Drury Lane prosso l'Editori Cadell, White, et al. In prezzo 10s 6d.' Front. eng. Bartolozzi.

1783 William Shield, *Rosina. A Comic Opera* (Covent Garden). Oblong 4to. 'For W. Napier, Music-seller in the Strand.' Title-piece eng. Bartolozzi.

1784 James Anderson D.D., revised J. Noorthouck. *Constitutions of the Antient Fraternity of Free and Accepted Masons . . . brought down to 1784.* 4to. 'By J. Rozea, No. 91 Wardour St., Soho.' Front.: interior of the Mason's Hall in Great Queen St., Lincolns Inn Fields, with allegorical figures, 'delin.' Cipriani and P. Sandby, 'sculp.' Bartolozzi and J. Fittler.

1785 *Commemoration of Handel* [see under Burney]. Pls. eng. Bartolozzi.

1782–6 *Shakespeare's Plays* [See under Rooker]. 2 pls.

Robert CLEVELEY, *fl.* 1767–1809

Known as a marine painter, much employed on naval subjects, which he frequently contributed to the Royal Academy. He died in 1809 as the result of a fall from Dover Cliff.

1789 *The Voyage of Governor Phillip to Botany Bay . . . compiled from authentic papers . . . The plans and views drawn on the spot by Capt. Hunter, Lieuts. Shortland, Watts, Dawes, Bradley, Capt. Marshall etc.* 4to. Several of the plates 'R. Cleveley del.'
An example of the work of naval draughtsmen afterwards worked over by professional artists.

S. COLLINGS, *fl.* 1784–95

Exhibited at the Academy in 1784 and 1789, but best known as a caricaturist. He contributed designs to *The Wits Magazine* (1784) and to *The Bon-Ton Magazine; or, Microscope of Fashion and Folly* (1792–5, see under Ansell).

Richard COOPER, d. 1764

He practised engraving in Edinburgh where he was the master of Sir Robert Strange. His son, also Richard (?1740–?1814), was well known as a landscape painter, chiefly of Italian scenes, and was for a time drawingmaster at Eton College.

1727 *The Vineyard: Being a Treatise shewing the Nature and Method of Planting Vines etc. . . . being the Observations made by a Gentleman (S.J.) on his Travels.* 8vo. 'For W. Mears.' Front. eng. H. Fletcher.

1728 John Bunyan, *The Pilgrim's Progress.* 22nd edition adorned with twenty-two copper plates, engraven by J. Sturt. 8vo. 'For J. Clarke and J. Brotherton.' 1 of the pls. s. 'R. Cooper invent, H. Fletcher sculp.'

Richard COOPER junior

1780 [Eyles Irwin], *Eastern Eclogues written during a tour through Arabia in 1777*. 4to. 'For Dodsley. Oblong title-vig. in aquatint, 'R. Cooper fecit'.

Richard CORBOULD, 1757–1831

He exhibited at the Free Society in 1776 and at the Academy from 1777–1811 without ever becoming an Associate. He was a pupil of the landscape painter R. Maris, residing with him in the early seventies at his house in Glanville Street.[1] Competent and industrious, he seems to have played little part in the politics or social life of his fellow artists, and there is little mention of him in their reminiscences. He was one of the most prolific book illustrators of the time, working for most of the popular editions. Given his output, it is not surprising that much of his work is repetitive in design and gesture, and the format in which much of it is set, vignettes and roundels, must have been a limiting factor. But he had a nice narrative sense, and was well served by the engravers, particularly Charles Warren (1767–1823). He painted also on porcelain and miniatures on ivory. Some drawings for his illustrations are in the V. & A. Two of his sons, George and Henry, were engravers, the latter being particularly concerned with copies from the Elgin marbles.

1785 Harrison's *British Classics*: [see under Stothard] Illustrations to the *Spectator*.

1780–87 *The Novelist's Magazine*. 8vo. 'Harrison and Co., No. 18 Paternoster Row': Vol. XVIII *The Arabian Nights*. 1 pl. eng. Walker; Vol. XIX Mr. Coventry, *Pompey the Little*. 2 pls. eng. Walker; Miss Fielding, *Ophelia*. 3 pls. eng. Walker, Angus and Heath; *Tartarian Tales*. 3 pls. eng. Angus, Walker, Birrell; Vol. XXI *Peruvian Tales*. 7 pls. eng. Angus, Grignion, Walker; *History and Adventures of an Atom*. 2 pls. eng. Walker, Heath; *The Sincere Huron*. 1 pl. eng. Walker; *The English Hermit or Unparalleled Sufferings and Surprising Adventures of Mr. Philip Quarl, who was lately discovered on an Uninhabited Island in the South Sea, where he had lived above fifty years without human assistance*. 2 pls. eng. Walker and Birrell; John Shebbeare, *Lydia*. 3 pls. eng. Angus and Heath.

[1] Farington, *Diary* (ed. Greig), IV, 1928, p. 108.

1789 Charlotte Smith, *Elegiac Sonnets* [see under Stothard]. 5 pls. eng. Milton, Neagle and Heath.

1788–91 *The Plays of William Shakespeare*. 8 vols. 8vo. 'Published as the Act directs by Bellamy and Robarts Jan 1 1788.' Each vol. has an elaborate title-page representing some form of Shakespeare's muse as a female figure in a romantic setting, and 2 pls., many of fairly poor quality, to each play. Title-page and 14 pls. eng. Angus, Goldar, Walker, Grignion, Taylor.

1 of the pls. is s. 'W. I. Taylor sc.', but whether this is to distinguish him from 'Taylor sc.' cannot be certain. The most likely member of the Taylor family to have been employed here was James, younger brother of the elder Isaac Taylor. Similarly the Walker family presents problems: 1 pl. des. Riley is s. 'W. and J. Walker sc.', that is William (d. 1793) younger brother of Anthony, and John, William's son. Another of Riley's pls. is s. 'Geo. Walker sc.', possibly the landscape painter who died *c.* 1795. There was a James Walker, apparently no relation, who practised engraving, and from 1784 to 1802 held the appointment of engraver to the Empress of Russia in St. Petersburg.

1793 *Cooke's Pocket Edition*: [see under Stothard] Hume, *History*. Fronts.

1796 John Milton, *Paradise Lost*. 8vo. 'For J. Parsons.' Pls. by Corbould and Singleton.

1796–7 *Cooke's Cheap and Elegant Pocket Library of Select Poets*. This is the famous sixpenny edition in paper covers. Plates were certainly re-used between Cooke's various editions, and an exact bibliographical account of his various series would be a confusing business. The Bodleian Library has a short run of the pink sixpennys in which Corbould provides pls. as follows: *Armstrong*. Front. eng. Hawkins; *Blackmore*. Pl. and front. eng. Warren and Raimbach; *Blackmore, The Creation*. Pl. eng. Warren; *Pomfret*. Front eng. Hawkins; *Otway*. Front. eng. Warren; *Lansdowne*. Front. eng. Hawkins; *Matthew Prior*. Front. eng. Warren; *Addison*. 2 pls. eng. Heath and Wyatt; *Pope*. 1 pl. eng. Dodswell; *Milton*. 2 title-pages eng. Warren; *Dryden*. 10 pls. eng. Hawkins and Warren; *Congreve*. 2 pls. eng. Warren and Armstrong; *Moore*. 2 pls.

eng. Warren; *Broome*. Title-vig. eng. Hawkins; *Rowe*. Title-vig. eng. Warren; *Hammond*. Title-vig. eng. Hawkins; *Tickell*. Title-vig. eng. Grainger; *Sheffield*. 1 pl. eng. Chapman.

1796–8 *Cooke's Pocket Edition of English Poets superbly embellished.* 12mo.: *Addison*. 2 eng. Heath and Wyatt; *Pope*. 1 eng. Dodswell; *Dryden*. 11 eng. Hawkins and Warren, (Plate 40); *Congreve*. 2 eng. Armstrong and Warren; *Moore*. 1 eng. Warren; *Rowe*. Title-page; *Broome*. Title-vig. eng. Hawkins; *Hammond*. Title-page, eng. Hawkins; *Sheffield*. Title-page.

1791–7 *Bell's British Theatre*: [see under Fuseli]. Goldsmith, *The Good-Natured Man*. Pl. eng. Heath.

1797–9 *Cooke's Pocket Edition of Select Novels, or, Novelist's Entertaining Library, containing a complete collection of Universally Approved Adventures, Tales etc. by the most Esteemed Authors. Superbly embellished*: Humphry Clinker. 2 title-vigs., 5 pls. eng. Warren; *Roderick Random*. Title-page eng. Warren; *Joseph Andrews*. Title-vig., 2 pls., eng. Dodsley, Hawkins and Grainger; *Sir Launcelot Greaves*. 3 pls. eng. Raimbach, Hawkins and Saunders; *Peregrine Pickle*. Title-vig., 11 pls. eng. Warren, Rhodes and Saunders; *Adventures of an Atom*. 2 pls. eng. Hawkins and Saunders; *Jonathan Wild*. 1 pl. eng. Warren; *Amelia*. Title-vig. eng. Hawkins; Treyssac de Vergy, *Henrietta*. Title-vig., 4 pls. eng. Warren, Granger and Woodman; Mrs. Lennox, *Female Quixote*. 2 title-vigs., 4 pls. eng. Hawkins and Armstrong; *Gil Blas*. 1 pl. eng. Saunders; *Devil upon Two Sticks*. Title-vig., 2 pls. eng. Hawkins; *Robinson Crusoe*. 2 title-vigs., 4 pls. eng. Hawkins and Granger; Fielding, *Journey to the Next World*. 2 pls. eng. Warren; Kelly, *Louisa Mildmay*. 2 pls. eng. Warren and Satchwell; *Vicar of Wakefield*. 2 pls. eng. Granger and Chapman (Plate 33); *Don Quixote*. 9 pls. eng. Warren and Hawkins; *Tristram Shandy*. Title-vig., 1 pl.; Dr. Dodd, *The Sisters*. 4 pls. eng. Warren; *Peruvian Princess*. 1 pl. eng. Warren. Corbould illustrated *Pamela* for Cooke 1802–03.

1799–1800 *Cooke's Select British Classics or Scholars' Entertaining Companion . . . Essays on Men and Manners: Adventurer*. Title-vig., 3 pls.

eng. Hawkins and Waite; *Rambler*. 3 pls. eng. Chapman; *Idler*. Title-vig., 2 pls. eng. Hawkins, Granger and Chapman; *Gulliver*. Title-vig., 4 pls. eng. Warren and Chapman; *Tale of a Tub*. 3 pls. eng. Warren; Charles Johnstone, *Adventures of a Guinea*. Title-vig., 1 pl. eng. Warren.

1798–1800 W. Shakespeare, *Plays* [see under Thurston]. 12mo. 'For E. Harding.' 2 pls.

1793–1802 *Cooke's Pocket Edition of Sacred Classics, or, Moralists Instructive Companion*: William Dodd, *Thoughts in Prison*. 12mo. Title-vig., 1 pl.; William Dodd, *Thoughts on Death*. Title-vig., 1 pl.; *Reflections on Death*. 1 pl.; Hervey's *Evidences of the Christian Religion*. 2 pls.; *Meditations*. Title-vig. and 2 pls.; *Citizens of the World*. 6 pls. All these eng. C. Warren. Mrs. Rowe's *Letters*. Title-vig. and 4 pls. eng. Chapman, Hawkins and Hopwood; Bunyan, *Pilgrim's Progress*. Title-vig. eng. Hawkins.

The Rev. William Dodd was hanged for forgery in 1772, despite numerous appeals on his behalf, one by Dr. Johnson. His pious writings were much in demand.

William Marshall CRAIG, d. *c.* 1834

He was a watercolourist and miniature painter who came to London from Edinburgh about 1791. He was much employed making drawings for engravers, particularly for the serial publication, *The British Gallery of Pictures* (1808). He was a nephew of the poet James Thomson, and brother of the architect James Craig who designed Princes Street and George Street in Edinburgh. See Ralph Edwards, 'Queen Charlotte's Painter in Watercolours', *The Collector*, December 1930.

1795 *Bell's British Theatre*: [see under Fuseli] Dr. Brown, *Barbarossa*. 1 pl. eng. Neagle.

Isaac CRUIKSHANK, 1756/7–1810/11

Born at Edinburgh, he came to London with his father after the latter had been impoverished as a result of Jacobite sympathies during the '45. He was mainly employed as a caricaturist, in which branch he was succeeded by his much better-known son, George. He was employed by Lawrie and Whittle for designing humorous drawings illustrating Swift and other writers.

1792–5 *The Bon Ton Magazine* [see under Ansell]. Some pls. in vol. 5.

1796 John Baxter, *A New History* [see under

Ansell]. 2 pls.: execution of Countess of Salisbury, and murder of Duke of Orleans.

J.S.D. See under **J.**

Bartholomew DANDRIDGE, 1691–*c.* 1763
Painter of portraits and conversation-pieces, he at times supplied ornamental designs for the book producers.

1730 M. A. Ramsay, *Les Voyages de Cyrus.* 4to. 'A Londres chez Jacques Bettenham.' Head-piece to Book VII, eng. J. van der Gucht. The title and other headpieces are after French artists, Coypel junior, Le Moyne and de Gaumons.

1732 *Select Comedies of Mr. de Molière. French and English in eight volumes, with a frontispiece to each comedy.* 12mo. 'For John Watts at the Printing Office in Wild-Court near Lincolns Inn Fields.' 2 pls. eng. G. van der Gucht.
See P. Lacroix in *Iconographie Molièresque* No. 576, where the total number of plates is wrongly given as nineteen instead of seventeen.

Matthew DARLEY, latter part of 18th century
Mainly known as a caricaturist. He taught engraving, and also sold prepared artists' colours.

1764 [R. M. Lesuire and — Louvel], *The Savages of Europe. From the French [A satire on the English Nation].* 8vo. 'By Dryden Leach for T. Davies.' Front. and 3 pls. 'M. Darley fec.'

Edward DAYES, 1763–1804
His most successful works are topographical water-colours, some of which were used for book illustration, particularly in conjunction with the antiquary, James Moore, whose own drawings were sometimes touched up by Dayes. Girtin was one of his pupils.

1788–91 W. Shakespeare, *Plays* [see under Cor-bould]. 1 title-page, 15 pls. eng. Grignion, Walker, Goldar, Taylor, Ridley, Angus, Wooding.
A drawing for the pl. to *Love's Labour's Lost* is in the Huntington Library.

1794 *Bell's British Theatre:* [see under Fuseli] Richard Steele, *The Funeral or Grief à la Mode.* eng. Neagle; Congreve, *The Double Dealer.* eng. A. Smith; Congreve, *The Old Batchelor.* eng. Wilson.

John (or **James**) **DEVOTO,** *fl. c.* 1708–52
Of Italian origin, he came to England in 1708, and had considerable repute as a scene painter and decorator. Another John Devoto, presumably a son, exhibited at the Society of Artists in 1776, and had designed the frontispiece for their catalogue ten years previously.
See E. Croft-Murray, *Decorative Painting in England,* II, 1970, p. 200; I. A. Williams, *Early English Water-Colours,* 1952, p. 14.

1735 [John Barrow] *Dictionarium Polygraphicum: or, the whole Body of Arts regularly digested, adorned with proper sculptures, curiously engraven on more than fifty copper plates.* 8vo. 'For C. Hitch and C. Davis.' Front. eng. Toms.

1766 Catalogue of Society of Artists VII. Front. eng. Toms.

1786 *An Astrological Collection, wherein the Principles of Astrology are demonstrated by Question and Answer . . . translated from Leovitius . . . by Robert Turner, Astro-Phile.* 12mo. 'For G. Kearsley.' Folding front. eng. G. van der Gucht [presumably from some earlier edition].

Robert DIGHTON, 1752–1814
As well as being a caricaturist, he was a man of very varied talents: portrait painter, scene painter, actor and dramatist. He contributed four plates to *Bell's Shakespeare,* 1773–4 (see under Edwards) but otherwise does not seem to have had any regular employment by the book trade.

Daniel DODD, *fl.* 1763–93
He was a member of the Free Society of Artists, contributing oil and crayon portraits to their exhibitions. He was employed by Harrison on *The Novelist's Magazine.*

1775 [P. J. Buc'hoz], *The Toilet of Flora; or, a Collection of the most simple . . . methods of preparing baths, essences, pomatums . . .* 12mo. 'For J. Murray.' Front. 'Dodd delt.', eng. W. Walker.

1772–8 Flavius Josephus, *Works* [see under Wale]. 2 pls.

1779 C. [hristopher] A.[nstey], *A Pindaric Epistle, address'd to Lord Buckhorse.* 4to. Title-vig. eng. J. Collyer.

1779–80 *Trials for Adultery; or, the History of Divorces. Being select trials at Doctors Commons for Adultery, Fornication, Cruelty, Impotence, etc. from the year 1760 to the present time . . .*

the whole forming a complete History of the Private Life, Intrigues and Amours of many Characters in the most elevated Sphere. Taken in Short-Hand by a civilian. 7 vols. 8vo. 'For S. Bladon, No. 13 Paternoster Row.' 29 pls. after Dodd mainly eng. Cook and Grignion.

1780 *The Novelist's Magazine:* [see under Corbould] Dr. Hawkesworth, *Almovan and Hamet.* 2 pls. eng. Heath; *Joseph Andrews.* 4 pls. eng. Heath; *Amelia.* 6 pls. eng. Heath and Walker; Dr. Langhorne, *Solyman and Almena.* 1 pl. eng. Heath; *Vicar of Wakefield.* 1 pl. eng. Walker; *Roderick Random.* 4 pls. eng. Heath and Walker; *Pamela.* Title-vig. eng. Heath.

1781 John Milton, *Paradise Lost* (The Poetical Magazine). 3 pls. eng. Birrell.

1783 [S. J. Pratt], *Liberal Opinions; or, the History of Benignus. A new edition.* 4 vols. 12mo. 'For G. Robinson.' Title-vig. eng. T. Cook [the same in each vol.].

1784 Oliver Goldsmith, *The Vicar of Wakefield.* 2 vols. 12mo. 'For Wenman, No. 144 Fleet Street.' 2 pls. eng. Goldar and Buril.
This edition formed part of a project 'Entertaining Museum and Complete Circulating Library'.

n.d. [1780–85] Henry Southwell, *The New Book of Martyrs.* Folio. 'J. Cooke'. Several pls.

n.d. [1785] G. F. Raymond, *History of England* [see under Wale]. 1 pl.

1788–91 W. Shakespeare, *Plays,* [see under Corbould]. 1 pl. eng. Goldar.

1793 Samuel Richardson, *Clarissa Harlowe* [see under Chalmers]. 6 pls. eng. Kidd, Goldar and Thornton.

John DUNCOMBE, 1729–86

1767 J. Duncombe et al., *The Works of Horace, in English verse, Second edition.* 12mo. 'For B. White et al'. Title-vig. s. 'J. D. inv. et del, A. Walker sculp.'

1772 [ed. John Duncombe], *Letters by several eminent persons deceased, including the correspondence of John Hughes, Esq.* 8vo. 'For J. Johnson, St. Paul's Churchyard.' Title-page vig. 'Duncombe inv. et del. Will. Walker sculp.'

1774 J. Boyle, Earl of Cork and Orrery, *Letters from Italy in the Years 1754 and 1755 with*

explanatory notes by J[ohn] D[uncombe]. 8vo. 'For B. White.' Title-vig. eng. Isaac Taylor. 2nd ed.

John DUNTHORNE, *fl.* 1783–92

His father was a portrait painter of the same name, and both of them resided mainly at Colchester. The son exhibited several genre scenes at the Academy, and is said to have died young.

1788 *The Country Book-Club. A poem.* 4to. 'For the Author and sold by W. Lowndes, et al.' Title-vig. etched by T. Rowlandson.

Edward EDWARDS, 1738–1806

The son of a London chair-maker, he studied in the St. Martin's Lane Academy, and won three premiums from the Society of Arts. He was elected A.R.A. in 1773. In 1775 he visited Italy and on his return was for a time a scene painter in Newcastle. In 1788 he was appointed teacher in perspective at the Academy. He contributed a painting to the Boydell Gallery. He is best known for his invaluable *Anecdotes of Painters* posthumously published in 1808. A protégé of Horace Walpole, he drew for him some of the designs at Strawberry Hill. Much of the information for the *Anecdotes* came from Charles Grignion. See Farington, *Diary,* (ed. Greig), III, 1928, p. 14.

1773–74 *Bell's Edition of Shakespeare's Plays, as they are now performed at the Theatres Royal in London, regulated from the Prompt Books of each House.* 9 vols. 12mo. 'For John Bell near Exeter Exchange in the Strand and C. Etherington at York.' 33 pls. 'E. Edwards del.' (Plate 28.).
See T. S. R. Boase, *JWCI,* X, 1948, p. 93.

1773 J. H. Wynne, *The Four Seasons; a poem.* 4to. 'For G. Riley, Curzon Street.' Title-vig. 'E. Edwards del., C. White sculp.'

1774 [J. H. Wynne], *Evelina, Daughter of Caractacus. A sacred Elegy.* 4to. 'By J. P. Coghlan and G. Riley.' Oblong title-vig. eng. White.

1778 *The Copper Plate Magazine; or, a Monthly Treasure for the Admirers of the Imitative Arts.* 4to. 'For G. Kearsley.' Full-page pls. from *The History of England* [probably originals for this work] by Edwards. Other pls. by P. Sandby.

1779 [J. Hanway], *Midnight the Signal. In sixteen letters to a lady of quality.* 8vo. 'For R. Dodsley'. Title design eng. J. Hall.

1779 Jonas Hanway, Letter to Mr. — aged — a

sailor in the Maritime School. 12mo. Front. eng. Roberts.

1782–6 *Shakespeare's Plays* [see under Rooker]. 3 pls.

1778–89 *Bell's British Poets*: [see under Mortimer] *Donne*. 1 pl. eng. Delattre; *Dryden*. 3 pls. eng. Hall.

1796 *Cooke's Pocket Edition of English Poets*: [see under Corbould] *Akenside*. 1 pl. eng. Hawkins.

1796 Baxter's *History* [see under Ansell]. 1 pl.

Franz EISEN, 1695–1777

He was born in Brussels and worked mainly in Valenciennes and Paris as a history and genre painter. He was sometimes employed by the English book trade, but there is no evidence that he visited England.

1754 John Blair, *The Chronology and History of the World*. Folio. n.p. Title-page vig. 'Eisen inv. et del., S. F. Ravenet sculpt.' The same engraving appears in the 1768 ed.

1762 J. J. Rousseau, *Emilius; or, an Essay on Education . . . Translated from the French, by Mr. Nugent*. 2 vols. 8vo. 'For J. Nourse and P. Vaillant.' 2 fronts.

1774 Madame Fauques de Vaucluse, *The Vizirs: or, the Enchanted Labyrinth. An oriental tale*. 3 vols. 12mo. 'For G. Riley.' Title-vig. eng. Charles White [the same in each vol.].

Joseph FARINGTON, 1747–1821

He is better known for his diary (published in selection, 1922–8, 8 vols.) than for his paintings. His major contribution to book illustration was topographical.

1794–6 William Combe, *An History of the River Thames*. [*With aquatints by J. C. Stadler after drawings by Joseph Farington*.] 2 vols. Folio. 'W. Bulmer & Co., for John & Josiah Boydell.'

James FITTLER, 1758–1835

He had considerable repute as an engraver, was appointed Marine Engraver to George III, and A.R.A. in 1800. He was employed as an engraver for *Bell's British Theatre*, but seems to have done little designing.

1778 William Pearce, *The Haunts of Shakespeare: a poem*. 4to. 'For D. Browne.' Oval title-vig. des. and eng. Fittler.

F. FITZMAURICE

1766 Francis Gentleman, *Royal Fables*. Small 8vo. 'For T. Becket and de Hondt near Surrey Street in the Strand.' Front. and headpiece eng. I. Taylor.

John FLAXMAN, 1755–1826

Flaxman's drawings for Homer, Aeschylus and Dante were published with only excerpts of the text and are not strictly book illustration, nor products of English publication, but they were to have a lasting influence. The *Iliad* and *Odyssey* were published engraved by Tommaso Piroli in Rome in 1793 and in England (with some plates re-engraved by Blake) in 1795, the *Aeschylus* in London in 1795 and the *Dante* in Rome in 1802, both engraved by Piroli.

See W. G. Constable, *John Flaxman*, 1927, p. 136; T. S. R. Boase, *Oxford History of English Art*, X, Oxford, 1959, pp. 136–38.

Paul FOURDRINIER

There were two artists of this name, presumably father and son. The elder came to London from France in 1720 (Vertue, III, p. 136) and died 1758 in London. He was much employed on architectural engravings (*The Villas of the Ancients*, 1728, and the plans and elevations of Houghton Hall), but also engraved many plates for general literature. The younger was born in England and died *c.* 1769.

1723 Joseph Addison, *The Free-Holder, or Political Essays*. 12mo. 'For D. Midwinter and J. Tonson.' Front. eng. possibly des. P. Fourdrinier. 3rd ed.

1731 Joseph Trapp, *The Works of Virgil: translated into English blank verse*. 3 vols. 12mo. 'For J. Brotherton et al.' 3 fronts. 'P. Fourdrinier fecit.'

Henry FUSELI, 1740–1825

'To confine the illimitable!' Charles Lamb exclaimed with disdain in his famous verdict on Boydell's Shakespeare Gallery, a venture in which Henry Fuseli, 'light-headed Fuseli', played so prominent a part. It is by no means certain whether the Swiss artist, who had become Professor of Painting and Keeper of the Royal Academy in London, might not, after all, have been prepared to concur. Among the galaxy of talent which was engaged, at immense cost, in the task of covering vast canvases for the greater honour of the great dramatist, Fuseli's nine contributions stand out for their almost disconcerting intensity. Where most

of his fellow-artists occupied in this ambitious venture were content to provide a visual description of some scene from the plays, Fuseli's share in the Gallery aimed at far more than mere paraphrase. 'Illustrating' Shakespeare meant to him to seize and heighten a climax of dramatic action and so to fill it with his spirit and outlook as to give expression to his own daring and often violent dreams.

In the sense that his imagination responded most readily to great themes derived from literature, Fuseli was an illustrator of books *par excellence*; and since it was English literature, Shakespeare and Milton above all, which preoccupied him throughout his creative life and from which he drew his most striking themes, he holds an important place in English book illustration. Not all his plates, however, were based on designs expressly made for this purpose; often a subject or theme had been treated by the artist, perhaps several times, in oils on a large scale before Fuseli reduced it to essentials in a drawing destined for the engraver. In other cases the whole task of reducing a picture to the size prescribed by the publisher was left altogether to the craftsman who engraved the copperplate.

In the catalogue of paintings exhibited at the Royal Academy in 1781—the year of Fuseli's return from his prolonged Italian studies and after his final break with his native Switzerland—there figures among Fuseli's three exhibits one with a title unusual in the artist's *oeuvre*: A Conversation. The picture, measuring five foot square, shows the young artist listening to his teacher, J. J. Bodmer, the outstanding Swiss scholar of his time; the group is overshadowed by the vast, and somewhat formidable figure of Homer—no doubt an evocation of Fuseli's literary sources. There is evidence that, even late in life, Fuseli took pride in thinking of himself as a poet and writer, and parallels between literature and the visual arts can be found interspersed in all his art criticism, even in his Royal Academy Lectures.

Upon his first arrival in England in 1765, it was his ability as a linguist and his considerable knowledge of art history which enabled Fuseli to gain a living through translations, articles and pamphlets. Among those who befriended the foreigner in London, perhaps the most remarkable man was Joseph Johnson, the radical publisher who was to count among his authors Joseph Priestley, Erasmus Darwin, John Howard, Horne Tooke, Mary Wollstonecraft and Maria Edgeworth. In one of

his letters from London to his friend Lavater, Fuseli says that he is spending all his time 'in study, happy with my friend Johnson whom I pay for my keep with drawings and occasionally by writing'. Among these early drawings for the booksellers are a number of allegorical frontispieces and vignettes (most of them unsigned), and above all the four frontispieces which he designed for Smollett's *Peregrine Pickle*, 1769, the earliest illustrations for this novel. Not wholly uninfluenced by Hogarth and the English popular caricaturists of the time, these plates show as yet no more than a faint promise of his later distinct and highly personal manner.

It was not until the age of thirty that Fuseli, upon the advice and encouragement of Reynolds (beside whom he lies buried in St. Paul's), turned to painting as a profession. To convey his splendid dreams and grandiose visions he required, so he thought, a proportionately vast canvas. 'I have lost the desire', he wrote to Lavater from Rome when asked to provide further illustrations for his friend's big work on the fashionable 'science' of physiognomy, 'and perhaps also the ability to squeeze great thoughts and noble lines into the compass of three inches, so that even a bungling engraver must see the point of them.' And again: 'I find myself neither competent nor in the mood to draw physiognomies on the scale of nine to a page. I leave it to "the most soulful draughtsman in Europe" [the reference is to Daniel Chodowiecki whose diminutive engravings of Almanach size were then the rage on the Continent] to draw the Iliad in a nutshell or chariot and horses of Elijah on a gnat's wing. I need space, height, depth, width. Let those who will raise a storm in a wine-glass or weep over a rose; I can't do it.'

His chance to work on the scale he dreamt of for a wholly congenial subject came in 1785 with Alderman Boydell's Shakespeare Gallery. Encouraged by the apparent success of this great project, Fuseli ventured on a similar enterprise single-handed and began to produce more than forty paintings on no less large a scale to fill a Milton Gallery, which was opened to the public in 1799. It was an admirable effort of industry and daring, but financially it ended in fiasco.[1]

In the meantime, however, Fuseli, who was hailed or, according to taste, execrated by his contemporaries as a 'natural genius' and one 'capable

[1] Gert Schiff, *Johann Heinrich Füsslis Milton-Gallerie*, Zürich, 1963.

of the most wild and grotesque combinations of fancy', had succeeded in gaining the formal approbation of the Royal Academy, and was elected Professor of Painting. In his Academy Lectures, he used to say of himself 'I found colour a coy mistress, so I left her.' Perhaps, too, with the failure of his Milton Gallery, he had worked off the need for expressing himself on a scale physically commensurate with the grandeur of his spiritual conceptions. It was, in any case, in the closing years of the eighteenth century and during the first decade of the nineteenth that he did almost all his important work as a book illustrator, less than a hundred designs but practically every one of them standing out unmistakeably with characteristic vigour among the common run of sentimental illustrations of the period.

In January 1803, Fuseli told his colleague Farington with evident satisfaction that he was 'engaged in making a complete set of drawings for an edition of Shakespeare for a body of Booksellers who oppose that with wooden Cuts from designs by Thurston', which appeared between 1803 and 1805. Fuseli's thirty-seven plates for Chalmers's ten-volume edition (published 1805) strike an altogether new note in Shakespearean illustration; it is indeed difficult not to consider them, for all their occasional exaggeration and oddity, bolder and less inadequate than most (if not all) other attempts made in this somewhat over-exploited field before or since. Comparison with Fuseli's own work for the Shakespeare Gallery shows how the artist had learnt to make a virtue of the awkward format required by an octavo volume. The narrow high shape of the drawing forbade any overcrowding of the scene; there was space only for a very few human figures and even these are so simplified and stylized as to give them—at their best—memorable stature.

Fuseli's designs for the 1805 edition of Shakespeare (and to a lesser extent the illustrations which he contributed to Cowper's translation of Homer published five years later) constitute his finest achievement in 'historial' or, as he would have called it, 'poetical' book illustration. Already a few years earlier, engravings from his paintings had been used for the luxury editions of various poets which the publisher Du Roveray produced with the assistance of those fine printers, Bensley and Bulmer, between 1798 and 1802. In these volumes, Fuseli's threateningly accented figures and groups make somewhat strange bedfellows with the idyllic compositions of William Hamilton, another Academician. The eight illustrations he drew for a new edition (1806) of the *Poems* of his friend Cowper ('whom he liked best', says Farington, 'of all the poets of his period') show that Fuseli could even find a fresh and novel angle for domestic subjects. Perhaps the scenes in the drawing-room or in the boudoir, his ladies of obvious light virtue and high passions at their toilet-table, are all too plainly out of tune with the poet's intentions. Fuseli was not the kind of man to subordinate himself to other people's imagination; even where sentiment is demanded of him he imbues it with grandeur.

It may be regretted that Henry Fuseli, with all his predilection for the weird, the grand and the striking, should (as it seems) never have been given an opportunity to try his imagination on the Gothick novels which enjoyed their immense vogue just when he was at the height of his powers. But even what we have of his illustrative work places him in a category apart, a far cry from the contemporary efforts of a Stothard, a Burney or a Westall.

H. A. Hammelmann, *Book Collector*, VI, 1957, pp. 350–60. There is a considerable literature on Fuseli, but the definitive work is Gert Schiff, *Johann Heinrich Füssli*, 2 vols., Zürich, 1973, where all the book illustrations are listed and reproduced.

1765 [Johann Jacob Bodmer], *Die Noachide, in zwoelf Gesaengen.* 8vo. 'Berlin bei Christian Friedrich Voss.' Oblong allegorical title-vig. (unsigned) and 12 poorly etched but interesting pls. by C. G. Matthes after Fuseli (8) and Bernhard Rhode (4). The pls. after Fuseli's designs are all dated 1764, those after Rhode 1765.

1765 J. J. Winckelmann, *Reflections on the Painting and Sculpture of the Greeks: with Instructions for the Connoisseur, . . . translated from the German . . . by H[enry] F[useli].* 8vo. 'Printed for the Translator and sold by A. Millar.' Eng. title-vig. 'Diis Graeciae S.' and ornamental headpiece to first page of text des. Fuseli but bearing no signature.

1767 Henry Fuseli, *Remarks on the Writings and Conduct of J. J. Rousseau.* Sm. 8vo. 'For T. Cadell, J. Johnson &c.' Satirical front.: Justice and Liberty on the Gallows, Voltaire riding humanity and unmasked by Rousseau, by Fuseli [unsigned], eng. C. Grignion.

The subject is described by Fuseli himself in the *Critical Review* for May 1767, p. 180; reproduced in E. C. Mason's ed. of the *Remarks*, Zürich, 1962, p. 55.

1768 Joseph Priestley, *An Essay on the First Principles of Government; and on the nature of . . . liberty.* 8vo. 'For J. Dodsley, T. Cadell et al.' Title-vig.: Sphinx and cherub with cap of liberty, eng. C. Grignion after Fuseli.

1769 G. Drazonetti, *A Treatise on Virtues and Rewards* (translated by Henry Fuseli). 8vo. 'For Johnson and Payne, and J. Almon.' Title-vig., headpiece to dedication and 2 tailpieces [1 of them identical with the title-vig. to the Priestley vol.], all eng. Grignion after Fuseli.

1769 Tobias Smollet, *The Adventures of Peregrine Pickle.* 4 vols. 12mo. 'For R. Baldwin, and Robinson and Roberts; and T. Becket and T. Cadell.' 4 fronts. des. Fuseli [unsigned], eng. C. Grignion. 4th ed.
Ganz (*The Drawings of Henry Fuseli*, 1949, p. 30) suggests that these illustrations appeared in 1765, but the 3rd ed. contained no pls. Antal (*Fuseli Studies*, 1956) reproduced the front. to vol. II (pl. 3a), but wrongly assumed that the ed. containing Fuseli's illustrations was never published.

1772 The Hon. and Rev. Francis Willoughby, *A practical Family Bible on a Plan entirely new . . . Embellished with a Set of beautiful Engravings of the most interesting historical Passages in the Sacred Scriptures, engraved from the best Copies of capital Paintings, by able Artists.* Folio. 'Printed for J. Wilkie.' Front. eng. Grignion after Samuel Wale, and numerous full-page pls. within ornamental border, mostly after French and Italian paintings, but a number after designs by Samuel Wale and after Fuseli; eng. Collier, June, Müller, Grignion and Benoist, except those of Johan, 'Fuseli inv. del. et in ac. fort. excudit,' and of Isaiah and Ahab's seventy sons slain by the rulers of Samaria, 'Fuseli inv. et delin. et sculp.' A 2nd. ed., 1775, folio, contains the same pls. The editorship is there attributed to Joseph Wise. (Plates 43, 44.)

1775–8 Johann Caspar Lavater, *Physiognomische Fragmente, zur Befoerderung der Menschenkenntniss und Menschenliebe; . . . mit vielen Kupfern.* 4 vols. 4to. 'Leipzig und Winterthur. Bey Weidmann's Erben und Reich, und Heinrich Steiner &c.' 4 title-vigs., 488 pls., vigs., and tailpieces in text and 343 full-page engravings, including a few by Fuseli, eng. Chodowiecki, Lips, Berger, Holzhalb, Schellenberg, &c.

1781–83–86–1803 Jean Gaspard Lavater, *Essai sur la Physiognomie, destiné à faire connoître l'homme, et à le faire aimer.* 4 vols. 4to. Imprimé à La Haye [Jaques van Karnebeek, Vol. IV: Teeckelenburch, but published by Steiner, Winterthur]. The Preface declares that this French ed. contains 'des planches mieux executées' and 'les images plus interessantes' than the original German ed. There are in fact many additional engravings, a number of new ones by Fuseli. The pls., though better engraved and printed, are engraved by German and Swiss artists.

1786 John Bonnycastle, *An Introduction to Astronomy, in a series of letters from a preceptor to his pupil.* 8vo. 'For J. Johnson.' Front. unsigned, eng. Sherwin in the 5th ed. (1807) the same front. is s. 'Fuseli delineavit.'

1788 J. C. Lavater, *Aphorisms on Man. Translated [by Henry Fuseli]* Sm. 8vo. 'Printed for J. Johnson.' Front. des. by Fuseli [unsigned] and eng. Blake. It has been suggested that the seated man may be Blake himself.
In a short advertisement the Editor (Fuseli) foreshadows another companion vol. by himself, *Aphorisms on Art*, but this did not appear. At the foot of p. 224 the words 'End of vol. I' are sometimes erased with care. The front. occurs again in the 2nd ed. by T. Bensley for J. Johnson, 1788.

1788 *Thomas Macklin's British Poets. [A series of prints illustrative of the most celebrated British Poets, . . . with explanatory letter-press extracted from the writings of the respective Poets.]* Oblong folio. Published by Thomas Macklin. According to the 'Proposals', this work was to contain 'one hundred Pictures of the most interesting subjects from the Poets of Great Britain' to be issued in sets of 4 prints each number, 2 numbers to be published each year. The scheme was never completed; between April 1788 and November 1799 6 separate numbers appeared containing 24 pls. measuring 18 in. by 14 in., each pl. accom-

panied by one page of letterpress. The engravings were made mostly by Bartolozzi and his pupil Tomkins from pictures specially painted by Angelica Kauffman, Maria Cosway (2), Gainsborough (2), W. Hamilton (4), Reynolds, H. Bunbury (4), Opie (3), Wheatley (2), Stothard, Artaud, Rigaud and two by Fuseli: 'The Vision of Prince Arthur' (Spenser) and 'Queen Catherine's Dream' (*Henry VIII*). The last-named picture was the only Shakespearean subject to be published in this collection; like Fuseli's other contribution, it appeared in the first number and is dated 'April 4, 1788' by the engraver Bartolozzi. (Plate 45.)

See T. S. R. Boase, *JWCI*, XXVI, 1963, pp. 148–55.

1789–92–98 Johann Caspar Lavater, *Essays on Physiognomy designed to promote the knowledge and the love of Mankind . . . illustrated by more than eight engravings accurately copied; and some duplicates added from originals. Executed by or under the inspection of T[homas] Holloway. Translated from the French by Henry Hunter.* 3 vols. [sometimes bound in 5]. 4to. 'Printed for John Murray, H. Hunter and T. Holloway.' This ed. was supervised by Fuseli who wrote for it an 'Advertisement' of 6 pages which describes it as 'much more instructive and complete in plates and vignettes than they will be found in the French edition'. All the pls. (21 by Fuseli) were in fact re-engraved by Bartolozzi, Holloway, Grignion, William Blake, Gillray, Taylor, Bromley, etc., and a number of illustrations (4 by Fuseli) were added. Lawrence drew a profile portrait of Fuseli for this ed. which is eng. T. Holloway. A 3-vol. ed., trans. by Thomas Holcroft from the German, large 8vo, 1789–93, contains 360 of the engravings, some reduced.

1789–91 Erasmus Darwin, *The Botanic Garden. Part II. The Loves of the Plants.* 4to. 'For J. Johnson.' 9 pls. of various kinds, including 4 des. by Fuseli, eng. Anker Smith, Blake and Holloway. Part III has the Nightmare, a version of Fuseli's famous theme, and Zeus fighting with the Python. All the illustrations are reprinted (reduced) in the 'fourth edition', 2 vols. 8vo, 1799. Fuseli's drawing for the Fertilization of Egypt and the wash-drawing

of his own from which Blake engraved it are in the B.M.

1795–6 [William Seward], *Anecdotes of some distinguished persons.* 8vo. 'For Cadell and Davies.' 3 pls. eng. William Sharp.

1796 [Sir Brooke Boothby], *Sorrows. Sacred to the memory of Penelope.* Folio. 'Printed by W. Bulmer and sold by Cadell, Davies, Edwards and Johnson.' Front.: angel raising up Penelope, s. 'Fuseli pinxt', eng. F. Bonedetti. The other pls. and vigs. in the vol. are not by Fuseli.

1791–7 *Bell's British Theatre, consisting of the most esteemed English Plays.* 34 vols. 12mo. 'Printed for George Cawthorn.' 140 elaborate pictorial title-pages incorporating scenes from the plays and engraved from designs by Burney, Wheatley, Hamilton, Corbould, Craig, Stothard, Smirke, Opie, Tresham, Metz, Ibbetson, Westall, Peters, Dayes or Dayce, Graham, and 5 by Fuseli: *Jane Shore* (1791). eng. Holloway; *Every Man in his Humour* (1791). eng. Grignion; *The Revenge* (1793). eng. Leney; *Tancred and Sigismunda* (1792). eng. Legat; *Oedipus* (1792). eng. Holloway. This collection contains also 140 full length portraits of actors in costume, as they appeared in the plays, [1 for each play] mostly from paintings or drawings by De Wilde, Roberts and Graham. Bell's Prospectus modestly stated that 'the Productions of the British Press are not at present to be excelled by the Artists of any country upon Earth.'

1798 A. Pope, *The Rape of the Lock. An heroi-comical poem.* 8vo. 'Printed by C. Bensley for F. J. Du Roveray.' Front. by W. Hamilton, eng. Bartolozzi, and 5 pls. by E. F. Burney, T. Stothard and one signed 'H. Fuseli pinx.': 'The gnome, rejoicing bears her gifts away', eng. by T. Holloway.

1798 Charles Allen, *A New and Improved Roman History, from the foundation . . .* 12mo. 'For J. Johnson.' 4 pls. eng. William Blake dated 'December 1797', probably after designs by Fuseli. 2nd. ed.

1798 Charles Allen, *A New and Improved History of England.* 12mo. 'For J. Johnson.' 4 pls. by Fuseli, eng. William Blake. 2nd ed. Mentioned by Antal, *Fuseli Studies*, 1956,

where 1 pl.: King John absolved by the Cardinal Pandulph, is reproduced: pl. 33a.

1791–1800 Macklin's *Bible* [see under de Loutherbourg]. Fuseli contributed 1 pl.: The Vision of St. John.

1800 Thomas Gray, *The Poems . . . A new edition, adorned with plates*. 8vo. 'Printed by W. Bulmer for F. J. Du Rouveray.' Front. and 5 pls., 3 of them eng. after Fuseli by Holloway and Neagle, the remainder des. by W. Hamilton. All the pls. are dated 'January 1st, 1800'. An 'Advertisement' at the beginning of the vol. states that 'no expense has been spared to render the embellishments . . . worthy of the progress made by the national taste within these few years.'

1801 Henry Fuseli, *Lectures on Painting, delivered at the Royal Academy. March 1801*. 4to. 'For J. Johnson.' Oval title-vig.: a crouching woman ['Silence', a subject from the Milton Gallery], s. 'F. Legat sculpt,' and large tail-piece 'Ancora imparo' [probably from Lavater's *Physiognomy*], s. 'Blake sc.,' both after Fuseli. Reprinted with the 2 engravings in 1830, the tailpiece now s. 'Engleheart sc.'

1793–1801 *The History of England from the Invasion of Julius Caesar to the Revolution in 1688*. 5 vols. in nine. Folio. 'By R. Bowyer at the Historic Gallery.' Numerous pls. after Smirke, Opie, Stothard, de Loutherbourg, etc., including: The Death of Cardinal Beaufort, eng. W. Bromley after a painting by Fuseli, (in vol. 2 part 1).

1802 James Thomson, *The Seasons. A new edition. Adorned with Plates*. 8vo. 'Printed by T. Bensley for F. J. Du Roveray.' Front. and 6 pls., 2 of them eng. Bromley after Fuseli, the remainder des. by Hamilton and Burney. Also on large paper, with proofs before letters.

1802 *The Dramatic Works of Shakspeare. Revised by G[eorge] Steevens*. 9 vols. Folio. 'By W. Bulmer and Co., Shakspeare Printing Office, for John and Josiah Boydell.'
According to the Prospectus, dated 'Dec. 1st, 1786', the work was to consist of 8 volumes and to be illustrated by 72 scenes; publication in parts began in 1791. Simultaneously Boydell issued large plates in imperial folio after the paintings in his Shakespeare Gallery

which were eventually collected under the general title: *A Collection of Prints, from pictures painted for the purpose of illustrating the Dramatic Works of Shakspeare by the Artists of Great Britain*. 2 vols., 1803, 100 pls. which included 8 after paintings by Fuseli eng. Simon (2), Thew (2), Earlom, Caldwell, Leney and Ryder. The 'Directions to the Book-Binder' in Vol. I of the 9-vol. ed. with the text makes it clear that the plan of publication was modified before completion. 'The Proprietors of this Work', it runs, 'in their original plan proposed to engrave the small plates from the same subjects as the large plates; but they afterwards improved their plan, and gave their subscribers more than they promised, by procuring seventy-nine pictures to be painted on purpose for the small plates', which included one by Fuseli (for *Midsummer Night's Dream* in Vol. II) engraved by J. Parker. The total number of plates accompanying the 9-vol. folio edition is given in Boydell's Catalogue for 1803 as 96 (not 100 as is stated by Lowndes and elsewhere), of which 79 represent scenes *not* identical with those of the large imperial folio prints. These 96 smaller plates were also separately issued (without text) with contents leaf and title: *Graphic Illustrations of the Dramatic Works of Shakspeare*, consisting of series of prints, folio, 1802.
See W. H. Friedman in *JWCI*, XXXVI, 1973, pp. 396–401.

1802 John Milton, *Paradise Lost. A new edition. Adorned with plates*. 2 vols. 8vo. 'Printed by T. Bensley for F. J. Du Roveray.' Eng. front.: portrait after a miniature and 12 pls., 6 of them des. Fuseli and eng. Bromley (2), A. Smith (2), C. Warren and Neagle. Also on large paper, with proofs before letters. The other pls. by Westall.
A full description and one reproduction are given in Mr. C. H. Collins Baker's 'Milton Iconography', *The Library* (1948) pp. 101–2. The pls. were used again in 1808. See G. Schiff, *Johann Heinrich Füsslis Milton-Gallerie*, Zürich, 1963.

1805 *The Plays of William Shakspeare, accurately printed from the text of the corrected copy left by the late G[eorge] Steevens, Esq. With a series of engravings, from original designs of H[enry]*

Fuseli, and a selection of . . . notes . . . by A[lexander] Chalmers. 10 vols. 8vo. 'For F. C. and J. Rivington, J. Johnson and about forty others.' Portrait front. eng. Neagle, and 37 pls. drawn by Fuseli and eng. Cromek (8), J. Neagle (6), Bromley (5), Rhodes (4), C. Warren (3), S. Noble (2), Dadley (2), W. Blake (2—for *Romeo and Juliet* and *Henry VIII*), Taylor, Joseph Smith, T. Milton, Lee, J. G. Walker. The earliest engraved pls. are dated 'Jan. 1, 1803', the latest 'July 14, 1804'. A number of original drawings for this ed. are in the Kunsthaus, Zürich.

1806 William Cowper, *Poems . . . A new edition.* 2 vols. 8vo. 'For J. Johnson by T. Bensley.' 8 pls. des. Fuseli, eng. Raimbach (2), Rhodes (2), Bromley (2), Neagle and Warren. All the pls. are dated 'March 1, 1807'. They are found again in an ed. published by Johnson in 1811.

All the original paintings are preserved in Swiss collections; one of them is reproduced in the Exhibition Catalogue, Kunsthaus, Zürich, 1941, Plate XII.

Thomas GAINSBOROUGH, 1727–88

He studied at the St. Martin's Lane Academy, where he came under the influence of Gravelot and Hayman. In an article in the *Morning Chronicle* printed shortly after Gainsborough's death it is stated that 'he became a pupil to Mr. Gravelot, under whose instructions he drew most of the ornaments which decorate the illustrious heads, so admirably engraved by Houbraken.' There is, however, no confirmation of this from other sources, or from Gainsborough's known style at the time. Charles Grignion, a good authority, told Edwards that Gainsborough worked with Gravelot (Edwards, *Anecdotes*, p. 130). See J. Hayes in *Notes on British Art, Paul Mellon Foundation*, 13, 1969 (also in *Apollo* supplement Jan. 1969, pp. 1–3).

1754 Dr. Brook Taylor's, *Method of Perspective* [see under Kirby]. 1 landscape pl. 'T. Gainsborough fecit acqua forte, J. Wood perfecit.'

William Nelson GARDINER, 1766–1814

Born and trained in Dublin, he came to London, where he was for a time on the stage, acting and scene-painting. He then had training in engraving from Bartolozzi. He engraved some of Lady Diana Beauclerk's designs for Dryden's *Fables*. His own designs are in the manner of Rowlandson, and are hardly effective as Shakespearian illustration.

1798–1800 *The Plays of William Shakespeare* [see under Thurston]. 12 pls. 2 drawings for *Hamlet* are in the Huntington Library.

James GILLRAY, c.1757–1815

Though in the early stages of his career he published a series of illustrations to Goldsmith's *Deserted Village* (1784), he was never employed to any extent by the book trade. His caricatures were published as single prints (normally in the last decade of the century at one shilling plain, and one and six or two shillings coloured). A great draughtsman, his influence on book illustration came in the nineteenth century rather than the eighteenth.

See Draper Hill, *Mr Gillray; the Caricaturist*, 1965; and *Fashionable Contrasts: a Hundred caricatures by James Gillray*, 1966.

William GILPIN, 1724–1804

His father, Captain John Bernard Gilpin, was a talented amateur artist, and his younger brother, Sawrey (1733–1807), trained as a painter and eventually became R.A. A clergyman and a schoolmaster, William himself remained an amateur painter. When in 1784 one of his *Tours*, that had for some time circulated in manuscript with his own drawings, was prepared for publication, John Warwick Smith and his nephew William Sawrey Gilpin were entrusted with the aquatints and were given some latitude in following the original drawings. The *Tour of the Lakes* and the *Scottish Tour* were published in 1789, the *Remarks on Forest Scenery* in 1791, the *Three Essays* in 1792, the *Western Tour* in 1798. The plates are illustrations of his views as to rendering landscape, but their importance is in the theory of the Picturesque rather than in the development of book illustration.

John GLOVER, 1767–1849

Landscape painter, particularly in watercolour, who in 1831 emigrated to Tasmania, where he continued to paint.

1796 [Sir Brooke Boothby], *Sorrows. Sacred to Penelope* [see under Fuseli]. 3 square-headpieces: views of Ashbourne s. 'Glover del. Byrne sculp.'

Joseph GOUPY, c.1680–?1763

Born at Nevers, he belonged to a family of artists who settled in London. He became drawing master to Frederick, Prince of Wales. Louis Goupy was a relative.

See E. Croft-Murray, *Decorative Painting in England*, II, p. 211

1718 A. De Moivre, *The Doctrines of Chances: or, a method of calculating the probability of events in play*. 4to. 'By W. Pearson for the Author.' Title-page vig., decorative design unsigned. 1 headpiece s. 'J. Goupy inv., B. Baron scu.'

1729 *A Select Collection of Novels* [see under Vanderbank]. 2 pls., eng. G. van der Gucht.

1765 Charles Cotton, *The Genuine Poetical Works . . . The fifth edition*. 12mo. 'For T. Osborne and many others.' Pls. after Goupy, almost certainly used in earlier editions.

Louis GOUPY

1721 John Sheffield, Duke of Buckingham, *The Works of The Most Noble . . . Published by his Grace, in his lifetime*. 4to. 'For E. Curll.' Title-page vig. unsigned. 2 headpieces eng. M. van der Gucht.

John GRAHAM, 1754 or 1755–1817

He was apprenticed to a coach-painter in Edinburgh. He then came to London and between 1780 and 1797 exhibited history-paintings at the Academy. In 1798 he was appointed Master of the new Trustees' Academy in Edinburgh, where Wilkie was among his pupils.
See Hamish Miles, 'John Graham and the Trustees' Academy', *Scottish Art Review* (forthcoming).

1791–2, 1796–7 *Bell's British Theatre*: [See under Fuseli] Howard, *Committee*. eng. Leney; Young, *Brother*. eng. Thomson; Hill, *Zara*. eng. Fittler; Whitehead, *Roman Father*. eng. A. Smith; Lillo, *Fatal Curiosity*. eng. Skelton; E. Smith, *Phaedra and Hippolitus*. eng. Heath; Brooke, *Gustavus Vasa*. eng. Smith; Murphy, *School for Guardians*. eng. Skelton; S. Lee, *Chapter of Accidents*. eng. Wilson; Whitehead, *Creusa*. eng. Audinet; Young, *Busiris*. eng. Leney; Mason, *Caractacus*. eng. Leney; Home, *Douglas*. eng. A. Smith; Jonson, *Alchymist*. eng. Grignion; Rowe, *Fair Penitent*. eng. Grignion; Otway, *Venice Preserv'd*. eng. Hall. Graham also des. 13 portraits of actors in costume for Beall's publication.

1799 Thomas Campbell, *The Pleasures of Hope*. 4 pls. eng. R. Scott, E. Mitchell, D. Somerville.

William GRAINGER, *fl.* 1784–93

1781 [J. H. Wynne], *Fables of Flowers . . . With*

Zephyrus and Flora, a vision. 12mo. 'For E. Newbery and G. Riley.' Small pls. eng. and probably des. Grainger. V. and A.

1793 Samuel Richardson, *Clarissa Harlowe* and *Sir Charles Grandison* [see under Chalmers]. Fronts. 'del. et sculp.'

1797 *Cooke's Select Novels* [see under Corbould]. Title and dedication pls., des. and eng. Grainger.

GRAVELOT, 1669–1773
Hubert François Burguignon

'Mr. Gravelot, designer and etcher of history, ornaments etc. has returned to Paris'—so runs a passage in George Vertue's note-books under the year 1746—'. . . having obtained a reputation of a most ingenious draughtsman during the time he has been at London.' 'He is endowed with a great and fruitful genius for designs' says another entry —and this is no faint praise from a fellow engraver, a native competitor, one might say, of the young Parisian—'. . . and besides that he practises etching in which business he has done many curious plates from his own designs, masterly and free and *de bon goût* which is another branch of improvement of Art in a higher degree of perfection than has been done before in England.'

It was in late 1732 or early 1733 that Gravelot, summoned by Claude du Bosc, had come to England. He had an important contribution to make. He brought from France the vogue of the elegant engraved book of the rococo, the notion that a book should not only be pleasant to read, but also attractive to look at and to handle. His accomplished drawings and his carefully finished engravings with their remarkable play of light and shade helped, more than anything else, to speed the transition from the absurdly stilted and in almost every case smudgy illustrations which had hitherto served on such occasions to the polished work of a Taylor, Wale or Stothard. Gravelot's influence reached further still: he must be given credit for having transmitted something of the spirit of Gillot and Watteau to a whole generation of minor English artists, and even to Gainsborough, Hogarth and Hayman.

At Gravelot's studio, at the sign of the Pestle and Mortar in Covent Garden, young Gainsborough, when he first arrived in London, was among his pupils; so was Thomas Major, distinguished later as the first engraver to be elected Associate to the Royal Academy, and that most

THE
UNIVERSITY OF WINNIPEG
PORTAGE & BALMORAL
WINNIPEG 2. MAN. CANADA

prolific of engravers for the booksellers, Charles Grignion. In the hub of the artists' quarter, between Covent Garden and the Strand, where bookshops and print galleries, publishing houses and artists' taverns, painters' studios and writers' studies were perched one upon the other in the narrow streets, Gravelot made his home at the Golden Cup in King Street. Just round the corner, in Peter's Court, was the St. Martin's Lane Academy of which he was, with Hogarth and Hayman, among the leading spirits. In St. Martin's Lane, too, was the famous Beefsteak Club and Old Slaughter's Coffee House, convivial haunts where hacks and artists, cranks and connoisseurs of all tongues and nations got together without much ceremony. Here Gravelot used to take his evening ale with Hogarth and Hayman, both by all accounts rather boisterous boon companions, himself inclined, it is said, 'to hold forth with considerable violence and freedom for or against whom he pleases'. In the teeming coffee houses and taverns of 'the Lane' he may have made first acquaintance with Garrick whose life-long friendship he honoured later by hanging a print of Reynolds' *Garrick between Tragedy and Comedy* on a wall of his Paris home. 'We may be clever as Pugilists,' William Blake wrote in his prose pieces known as *Public Address*, 'but as Artists we are and have long been the Contempt of the Continent. Gravelot once said to my Master, Basire: "De English may be very clever in deir own opinions, but dey do not draw de draw."' The remark bears all the authenticity of the Frenchman's sarcasm, and it fits in point of time: James Basire was almost sixteen before Hubert Gravelot returned to Paris after his long residence in this country, and his father, Isaac, had engraved a Gravelot frontispiece in 1739. James may well have heard the foreigner arguing in this fashion (as he was prone to do) during classes at the drawing school.

Though known today only as an illustrator, Gravelot, during his time in England, tried his skill in many fields. No examples, unfortunately, appear to survive of the work he undertook, probably in the early days of his stay, for the gold- and silversmiths in London, nor of the 'many designs' he is said to have made 'for cabinet-makers and other workmen in upholstery and furniture'. In the print collections of the B.M., the V. and A. and elsewhere, however, there is still evidence to be found of versatile activity coming within the range of a draughtsman and engraver;

invitation cards, a trade-card for a snuff manu-facturer, book plates (including one for Boling-broke), even fans, as is shown by the following advertisement preserved among the Whitley MSS.: 'This day is published a fan mount, a view of the most extraordinary scenes of the celebrated musical entertainment of *Orpheus and Eurydice* . . . drawn by the ingenious Mr Gravelot with the utmost accuracy as they appear up on the stage, and engraved by C. Mosley.'

There was apparently little Gravelot refused to put his hand to when occasion arose. At one time we hear of him drawing ancient church monu-ments in Gloucestershire, at another we find him depicting *Owen Farrel, the Irish Dwarf*, or *A Chimpanzee newly brought from Angola*, the folio print of which is proudly signed *H. Gravelot ad vivum delineavit*. The most interesting of the large loose prints which bear his name as designer is perhaps *The House of Commons as it appeared in 1741–2*, and it is pleasant to think that in the gallery Gravelot may have rubbed shoulders with Samuel Johnson, just then engaged on his *Debates in the Senate of Lilliput* for the *Gentleman's Magazine*. Finally, there were commissions for decorations and ornaments, above all that for the elaborate surrounds to Houbraken and Vertue's *Heads of Illustrious Persons of Great Britain*, over a hundred different designs full of shells and festoons, wreaths and trophies, fat cherubs or gods and goddesses riding on puffy clouds or foaming waves—a major piece of work indeed on which Gravelot is said to have had the assistance of the young Gainsborough.

But it was in book-illustration proper that Gravelot eventually found 'son aise et son vrai terrain' (Goncourt). His first independent oppor-tunity of a major illustrative work for the book-sellers came already in 1735 when Jacob Tonson asked him to provide frontispieces to a new edition of Dryden's *Works*. This series, interesting though it remains as an indication of the stage costumes and conventions of the time, was unfortunately hardly better suited to bring out the artist's true gifts than the historical engravings and antiquities on which he was at first engaged. Nor did Shake-speare's works, which he was called upon to illustrate twice within a few years, present a more promising subject.

Of the thirty-six play scenes which Gravelot designed for Theobald's second edition of *Shake-speare's Works* (the first was unillustrated), only eight were eventually engraved by the artist

himself. The remainder of the copperplates were executed by Gerard van der Gucht, who was faithful enough in his work on the copper, but his manner of graving tended to be rather blunt, dry and mechanical. Since, moreover, adequate impressions of his plates are only to be found in a small proportion of the Shakespeare sets issued in 1740 and none in the later reprints, his engravings convey but an inadequate idea of Gravelot's stylish and elegant line.

Gravelot's original Shakespearean designs in the Albertina, drawn in the small format required for publication in a duodecimo volume, give a far better impression of the delicate draughtsmanship which has caused him to be described, with justification, as the most important French artist to work for any length of time in England. Done, like most of his drawings for book-illustration, in pen and brown Indian ink with a little light wash here and there, they are minutely finished and show that the artist was determined to leave nothing to the engraver's conjecture.

Authenticity of costume and manners was not a matter by which the eighteenth-century stage set any great store until, in the next century, Charles Kean discovered, or created, among theatre audiences a taste for the blend of historical instruction with amusement and spectacle. It is somewhat unfair, therefore, to blame Gravelot for the incongruity of some of his Shakespearean pictures. Even so it comes as something of a shock to discover, among the designs for the 1740 edition, Prince Hal at the bedside of his father in the Palace of Westminster kneeling beside a couple of the most elaborate Louis Quinze chairs; or Henry VI's 'bloody-minded Queen' bending over the dying Clifford on the field of battle in the alluring, flowing robes of a mid-Georgian lady-about-town.

Gravelot's work for Theobald's edition, sufficiently regarded in its time to be reprinted at least three times (in 1752, 1772, and 1773), did not, as it proved, exhaust his own activity as a Shakespeare illustrator. Within a few years he was back at a similar task for Sir Thomas Hanmer's big luxury edition of 1743-4, published at Oxford, this time in company with his pupil and associate Francis Hayman—a collaboration so close that, but for the signature under the prints, it would sometimes be difficult to distinguish their individual contributions.

What an amazing difference appears when Gravelot came to employ his pen and pencil on narrative pictures of the contemporary scene. He was, after all, the illustrator of domestic life, of the well-proportioned houses and interiors and of the ladies and gentlemen who peopled them. Illustrations for Richardson's sentimental *Pamela*, for Gay's *Fables* or for the adventures of Fielding's *Tom Jones* offered full scope to his supreme capacity for catching the fleeting elegant gesture, the soft and graceful fall of the ladies' silks and the gentlemen's velvets which he had inherited from Watteau. Here, and in the gently humorous vignettes of country scenes which accompany *Flora* he was free to represent life such as he saw it around him, or at least those aspects of it which he wished to see, and if he sometimes idealized here, it was only in order to create a wholly enchanting world such as might have been. There are scenes in the theatre, in church, in the park or in the bed-chamber; families assemble round exquisitely laid tea-tables and young ladies in gorgeous disarray step daintily out of overturned carriages supported by the arm of their gallant rescuers; a rich record of Georgian England, the more attractive because with a fine eye for the stylish detail the artist has placed his heroes and heroines in a setting which enables them to display their *joie de vivre*, their prosperity and their refined taste.

There can be no better demonstration of Gravelot's achievement than by comparing the second volume of Gay's *Fables*, which contains his designs, with Kent's and Wooton's work in the first, published thirteen years earlier; it is indeed a splendid book which may be placed beside the best of Boucher's illustrations. Unfortunately Gravelot was not always so well served by his engravers as here by Scotin and later by his own pupil Grignion; at the outset of his career there were few engravers on this side of the Channel who could do justice to the subtlety and the exceedingly fine point of his pen-and-ink drawings. Though he appears to have ceased engraving altogether after his return to France, during his English period he frequently worked his own copperplates and sometimes even, as in the case of *Pamela* and the Hanmer *Shakespeare*, engraved after others, notably Francis Hayman. The contrast between these plates and Hogarth's engravings or, let us say, Hullet's naïve and artless cuts to *Joseph Andrews* which belong to the same years, makes it obvious that his minute technique, which he passed on to Grignion and other pupils, was far in advance of the careless practice then customary in England.

On his designs, too, Gravelot worked with great care and it is certain that he usually made several sketches of various sizes before an illustration was ready for the graver. Of one eighteenth-century artist it has been said that his nude figures always looked as if they had just been undressed for the occasion. In Gravelot's case almost the opposite was true, for he drew the naked body first and then clothed it, thus giving his figures a firm, definite construction. One of the secrets of his drawing was revealed at the sale of Gravelot's effects after his death. The auction catalogue enumerates as lots 11 and 12 'three lay figures made in England, two foot high and capable of every movement of the body, down to the fingers of both hands'. Each of these padded dolls possessed a number of clothes (the Roman toga is mentioned prominently among them, as might be expected) and could thus be turned, by the hand of the artist, into an adequate model for any small-sized figure that might be required. How carefully Gravelot studied costume is well shown by one of his last productions in this country, a very fine series (known as Truchy's) of elegant male and female personages in fashionable dress.

Gravelot's device of fusing sitters and background, and the charming antithesis between the elaborate dresses of the human figures and the arcadian pursuits in which they are engaged, also forms the distinctive feature of that almost exclusively English form of composition, the eighteenth-century conversation piece. These 'familiar conversations', as they used to be called, usually represent the country gentleman with his family, at a leisurely occupation, set significantly, but without ostentation, against the background of his stately property, the vast park, the country mansion or the reception rooms of the house in town. It has long been known that Gravelot, though in the first place a draughtsman, did in fact occasionally try his hand at genre paintings of this kind in oils, but it is only fairly recently that works in this medium have been discovered which can with any assurance be attributed to him. One is the charming *Building Card Houses* which, for a time, under a wrong attribution, was to be seen at the National Gallery of Sports and Pastimes; the two others, namely *The Reader* which is only known from a print by Guillard, and a large group in the collection of the Earl of Bristol at Ickworth which has long been attributed to Liotard, are a mixture of portrait and genre-painting that indicates the part played by this friend of Boucher in the chain of transmission which led from Watteau's *Fêtes Champêtres* to Highmore, Hayman and Zoffany.

Nowhere does this link become more obvious than in the *Musical Entertainer*, the song-book on which Gravelot collaborated with George Bickham, the writing master. Only a dozen or so of the engraved song sheets and one of the title-pages bear the name of the young French illustrator himself, while more than 100 of the large vignette headings seem to have been lifted from Jullienne's great edition of Watteau's work, published only a year or two earlier. Bickham's was indeed almost certainly a piratical enterprise, for without, in most cases, as much as mentioning their names, he borrowed freely not only from Watteau but also from Gillot and Lancret to make his song-book attractive to the noble patrons to whom it was issued in fortnightly parts. But if exception may be taken against the volumes from a legal point of view and even if, a more serious objection, the illustrations, thoroughly French in taste, accorded but ill with most of the English and Scottish songs which they accompanied, it was a highly deserving venture, for it plainly did much to spread a knowledge of the best Parisian work in England.

In 1745, after the battle of Fontenoy when French and English soldiers were once again pitted against each other in battle, and fear of a French invasion ran high here, Gravelot suddenly decided to return to Paris, irritated, it is said, by some London gallophobes who taunted the industrious foreigner with being a spy in the pay of the enemy. By that time not only the number, but above all the importance and quality of the books which he was called upon to provide with a frontispiece or more extensive embellishment had placed him clearly among the leading illustrators in London. So overwhelmed was he with commissions, a chronicler reports, that at times he was obliged to shut himself up in his studio and work there day and night. In return, it was rumoured, he had amassed, and was able to take back with him, savings to the tune of £10,000, a figure which gives some indication of the popularity of his art. The taste for books embellished with copperplate engravings, which he had stimulated, could now hardly be satisfied. Even after his departure his work remained in demand; however worn the plates from the designs of the 'celebrated Mr Gravelot', they continued to adorn edition after edition, and they were even reproduced, as late as

the sixties, by Robert Hancock when he came to decorate porcelain by his new method of 'transfer printing'. A letter preserved among Garrick's correspondence speaks of requests for illustrations still reaching the artist in Paris twenty years after his return from England. In turning them down, Gravelot was at least able to point out that he had left behind him in London pupils who were now fully capable of producing first-class work themselves.

Gravelot's later French work shows little trace of influence by any individual English artist, yet he was influenced, lastingly, by England as a whole, by her aloofness and her measured sense of proportion which helped to lend distinction to his most frivolously conceived *galant* plates. Among his hosts in England, he had left a lasting mark and the impetus he had given to book illustration here was not entirely exhausted until the very end of the century.

Dufour, 'Élogie de Monsieur Gravelot', *Nécrologie des hommes célebres de France*, Maestricht, 1771.

Yves Bruand, 'Hubert Gravelot et l'Angleterre', *Gazette des Beaux Arts*, CV, 1960, pp. 35–44.

H. A. Hammelmann, *CL*, 1959, p. 1085.

H. A. Hammelmann, *Book Handbook*, Vol. II no. 3, 1951, p. 129, and Vol. II no. 4, 1951/52, p. 180.

V. Lauckoronska, 'Gravelot in London', *Philobiblion*, X, 1938, pp. 97–113.

1733–7 *The Ceremonies and Religious Customs of the Various Nations of the World . . . written originally in French, and illustrated with a large Number of Folio Copper Plates, all beautifully designed by Mr. Bernard Picart, and curiously Engraved by most of the Best Hands in Europe. Faithfully translated into English, by a Gentleman some time since of St. John's College in Oxford.* 7 vols. Folio. 'Printed by William Jackson, for Claude du Bosc, Engraver at the Golden Head in Charles Street, Covent Garden.'

Claude du Bosc set up in London as a printseller after he had completed work on the Raphael cartoons in 1719. The 223 pls. are re-engraved from the French ed. by du Bosc, Scotin and Gravelot, but Gravelot added 22 new headpieces; 1 pl. is signed 'Gravelot inv. et fec. London 1733,' the first indication of his presence in London.

1735 [T. Blackwell], *An Enquiry into the life and*

writings of Homer. 8vo. Frontispiece, 12 headpieces and 1 tailpiece eng. Scotin (3), Fourdrinier (3) and van der Gucht (8).

1735 *Xenophontis de Cyri Expeditione*, ed. Th. Hutchinson. 4to. Oxoniae. Front. eng. Pine. Exists on Large Paper—Lowndes.

1735 *The Dramatick Works of John Dryden.* 6 vols. 12mo. Tonson. Front. portrait eng. Vertue, 27 pls. eng. G. van der Gucht. The same plates still in J. and R. Tonson edit. of 1762/3.

1735 *The Kit-Kat Club done from the original paintings of Sir Godfrey Kneller by Mr Faber.* Folio. Tonson and Faber. Title eng. in mezzotint by Faber, and 48 portraits.

1735 William Somerville, *The Chace. A Poem.* 4to. 'For Hawkins.' Front. eng. Scotin. Frequently reprinted in 8vo.

1735 *The History of Popery: with such Alterations of Phrase, as may be more suitable to the Taste of this Age . . . By several Gentlemen.* 2 vols. 4to. 'For J. Oswald.' 2 fronts. eng. G. van der Gucht and title-vig. eng. J. Pine.

1736 Frederick Scheffer, *The Toast, an Heroick Poem in four books originally done in Latin . . . now done into English . . . by Peregrine Odonald Esq.* [Dr W. King]. 4to. Dublin printed, London reprinted. Front. eng. B. Baron. Another ed. with same plate, Dublin 1747.

1736–7 [Henry Coventry], *Philemon and Hydaspes, relating a Conversation with Hortensius, upon False Religion.* Pts I and II. 8vo. 'For M. Steen'. Title-vig. eng. G. van der Gucht, headpieces eng. B. Cole.

1736–7 *The Military History of the late Prince Eugene of Savoy and of the late John, Duke of Marlborough . . . collected from the best Authors in All Languages . . . the whole illustrated with Variety of Copper Plates of Battles, Sieges, Plans etc. carefully engraved by Claude du Bosc.* 2 vols. Folio. 'By James Bettenham for Claude du Bosc, Engraver at the Golden Hind in Charles Street, Covent Garden.' 2 oblong headpieces and 1 initial letter. 'F. Gravelot inv. et del, Scotin sc.'

1736–9 Virgil, *The Aeneid.* Translated by John Theobald. 4to. 'Printed by J. Hughs [sic] for the Author.' *The Second Book* (1736): Front., 4 Pls. and head- and tailpieces, eng. Toms

after Nicholls and Ross; fleuron on title des. Gravelot. *The Fourth Book* (1739): Title-vig. and 4 head- and tailpieces, eng. Scotin and Toms.

Theobald's *Proposals for Printing a New Translation of Virgil's Aeneid* is bound up with the Bodl. copy of Book IV. It states that there will be 'Copper-Plates, expressing the Subject (design'd by Mr Gravelot, and engraved by the most Eminent Hands) to adorn the Title Page of every single Book, and Beginning and Inclusion of each Canto.' The subscriptions, however, do not seem to have been forthcoming for the project. Some leaves of a further book, with 4 designs by Gravelot eng. Toms, are in the B.M. and were probably printed as specimens. Books II and IV may have been issued only to original subscribers. See *Catalogue of British Drawings at the British Museum Vol. II: A Ledger of Charles Ackers*, ed. D. F. McKenzie and J. C. Ross, Oxford Bibliographical Soc. 1968.

1737 *Réglemens de la Société des Suisses Etablie à Londres, l'Année 1703.* Small folio. 'À Londres, Pour Messieurs de la Société.' Title-page: Scene of Tell and the Apple, eng. Scotin.

1737 *Songs in the Opera of Flora.* Large 8vo. 'Sold by J. Cooper and Geo. Bickham.' 22 vig. headings eng. George Bickham jnr.

1737 J. Spence, *An Essay on Mr Pope's Odyssey.* 12mo. 'For S. Wilmot and sold by Birt and Longman.' Front. eng. J. Pine.

1737–8 *The Musical Entertainer* [see under Bickham]. 7 vig. headings by Gravelot.

1737 *The Beauties of the English Stage.* 2 vols. 12mo. 'For Ward and Chandler.' 2 unsigned front., that for the 1st vol. representing a stage and audience, probably by Gravelot.

1738 John Gay, *Fables by the Late Mr Gay.* Volume the Second. [i.e. second series.] 8vo and 4to. 'For J. and P. Knapton, in Ludgate Street, and T. Cox under the Royal Exchange.' [Some textual changes suggest that the 8vo was the first edition.] Front.: Gay's Funeral Monument, and 16 full-page plates eng. Scotin. Frequently reprinted with plates, sometimes re-engraved, sometimes as woodcuts, as late as 1793. 13 of the original drawings are in the B.M.

1738–71 N. Hooke, *Roman History from the Building of Rome.* 4 vols. 4to. James Bettenham et al. Fronts. to each volume, that in 4th vol. (1771) des. Gravelot, eng. Miller.

1738 Handel, *Alexander's Feast, an Opera.* Folio. John Walsh. Ornamental surround for Handel's portrait eng. Houbraken.

1738 Thomas Shaw, *Travels and Observations in Barbary and the Levant.* Folio. 'Oxford printed at the Theatre.' Numerous technical pls. and 5 headpieces, 1 des. and eng. Gravelot, who also engraved 3 of the outer plates by C. Frederick.

1738–40 Charles Rollin, *The Ancient History of the Egyptians, Carthaginians, Assyrians, Babylonians, Medes and Persians . . . Translated from the French.* 10 vols. 12mo. 'For J. and P. Knapton.' Front. and 10 pls. des. Gravelot, eng. Lebas or Gravelot; 2 unsigned folding plates. 1st ed. 1734 not illustrated; many reprints. See P. S. Walsh, *Art Bulletin*, 1967, pp. 123 ff.

1739 Moses Browne, *Poems on Various Subjects, Many never printed before.* 8vo. 'By and for Edward Cave.' Front. 'H. Gravelot inv. et del., J. Basire sculp.'

1739 [Henry Coventry], *Philemon and Hydaspes . . . the Third Conversation* 8vo. 'For M. Steen.' Headpiece eng. B. Cole.

1739–45 Charles Rollin, *The Roman History from the Foundation of Rome to the Battle of Actium . . . Translated from the French.* 16 vols. 8vo. For John and Paul Knapton. General front. and front. to each of the first 7 vols. des. and mostly eng. by Gravelot, 1 eng. Scotin, 1 eng. Lebas. Original drawings for front. to Vol. VII is the Louvre. (Plate 11).

1739 John Pine, *The Tapistry Hangings of the House of Lords . . .* Atlas folio. 10 battle scenes by Lempriere and 6 charts with elaborate allegorical surrounds in black and green des. Gravelot eng. Pine. 2nd ed. 1753.

1740 A. da lo Frasso, *Los diez Libros de Fortuna d'Amor.* 2 vols. 8vo. London. Portrait des. and eng. Mosley and 10 plates eng. by the same, 2 of them after Gravelot.

1740 *The Works of Shakespeare . . . with notes . . . by Mr. Theobald.* 8 vols. 8vo. Lintot et al. Front. portrait eng. G. van der Gucht; 36 pls. des. and 8 eng. Gravelot, the remainder

eng. van der Gucht. Theobald's 1st ed. had no illustration: the 2nd was reprinted with the pls. 1752, 1757, 1762, 1767, 1773. They were re-engraved in reverse for separate editions of the plays *c.* 1770 by Robert Pranker. (Plates 7, 8, 9, 10.)
Thirteen of the original drawings are in the Albertina: see H. A. Hammelmann, *Connoisseur*, CXLI, 1958, pp. 144–49; fifteen in the Huntington Library: see R. R. Wark, *Drawings from* The Turner Shakespeare, Los Angeles, 1973.

1740 Francis Bacon, Baron of Verulam, *The Works.* 4 vols. Folio. For A. Millar. 5 medallion title-vigs. [identical for each vol.] des. and eng. Gravelot.

1741 *Psalms: Arturi Jonstoni Psalmi Davidici, Interpretatione, Argumentis Notisque, Illustrati.* 4to. 'Apud Gulielmum Innys et al.' Front.: David harping, eng. Scotin. The original drawing for this is at Windsor: Oppé, *Catalogue*, no. 257.

1741 Conyers Middleton, *History of the Life of Cicero.* 2 vols. 4to. 'For the Author.' 12 headpieces, 2 initials and 12 tailpieces des. and eng. Gravelot.

[1741] Edward Young, *A Poem on the Last Day.* 8vo. 'For E. Culll [Curll] and C. Hitch.' Front. eng. R. Parr. The same front. in the collected edition of Young's works, 2 vols. 1761.

1742 Thomas Broughton, *An Historical Dictionary of All Religions . . . compiled from the Best Authorities.* Folio. 'For C. Davies and T. Harris.' Front. 'H. Gravelot inv et del.; G. Scotin sculp.'

1742 S. Richardson, *Pamela, or Virtue Rewarded* [See under Hayman]. 3 portraits, title-vigs. and 3 tailpieces all eng. Gravelot, 16 from his own designs.

1742 Th. Stackhouse, *New History of the Holy Bible.* 2 vols. Folio. 'For Stephen Austen.' Front. to Vol. I eng. Scotin. 2nd ed.

1742 George Bickham, Jnr., *Deliciae Britannicae* [see under Bickham]. 9 pls. eng. Bickham.

1742 Samuel Richardson, *Pamela or Virtue Rewarded* [see under Hayman]. 16 pls. des. and eng. Gravelot. 5 original drawings in B.M., 1 in Ashmolean.

1743 G. Faerno, *Fabulae Centum* [*in Latin and French*], *Editio Nova.* 4to. 'Londini, apud Guill. Darras et Claude Du Bosc.' Frontis. s. 'Claude du Bosc sculp.,' and 100 half-page plates, all unsigned. Some of these are by Gravelot, e.g. those to Fables 63 and 64.

1743 Richard Pococke, *A Description of the East and some other Countries.* 2 vols. in 3 pts. Folio. 'For the Author by W. Bowyer and sold by J. and P. Knapton and others.' Title-vig. to Vol. I des. and eng. Gravelot, Vol. II: Europa and the Bull, des. Gravelot, eng. Grignion, repeated Vol. II Pt. 2.

1743 Francis Godwin, *De Praesulibus Angliae.* Folio. 'Cantabrigiae, J. Bentham.' 30 headpieces, 29 tailpieces, all des. and eng. Gravelot, except 1 headpiece and 4 tailpieces eng. François Vivares. A few of Gravelot's drawings are in the Ashmolean Museum, Oxford.

1743 Bickham's *Universal Penman.* Folio. Sayer. Front. and dedication leaf.

1743 E. Young, *The Complaint or Night Thoughts.* 4to. 'For Dodsley.' Title-vig., eng. C. Mosley.

1743-4 *The Works of Shakespeare* [see under Hayman]. Portrait surround, vig. on title, 3 tailpieces and 5 pls. (Vol. IV) by Gravelot (Plate 12.). Copperplates for the tailpieces in 2 states are still at the Clarendon Press, Oxford.

1743-51 Houbraken and Vertue, *Heads of Illustrious Persons of Great Britain* [by Thomas Birch], 2 vols. [usually in one]. Folio. 108 portraits by Houbraken in elaborate surrounds by Gravelot, eng. Vertue. Original wash drawings of surrounds are at the Ashmolean Museum, Oxford. See J. Hayes in *Notes on British Art*, Paul Mellon Foundation XIII, 1969, also printed in *Apollo*, Jan. 1969, supplement pp. 1–3.

1743-7 Rapin de Thoyras, *The History of England.* [Trans. by N. Tindall M.A.] . . . *illustrated with Heads of the Kings, Queens and several eminent Persons also with Plans of Battles and Cities, Maps, Medals and other copper plates.* Folio. 'For J. and P. Knapton.' Title-vig. s. and some headpieces, eng. Scotin and Grignion. See T. S. R. Boase, 'Macklin and Bowyer', *JWCI*, XXVI, 1963, p. 170.

1744 J. B. Gelli, *Circe.* Trans. from the Italian by H. Layng. 8vo. Printed by James Bettenham. Front., portrait and vig. eng. Parr and Basire.

1744 Robert Boyle, *The Works*. 4 vols. Folio. 'For A. Millar.' Title, title-vig. des. and eng. Gravelot.

1744 Richard Grey, D.D., *A Sermon Preached in the Parish Church of Northampton before the President and Governors of the County Infirmary . . .* 8vo. 'Northampton, by William Dicey, also sold by J. and P. Knapton et al.' Front.: Hospital scene, 'H. Gravelot inv. et del, J. Pine sculp.'

1745-7 *A New General Collection of Voyages and Travels . . . Published by His Majesty's Authority*. 4 vols. 4to. 'For Thomas Astley.' Front. Vol. I eng. Grignion.

1745 D. Fordyce, *Dialogues concerning Education.* 8vo. Fleuron on title of Vol. I eng. van der Gucht.

1746 *Funeral Eulogies upon Military Men, in the original Greek*. 8vo. 'Oxford at the Theatre.' Title-vig. and headpiece eng. C. Grignion. Reprinted 1768.

1747 *Memoires de Sully*. 3 vols. 4to. Londres. Head-pieces by Gravelot.

1748 Mme. Dubocage, *Le Paradis Terrestre: Poème imitié de Milton. Ouvrage enrichi de figures en taille-douce*. 8vo. 'A. Londres.' 6 vigs. by Gravelot, 'Louise le D. sculp.'

1748 Michael Drayton, *A celebrated Poet in the Reigns of Queen Elizabeth, King James I and Charles I . . . Being all the Writings of that celebrated Author, Now first collected into One Volume*. Folio. 'By J. Hughes sold by R. Dodsley.' Title-page vig. 'H. Gravelot inv. Bickham sc.' 1 headpiece Bickham sc., 5 head-pieces N. Parr sc.

1748 *Bickham's British Monarchy*. Folio. Engraved throughout by G. Bickham Jnr. Front. and numerous ornaments and vig. headings, several after Gravelot, one of them reprinted from 'Flora.' Other eds. 1743, 1749.

1748 J.-L. Rocque, *Survey of London and the Country about it*. Imp. folio. Dedication leaf.

1750 H. Fielding *Histoire de Tom Jones etc., traduction de l'Anglois de M. Fielding par M.D.L.P. [de la Place], enrichie d'estampes dessinées par M. Gravelot*. 4 vols. 12mo. 'À Londre chez Jean Nourse.' 16 pls. eng. Pasquier (7), Fessard (3), de la Fosse (2), Chedel (2) and Aveline (2). The date 1749 on 2 of the plates estab-

lishes this as the 1st of several French eds. of the same year and as the 1st appearance of these fine plates. Probably printed in Paris.

1751 [R. O. Cambridge], *The Scribbleriad. An Heroic Poem, In Six Books* [See under Boitard]. 4to. 'For R. Dodsley by M. Cooper.' Title-page eng. C. Mosley.

1752-3 Thomas Salmon, *The Universal Traveller: or a Complete Description of the several Nations of the World* [See under Wale]. 2 vols. Folio. 'For Richard Baldwin.' Front. eng. Ch. Grignion.

1751 *Epicedia Oxoniensia in Obitum Frederici Principis Walliae*. Folio. 'Oxford, apud Theatrum.' 1 tailpiece, previously used in Hanmer's *Shakespeare*.

1754 *Collection of [29] prints engraved from the finest paintings of the greatest masters chosen out of the most celebrated collections in England and France* [repeated in French]. Atlas folio. Eng. and sold by Thomas Major. Title-page eng. Major. An ed. with 67 plates publ. 1768.

1759 *Soldier and Gentleman's Companion Gladiatory, with borders in the most elegant manner*. Folio. 'J. Millar.' Eng. Scotin.

[1760] *Opera Gul King, Aulae B.V.M. apud Oxon olim Princip*. 4to. Front. 'H. Gravelot inv. et sculp.'
This seems to be a collected publication of various works, and includes Gravelot's plate to The Toast, 1736.

1767 Moses Mendez, *Collection of Poems* [See under A. Walker]. Front. eng. I. Taylor.

1767 *The Masque. A New and Select collection of the best English, Scotch and Irish Songs*. For Richardson and Urquhart. Front. 'H. Gravelot inv.ᵗ, Isaac Taylor sculp.'

1768 D. Bellamy, *Ethic Amusements*. 4to. 'For the Author.' Front. eng. G. Bickham. The remainder of the fine plates in this vol. are by Bickham and Samuel Wale.

1770 *The Loves of Mirtil, Son of Adonis, a Pastoral*. Sm. 8vo. Eng. title by J. Caldwall and 6 fine plates eng. by the same after Gravelot. These plates appeared first in a French ed., 1761, Paris, eng. Le Grand.

1770 *Horatii Opera*. 4to. Birmingham, Baskerville. Front. and 4 plates by Gravelot. The pls. exist in proofs before letters: Bibl. Nat.

1775 Richard Savage, *The Works*. 2 vols. 12mo. Evans. 2 identical vig. on titles eng. Isaac Taylor. The original drawing for this vig. is in the possession of Messrs. Elkin Mathews.

During the sixties and seventies, a number of Gravelot's illustrations which had appeared in French books were copied, probably without authority and usually in a very inferior manner, by English magazines such as the *Town and Country Magazine*. Though Gravelot remained in contact with friends and publishers in England after his return to France in 1745 and was several times asked to design illustrations for English publishers, there is no evidence that he accepted any such commissions except in the case of the Baskerville *Horace*; the other original illustrations by him appearing in English books published after 1745 were probably designed by him before his departure, though in some cases not used until almost twenty-five years later. At the end of his life he was working in Paris on his 'Iconologie par Figures ou Traité complet des Allégories, emblèmes, etc.', completed and published (undated) by C. N. Cochin. (Minkoff Reprint, Geneva, 1972.)

James GREEN, d. *c*. 1757

He was based on Oxford, and much employed on the University Almanacs. He engraved the plates for William Borlase's *Observation on the Antiquities Historical and Monumental of Cornwall* (1754), a folio printed by W. Jackson in the High-Street, Oxford. He signs 'Jas. Green Oxon'.

1754 John Rotheram, *A Sketch of the one great Argument, formed from the several concurring evidences for the truth of Christianity*. 8vo. 'Oxford printed at the Theatre for Richard Clements.' Oblong title-vig.: Radcliffe Camera and St. Mary's, Oxford, 'I. Green delin et sculp Oxon.'

William GREEN

[1760] *Opera Gul. King* [see under Gravelot]. Numerous head- and tailpieces 'Guil. Green inv. del. P. Fourdrinier sculp.' The vol. appears to be a collection of King's works published at various dates.

Simon GRIBELIN, 1661–1733

Born at Blois, he came to England in 1680, but did not make much mark till employed by Dorigny on the engraving of the Raphael cartoons. There is a frontispiece by him ('inven. et sculps.') to Playford's *Harmonia Sacra* in 1688.

1716 John Gay, *Trivia*. The L.P. edition has 3 head-pieces des. and eng. Gribelin. The ordinary ed. has unsigned woodcut headpieces. The 3rd ed. [1730] has Gribelin's headpiece to Book I, with a new front. eng. Kirkall.

1717 Alexander Pope, *The Works*. 4to. 'Printed by W. Bowyer for Bernard Lintot.' Title-vig., 10 headpieces, 21 tailpieces and 24 initials, some unsigned, but all by Gribelin, eng. King.

Moses GRIFFITH, 1749–*c*. 1809

He was a servant of the naturalist and antiquarian Thomas Pennant (1726–98), who had him trained in the school of the Artists' Society and then employed him as a draughtsman, with Peter Mazell (q.v.) as engraver. Between them, this team produced several books, and the zoological plates reach a very respectable standard.

1770 Thomas Pennant, *British Zoology*. 8vo. 'Printed by Eliz. Adams, Chester.' Pls. by Griffith, eng. Mazell.

1771 Thomas Pennant, *Synopsis of Quadrupeds*. 8vo. 'Printed by J. Monk, Chester.' Many pls. of animals by M. Griffith, eng. P. Mazell.

1778–81 Thomas Pennant, *A Tour in Wales and The Journey to Snowdon*. 'Printed by Henry Hughes, London.' 2 vols. 4to. Views 'del' by Griffith, eng. P. Mazell, D.L. and W. Watts. The Preface states: 'The drawings marked Moses Griffiths, are the performances of a worthy servant, whom I keep for that purpose. The candid will excuse any little imperfections they may find in them; as they are the works of an untaught genius, drawn from the most remote and obscure parts of North Wales.' The author then refers to Mr. Paul Sandby's 'Setts' of views in Wales, as uniting 'fidelity and elegance'.

Pennant's *A Tour in Scotland* (1771) has engravings by Mazell after paintings by Sandby and W. Tomkyns. His *Of London* (1790) has a somewhat crude plate of the Fire of London signed Peter Mazell 'del. et sculp.'

Charles GRIGNION, 1721–1810

His father, Daniel Grignion, a watch-maker, had come to England as a refugee in 1688 (London, *Evening Post*, 15.4.1763). The family name was Grignon, but Charles's grandfather had added an i to it 'to make it seem more English.' Charles became a pupil of Gravelot at the age of ten. A

long obituary notice in the *Gentleman's Magazine*, II, 1810, p. 499, states that he 'passed a portion of his early youth in Paris, in the study of the celebrated Le Bas . . . He could draw as well as engrave . . . Of the elegant art of engraving, he first planted the seed which has risen to such luxuriance and maturity under the more polished hands of our chief engravers, either of whom he would have equalled, had he in conjunction with his knowledge of drawing and his various taste, been competent to a more powerful production of effect and to that mechanical dexterity of style and finishing.' It seems that in his later years his failure to keep up with changing techniques lost him general favour, 'but a few Artists and Lovers of Art, to whom his virtues and his talents were equally dear, by a prompt and efficient subscription smoothed the path of his declining age'. In series such as Harrison's *Novelist's Magazine* the hard lines of Grignion's plates are in marked, though not always unpleasing, contrast with the work of his younger contemporaries. Grignion does not seem to have himself designed and therefore does not qualify here as an illustrator; but over a long period he was a key figure in the production of English books, and a much loved friend in the circles that worked on them.

For Grignion's account of his family see the *Farington Diary*, (ed. Greig) III, p. 267.

Samuel Hieronymus GRIMM, 1733–94

Born at Berne, he came to England in 1768 and was much employed in topographical work. Three drawings of Shakespearian subjects are in the Huntington Library, but no engravings of them are known.

1771 *The Shipwreck and Adventures of P[ierre] V[iaud] . . . Translated from the French by Mrs. Griffith*. 8vo. 'For T. Davies.' Front.: shipwreck scene, eng. J. Collyer.

1783 [Jonas Hanway], *Proposal for County Naval free-schools, to be built on waste lands, giving such effectual instruction to poor boys as may nurse them for the Sea-Service*. Folio. n.p. n.d. Pl. of Naval Free School painted by S. H. Grimm, eng. Francis Chesham.

Giuseppe (Joseph) GRISONI (or GRISON), 1699–1769

He came to England from Florence in 1715, and according to Vertue (III, p. 20) he married about 1724 'an English gentlewoman of a handsome

fortune'. He left England in 1728 and died in Rome. See E. Croft-Murray, *English Decorative Painting*, p. 214.

1728 [Henry Pemberton], *A View of Sir I[saac] Newton's Philosophy*. 4to. S. Palmer. 12 folding pls., 12 vigs., and tailpieces and 5 initials, S. J. Grison, eng. J. Pine.

1734 Paolo Rolli, *David e Bersabea: oratorio*. 8vo. 'Londra, per Sam Aris.' Front. eng. B. Baron.

Louis du GUERNIER, 1687–?1716

Born in Paris, he came to England in 1708 to work with Dorigny. According to Vertue (II, p. 131) he died of smallpox in 1716, 'lamented as the foremost of engravers'. If his death were as early as that, and there is no confirmation for Vertue's statement, his designs and plates continued to be used for some time after his death. When not engraving his own designs, he worked with one of the foreign contingent, Du Bosc, Gribelin or Van der Gucht.

1714 John Fortescue, *The Difference between an Absolute and Limited Monarchy*. 8vo. 'For Parker and Ward.' 2 headpieces and 2 figure initials, 1 s. 'Lud. du Guernier inv. et sculpsit.'

1714 A. Pope, *The Rape of the Lock. An heroi-comical poem. In five canto's*. 8vo. 'For Bernard Lintot.' Front. 'Lud. Du Guernier 2 inv. C. Du Bosc sculp.', 4 unsigned pls., 2 headpieces s. 'S. G.[ribelin].' 2nd ed.

1714 John Gay, *The Shepherds Week. In six pastorals*. 8vo. 'By Ferd. Burleigh for J. and R. Tonson.' 7 pls. des. and eng. du Guernier.

1714 Shakespeare, *Works*. 8 vols. 12mo. 'For J. Tonson et al.' Revision of Rowe's ed. of 1709 [see F. Boitard].
Many of the pls. are recut and du Guernier signs 14 new ones. The pls. are now called 'cuts' instead of 'cutts', perhaps symbolically of a general modernization. The pls. were re-engraved by Fourdrinier for Tonson's publication of Pope's *Shakespeare* in 1728.

1715 *P. Ovidii Nasonis Opera*. 3 vols. 12mo. 'For Jacob Tonson and John Watts.' 3 fronts. L. du Guernier 'inv. et sculp.'

1716 Ben Jonson, *The Works*. 6 vols. 8vo. 'For J. Tonson et al.' 11 pls. 'inv. et sculp.'

1720 N. Rowe, *Tamerlane. A Tragedy*. 8vo. 'For J. T. sold by T. Jauncy at the Angel without Temple Bar.' Pl. 'Lud. du Guernier inv. et sculp.' [Presumably the pl. was used in early

editions: several plays, including *Tamerlane*, are bound together in *The English Theatre*, 3 vols., printed for T. Jauncy at the Angel . . . 1721.] 5th ed.

1724 William Cowper, F.R.S., *Myotomia Reformata: or, an Anatomical treatise on the muscles of the human body*. Atlas folio. 'For Robert Knaplock and William and John Innes.' Unsigned front. and 68 full-page and many smaller anatomical pls., all unsigned, but by Cowper. 2 tailpieces s. 'du Guernier,' one 'inv. et sculp,' the other 'L.C.f C.D.B[osc] sculp.'

1725 Joseph Addison, *Rosamond. An opera. Inscribed to her Grace the Dutchess of Marlborough*. Pl. 'inv. et sculp.' 4th ed. (Plate 5.)

1729 *Select Collection of Novels* [see under Vanderbank]. 1 pl. eng. G. van der Gucht.

1735 Joseph Addison, *Cato. A tragedy*. 12mo. 'For Jacob Tonson in the Strand.' Pl. 'Du Guernier inv. V^der Gucht sculp.'

1735 Sir George Etherege, *The Works. Containing his plays and poems*. 8vo. 'For J. Tonson.' Pls. des. and eng.

William HAMILTON, 1751–1801

He was trained as a decorative painter in the studio of Robert Adam, who sent him, as a promising youth, to study in Italy under Zucchi. Some watercolours of classical ruins, unfortunately not dated, recall this Roman sojourn. On his return he was in demand for very varied employments: portraits, historical or pastoral paintings, stained glass, transparencies for the recovery of the king's health in 1789, and panels for the Irish Lord Chancellor's state coach. His career is a striking example of the miscellaneous activities to which artists still turned their hands. The transparencies produced for Sir Joseph Banks, Soho Square, and the front of the Bank of England for 'the night of Jubilation for the Recovery of the King' recall the *apparati* of cinquecento Italy. From 1779 he was employed by John Murray for book illustration, and later by Dodsley and Du Roveray. Macklin, Boydell, and Bowyer all commissioned paintings from him for their galleries. He collaborated with Fuseli in editions of Thomson's *Seasons* and Gray's and Milton's poems, and his later style was considerably influenced by him. He was elected A.R.A. in 1784 and R.A. in 1789. Many of his book illustrations are, following the Macklin, Boydell, Bowyer practice, based on oil paintings. His theatrical

portraits are fine, swaggering pieces: examples can be seen in the Town Hall and the Theatre Gallery at Stratford-upon-Avon. Despite an electric response to varying styles, his works have an individual quality. There are sketchbooks containing drawings by him in the V. & A. and the Huntington Library.

A. T. Spenton, *Connoisseur*, XXI, 1908, pp. 37–43; *CL*, CXL, 1966, p. 284; and article in *The Times*, 8 Oct. 1960.

1777 John Ogilvie, *Rona. A Poem* [see under I. Taylor]. 4 oval pls., eng. Caldwell.

1778 Clara Reeve, *The Old English Baron: A Gothic Story*. 8vo. 'For Edward and Charles Dilly.' Front. eng. J. Caldwell.

1778 James Thomson, *The Seasons, . . . A New edition, adorned with a set of engravings from original designs*. 8vo. 'For J. Murray, No. 32 Fleet Street.' Front. from the Thomson memorial in Westminster Abbey, eng. Caldwell. 2 pls. eng. Caldwell. [see also Allan.]

1779 Edmund Cartwright, *The Prince of Peace; and other poems*. 4to. 'For J. Murray.' Large oval title-vig.: Rescue of a girl from Red Indians, eng. C. Grignion.

1780 Apollonius Rhodius, *The Argonautics . . . revised, corrected, and completed*. 8vo. 'For J. Dodsley.' Front. eng. C. Grignion.

n.d. George Thomson, *Scottish Airs* [see under Allan]. Front. Vol. II, eng. P. Thomson.

1784 *The new, complete and universal history, description and survey of the cities of London and Westminster . . . written and compiled by a Society of Gentlemen, the whole corrected and improved by W[illiam] Thornton*. Folio. 'For Alex. Hogg.' Front. eng. Page. Numerous pls., some after Wale.

1786 Thomas Gray, *Poems. A new edition*. 8vo. 'For J. Murray.' 3 pls. eng. Sherwin and Sharp. The advertisement states that 4 new pls. have been designed and engraved for this ed. The 4th pl. is a new frontispiece, unsigned, eng. Sherwin.

1788 *The Dramatick Works of Will. Shakespeare:* [see under Burney] *Comedy of Errors, Twelfth Night, Henry VI Pts. 1 and 2*, and *Richard III*; eng. Bartolozzi, Hall, Dambrun and de Longueil. Drawings for *The Comedy of Errors* and *Henry VI Pt. 1* are in the Huntington Library.

1792 *Bell's Theatre:* [see under Fuseli] Glover, *Medea.* pl. eng. Grignion; *The Distrest Mother* [*Andromaque* of Racine, translated by Ambrose Philips], 1 pl. eng. A. Smith.

1798 A. Pope, *Rape of the Lock* [see under Fuseli]. Front. eng. Bartolozzi.

1797 James Thomson, *The Seasons. Illustrated with engravings by F. Bartolozzi and P. W. Tomkins from original pictures painted for the work by W. Hamilton.* Folio. 'By Bensley for P. W. Tomkins.' 5 full-page pls., 5 headpieces, 5 tailpieces and 5 vigs. (Plate 41.) A number of copies were published with the full-page pls. in colour.
This is Hamilton's masterpiece. The paintings for *Lavinia and her Mother* and for *Musidora* were shown at Thos. Agnew and Sons in Oct. 1972 and June 1973 respectively.

1799 *Conversations and Amusing Tales offered . . . for the Youths of Great Britain.* 4to. 'For the Author, published by Hatchard.' Front. by W. Hamilton, R.A., eng. Bartolozzi; and 12 oblong sepia engravings unsigned.

1800 Thomas Gray, *The Poems. A new edition, adorned with plates.* 8vo. 'Printed by W. Bulmer for F. J. Du Roveray.' 2 pls. eng. James Heath. See also Fuseli.

1802 James Thomson, *The Seasons.* 8vo. 'By T. Bensley for F. J. Du Roveray.' 4 pls. eng. J. Fittler (2), J. Heath and R. Rhodes. See also Burney and Fuseli.
For Hamilton's contribution to *Macklin's Poets* and *Bible, Bowyer's History* (Plate 32) and *Boydell's Shakespeare* see T. S. R. Boase, *JCWI*, X, 1948, pp. 98–9, and *JWCI*, XXVI, 1963, pp. 152–5, 166–8, 173–5.

1802 Milton, *Paradise Lost* [see under Fuseli]. 6 pls. See M. Pointon, *Milton and English Art*, pp. 197–9.

J. W. HARDING, 2nd half of 18th century

He was much employed in the production of prints after Angelica Kauffman.

1796 G. A. Bürger, *Leonora* [see under Blake]. Head- and tailpieces to German text 'J. Harding del et sculp.' The front. to the German is by D. Chodowiecki (1726–1801), the famous Polish illustrator, and is eng. Harding, presumably from a pl. for some continental ed.

Sylvester HARDING, 1745–1809

He began as a member of a company of strolling players, then turned with some success to miniature painting. He eventually took to publishing and in 1793 he produced, engraving them himself, a series of portraits of Shakespearian subjects for T. Longman's edition of the plays in 15 8vo volumes. He published in 1795 *The Biographical Mirror*, and made his own designs for the *Economy of Beauty.* His son Edward was also an engraver, but died in his early twenties.

1798 William Collins, *Poetical Works.* 8vo. 'By T. Bensley for E. Harding.' 20 vigs. des. and eng. Harding, some possibly by Edward Harding.

Francis HAYMAN, ?1708–76

In *Beer Street*, Hogarth's cheerful print which extols the advantages of lusty beer-drinking over the pernicious habit of gin, there appears amid the bloated prosperity of the drinkers the figure of a huge-nosed sign-painter, brush in hand. He stands there on his ladder, his coat out at the elbows, the shirt-tail hanging over the torn trousers and wags his head from shoulder to shoulder as if lost in complacent admiration of his own handiwork. It is one of Hogarth's private little jokes, for in the dishevelled sign-painter so caricatured Londoners might recognize none other than his friend Frank Hayman from Exeter, a well-known artist himself and by many regarded as 'the foremost historical painter' of his age.

A Falstaffian character by habit and predeliction, with all the fat knight's fondness for the good things of life, Francis Hayman has sometimes been best remembered as Hogarth's favourite boon companion, whose exploits after lengthy sessions at the Beefsteak Club used to be the talk of the town. Even so, it is certain that, as a painter of 'conversation pieces', narrative pictures and theatrical portraits, Hayman enjoyed a very high reputation among the cognoscenti of his time and was one of the central figures in the London artists' circle in the mid-eighteenth century. Rouquet,[1] the foreign critic, devoted almost as much attention to him as to Hogarth and Reynolds; Mrs. Delaney described him in 1748 as 'the best master (i.e. teacher) I know of', and already a few years earlier one of his patrons, Lord Radnor, had written to Dr. Cox Munro that '. . . if he had not fooled away many years at the beginning of life in painting

1 Rouquet, *The Present State of the Arts in England*, [1755].

Harlequins, trap-doors etc., for the playhouse, he would certainly by this time be the greatest man of his age, as he is now of his country.' Lord Radnor also described him as 'a very quiet, good-tempered man and will not cause the least trouble in your family'. He would hardly have recommended Hayman in these terms to an eminent divine if the artist had been the debauched character that gossip and Hogarth's caricature sometimes suggest.[1]

The date of his birth is always given as 1708, but on no confirmed authority, and the list of apprentices at the Genealogist Society shows him as apprenticed to Robert Browne in 1718. Ten years of age would not necessarily be too young for apprenticeship, but a year or two later would be more normal. Browne, a citizen of Exeter, is described as 'a history painter', and it was in scenery (at Drury Lane) and wall-painting that Hayman was first employed when he left Exeter for London, but nothing remains of the decorations carried out for Lord Radnor at Twickenham, for Dr. Maro at Norton in Suffolk, for the Spa at Bermondsey[2] and for Jonathan Tyers' house at Denbies in Sussex. This last commission, and portraits painted by him of the Tyers family, led to further work for Tyers at Spring Gardens, Vauxhall. For this famous eighteenth-century pleasure ground, which, in the words of Oliver Goldsmith, 'united rural beauty with courtly magnificence', Hayman chose his subjects chiefly from the popular sports and amusements of the time. There we have the boisterous dance round the Maypole, the milkmaids' garland[3] and the stately quadrille, the bonfire at Charing Cross or the 'See-Saw' with buxom maidens perilously suspended in mid-air to the glee of their beaux. Children are 'hunting the whistle' or playing at leap-frog and grown men are gravely engaged at cricket, though as yet without their top hats. It is a uniquely rich, entertaining record, fascinating to anyone eager to find out how his ancestors amused themselves. The Vauxhall paintings, 'nailed to

boards and much obscured by dirt', were disposed of at low prices when the Gardens were closed down in 1841.[4] Some of them found a home at Lowther Castle and were once more dispersed by sale in 1947, two of them being bought by the Victoria and Albert Museum, a mark of the reviving interest in Hayman. Of his more ambitious history paintings, one, the *Finding of Moses*, has remained in its original position in the Foundling Hospital. This was a charity with which Hayman was closely associated. As it was unable to afford decorations for its bare walls, he and many leading artists of the day, Hogarth, Highmore, Gainsborough and Richard Wilson among them, presented paintings. This generosity had its own reward. The spectacle of pictures by living painters accessible to the public was new, and a visit to the Foundling Hospital became the most fashionable morning lounge of the reign of George II. Commissions increased apace and such was the popularity of the pictures that Hayman, elected in 1755 Chairman of the Committee for establishing a Public Academy, eventually, while this major project was still hanging fire, suggested organizing a public exhibition of paintings. This took place in 1760 in the Great Room of the Society of Arts in the Strand. Hayman contributed a picture of Garrick in the character of Richard III. In 1761 the artists split into two bodies. Hayman seceded with the best-known artists, who formed the Society of Artists of Great Britain, holding an exhibition in Spring Gardens to which Hayman sent a picture of *Sir John Falstaff raising Recruits*. That Society was in 1765 incorporated by charter with G. Lambert, the landscape painter and founder of the Beefsteak Club, as president and Hayman as vice-president. In 1766 Hayman succeeded Lambert as president. In 1768 further dissension arose, and Hayman was replaced as president by Kirby. A fresh secession on the part of Hayman and his friends took place, which resulted in the constitution by royal charter on 10 December 1768 of the Royal Academy of Arts of London. Hayman was one of the original forty academicians, and contributed two scenes from *Don Quixote* to their first exhibition in 1769. He was elected one of the visitors, and from 1771 till his death held the office of librarian. He exhibited for the last time in 1772. Hayman suffered greatly from the gout, and died at his residence in Dean Street, Soho, on 2 February 1776. He married

[1] Quoted Whitley, *Artists and their Friends*, I, 1928, p. 81. There is a letter from Hayman to Dr. Macro, 28.7.1741, in the B.M.

[2] Thomas Keyse, *Description of some of the Paintings in the Perpetual Exhibition at Bermondsey Spa*, 1785.

[3] The Milk-maid's Garland was one of the Hayman designs used by Robert Hancock for his prints on Worcester china: see Cyril Cook, *Robert Hancock*, 1948. Some of the Vauxhall scenes were also used on printed cottons. An example is in the Art Institute of Chicago, 24.1225.

[4] See L. Gowing, 'Hogarth, Hayman and the Vauxhall Decorations', *Burlington Magazine*, XCV, 1953, pp. 4 ff.

the widow of his old friend and patron, Fleetwood, and left one daughter. Pierre Falconet, son of the famous sculptor and another of the French artists working in London, drew Hayman's portrait as one of a series of the twelve most reputed artists in London; and Hayman has a prominent position in Zoffany's group of the Royal Academicians.

Hayman etched a few plates, but did not himself engrave any of his numerous illustrations for books. His first important commission (1742) in this branch of the arts was eleven plates designed for the sixth edition of Samuel Richardson's *Pamela*, 'embellished with copper plates designed and engraved by Mr. Hayman and Mr. Gravelot'. Of the twenty-six plates, eleven were by Hayman, and the remaining fifteen were designed as well as engraved by Gravelot. The next undertaking, by the same two artists, was for the thirty-six plates for Sir Thomas Hanmer's *Shakespeare* printed in six volumes by the Oxford Press. Hayman provided thirty-one of the designs, Gravelot the remaining five. Gravelot had already in 1740 provided illustrations for Theobald's *Shakespeare*, but in the Oxford edition the scenes to be illustrated were such as Hanmer 'shall direct' and quite different subjects, with only one exception, were chosen. Hayman signs his plates simply 'inv.', though drawings for all of them are in the Folger Library. A comparison of plates and drawings shows that Gravelot exercised some freedom in rendering of details, and in one plate, for *The Two Gentlemen of Verona*, omits three figures from Hayman's background. In faces and foliage he adds a sharper precision to the design, but the sense of grouping as compared with the Theobald edition shows Hayman's firmer mastery. There can, however, be no doubt that Gravelot's influence and his experience were of considerable importance in Hayman's development. There is for instance in Hayman's (as incidentally in many of Gainsborough's) female figures with their long and very narrow waist-lines a stylish, slightly exaggerated grace which can be traced only to the French rococo school. But other qualities of his, especially his directness of observation and construction, are distinctly English. Hayman was a far less careful artist than Gravelot and frequently his draughtsmanship is not free from mannerisms and even faults, but it is difficult to deny that his drawings possess great freedom and that his figures have more substance and stability than those of his French master, while his backgrounds, whether of Georgian interiors or of landscape, are more definite and less artificial. Above all it would seem that, when he took up brush or pencil, Hayman set to work with the same gusto with which he tackled other good things in life, and that his work at its best has a virility and dramatic freshness quite alien to his more sophisticated contemporaries on the other side of the Channel.

With Gravelot's departure to France in 1745 the combination ended. From then on (*Fables of the Female Sex*, 1744) Hayman largely depended on Charles Grignion, Gravelot's pupil, for his engravings. The signatures now more frequently use the term 'del', sometimes 'inv. et del', and this may indicate a greater authority on Hayman's part. There are plates bearing his name as designer for almost every kind of work, carried out for various publishers rather than for any one particular firm. A pleasing incident was his relationship with the traveller and founder of the Marine Society, Jonas Hanway. Hayman designed a frontispiece and two plates for his *Historical Account of the British Trade over the Caspian Sea*, and later donated designs to two works in aid of Hanway's Marine Society. The charitable impulses, evidenced at the Foundling Hospital, were still there.[1] As public taste demanded more and more book embellishments, Hayman was in constant demand. The 'curious cuts', which accompanied books at the beginning of the century, had now indeed become 'elegant engravings'. They were not, however, a source of much remuneration. Hayman's price for a drawing is said to have usually been two guineas, while the other English designers rarely charged more than one.[2]

'More convivial than studious', Hayman appears to have been on terms of intimacy with almost every well-known artistic and literary figure of his time: he accompanied Hogarth on his one curious trip to France, drank with Beau Nash, Captain Laroon and Church the poet, celebrated on oysters and venison with the actor Quin, supped at the Turk's Head Tavern or the Beefsteak Club with Richard Wilson and Sir Joshua Reynolds, and enjoyed the friendship of Garrick and Dr. Johnson. His married life was not a happy one, which perhaps drove him to the clubs and taverns. His friend James Paine the architect found him after

[1] For Jonas Hanway see N. M. Bistod, 'Jonas Hanway and the Marine Society', *History Today*, XXIII, 1973, pp. 434–40.
[2] J. Pye, *Patronage of British Art*, 1845, p. 56.

his wife's death going through the bills for the funeral, and Hayman remarked, 'she would have paid such a bill for me with pleasure.'[1] Victorian critics found it difficult to believe that a man who 'preferred the prize-fighters to the Academy' could be a competent artist, and in their eyes Hayman as a painter possessed 'no consciousness of the responsibility of Art . . . and is chiefly interesting as reflecting the artistic barbarism of his age'.[2] The rediscovery of the Vauxhall canvases, the proper attribution of Hayman's theatrical portraits and those conversation pieces which have long been ascribed to other artists (even to Gainsborough and Hogarth), and an over-all view of his illustrative work, can throw much fresh light on this unjustly neglected artist. It is bound to lead to a fresh assessment of his work and influence which, no less than the important part he played as a moving spirit of the early Academy for Painting, in the activities of the Society of Artists and in the foundation of the Royal Academy, must give him a lasting place in the annals of English art. (Plate 1.) H. A. Hammelmann, *Book Collector*, Summer 1953, pp. 285–99, and *CL*, CXVI, 1954, pp. 1258–9; Graham Reynolds, 'Painters of the British Stage I, Francis Hayman and John Zoffany', *New English Magazine*, 1948.

1742 S. Richardson, *Pamela: or, Virtue Rewarded . . . in four volumes, . . . Sixth edition* [vols. 3 and 4, the 3rd edition], *corrected. And embellished with copper-plates designed and engrav'd by Mr. Hayman and Mr. Gravelot.* 8vo. 'For S. Richardson.' 11 pls., eng. Gravelot.
Richardson wrote on 8 Oct. 1741 that in this edition there were to be cuts 'done by the best hands': J. Carroll, *Select Letters of Samuel Richardson*, Oxford, 1964.

1743–4 *The Works of Shakespear. In six Volumes. Carefully revised and corrected by the former editions, and adorned with sculptures designed and executed by the best hands* [edited by Sir Thomas Hanmer]. 4to. 'Oxford, printed at the Theatre.' 3 portraits eng. by Gravelot, large title-vig. and 3 tailpieces [repeated several times] designed and engraved by Gravelot; 3 pls. [1 to each play] engraved by the same (Plate 12). Reprinted 6 vols., 4to., 1770, plates worn.
The drawings for all the plates, including

Gravelot's, are in the Folger Library, Washington, along with a copy of the agreement between Hanmer and Hayman (Plate 17). Hayman used one of his designs (the Wrestling Scene from *As You Like It*) as the basis of an oil painting now in the Tate Gallery, but it is impossible to say whether the painting preceded or followed the drawing. Several of the Shakesperian scenes were later used by Hayman as the basis of some of his Vauxhall paintings. See W. M. Merchant, 'Francis Hayman's Illustrations of Shakespeare', *Shakespeare Quarterly*, IX, 1958, pp. 141–52.

1744 [E. Moore and H. Brooke], *Fables for the Female Sex.* 8vo. 'For R. Franklin.' Front. eng. Ravenet, title-vig. by Grignion after G. Moser and 16 plates designed by Hayman eng. Grignion (10) (Plates 19, 20), Mosley (4) and Ravenet (2). The same pls. are used for 2nd ed., 1746 and 3rd ed., 1766.
The original drawings for this book are now at Waddesdon Manor, Bucks (National Trust).

1744 [Mark Akenside], *An Epistle to Curio.* 4to. 'For R. Dodsley.' Allegorical oblong title-vig. eng. Grignion.

1745 [Mark Akenside], *Odes on Several Subjects.* 4to. 'For R. Dodsley.' Unsigned title-vig., perhaps by Hayman.

1746–7 *The Museum; or the Literary and Historical Register.* 3 vols. 8vo. 'For R. Dodsley.' Large allegorical title-vig.: Apollo with the lyre sitting beneath a tree, (identical for each vol.) eng. Ravenet.

1747 [William Mason], *Musaeus: a monody to the memory of Mr. Pope.* 4to. 'For R. Dodsley.' Oblong title-vig. eng. C. Grignion.

1747 *The Spectator.* 8 vols. 12mo. 'For J. and R. Tonson and S. Draper.' 8 fine, large title-vigs. eng. C. Grignion (5) and Ravenet (3). The 12mo ed., 8 vols., 1747, does not contain any plates. New plates from Hayman's designs, to serve as full-page frontispieces, were engraved for the edition of 1749 in 12mo, same publishers, by Grignion (2), J. S. Müller (3) and Mosley (3). In the 1753 ed. 12mo, these designs were once again re-engraved, this time all by Grignion. With very slight differences, these plates reappear in numerous later reprints.

[1] Whitley, *Artists and their Friends*, I, pp. 81–84.
[2] J. E. Hodgson and F. A. Eaton, *The Royal Academy and its Members*, 1905, p. 55.

1747 *The Guardian.* 2 vols. 8vo. 'For J. and R. Tonson and S. Draper.' 2 large title-vigs. eng. C. Grignion. New plates from Hayman's designs in different format were engraved by Grignion to serve as full-page frontispieces for the 12mo. edition of 1751, same publishers. They appear again in numerous reprints.

1748 [Tobias Smollett], *The Adventures of Roderick Random. The second edition.* 2 vols. 12mo. 'For J. Osborn.' 2 fronts. eng. Grignion. The illustrations first appeared in this ed.

1748 *The Preceptor: containing a general course of education . . . Illustrated with maps and useful cuts.* 2 vols. 8vo. 'For R. Dodsley.' 2 allegorical fronts. eng. Grignion. Frequently reprinted: 6th ed. 1775.
The original drawing for the frontispiece of Vol. I: 'Youth led by Wisdom', is in the Witt Collection, Courtauld Institute of Art.

1748 Ch. Coffey, *The Devil to Pay: or, the Wives metamorphos'd. An opera [with music].* 8vo. 'For J. Watts.' Front. eng. G. van der Gucht.
This frontispiece bears close resemblance to a large painting by Hayman for one of the supper-boxes at Vauxhall Gardens which was formerly at Lowther Castle.

1749 A. Selden, *Love and Folly. A poem. In four canto's. The second edition.* 'For W. Johnston.' 8vo. Title-vig. eng. C. Grignion.

1749 John Milton, *Paradise Lost.* 2 vols. 4to. 'For Tonson and Draper.' 2 portraits eng. Vertue and 12 plates eng. Grignion (8) and Ravenet (4). 2nd ed. 2 vols. 8vo, same publishers, contains the same illustrations newly engraved in smaller size by J. S. Müller.
Full descriptions of these illustrations and their subsequent use is given in Mr. C. H. Collins Baker's 'Milton Iconography' in *The Library* (1948) 5th series, Vol. III, p. 14 ff: 'In various stages of deterioration these designs survived for almost seventy years . . .' Mr. Baker has traced at least 14 subsequent editions, the last of 1818, in which these designs re-appeared either newly engraved or re-worked by various artists. See also M. R. Pointon, *Milton and English Art*, pp. 47–57.

1749 Horace, *Q. Horatii Flacci Opera.* 2 vols. 8vo. 'Apud Gul. Sandby in vico dicto Fleetstreet.' Dedication plate to George, Prince of Wales: Portrait surrounded by trophies of the arts, s. 'Wilson pinxit, Hayman delin. Orn., Ravenet sculp.'

1749 Benjamin Hoadly, *The Suspicious Husband. A comedy.* 12mo. 'For Tonson and Draper.' Front. eng. Grignion. This pl. appears in 3rd ed. for the first time. Not in 2nd ed. 1747. Again, re-eng. 1759.

1749 Horace, [Latin-English] *A Poetical Translation of the Works of Horace* [by Philip Francis]. 2 vols. 4to. 'For A. Millar.' 2 fronts. eng. Grignion. 3rd ed.

1750 James Hervey, *Meditations and Contemplations.* 8vo. 'For Rivington and Leake.' 2 vols. 2 fronts. 'F. Hayman del. J. Wall M.D. inv. C. Grignion sculp.'
A note by the author explains that 'the two beautiful and ingenious frontispieces' are 'owing to the delicate Design, the eloquent Pencil, and the still more amiable condescension, of the very ingenious Dr. Wall, an eminent Physician at Worcester.' The same plates, re-engraved by T. Cook, are in the 23rd ed. 1777.

1750 *Poetic Essays, on nature, men, and morals. Essay I to Dr. Askew of Newcastle.* 4to. 'For R. Akenhead, jun., in Newcastle upon Tyne, and C. Hitchin.' Large title-vig. eng. Grignion. Newcastle Central Reference Library.

1750–1 *The Student . . . or, the Oxford and Cambridge Monthly Miscellany* [edited by Chr. Smart]. 2 vols. 8vo. 'For Newbery, Barrett and Merrill.' Front. (identical for each vol.) eng. Grignion and calligraphic engraved title s. 'T. Kitchin sculp.'

c.1751 *The Magazine of Magazines* [periodical]. 2 vols. 8vo. An original drawing by Hayman for a frontispiece to this publication is in the B.M. Print Room.

1751 James Paine, *Plans, Elevations, Sections and other Ornaments of the Mansion-House [at] Doncaster.* Folio. 'For the author.' Medallion portrait of Paine in ornamental surround, eng. Grignion.

1751 *The Works of Alexander Pope. In nine volumes complete . . . with the notes . . . of Mr. Warburton.* 8vo. 'For Knapton, Lintot, Tonson and Draper.' Front. and 23 pls. by N. Blakey, S. Wale (4), Anthony Walker (2) and Francis Hayman (9), eng. Grignion.

These illustrations appear again, poorly reduced by an unnamed engraver, in the 12mo ed. 10 vols., 1757. The same designs were engraved by French engravers for the Amsterdam 1754 ed. of the *Oeuvres* in French. One of Hayman's original drawings (for *Dunciad*, Book I) is in the Witt Collection, Courtauld Institute.

1752 John Milton, *Paradise Regained . . . To which is added Samson Agonistes; and Poems upon Several Occasions . . . A new edition . . . by Thomas Newton*. 4to. 'For J. and R. Tonson and B. Draper.' Front. portrait eng. Vertue after Richardson and 5 plates eng. Grignion (3), Ravenet (1) and J. S. Müller (1).

1752 Christopher Smart, *Poems on several occasions*. 4to. 'For the author by W. Strahan.' 2 fine pls.: 'Hop Garden' by Francis Hayman, eng. C. Grignion (Plate 18), and 'The Mowers at Dinner', designed and etched by Thomas Worlidge.

1753 J. H. Merchant, *The Revolution of Persia*. 4to. 'Sold by Mr. Dodsley.' 2 vols. Front. Vol. I: 'F. Hayman inv. et del, Grignion sculp.'

1753 *The Works of Mr. William Congreve*. 3 vols. 12mo. 'For Tonson and Draper.' 5 pls. eng. Grignion. 6th ed.
The identical plates were used again for the Baskerville ed. of 1761, imposed on larger (8vo) paper and again for the 7th ed., 2 vols. 12mo, 1774. One of Hayman's original drawings (for *The Double Dealer*) was reproduced in *Book Handbook*, vol. 2 (1951), p. 142; it is now, together with two other drawings for this work, in the V. and A.

1753 Jonas Hanway, *An historical Account of the British Trade over the Caspian Sea. . . . 4 vols*. 4to. 'Dodsley, Nourse, et al.' 4 fronts., including 1 eng. Grignion after Hayman and 2 full-page plates eng. Grignion. 1 of Hayman's original wash drawings is in the Witt Collection, another in the Huntington Library (Plate 21).

1754 Charles Denis, *Select Fables*. 8vo, 'For Tonson and Draper.' Front. eng. Grignion.

1754 John Gay, *The Beggar's Opera*. 8vo. 'For John Watts.' Front. eng. C. Grignion. 7th ed.

1755 M. Cervantes, *The History and Adventures of the Renowned Don Quixote. Translated . . . By T. Smollett. Illustrated with twenty-eight*

new copper-plates, designed by Hayman. 2 vols. 4to. 'For A. Millar etc.' 28 pls. des. Hayman, eng. Grignion (12), G. Scotin (6), J. S. Müller (2), Ravenet (8).
Reduced by G. V. Neist for 2nd ed. 12mo, 1761; 3rd ed. 1765; 4th ed. 1770 (with the plates rather worn), all in 4 vols. The designs, engraved by Warren, Bate, Deeves and Audinet, appear, perhaps for the last time, in an ed. 2 vols. 8vo, published in London 1811. The full set of the original drawings by Hayman, in Indian ink, with pen outlines, is in the B.M.

1756 Edward Young, *The Complaint: or, Night-Thoughts on Life, Death and Immortality. To which is added, a Paraphrase on part of the Book of Job. A new edition, corrected by the author*. 8vo. 'For A. Millar and R. and J. Dodsley.' 'F. Hayman inv. et del, front. C. Grignion sculp.'

1757 Jeremiah Seed, *Discourses on several important subjects*. 2 vols. 8vo. 'For R. Manby and H. S. Cox.' Portrait of the author by Hayman, eng. Ravenet. 5th ed.

1757 Edward Young, *The works of the author of the Night thoughts, revised and corrected*. 4 vols. 8vo. D. Browne. Front. eng. Grignion.

1757 T. Smollett, *A Complete History of England . . . from . . . Julius Caesar, to the Treaty of Aix*. 4 vols. 4to. 'For J. Rivington and J. Fletcher.' 4 fine allegorical fronts. eng. Grignion (1) and J. S. Müller (3). The 2nd ed. 1758–60 11 vols. 8vo has 5 different (historical) illustrations by Hayman, eng. A. Walker (3) and Grignion (2).

c.1757 Jonas Hanway, *To the Marine Society, in Praise of the great and good work they have done*. 4to. Front. 'F. Hayman delin^t et donavit Ant. Walker Sculp^t et donavit.'

1758 Jonas Hanway, *Three Letters on the subject of the Marine Society*. 4to. 'For Dodsley, Vaillant and Waugh.' Fine front.: the Society in session, 'J. B. Cipriani delineavit piaeque institutioni dicavit', front. to Letter III by Francis Hayman, eng. Anthony Walker [not identical with the preceding entry], presented by both; fine three-quarter-page vig. eng. T. Major after Samuel Wale and tailpiece signed 'Major Sc.'

1759 *The Tragedies of Sophocles from the Greek. By*

Thomas Francklin. 2 vols. 4to. 'For R. Francklin.' Front. eng. Grignion.

1759 R. Dodsley, *Cleone. A tragedy* . . . 8vo. Dodsley. Front. eng. W. Ryland. 3rd ed.
The 4th ed. of this play, 1765, has an unsigned title-vig. and a tailpiece s. 'C. Grignion sculp.' after D. Bond in addition to Hayman's frontispiece.

1759 *The Tatler; or, The Lucubrations of Isaac Bickerstaff Esq.* 4 vols. 4to. 'For J. and R. Tonson.' Title-vig.: portrait of Steele, eng. J. S. Müller [identical for each vol.] and 4 fine pls. eng. Grignion.
Hayman's original drawing for Vol. I is in the collection of the late A. P. Oppé, that for Vol. II in the B.M. Print Room.

1760 [Anne Steele], *Poems on subjects chiefly devotional, in two volumes. By Theodosia.* 8vo. 'For J. Buckland and J. Ward.' 2 allegorical fronts. eng. Grignion.

1761 Jonas Hanway, *Reflections, essays and meditations on life and religion.* 2 vols. 8vo. 'For Rivington, Dodsley and Henderson.' 2 finely eng. fronts. in border ornament, unsigned possibly by Hayman.

1761 Joseph Addison, *The Works.* 4 vols. 4to. 'Birmingham, Baskerville for J. and R. Tonson.' Front.: portrait, by Müller after Kneller and 3 pls. eng. C. Grignion. These illustrations appeared again in the 8vo ed. of 1765, 4 vols., same publishers, reduced by Isaac Taylor.

c.1763 Frances Sheridan, *The Discovery* [a play]. Front.
A drawing for this play is in the Witt Collection. All editions of the play in the B.M. are without illustration.

1764 *An Essay on Immorality. In Three Parts.* 4to. 'For the Author and sold by John Hart.' Front. eng. Grignion.

1765 John Gay, *The Beggars Opera . . . To which is prefixed the ouverture in score, and the musick to each song.* 8vo. 'For J. and R. Tonson 1765.' Front. 'F. Hayman inv. et del., C. Grignion sc.'

1767-8 William Guthrie, *A general history of Scotland.* 10 vols. 8vo. 'Printed for the author by A. Hamilton.' Front. eng. Isaac Taylor. Numerous portraits in first 2 vols. by various engravers.

1773 W. Shakespeare, *Hamlet, Prince of Denmark; a tragedy . . . Collated with the old and modern editions* [by Charles Jennens]. 8vo. Bowyer and Nichols. Front.: Act III, scene 2, eng. Grignion.
This frontispiece appears to be taken from Hayman's painting in the Garrick Club (No. 115).

1773 W. Shakespeare, *Othello . . . A tragedy . . . Collated with the old and modern editions* [by C. Jennens]. 8vo. W. Owen. Front.: Act V, scene 2, eng. Grignion.

1773 W. Shakespeare, *Macbeth. A tragedy . . . Collated with the old and modern editions* [by C. Jennens]. 8vo. W. Owen. Front.: Act III, scene 5, Banquo's ghost, eng. W. Ryland.

1774 W. Shakespeare, *Julius Caesar, a tragedy. Collated with the old and modern editions* [by C. Jennens]. 8vo. W. Owen. Front.: Act IV, scene 10, eng. Ryland.

Joseph HIGHMORE, 1692–1780

His work as a designer for books seems to have been due to his friendship with Samuel Richardson; he painted a series of twelve pictures illustrating *Pamela*, engravings of which were delivered to subscribers in 1745. The paintings are now divided between the Fitzwilliam Museum, the Tate Gallery and the National Gallery of Victoria, Melbourne. In a contribution to the *Gentleman's Magazine*, XXXVI, 1766, pp. 353–6 Highmore writes: 'The choice of subject is of as much consequence in painting, as the choice of Fable in an Epic poem . . . where the principal incidents are crowded into a moment, there is room for the display of a painter's skill . . . Such a story is better and more emphatically told in picture than in words, because the circumstances that happen at the same time must, in narration, be successive.'
See catalogue, *The French Taste in English Painting*, Kenwood, 1968; obituary in *Gentleman's Magazine*, 1780, pp. 176–9; J. W. S. Armstrong, *Connoisseur*, LXXXVI, 1930, pp. 209–19.

1729 *A Select Collection of Novels* [see under Vanderbank]. 2 fronts. and 10 pls. all eng. G. van der Gucht.

William HOGARTH, 1697–1764

As an engraver Hogarth was mainly concerned with separate prints or series such as the *Harlot's Progress* (1733—and much pirated, sometimes with letterpress attached), *Marriage à la Mode* (1745) and

Industry and Idleness (1747). Book illustration was of less interest to him, particularly after his designs for Tonson's *Don Quixote* (1738) had been rejected in favour of those by Vanderbank. His activities in connection with the St. Martin's Academy and the Copyright Act of 1735 are mentioned in the Introduction. All his engraved work is very fully dealt with in the following books: R. Paulson, *Hogarth's Graphic Works*, 2 vols. New Haven and London, 1965; and *Hogarth, His Life, Art and Times*, New Haven and London, 1971; J. Burke and C. Caldwell, *Hogarth: the Complete Engravings*, London, 1968. Paulson gives full discussion of the problems involved, drawings related to the plates, and variations in them as new editions appeared.

Before 1722 William King, *An Historical Account of the Heathen Gods and Heroes*. 8vo. 'For Bernard Lintott at the Cross-Keys.' 6 etched pls. 2nd ed.

1723–4 A. De La Motraye, *Travels through Europe, Asia, and into parts of Africa; with proper cutts and maps*. 3 vols. Folio. 'For the Author.' 15 pls. of Oriental scenes, plans, maps.

1724 Charles Gildon, *New Metamorphosis*. 8vo. 'For Sam Briscoe at the Bell-Savage on Ludgate Hill.' 7 pls., all except 1 s.

1724 Anthony Horneck, D.D. *The Happy Ascetick: or, the Best Exercise . . . To which is added, a Letter to a person of quality, concerning the holy lives of the primitive Christians*. 8vo. 'For Samuel Chapman and Richard Ware.' Front.: 'Son, go work today in my vineyard', unsigned but accepted by Paulson (No. 42) as des. and eng. Hogarth. [It is based on the front. by N. Yeates to the 1st ed. 1681.] 6th ed.

1725 G. de Costes, S. de la Calprenède, *Cassandra, a romance . . . translated into English by Sir Charles Cotterell*. 5 vols. 12mo. 'For John Darby' et al. 5 fronts. 3rd ed.

1725 John Beaver, *Roman Military Punishments*. 8vo. Privately printed. 14 small etchings of grim scenes of executions.

1726 Samuel Butler, *Hudibras*. 2 vols. 12mo. 'For D. Browne' et al. Portrait front. and 16 pls., all s. except front. The designs are freely based on the unsigned illustrations in an edition of *Hudibras* of 1710. Pls. re-engraved for Zachery Grey's ed. of 1744. The larger pls., advertised as a set in 1725, are independ-

dent designs, but were not used as book illustration.

1726 [N. Amhurst], *Terrae-Filius: or, the Secret History of the University of Oxford*. 12mo. 'Printed for R. Francklin, under Tom's Coffee-House, in Russel-street, Covent Garden.' Front.: scene in the Sheldonian.

1726 John Blackwell, *Compendium of Military Discipline*. 4to. 'For the Author.' 2 folding pls.: positions in military drill.

1727 Richard Leveridge, *Collection of Songs*. 2 vols. 8vo. 'Printed for the Author.' Front.

1730 Lewis Theobald, *Perseus and Andromeda. A Verse Drama*. 4to. 'Printed and sold by Tho. Wood.' Front. and 1 pl.

1730 [James Miller], *Humours of Oxford, a comedy. By a gentleman of Wadham College*. 8vo. 'For J. Watts, at the Printing-office in Wild-Court near Lincolns-Inn Fields.' Front. eng. G. van der Gucht.

1730–31 P. F. Guyot Desfontaines, *The Travels of Mr. John Gulliver, son to Capt. Lemuel Gulliver. Translated from the French by J. Lockman*. 2 vols. 8vo. 'For Sam. Harding at the Bible and Anchor, on the Pavement in St. Martin's Lane.' Front., Vol. I, 'Wm. Hogarth invt Ger. Vandergucht sculpt.'

1730–31 Henry Fielding, *The Tragedy of Tragedies; or the Life and death of Tom Thumb the Great*. 8vo. 'Printed and sold by J. Roberts in Warwick Lane.' Front. eng. G. van der Gucht.

1731 Joseph Mitchell, *The Highland Fair . . . An opera with the Musick which wholly consists of select Scots Tunes*. 8vo. 'For J. Watts.' Front. eng. Ger. van der Gucht.

1732 *Select Comedies of Mr. de Molière*: [see under Dandridge] Front. to *L'Avare* and *Sganarelle ou le Cocu Imaginaire*, eng. J. van der Gucht. Re-issued 1748 and 1771.

1733 [William Huggins], *Judith: an Oratorio, or sacred drama*. 8vo. n.p. 1 pl. eng. G. van der Gucht.

1753 William Hogarth, *The Analysis of Beauty*. 4to. 'By J. Reeve for the Author and sold by him at his House in Leicester-Fields.' Front. and 1 pl. etched and eng. Hogarth. See J. Burke, *William Hogarth, The Analysis of Beauty*, Oxford, 1955.

1754 Dr. Brooke Taylor, *Method of Perspective* [see under Kirby]. Front.: scene illustrating errors in perspective, eng. Sullivan.

1760 Laurence Sterne, *The Life and Opinions of Tristram Shandy, Gentleman.* 9 vols. 8vo. 'For R. and J. Dodsley in Pall Mall.' Front. Vol. I, pl. in Vol. II, eng. F. Ravenet. 2nd ed.

1761 *A catalogue of the Pictures, Sculptures, Models, Drawings, Prints, etc. exhibited by the Society of Artists of Great Britain at the Great Room in Spring-Garden, Charing Cross, May 9th 1761 (Being the second year of the Exhibition).* 4to. n.p. Front. and full-page tailpiece, eng. Grignion.

1762 David Garrick, *The Farmer's Return from London. An Interlude.* 4to. 'For J. and R. Tonson.' Front. etched J. Basire.

James HOPWOOD, 1752–1819

He was a self-trained engraver, who achieved little success till he was middle-aged. In 1813 he became Secretary to the Artists' Fund. He contributed 2 plates to the Harding *Shakespeare*, 1798–1800. See under Thurston.

Hugh HOWARD, 1675–1737

Born in Dublin, he came to England after 1688, travelled in Italy, returned for a time to Dublin, and finally settled in London, where he became Keeper of the State Papers and Paymaster of the Royal Palaces. He was chiefly known as a portrait painter and collector of prints and drawings.

1769 [Matthew Prior], *Poems on Several Occasions.* 8vo. 'For J. Tonson.' Front. 'H. Howard inv., L. du Guernier sculp.'

James HULETT (or HULET), d. 1771

Dodd (IX, p. 124) states that he was 'an engraver of inferior practice' whose productions were commonplace portraits and miscellaneous pieces 'embodied in various publications of the press'.

1737–8 Henry Roberts, *Calliope or English Harmony.* 2 vols. 8vo. 'For John Simpson.' 200 pls. in each volume, all eng. Roberts; 9 s. 'Hulet inv. H. Roberts fecit.'

1743 Henry Fielding, *The History of the adventures of Joseph Andrews . . . Third Edition, illustrated with cuts.* 2 vols. 12mo. For A. Millar. 10 pls. des. and eng. J. Hulett; repeated 4th, 5th and 6th (1762) eds.; the 7th ed. for W. Cavell (1780) contains simplified versions of 2 of Hulett's designs.

Samuel IRELAND, d. 1800

He produced a series of *Picturesque Views* (Medway, Avon, Wye, Inns of Court) in large 8vo and 4to (1793–1800) with coloured or sepia aquatint plates. His son was the noted forger of Shakespeariana.

J. S. D.

1787 *The Contrast: or the Opposite consequence of good and evil habits . . . For the benefit of intelligent servants.* 12mo. 'For T. Longman et al.' Front. s. 'Isaac Taylor sculp.', and 16 full-page pls. in bistre of scenes of everyday life, s. 'sketched by J.S.D., etched by I. Cruikshank.'

John JUNE, mid-eighteenth century

He engraved some portrait frontispieces, and some plates after John Collett (*c.* 1725–80, a painter of popular genre scenes, according to Redgrave, 'not of the most pure character'.)

1766 R. Brookes, M.D., *The Art of Angling . . . Now improved with additions.* 12mo. 'For T. Lowndes.' Front. 'J. June del et sculp.'

1767 F. Gomez de Quevedo Villegas, *Visions. Translated from the original Spanish* [by Sir R. L'Estrange]. 12mo. 'For S. Bladon in Pater-Noster Row; and G. Knapp, at Peterborough.' Front. 'J. June del. et sculp.,' and 6 unsigned pls.

Angelica KAUFFMAN, 1740–1807

A foundation member of the Royal Academy, she enjoyed great repute, and engravings of her works had much popularity. She was commissioned by Boydell and Macklin, but did little minor work for the publishers, with the exception of designs for *Bell's British Poets.*

1782 John Scott, *Poetical Works* [see Stothard]. Front. eng. Bartolozzi.

1782–86 *Shakespeare's Plays* [see under Rooker]. 1 pl.

1794 *Angelica's Ladies Library; or Parents and Guardians Present.* Title-vig. and pls. by Kauffman and Bunbury.

William KENT, 1685–1748

Horace Walpole said of him that Lord Burlington 'the Apollo of the Arts found a proper priest in the person of Mr. Kent', and it is as a decorator and designer of gardens that he has a claim to fame. His book designs, particularly those for Thomson's *Seasons*, show the results of his foreign travels and his decorative sense.

See E. Croft-Murray, *English Decorative Painting* II, pp. 229–32.

1720 John Gay, *Poems on Several Occasions*. 4to. 'For Jacob Tonson and Bernard Lintot.' Title and 2 pls. 'W. Kent invt et fect.' (Plate 16.)

1725 A. Pope, *The Odyssey of Homer*. 4to. 'For Bernard Lintot.' Title-page eng. P. Fourdrinier. Head- and tailpieces to each book 'W. Kent inv. P. Fourdrinier sc.'

1727 John Gay, *Fables*. 4to. 'For J. Tonson and J. Watts.' 21 pls. eng. Fourdrinier, Baron and A. Motte. Frequently reprinted.

1730 James Thomson, *The Seasons*. 2 vols. 4to. 'For John Millan.' 4 pls. eng. 'P. F[ourdrinier].'
The plates were constantly re-used in later editions. In that of 1744 they were reduced to octavo. In a 2nd ed. of 1730 the *Poem to Sir Isaac Newton* was added with a plate of Kent's monument to Newton (carved by Rysbrack) in Westminster Abbey, and Kent's plates re-engraved by Nicholas Tardieu (1674–1749), a Frenchman resident in Paris. This edition was printed by subscription, and a note by Lowndes in the Bodleian copy says that about 350 copies were subscribed for at £1.1.0 each. (Plate 15.)

1734 [Alexander Pope], *An Essay on Man*. 4to. 'For Lawton Gilliver.' 6 head- and tailpieces eng. Fourdrinier.

1738 Andrea Palladio, *The Four Books of A[ndrea] Palladio's Architecture*. Folio. 'Published by Isaac Ware'. 2 small ornamental engravings des. Kent, eng. P. Fourdrinier and Isaac Ware. Dedicated to Lord Burlington.

1742 Andrea Palladio, *The First Book of his Architecture . . . correctly drawn from his original work . . . and accurately engraved by Isaac Ware*. 8vo. n.p. Ornamental surround to portrait eng. Isaac Ware.

1744 Dr. Thomas Tanner, *Notitia Monastica: or an account of all the abbies, priories . . . heretofore in England and Wales*. Folio. 'Printed by William Bowyer at the Expense of the Society for the Encouragement of Learning.' Square vig.: Minerva, eng. Vertue.

1744 *Some Designs of Mr. Inigo Jones and Mr. Wm. Kent*. Folio. 'By John Vardy.' Title-page 'W. Kent invt., J. Vardy delin. et sculpt.'

1751 Edmund Spenser, *The Faerie Queene*. 3 vols.

4to. 'For J. Brindley.' 32 pls. from the original drawings by Kent. 25 of the drawings are in the V. and A.

Joshua KIRBY, 1716–74
An early and lasting friendship with Gainsborough led him to landscape painting. He lectured on linear perspective at the St. Martin's Lane Academy. In 1770 he was elected President of the Incorporated Society of Artists.

1754 Joshua Kirby, *Dr. Brook Taylor's Method of Perspective made easy, both in Theory and Practice . . . Illustrated with fifty copper plates; most of which are engraved by the Author*. 4to. 'Ipswich, by W. Creighton for the Author.' Most of the pls. are technical but there is a front. by Hogarth, a landscape by Gainsborough, and 2 pls. by Kirby eng. J. Wood and J. S. Müller.

Thomas KIRK, 1765–97
He studied under Cosway and first exhibited at the Academy in 1785. He was one of the Boydell group. His scene from *Titus Andronicus* is in the Theatre Gallery at Stratford-on-Avon. He was much employed by Cooke on his illustrated editions of the classics, and his dramatic, forceful scenes stand out from the prettier versions of his contemporaries. Dayes said of him: 'He passed like a meteor through the region of art,' and he was reaching considerable achievement when he was cut off by consumption. He frequently signs his plates 'painted by' or 'pinxt.', and some of them are described as 'ornamented' by R. W. Satchwell, who presumably drew the surrounds.

1793–5 David Hume, *History* [see under Stothard]. 1 pl.: massacre of Glencoe.

1793 James Thomson, *The Seasons* [see under Singleton]. 1 pl. eng. Ridley.

1793–6 *Cooke's Pocket Edition of Sacred Classics*. Kirk's pls. were as follows: *Pilgrim's Progress*. 3 pls. eng. Warren and Rhodes; *Hervey's Meditations*. 1 pl. eng. Taylor; *Devout Meditations*. 1 pl. eng. Warren.
Cooke's Select British Classics: Johnson, *Rasselas*. 3 pls. eng. Warren; *Nourjahad*. 1 pl. eng. Saunders; Walpole, *Castle of Otranto*. 1 pl. eng. Saunders (Plate 39); *Belisarius*. 1 pl. eng. Warren.
Cooke's Pocket Edition of Select Novelists: *Don Quixote*. 4 pls. eng. Warren and Saunders; Kelly, *Louisa Mildmay*. 1 pl. eng. Warren;

Voltaire, *Candide*. 2 pls. eng. Saunders; *Robinson Crusoe*. 2 pls. eng. Warren; Lennox, *Female Quixote*. 2 pls. eng. Raimbach and Hawkins; *Peruvian Princess*. 2 pl. eng. Thorndike; *Chinese Tales*. 2 pls. eng. Warren.

1796–8 *Cooke's Pocket Edition of English Poets superbly embellished*. 12mo. [For all the Cooke editions see under Corbould.] Kirk's pls. are as follows: *Waller*. 2 pls. eng. Ridley and Chapman; *Shakespeare*. 1 pl. eng. Neagle; *Pope*. 1 pl. eng. Raimbach; *Milton*. 6 pls. eng. Riley; *Lansdowne*. 2 pls. eng. Neagle and Warren; *Broome*. Title-page 3 pls. eng. Hawkins and Chapman; *Smollet*. 1 pl. eng. Nutter; *Rowe*. 2 pls. eng. Neagle; *Fenton*. 2 pls. eng. Neagle; *Akenside*. 3 pls. eng. Nutter and Chapman.

1797 Mrs. Susannah Dobson, *The Life of Petrarch*. 2 vols. 8vo. Pls. eng. W. Ridley.

1797 *Cooke's Cheap and Elegant Pocket Library of Select Poets*. Kirk's pls. are as follows: *Armstrong*. eng. Warren; *Walsh*. eng. Nutter; *Lyttleton*. eng. Nutter; *Dodsley*. eng. Riley; *Otway*. eng. Neagle; *Lansdowne*. eng. Warren.

1798 Tasso, transplated by Hoole [see under Stothard]. 2 pls.

Elisha KIRKALL, 1685–1742

The leading English member of Tonson's team of engravers, Strutt (p. 1197) states that he 'discovered a new method of printing, composed of etching, mezzotints, and wooden stamps.' (See also Dodd IX, p. 219). Whether or not he himself designed is uncertain. In Tonson's 1714 edition of Rowe's *Shakespeare*, two plates (*King John* and *Antony and Cleopatra*), repeated from the 1709 edition, are here signed E. Kirkall, not below the plate but, unusually, on it. Stylistically they have much in common with the frontispiece to two plays, Beckingham's *Scipio Africanus* and Cibber's re-writing of *Richard III*, both printed for W. Mears and J. Browne in 1718 and 1720 respectively and both signed 'E. Kirkall scu.', (Plate 4.) *The Letters of Abelard and Heloise* (12mo, 1722) for the same publishers are signed by Kirkall 'fec.', which as there is no change in medium suggests that he did something more than engrave the plate. Certainly associated with his signature there is a designer of individuality who is not one of the known names.

He was born in Sheffield, and his father, Thomas Kirkall, seems to have been a clock-maker. He

went to London when he was twenty, and studied drawing in the Great Queen Street Academy. He married in 1707. He was widely known for his mezzotint engravings printed in green and other tints. Pope refers to him in the *Dunciad* Bk. II l.160 as 'bounteous Kirkall'. Administration of his estate was given to his son, Charles, and he was survived by his widow Deborah. His first wife was called Elizabeth.

See H. A. Hammelmann, 'Shakespeare's First Illustrators', *Notes on British Art*, 1968, pp. 1–4.

P. LA VERGNE

He was employed, mainly by E. Curll, in the years 1715 to 1718, but little is known of him. Possibly he was a visiting Frenchman, with only a brief residence in England.

1715 Jane Barker, *Exilus; or, The Banish'd Roman. A new romance in two parts: written after the manner of Telemachus, for the Instruction of Some Young Ladies of Quality*. 12mo. 'For E. Curll.' Front. eng. M. van der Gucht.

1715 Mary Manley, *The Adventures of Rivella; or, the History of* [Mrs de la Rivière Manley] *the Author of the Atlantis with Secret Memoir and Characters of several considerable Persons her Contemporaries . . . Done into English from the French*. 8vo. Front. eng. M. van der Gucht.

1715 Edward Young, *A Poem on the Last Day. The third edition corrected . . . Adorn'd with Cuts*. 12mo. 'For A. Bettesworth, E. Curll and J. Pemberton.' Front. and 2 pls. eng. E. Kirkall. Pls. eng. M. van der Gucht repeated in 1761 ed. [see Gravelot].

1717 N. Spinckes, *The Sick Man visited; and furnished with instructions*. 8vo. 'For William Taylor.' Front. eng. M. van der Gucht. 2nd ed.

1718 Joseph Addison, *The Resurrection, a poem*. 8vo. 'For E. Curll in Fleet Street.' Front. eng. E. Kirkall.

Sir Thomas LAWRENCE, 1769–1830

In 1785 the famous portrait painter was only seventeen, but he had gained a premium from the Society of Arts in that year, and it is possible that the illustration below is an early work.

1785 [S. J. Pratt] *Landscapes in Verse. Taken in Spring. By the author of 'Sympathy'*. 4to. 'For T. Becket.' Oval title: a pensive couple in a

landscape with ruins, eng. T. Bonnor after T. Lawrence.

Francis LE PIPER, d. 1695

An amateur painter, the son of a Flemish gentleman settled in England. He travelled much on the continent, and drew humorous subjects and landscapes.

1702 Samuel Butler, *Hudibras . . . adorn'd with cuts.* 2 vols. 12mo. 'For R. Chiswel, J. Tonson, T. Horne and R. Wellington.' Republished 1710. Pls., some folding, unsigned but after Le Piper, who had painted a series of illustrations, 4 of which are in the Tate Gallery and 3 in the Rye Art Gallery.
The French Taste in English Painting, Exhibition Catalogue, Kenwood, 1968, p. 3.

John LODGE, d. 1796

According to Redgrave 'he drew and engraved with some spirit, but in a slight unfinished manner.'

1776 *The Fine Gentleman's Etiquette: or Lord Chesterfield's Advice to his Son versified. By a Lady.* 4to. 'For T. Davies.' Oval title-vig. 'J Lodge delin. et sculp.'

Philippe Jacques de LOUTHERBOURG, 1740–1812

He is better known as a scene designer, painter and creator of the Eidophusikon, than as a book illustrator. In this last field his most important work was for Macklin's *Bible* (1791–1800). Of its seventy-one plates he was responsible for twenty-two, and also for almost all the headpieces to the various books, showing Hebraic emblems. He was also responsible for all the plates in the Apocrypha, published posthumously in 1816. He contributed seven plates of battle scenes to Bowyer's *History* (1793–1806), and a large number of plates to Bell's *Dramatick Writings of Shakespeare.*

He was born in Strasbourg, where his family changed the Swiss name of Lauterburger to Loutherbourg. The 'de' seems to have been added by Philippe. He came to England in 1771, where he at once made close contact with David Garrick. He already had an established reputation as a painter, and his pictures, coupled with those of Greuze, were said to be no longer available 'à bon marché' on the Paris market.[1] He was elected to the Royal Academy in 1781. In 1786 when Cagliostro visited London, Loutherbourg fell for a time under his influence, and set himself up as a faith

[1] *Journal de Jean-George Wille*, Paris, 1857, I, p. 523 (Letter of September 1772).

healer. In his art, he is at his best in turbulent scenes of storm or warfare.

The most up-to-date information is available in Dr. Rüdiger Joppien's catalogue of the Loutherbourg exhibition at Kenwood, Hampstead, in the summer of 1973. See also Hammelmann *CL Annual*, 1956, pp. 152–4, and A. Dobson, *Prior's Park and Other Papers*, 1912, pp. 94–127.

1774 *A New Dramatic Entertainment, called a Christmas Tale. Embellished with an etching by Mr. Loutherbourg.* 8vo. T. Becket. Front. s. 'P. P. de Loutherbourg inv. et sculp.'

1779 [Richard Brinsley Sheridan], *Verses to the memory of Garrick. Spoken as a monody at the Theatre Royal in Drury lane.* 4to. 'T. Evans et al.' Front. eng. A. Albanesi.

1784 Edward Jones, *Musical and poetical relicks of the Welsh Bards.* Folio. 'Printed for the Author and to be had of him, at No. 9 Princes-Street, Hanover Square.' Front. 'Drawn by Loutherbourg. The figures engraved by Hall and the landscape by Middiman.'

1788 *The Dramatick Writings of Will. Shakespeare* [see under Burney]. De Loutherbourg illustrated: *The Merry Wives, Much Ado, Measure for Measure, Loves Labours Lost, Midsummer Night's Dream, Merchant of Venice, As You Like It, Winter's Tale, Macbeth, Richard II, Henry IV Pt. 1, Henry V, Henry VI Pt. 3, Henry VIII, Coriolanus, King Lear, Hamlet, Titus Andronicus, Othello* and *Romeo and Juliet.* There are 20 drawings for these pls. in the Huntington Library, including 3 not apparently used. (Plate 31.)

1791–1800 *The Bible.* 8 vols. Large folio. 'For Thomas Macklin.' The 71 pls. were based on paintings previously exhibited at Macklin's Pall Mall Gallery. De Loutherbourg provided 22 and also almost all the headpieces to the various books showing Hebraic emblems, generally set in rolling clouds. His subjects favoured the catastrophic: *The Deluge, The Destruction of Pharoah's Host, The Shipwreck of St. Paul.* When in 1816 Cadell and Davies published the Apocrypha, in similar format, it contained an explanation of the Bible headpieces and all the plates were (posthumously) by de Loutherbourg.

Mauritius LOWE, d. 1793

He was said to be the natural son of Lord Sunderland, from whom he received a small annuity. He

was a pupil of Cipriani and for some time studied in Rome. Despite assistance from Dr. Johnson, he lapsed into poverty on his return to England. Fanny Burney has an account in her diary of a visit to him and the terrible conditions in which he was living.

1778–9 *Bell's Poets of Great Britain*: [see under Mortimer] *Waller*. 2 pls. 'M. Lowe inv., eng. Sharp.'

Thomas MAJOR, 1720–99

The first engraver elected A.R.A., he seems never to have designed for the book trade, and seldom to have engraved for it. His career, however, illustrates the growing prosperity of the English engraving industry. Major, though London born and said to be related to Oliver Cromwell on the mother's side, was French trained, first by Hubert Gravelot in London, and then by Le Bas in Paris. In October 1745 when Gravelot cautiously withdrew to Paris, Major, less cautiously, went with him. In later years he addressed to one of his patrons, Thomas Hollis, a long account of what befell him, which was published after his death in the *Monthly Magazine* (June and July 1809). It tells how one night in October 1746, when he was in his shirt 'just stepping into bed', he was taken to the Bastille, as a reprisal, it eventually turned out, for the French and Irish prisoners taken after the battle of Culloden. He was released after ten days at the intercessions of Le Bas and Gravelot supported by the Marquis d'Argenson, Minister of State for Foreign Affairs. The experience, frightening though it must have been, left Major with no permanent grievance, for when in 1767 he published his *magnum opus*, *The Ruins of Paestum*, he took occasion to express in the Preface his 'Gratitude to the French Nation, for the many Civilities and Instructions he has received from their artists, notwithstanding the Affair which happened to him while he was pursuing his Studies at Paris.' He continues with some comments on the state of the arts in England: 'We cannot but observe with Pleasure, the great Improvements (the Effect of generous Encouragement) that his Countrymen have made in the several Branches of Art. Their Productions, particularly in Painting and Engraving, so generally approved at the annual public Exhibitions, sufficiently refute invidious Reflections sometimes thrown on them, that their chief Efforts centre in Schemes of raising a Fortune: and also the unfavourable opinion, entertained by some

Foreigners, of the ability of the English Artists. If we consider the Disadvantage they labour under, of not having had hitherto any Public Academy; and of being, for the most Part, obliged to complete their Studies abroad; it is rather to be wondered at that they have made so great a Progress.'

Major was appointed both Engraver and Seal Engraver to the King, and he also busied himself importing and selling foreign prints. When he died, aged eighty, the sale of his prints and copperplates at auction by Leigh and Sotheby, Booksellers, took no less than six days. He left an estate of nearly £5000 'to my dear and loving wife Dorothy Major . . . upon full trust and confidence in her justice and equity that . . . she will make a proper distribution . . . to my children . . . apart from what they have already received as part of their share.'

See H. A. Hammelmann, *CL*, CXLII, 1967, pp. 616–18.

1753 Robert Wood, *The Ruins of Palmyra, otherwise Tadmor, in the Desert*. Folio. Folding front. eng. T. Major. The engravings were after G. B. Borra, and others employed were Fourdrinier and J. S. Müller.
 Giovanni Battista Borra (*fl.* 1747–86) of Turin accompanied the expedition to Syria in 1751 as draughtsman.

1768 Thomas Major, *The Ruins of Paestum otherwise Posidonia, in Magna Graecia*. Folio. This was a compilation made by Major himself, and for the engravings 'he has availed himself of whatever could be gathered from various authors.'
 For the complex question of early drawings of Paestum see S. Lang, 'The Early Publications of the Temples at Paestum', *JWCI*, XIII, 1950, pp. 48–64.

James MALTON, d. 1803

Architect and draughtsman of topographical views. He published *Picturesque Views of the City of Dublin* from drawings taken 1791–5, and *An Essay on Cottage Architecture* (1798).

1770 Henry Chamberlain, *A Survey of London and Westminster* [see under Wale]. 1 pl. 'J. Malton delin, Adam Smith sculpt.' There is also a pl. s. 'A. Smith delin.'

Clement Pierre MARILLIER, 1740–1808

He was much employed by the French book trade, but does not seem to have visited England.

1799 *Cooke's Select Classics:* [see under Corbould] *Devil upon Two Sticks.* 1 pl. eng. Saunders. The plate was probably taken from a French edition.

James MARRIOTT

A fellow of Trinity Hall, Cambridge, he signs the frontispiece to his *Poems* 'del. et inv.', and in a tailpiece 'figuras del'. He was presumably an amateur only concerned with his own publications.

1755 Mr. [James] Marriott, *Two Poems* [see under A. Walker]. Tailpiece: Senate House at Cambridge, s. 'I. Marriott figuras del. et inv. A Walker sculpsit.'

1760 James Marriott, *Poems, written chiefly at the University of Cambridge, together with a Latin oration . . . spoken in the Chapel at Trinity-Hall, Cambridge, Dec. 21, 1756.* 8vo. 'Printed by James Bettenham.' Front. 'del. et inv. J. Marriott sculp. A. Walker.' 6 endpieces eng. Walker, Major and J. Millar. [Amongst these are 2 pls. from the 1755 *Poems*, which also appear in *Poems* by John Duncombe. 4to, R. and J. Dodsley, 1756, but Marriott's name has been scratched away on the tailpiece, leaving only traces.]

Peter MAZELL, *fl.* 1774–92

He was a member of the Incorporated Society of Artists, and was employed as an engraver by Pennant and Boydell. He engraved all the plates for Cordinier's *Remarkable Ruins and Romantic Prospects in North Britain*, 1792. He also engraved, and possibly designed, some plates in the 1793 edition of Gay's *Fables*. See under Blake.

1774 Samuel Bentley, *Poems on Various Occasions.* 8vo. 'Printed for the Author.' Title-vig. 'P. Mazell del. et sculp.'

Sir John Baptist MEDINA, 1660–1710

Born in Brussels and Spanish by descent, he came to London in 1686, and spent most of his working life as a distinguished portrait painter in Edinburgh, where he was knighted. Tonson commissioned from him the plates for his edition of *Paradise Lost* in 1688 (re-issued in 1711). Medina's treatment combines medieval and renaissance motifs, but his bold outlines are very distinct from the elegance soon to be brought in by French engravers. The plates were engraved by Michael Burghers. In 1713 Tonson brought out an illustrated edition of Milton's *Paradise Regain'd* with the minor poems.

The plates are unsigned, but are almost certainly after designs by Medina.
See M. R. Pointon, *Milton and English Art.*

Caroline METZ

1793–94 *Cooke's Pocket Edition*: [see Stothard] Hume's *History.* 1 pl..: the Princes in the Tower.

Conrad METZ, 1755–1827

Born in Germany, he settled in London and several of the watercolourists had lessons from him. His daughter Caroline was a well-known flower painter, but also did some book illustration.

1788–91 Shakespeare's *Plays* [see under Corbould]. 3 pls. eng. Taylor.

n.d. (*c.* 1786) George Raymond, *History of England* [see under Wale]. Several pls., including a scene of a contemporary event, 'Gallant behaviour of an English sailor in offering a sword to an unarmed Spaniard to defend himself at the taking of Fort Omoa, in the Bay of Honduras, October 20th, 1779.'

1793 James Thomson, *The Seasons.* 8vo. n.p. 4 pls. eng Anker Smith and Medland. (Plate 42.)

1793 *Bell's British Theatre*: [see under Fuseli] Richard Cumberland, *The Fashionable Lover.* 1 pl. eng. Leney.

Peter MONAMY, *c.* 1670–1749

He was born of poor parents in Jersey and sent to London as apprentice to a house-painter. He made his name as a marine painter, and seems to have been little employed by the book trade.

1729 *Select Collection of Novels* [see under Vanderbank]. 1 pl. eng. G. van der Gucht.

Jean Michel MOREAU, known as MOREAU le Jeune, 1741–1814

There is no evidence that Moreau was ever in England, but he provided two designs for *Bell's Dramatick Writings of Will. Shakespeare* [1788, see under Burney] for *Antony and Cleopatra* and *Troilus and Cressida*, engraved by Bartolozzi and N. le Mire. Plates for *Julius Caesar, Timon of Athens, Coriolanus* and *Titus Andronicus* appear in later editions. Drawings for *Coriolanus* and *Titus Andronicus* are in the Huntington Library.

John Hamilton MORTIMER, 1740–79

Best known as a painter of historical and romantic bandit subjects, he himself etched from his own designs, and was employed by Bell for his *Theatre*

and *Poets*. Eight drawings of Shakespearian characters are included in the great Grangerized Boydell Shakespeare at the Huntington Library, but the etchings (eventually twelve) from them were published by the artist (1773–4) and therefore were presumably not used for book illustration (M. Allentuck, *Burlington Magazine*, CXV, 1973, p. 530). Garrick solicited subscriptions for these 'Principal Characters of Shakespeare' by 'a very ingenious man'. (Garrick *Letters*, 27 March 1775.) The most recent account of Mortimer is that by Benedict Nicolson in the Catalogue of the Exhibition of his works at Kenwood, 1968.

1778–9 *Bell's Poets of Great Britain Complete from Chaucer to Churchill*. 12mo. 'For John Bell': *Addison*. 1 pl. eng. Hall; *Butler*. 4 pls. eng. Grignion and Hall; *Congreve*. 1 pl. eng. Grignion; *Cowley*. 4 pls. eng. Grignion and Sharp; *Milton*. 4 pls. eng. Grignion and Hall; *Spenser*. 8 pls. eng. Grignion and Sharp; *Swift*. 3 pls. eng. Grignion and Cook. There are 12 pen and wash drawings for these fronts. in Nottingham Castle Museum, 4 in the B.M., and 3 in the V. & A.

1779 Matthew Prior, *Poetical Works: now first collected . . . and Memoirs of the author*. 2 vols. 8vo. 'For W. Strahan et al.' Front. to Vol. I eng. J. K. Sherwin.

1779 [Frances Burney], *Evelina, or the History of a young lady's entrance into the world*. 3 vols. 12mo. 'For T. Lowndes in Fleet Street.' 3 fronts. eng. J. Hall, F. Bartolozzi and Walker.
See letter from Lowndes to Dr. Burney in *Diary and Letters of Dr. Burney*, ed. Dobson, II, pp. 481–2.

1782–6 *Shakespeare's Plays* [see under Rooker]. 2 pls.

Charles MOSLEY, *fl.* 1745–70

Chiefly employed as an engraver by the booksellers, but occasionally designed himself, particularly caricatures.

1737 *An Impartial History of the Rebellion* [See under Vanderbank]. 1 pl. is s. 'des. Mosley.'

1742 E. Jenkins, *Joe Miller's Jests: or, the Wit's Vade-Mecum . . . now set forth and published by his late lamentable friend and former companion, Elijah Jenkins . . . The fifth edition, with large additions*. 'London, for T. Reed.' Front.: Mr. Millar in the character of Sir Joseph

Wittold in the *Old Bachelor*, C. Mosley 'del et sc.'

Andrew MOTTE, d. 1730

The younger brother of the publisher Benjamin Motte, he was a distinguished mathematician and also a talented designer though he does not seem to have supplied plates except for his brother.

1729 Sir Isaac Newton, *The Mathematical Principles of Natural Philosophy; . . . translated into English by A[ndrew] Motte*. 8vo. 'For Benjamin Motte.' 2 fronts. and 2 headpieces des. and eng. A. Motte.

1730 Joseph Thurston, *The Toilette*. 8vo. 'For Benj. Motte at the Middle-Temple Gate, in Fleet-Street.' Front. 'A. Motte delin et sculp.' 2nd ed.

1737 Joseph Thurston, *Poems on several occasions*. 12mo. 'For B. Motte and C. Bathurst.' Front. 'A. Motte del et sc.' 2nd ed.

J. MOWSON, *fl.* 1797–1808

1796 *Cooke's Pocket Edition of English Poets*: [see under Corbould] *Hammond*. 1 pl. 'Mowson del. Hawkins sc.'

1799 *Cooke's Select Classics*: [see under Corbould] C. Johnstone, *Adventures of a Guinea*. 1 pl. 'drawn by J. Mowson engraved by W. Hawkins.'
In the *Poets* the terms 'del.' and 'sc.' are still used; in the *Adventures*, three years later, 'drawn' and 'engraved' are substituted.

Johann Sebastian MÜLLER or John MILLER, *c.* 1715–*c.* 89

Born at Nuremberg, he came to England in 1744, and had probably been in Italy previously as he was one of the engravers of the *XXIV Vedute . . . della Città di Firenze*, the most important book of Florentine views of the century. His chief work was associated with botanical illustration. He signs his earlier works J. S. Müller or J. S. Miller, but after 1760 John Miller. Of his twenty-seven children, two sons, John and James, both followed their father's career. He, assisted by 'J. M. Müller junior', engraved the views in Robert Wood's *Ruins of Palmyra* [see under Major], and four plates for John Berkenhout's *Ruins of Paestum or Posidonia* published anonymously in London in 1797. He also engraved designs for Chippendale.
See H. A. Hammelmann *CL*, CXXXVIII, 1965, pp. 560–61.

1753 Richard Pearsall, *Contemplations on the Ocean, Harvest, Sickness and the Last Judgment in a series of Letters to a Friend.* 8vo. 'For J. Oswald and J. Buckland.' 2 pls.: a Storm and Harvest, 'J. S. Müller inv. del. et sc.'

1754 [Paul Hiffernon], *The Tuner.* 8vo. 'By M. Cooper.' Large title-vig.: The Tuner, or man who knows how to play on people's passions, orating in a public place, 'J. S. Müller del. et sc.'

1755 Jonathan Swift, *The Works . . . accurately revised in six volumes.* 4to. 'For Bathurst et al.' Numerous pls. des. and eng. J. S. Müller.

1756 D. W. Linden, M.D., *A Treatise on the three medicinal mineral waters at Llandrindod in Radnorshire.* 8vo. 'By J. Everingham and T. Reynolds and sold by T. Owen.' Front. des. and eng. J. S. Miller.

1757 *A Compendium of the Most Approved Modern Travels . . . Illustrated and Adorned with many useful and elegant Copperplates.* 4 vols. 12mo. 'For J. Scott.' Folding pls. eng. and in 2 cases also des. J. S. Müller.

1760 P. Miller, *Figures of the most beautiful, useful and uncommon plants described in the Gardners Dictionary, exhibited on three hundred copperplates accurately engraven after Drawings taken from Nature, to which are added the Descriptions . . . by Philip Miller, Gardner to the Worshipful Company of Apothecaries at the Botanic Garden at Chelsea.* 2 vols. Folio. 'For the Author.' Pls. eng. T. Jeffreys and J. S. Miller. Headpiece to dedication 'Miller inv. et fecit.'

1760 John Dryden, *The Miscellaneous Works, . . . containing all his original poems, tales and translations, now first collected and published together in four volumes.* 8vo. 'For J. and R. Tonson.' 13 portrait headpieces, those in Vol. III s. J. Miller. 1 headpiece and 3 tailpieces probably des. and eng. J. Miller. Repeated in ed. of 1767.

1760 John Milton, *Paradise Regain'd, . . . To which is added Samson Agonistes and Poems upon Several Occasions.* 12mo. 'For C. Hitch and L. Hawes' et al. Front. des. and eng. J. Miller. 6 pls. after Hayman [ed. of 1752] eng. J. Miller.

1762 James Thomson, *The Works.* 2 vols. 4to. 'For A. Miller in the Strand.' Vol. II, 5 pls. 'inv. del et sc. J. Miller.'

1773 [Edward Young], *The Passions personify'd in familiar fables.* 8vo. 'For J. Whiston.' 12 pls. des. and eng. J. Miller.

1776 John Evelyn, *Silva, or a Discourse of Forest-Trees.* 4to. 'By A. Ward for J. Dodsley' et al. Portrait and pls., 'J. Miller del. et sc.'

1777 *Illustratio Systematis Sexualis Linnaei . . . per Iohannem Miller.* 3 vols. Large folio. 'Published and sold by the Author at his House in Dorset Court.' [again for R. Faulder, 1794] Front.: portraits of Linnaeus and Miller, des. and eng. J. Miller; the coloured flower pls. are inscribed 'Painted, Engrav'd and published by J. Miller', 1773–7.
The Preface states that 'an early inclination to Botany was the Author's principal Inducement' to 'the great Expence and unremitting Application of Several Years . . . Oversights in English orthography the candid Reader will be disposed to pardon in a foreigner.' David Garrick, Joseph Banks and the Earl of Bute were among the subscribers.

Joseph NICKOLLS, NICHOLLS or NICOLLS, *fl.* 1730s

Painted topographical scenes in the City, some of which were engraved.

1734 Charles Johnson, *A General History of the Lives and Adventures of the Most Famous Highwaymen, Murderers, Street-Robbers etc. To which is added, a genuine account of the voyages and plunders of the most notorious pyrates . . . And adorned with the heads of the most remarkable villains, curiously engraven on copper.* Folio. 'For J. Janeway.' Front.: Sir John Falstaff and his Companions at Gad's Hill, and 15 pls. eng. Basire, Toms, Atkins et al.

1735 John Banks, *Cyrus the Great: or, the Tragedy of Love. As it is acted by their Majesties Servants.* 12mo. 'For W. Feales,' et al. Front. 'Jo. Nickolls inv[t] et delin, G. King sculp.'

1736 Virgil, *The Second Book of the Aeneid* [see under Gravelot]. 4 pls. and head- and tailpieces, eng. Toms.

Christopher NORTON, *fl.* 1760–80

He studied at the St. Martin's Lane Academy, and in 1760 was in Rome.

1780 [Mrs. Anne Steele], *Miscellaneous Pieces, in Verse and Prose . . . by Theodosia.* 8vo. 'Printed by W. Pine, sold by T. Cadell' et al. Front. eng. Heath.

John OPIE, 1761–1807
He was not strictly speaking a book illustrator, but paintings were commissioned from him for the Boydell *Shakespeare* (5), Macklin's *Poets* (2), Macklin's *Bible* (7), *History* (11). These brought him to the fore as a leading exponent of the historical school, and his work had some influence on contemporary illustrators. His large canvas, *The Death of Rizzio* (1787) was engraved by Isaac Taylor, not without many difficulties, but for a fee of 250 guineas. His second wife, Amelia Alderson, had something of a salon in London, frequented by artists and writers.
A. Earland, *John Opie and his Circle*, 1911.

Thomas PARKINSON
He exhibited at the Academy from 1775 to 1789, mainly portraits and theatrical scenes. He contributed 11 plates to *Bell's Shakespeare*, 1773–4. See under Edwards.

John PAXTON, d. 1780
Portrait and history painter, trained at Foulis Academy in Glasgow. He went to India and died in Bombay.

1771 John Langhorne, *The Fables of Flora*. 4to. 'For J. Murray.' Oval title-vig. 'J. Paxton invt, J. Simpson sculpt.' 2nd ed. 1771, 5th ed. 1773 for T. Becket.

John PINE, 1690–1756
He was probably a pupil of Bernard Picart, the great French engraver who lived and worked at Amsterdam, and a friend of Hogarth, who painted him as the friar in *Calais Gate*. His plates were much admired, and he played a considerable part in the disputes leading up to the foundation of the Royal Academy. His *Horace* (1733–7), engraved throughout, had a marked influence on book illustration. His son Robert (1730–88), who eventually emigrated to America, was also an engraver, and published his father's *Virgil*, begun in 1753, posthumously.
See also under Gravelot.

1774 Virgil, *Bucolica et Georgica*. [edited by John Pine]. Royal 8vo. Printed by John and Robert E. Pine. 100 pls. and headpieces eng. Robert Edge Pine. The text is engraved in the plates, and ornamented with designs from gems and reliefs. A very splendid book.

1727–38 *A Collection of Old Ballads . . . Illustrated with copper plates*. 12mo. 'For J. Roberts et al.' Fronts. Vols I and III s. and probably des. by Pine. Front. Vol. II and 42 pls. unsigned.

Arthur POND, 1705–58
Having studied under Vanderbank and others, he travelled to Rome with Roubiliac, 'at the expense of his father, a wealthy citizen' (Vertue, III, 37). On his return in 1727, most of his work was etched or done in the crayon method, and consisted of copies of the Old Masters. He was a Fellow of the Royal Society and also of the Society of Antiquaries. He joined with Charles Knapton as a publisher of prints. Vertue (VI p. 196) states that they had several workmen and presses 'and how far thus they will extend, only time will show.'

1737 [Richard Glover], *Leonidas, A Poem*. 4to. 'For R. Dodsley at Tully's Head.' Oblong title-vig. 'Arthur Pond inv. f.'

Sir Robert KER PORTER, 1777–1842
He began his career as a history painter, producing several large-scale altarpieces in the 1790s. He then took to scene painting, and in 1804 went to Russia and became historical painter to the Emperor. His travels and very varied career belong to the nineteenth century. He contributed 11 plates to Harding's *Shakespeare*, 1798–1800. See under Thurston.

R.A.
Possibly Robert Adam

1773 Rev. Robert Preston, M.A., *Meditations in the Seasons*. 8vo. 'For E. and C. Dilly.' Front.: the writer with an open book seated in a landscape, 'R.A. del., Isaac Taylor sculp.'

Johann Heinrich RAMBERG, 1763–1840
He was born in Hanover and came in 1781 to England, where he is said to have studied under Reynolds and Bartolozzi. He exhibited at the Academy from 1782 to 1788, and was employed by Boydell for the Shakespeare Gallery ('Malvolio') and in the decorations of Carlton House. He returned to Germany in 1788 and died at Hanover.

1788 *The Dramatick Writings of Will. Shakespeare*: [see under Burney] *Julius Caesar*. 1 pl. eng. Sharp. A drawing for the pl. is in the Huntington Library, and also a drawing for another scene from *Julius Caesar* which was not used.

Henry J. RICHTER, 1772–1857
Of German extraction, he was in London from

1788 onwards, mainly engaged in painting water-colour figure subjects. His edition of *Paradise Lost* was published in London in 1794 in conjunction with his father, John Richter, containing twelve plates designed by himself. He was a pupil of Stothard.

1788–91 *Shakespeare's Plays* [see under Corbould]. Title-page and 19 pls. eng. Angus, Goldar, Grignion, Corner, Hawkins, Neagle, Taylor, Walker. His pl. of 'Patience on a Monument' for *Twelfth Night* is an unusual piece of fancy. Drawings for *The Two Gentlemen of Verona*, *A Midsummer-Night's Dream*, and *King Lear* are in the Huntington Library.

1793 Samuel Richardson, *The History of Sir Charles Grandison* [see under Chalmers]. 2 pls. eng. Williams and Sparrow.

1793 Samuel Richardson, *Clarissa Harlowe* [see under Dodd]. 4 pls. eng. Cole and Charter.

RIVERS

He contributed 13 plates to Harding's *Shakespeare*, 1798–1800. See under Thurston.

James ROBERTS

There seems to have been both a portrait painter and engraver of this name in the second half of the eighteenth century. Redgrave is obviously confused about their relationship. A J. Roberts contributed 20 plates to *Bell's Shakespeare*, 1773–4 [see under Edwards].

Henry ROBERTS, d. *c*.1790

He kept a print shop in Hand Court, Drury Lane, and engraved mainly for works to be sold in his shop.

1765 John Hughes, *Letters of Heloise and Abelard* [see under Vanderbank]. Front. 'H. Roberts fecit.' Again in Lowndes ed. of 1788.

George ROMNEY, 1734–1803

Apart from his work for Boydell, he was not involved in the book trade, and his fame lies elsewhere. The volume below is a rare exception, and probably owes more to the engraver than to Romney.

1773 [Richard Cumberland], *The West Indian, A Comedy.* 8vo. 'For Edward and Charles Dilly.' Title-vig. eng. I. Taylor.

Michael Angelo ROOKER, 1743–1801

He was the son of Edward Rooker, and studied in the St. Martin's Lane Academy. In 1770 he was elected A.R.A. He was much employed on the Oxford Almanack. Later in life, his sight began to fail and he took to scene painting. His use of Angelo as a second name was not baptismal, but a nickname given him by Paul Sandby, after which Rooker often signed himself 'M. A. Rooker'.

1778 *The Dramatick Works of Beaumont and Fletcher; collated with all the former editions and corrected; . . . And Adorned with fifty-four original engravings. In Ten Volumes.* 8vo. 'For T. Evans et al.' Front. and 32 pls. mainly eng. Collyer and Grignion.

1782–6 *Shakespeare's Plays.* 8vo. 6 pls. eng. Angus, Taylor and Heath. 20 issued as separate works as a continuation of *Lowndes' New English Theatre.*

Thomas ROWLANDSON, 1757–1827

Rowlandson's activity as a book illustrator falls mainly in the nineteenth century. It was only in 1798 that Rudolph Ackermann began publishing his work, and at first this was in separate prints or collected volumes of prints such as the *Views of London* (1798). Previously to 1800 his book illustrations, in the normal sense of the term, were for the novels of Smollett and Fielding, and are signed Rowlandson 'inv. et del.' E. C. J. Wolf, *Rowlandson and his illustration of eighteenth-century English literature*, Copenhagen, 1945, 2nd ed. 1964; B. Falk, *Thomas Rowlandson, His Life and Art*, n.d.

1790 H. Wigstead, *An Excursion to Brighthelmstone.* Oblong 4to. 'For G. G. J. & J. Robinson, Paternoster Row.' 8 pls. drawn and etched by Rowlandson, aquatinted by S. Alken.

1791 T. Smollett *Novels.* 6 vols. 8vo. 'By and for J. Sibbald, Edinburgh.' 6 fronts.

1791 H. Fielding, *Tom Jones.* 3 vols. 8vo. 'By and for J. Sibbald, Edinburgh.' Fronts. and 11 pls.

1792 H. Fielding, *Joseph Andrews.* 8vo. 'For J. Murray, London, and J. Sibbald, Edinburgh.' 8 pls.

William Wynne RYLAND, 1738–83

He was the son of the engraver, Edward Ryland (d.1771) and a pupil of François Simon Ravenet (1706–74). He studied for some years on the continent, for a time with the stipple-engraver Jean Charles François, and was so successful on his return that he was appointed engraver to the king. He later had a print-shop in Cornhill, where he developed a trade in colour prints, largely based

on the designs of Angelica Kauffman. He and Bartolozzi led the way in this new departure. He does not seem to have designed for the book trade, but his ultimate fate gave him notoriety beyond any of the engravers of the century. Having run into debt, he used his engraving skill to forge two bills, for £7114, on the East India Company. The fraud was discovered and he was found in hiding, failed in an attempt at suicide, and was hanged at Tyburn. In prison he continued to work on engraving plates that he had in hand, and protested his innocence till the end.
Authentic Memoirs of W. W. Ryland, 1784.

Charles RYLEY, c.1752–98
He was an exhibitor of history paintings at the Academy, and also employed in decorative wall painting. He illustrated several of the popular *Histories*, such as *Cooke's Pocket Edition of Hume* (1793–4: see Stothard) and Baxter's *New and Impartial History*.

1782–6 *Shakespeare's Plays* [see under Rooker]. 4 pls. eng. Angus, Heath and Taylor. Drawings for 3 of them are in the Huntington Library.

1788–91 *Shakespeare's Plays* [see under Corbould]. 3 title-pages, eng. Angus, Goldar, W. and J. Walker, Geo. Walker. A drawing for *Measure for Measure* is in the Huntington Library.

1795 *Bell's British Theatre*: [see under Fuseli] N. Rowe, *The Royal Convert*. 1 pl. eng. A. Smith.

1796 Baxter's *History* [see under Ansell]. Front: Liberty protecting the British Constitution against the attacks of Anarchy and Despotism, and 2 pls. eng. Charter and Widmell.

Paul SANDBY, 1725/6–1809
The 'father of the watercolour school', and an original member of the Royal Academy, he was one of the early users of the aquatint process. Some of his landscapes were used for book illustration, and he published some collections of plates from his own work.
See A. P. Oppé, *The Drawings of Paul and Thomas Sandby in the Collection of His Majesty the King at Windsor*, 1947.

1778 *The Copper Plate Magazine, or Monthly Treasure for the Admirers of the Imitative Arts.* 4to. 'For G. Kearsley.' Title-vig. eng. G. Watts; several pls. of landscape and country houses.

1779 Capt. George Smith, *Universal Military Dictionary*. 4to. 'For J. Millan, near Whitehall.' Title-vig. and dedication headpiece eng. C. Grignion.

R. William SATCHWELL, 1732–1811
He was much employed by Cooke, and plates are sometimes described as ornamented by or drawn by him, where the main design is painted by some other artist. He probably was responsible for many of the elaborate surrounds, but seldom designed the main scene. His son, who had the same initials, was a successful miniature painter.

1793 *Cooke's Sacred Classics*: [see under Corbould] *Devout Meditations*. 1 pl. eng. Warren.

1798–1800 *Shakespeare's Plays* [see under Thurston]. 7 pls.

W. SAWYER
1768 Richard Jago, *Labour and Genius: or, the Mill-Stream and the Cascade, a Fable written in the Year 1762, and inscribed to the late William Shenstone*. 4to. 'For J. Dodsley.' Half-page headpiece: landscape with mill and cascade, 'W. Sawyer del, C. Grignion sc.'

SCOTIN family
The Scotins were an established family of French engravers for some generations. Two brothers, Gerard Jean-Baptiste (b. 1698) and Louis Gerard (b. c.1690) came to England c.1733 to assist Du Bosc with Tonson's edition of Picart's ceremonies. They were engravers not designers but G. (Gerard) Scotin signs 'in. f.' on a headpiece in *The Military History of the Late Prince Eugene* (see under Gravelot), and in *The Cupid* (1736: see under Chatelain) two plates are signed 'J. Scotin Ju. after G. Scotin.'

Dominic SERRES, 1722–93
Well known as a marine painter, and a foundation member of the R.A.

1774 Robert English, *The Naval Review. A Poem. The Third Edition.* 4to. 'For T. Becket.' Title-vig.: the naval review eng. P. C. Canot.

William SHERLOCK, c.1738–c.1806
He studied at the St. Martin's Lane Academy, and later with Le Bas at Paris. He engraved the portrait heads for Smollett's *History of England* (1793–4).

1760 E. de Vattel, *The Law of Nations . . . translated from the French*. 2 vols. 4to. 'For J. Newberry et al.' Title-vig. 'Sherlock fec.'

John Keyes SHERWIN, 1751–90
He started his career as a wood-cutter at Petworth, but showing talent in drawing was sent to London and eventually became a pupil of Bartolozzi. He had some success as an engraver, but died in comparative poverty. He was not much employed by the book trade.

1773–4 *Bell's Shakespeare* [see under Burney]. 2 pls.

1788 *Shakespeare's Works*: [see under Burney] *The Tempest.* 1 pl. 'Sherwin fec.'

Henry SINGLETON, 1766–1839
He worked frequently for book illustration, but much of his output is after 1800.

1792 *The Shakespeare Gallery: containing a select Series of Scenes and Characters . . . adapted to the Works of the Admired Author.* 8vo. 'For C. Taylor.' 49 pls. Drawings for 40 of them are in the Huntington Library.

1793 James Thomson, *The Seasons.* Large 8vo. 'For A. Hamilton, Grays Inn Gate, Holborn.' 2 pls. eng. J. Comer and Myers.

1796 John Milton, *Paradise Lost* [see under Corbould]. Pls.
See Pointon, *Milton and English Art,* p. 86.

1798–1800 *Shakespeare's Plays* [see under Thurston]. 10 pls.

Robert SMIRKE, 1752–1845
He entered the Royal Academy School in 1772, became an A.R.A. in 1791, and R.A. in 1793. He painted for Boydell and Bowyer, and his designs were much in demand by the publishers. His Shakespearian paintings are well represented at the Theatre Gallery at Stratford-upon-Avon. A sketch for a transparent painting to be used in the illumination of the Bank of England for the recovery of George III in 1789 is in the Soane Museum.

1783–7 Charles Taylor, *Picturesque Beauties of Shakespeare* [see under Stothard]. 32 pls. eng. Taylor. 18 preliminary designs are in the Huntington Library.

1785 Harrison's *Classics:* [see under Stothard] Pls. for *The Spectator.*

1792 *Bell's British Theatre:* [see under Fuseli] Henry Jones, *The Earl of Essex.* 1 pl. eng. Heath; *The Gamester* (as altered from Shirley and C. Johnson). 1 pl. eng. Neagle; Vanburgh and C. Cibber, *The Provoked Husband.* 1 pl. eng. Sharp.

Adam SMITH

n.d. (*c.*1767) *The New Pocket Companion to the Magdalen Chapel containing all the Odes, Psalms, Anthems and Hymns . . . Now in Use. Never before made public, with a thorough Bass for the Harpsichord and Organ by A.S. late Organist to the Charity.* 8vo. 'For S. Hooper.' Front.: the Magdalen with music books, s. 'Adam Smith delin. et sculp.'

1770 Henry Chamberlain, *A Survey of London and Westminster* [see under Malton and Wale]. 1 pl. 'A. Smith del.'

J. SMITH (probably Jacob Smith, *fl. c.*1730, not John Smith, the mezzotint engraver, who was much employed by Kneller, 1652–1742)

1736 Henry Carey, *The Honest Yorkshire-Man. A Ballad Farce refus'd to be acted at Drury Lane Playhouse . . .* 12mo. 'For L. Gilliver.' Front. des. and eng. J. Smith.

1738 *The Universal Musician: or Songsters Delight— Consisting of the most celebrated English and Scottish Songs.* 8vo. 'For William Rayner [Vol. I only].' Front. and headpieces 'J. Smith inv. et sculp.'

1738 Tom King, *Tom K——g's; or, the Paphian Grove. With the various humours of Covent Garden, The Theatre, The Gaming Table etc. A Mock-Heroic-Poem.* 8vo. 'For J. Robinson . . . and sold at Pamphlet-Shops at the Royal-Exchange, Temple-Bar and Charing-Cross.' Front. and 2 pls.: scene of night life, des. and eng. J. Smith.

1739 James Barber, *Poetical Works . . . Adorn'd with several Cuts adapted to each particular subject.* 12mo. 'For J. Torbuck.' 5 pls., all des. and eng. J. Smith.

Thomas STOTHARD, 1755–1834
Born in London, but brought up in Yorkshire, he stated in a brief autobiographical memorandum, written in his old age, that his interests in art were aroused by 'some of the heads of Houbraken . . . an engraving of the blind Belisarius by Strange, and some religious pictures from the unrivalled graver of the same artist'. Back in London, his widowed mother apprenticed him to a designer of silk brocades, where he served his seven years. From 1780 he began to find employment as an illustrator for the periodicals that were being produced by Harrison and by Robinson, and he

was soon fully occupied in meeting the demand for his work, receiving a guinea apiece for his designs. He married in 1783, and before long had a large family to support. Of his eleven children, six survived infancy. He was also painting and his *Holy Family* was exhibited in the Academy in 1778. In 1792 he became A.R.A., along with Westall, who was to be one of his main competitors in the book trade. In 1794, with unusually rapid promotion, they both became full Academicians. He provided paintings for the galleries run by Boydell, Macklin and Bowyer, and these were engraved in the resulting publications. His *Jacob's Dream* for Macklin is perhaps his masterpiece.[1] Stothard never engraved his own work, but found in William Blake and James Heath able interpreters of it. As a designer he was immensely prolific, and he himself calculated the number of his designs at about five thousand. He played an active part in Academy business, and is often mentioned in Farington's *Diary*. His early work, particularly for the *Novelist's Magazine*, shows an imaginative range that narrowed as his output constantly increased, and he found a vein of sentimentality that pleased the time, and that he too often repeated.

His illustrations have as their theme the simple domesticity to which the immense popularity of *The Vicar of Wakefield* (1776) had given a wide vogue, curiously at variance with the grand manner of the history painters or the brutal frankness of the caricaturists. This he portrayed with a clean line that owed something to Flaxman and contemporary neo-classicism.[2] At his best he is an artist of originality and certainty of touch, but his output was too large for the best to be always apparent. Both Charles Lamb and Coleridge praised his work, singling out his designs for that now forgotten story, Robert Paltock's *The Adventures of Peter Wilkins* in the *Novelist's Magazine*. Coleridge wrote of it in his *Table Talk* in 1834: 'A work of uncommon beauty, and yet Stothard's illustrations have added beauties to it.' Lamb's poem, contributed to *The Athenaeum*, 21 December 1833, is an example of the admiration Stothard inspired.

Active until the time of his death, much of his work falls after 1800, and he was one of the early illustrators of Scott and Byron. In particular, from 1794 onwards he was associated with the poet, Samuel Rogers. An edition of that year of *The Pleasures of Memory* has Stothard's designs cut in wood by Luke Clennell (1781–1840), a pupil of Bewick. At the end of his life, when Stothard was collaborating with Turner on Roger's *Italy* and collected *Poems*, the new process of steel engraving was in use.

The British Museum has a large collection of engravings after Stothard (2198 items, compiled by Robert Balmanne and acquired by the Museum in 1849). It includes many taken from books and not always securely identified. Much of the early work, done for periodicals and for the new cheap series of poems, plays and novels, has not survived so consistently as have earlier quartos and folios, and few libraries have complete holdings of them. Very frequently also plates have been abstracted. A. C. Coxhead, *Thomas Stothard, R.A.*, 1906, discusses the book illustrations in great detail, but without full bibliographical descriptions.

1769–93 *The Town and Country Magazine*. 'For Harrison.' 1780–5 Stothard contributed at least 15 designs.

1770–1818 *The Lady's Magazine*. 'For Robinson.' Stothard, beginning in 1780 and continuing till 1797, contributed at least 90 designs to this periodical.

1778–81 *Bell's Poets of Great Britain*: [see under Mortimer] *Chaucer*. 14 pls.; *Denham*. 1 pl.; *Donne*. 2 pls.; *King*. 2 pls.; *Fenton*. 1 pl.; *Lansdowne*. 1 pl.; *Garth*. 1 pl.; *Somerville*. 1 pl.; *Hughes*. 2 pls.; *Roscommon*. 1 pl.; *Tickell*. 1 pl.; *Cunningham*. 1 pl.; *Buckingham*. 1 pl.; *Watts*. 7 pls.; *Rowe*. 1 pl.; *Pitt*. 1 pl.; *Pomfret*. 1 pl.; *Armstrong*. 1 pl.; *Akenside*. 2 pls. The engravers were largely the same as those for the *Novelist's Magazine* with the addition of Jean Marie Delattre, a pupil of Bartolozzi and John Hall.

1780–86 *The Novelist's Magazine*: [see under Corbould] 8vo. Vol. II Voltaire, *Zadig*. 1 pl.; W. Combe, *Devil upon Two Sticks*. 3 pls.; Vol. III *Tales of the Genii*. 6 pls.; *Tom Jones*. 12 pls.; Vol. IV Le Sage, *Gil Blas*. 10 pls.; *Robinson Crusoe*. 7 pls.; Vol. V *Tristram Shandy*. 8 pls.; *Chinese Tales*. 3 pls.; Dr. Dodd, *The Sisters*. 4 pls.; Vol. VI *Peregrine Pickle*. 11 pls.; Marmontel, *Moral Tales*. 6 pls.; Vol. VII *The Fortunate Country Maid*. 6

[1] Sold at Christie's, 11 Oct. 1946: see T. S. R. Boase, *JWCI*, XXVI, 1963, p. 165.
[2] In a drawing in a private collection he used the famous classical figure of the boy extracting a thorn.

pls.; Hugh Kelly, *Louisa Mildmay*. 2 pls.; Langhorne, *Theodosius and Constantia*. 2 pls.; *Ferdinand Count Fathom*. 4 pls.; Vol. VIII *Don Quixote*. 16 pls. 3 drawings for *Don Quixote* are in the B.M.; Vol. IX Miss Fielding, *David Simple*. 4 pls.; *Sir Launcelot Greaves*. 4 pls. (Plate 36); *A Peruvian Princess*. 2 pls.; *Jonathan Wild*. 2 pls.; *A Sentimental Journey*. 2 pls.; *Gulliver's Travels*. 4 pls.; Vols. X & XI *Sir Charles Grandison*. 28 pls.; Vol. XII Mrs. Lennox, *The Female Quixote*. 4 pls.; Fielding, *A Journey from this World to the Next*. 3 pls.; Kimber, *Life and Adventures of Joe Thompson*. 4 pls.; Paltock, *Adventures of Peter Wilkins*. 6 pls. (Plate 35); Vol. XIII Mrs. Haywood, *Betsy Thoughtless*. 8 pls.; Ambrose Phillips, *Persian Tales*. 6 pls.; Vols. XIV & XV *Clarissa Harlowe*. 28 pls. (Plate 37); Vol. XVI Avellaneda, *A Continuation of Don Quixote*. 5 pls.; *The Virtuous Orphan*. [from the French of Marivaux] 9 pls.; Vol. XVII La Mothe Fénelon, *Telemachus*. 4 pls.; Lady Susannah Fitzroy, *Henrietta Countess Osenvov*. 2 pls.; Mrs. Haywood, *Jemmy and Jenny Jessamy*. 6 pls.; Vol. XVIII *The Arabian Nights*. 10 pls.
The team of engravers for the *Magazine* consisted of Heath, Angus, Walker, Birrell, Collyer, Cook, Sharp and Grignion. In 1782 Blake engraved some plates for *Don Quixote*, *The Sentimental Journey*, *Sir Launcelot Greaves* and *Sir Charles Grandison*. Isaac Taylor in 1785 engraved 2 plates for *The Arabian Nights*.

1781 *Lady's Poetical Magazine*. 4 vols. 'For Harrison.' 24 pls.

n.d. [1780–5] Henry Southwell, *The New Book of Martyrs*. Folio. 8 pls. Some drawings in B.M.

1781 Sime, *Military Science*. Front.

1781 *The London Magazine or Gentlemen's Monthly Intelligence*. Front.: The Proprietors of the London Magazine presenting the volume for the year 1781 into the hands of Futurity, to be preserved from the Ravages of Time.

1782 John Scott, *The Poetical Works*. 8vo. 'For J. Buckland.' 2 pls., 1 headpiece and 3 tailpieces, eng. Blake. See *Book Collector*, Vol. 14, 1965, p. 358.

1782 [J. Pinkerton], *Rimes*. 12mo. 'For Charles Dilly.' Front. eng. Trotter. 2nd ed.

1782 *The European Magazine*. Front. Vol. II.

1782–6 *Shakespeare's Plays* [see under Rooker]. 2 pls.

1783 Joseph Ritson, *Select Collection of English Songs*. 8vo. 'For J. Johnson.' 3 vols. Front. Vol. I and 12 vigs., some eng. Blake.
Ritson's *Caledonian Muse* was ready for publication in 1785, but was damaged in a fire and abandoned. In 1821 Robert Triphook revived the scheme and it was published with vignettes, probably the original ones by Stothard and eng. Heath.

n.d. George Thomson, *Scottish Airs* [see under Allan]. Title-vigs. the same in each vol. eng. Heath.

1783–7 Charles Taylor, *The Picturesque Beauties of Shakspeare*. 4to. 'For Charles Taylor.' 7 pls. eng. Taylor. Drawings for 3 of the pls. are in the Huntington Library.

1784 Tobias Smollett, *The Adventures of Peregrine Pickle*. 4 vols. 12mo. 'For W. Strahan et al.' Fronts. each vol. eng. Heath. 7th ed.

1784 Thomas Holcroft, *The Wits Magazine*. 'For Harrison.' Folding front. eng. Blake.

1785 Harrison's *British Classics*. 8 vols. Stothard illustrated: *The Rambler*, *Persian Letters*, *The Adventurer*. 15 pls.

1788 John Sargent, *Mine*. 'For T. Cadell.' Front. and 4 pls., 2 unsigned, but all by Stothard.

1788 William Hayley, *Triumphs of Temper*. 8vo. 7 pls. Reused in eds. of 1793 and 1796. 7th ed.

n.d. (c.1786) George Raymond, *History of England* [see under Wale]. 1 pl.: Boadicea.

1788–9 David Hume, *History of England*. 8vo. 30 small designs beneath portraits of the kings and queens.

1789 John Bunyan, *The Pilgrim's Progress*. 8vo. 17 pls. eng. Neagle, Rothwell et al.

1789 Charlotte Smith, *Elegaic Sonnets*. 2 vols. 16mo. 'For T. Cadell in the Strand.' 2 pls. eng. Neagle and Thornthwaite. The book contains a pl. eng. Neagle from a drawing by the Right Hon. the Countess of Besborough.

1790 [Daniel Defoe], *The Life and Strange Surprising Adventures of Robinson Crusoe*. 2 vols. Royal 8vo. 'For John Stockdale, Piccadilly.' 2 fronts., 14 pls. eng. Medland.

1792 T. Tasso, *Jerusalem Delivered . . . translated . . . by John Hoole*. 8vo. 'For J. Dodsley.' 2 pls.

1792–3 John Milton, *Paradise Lost*. Folio. Jeffreys. Title-vig. and 2 other vigs. and 10 pls. eng. Bartolozzi. See M. Pointon, *Milton in English Art*, pp. 75–77.

1792 John Milton, *Paradise Lost*. 8vo. 'For Edwards.' Front.

1792 Oliver Goldsmith, *The Vicar of Wakefield*. 8vo. 'For E. Harding and J. Good.' 6 pls. eng. J. Parker. (Plate 34).

1791–7 *Bell's British Theatre*: [see under Fuseli] Fronts. to Dryden, *Amphytrion*. David Garrick, *Cymon*. Murphy, *The Orphan of China*. Hoole, *Cyrus*. Rowe, *The Ambitious Stepmother*. Vanbrugh, *The Mistake*. Mallett, *Eurydice*. Vanbrugh, *The Relapse*. Hull, *Henry II*. Mrs. Cowley, *Albina*. Kelly, *False Delicacy*. Kelly, *A Word to the Wise*. Mrs. Griffiths, *The School for Rakes*. Kendrick, *Falstaff's Wedding*. Beaumont and Fletcher, *Bouduca*. Hoole, *Timanthes*. Mason, *Elfrida*. Milton, *Samson Agonistes*. Hoole, *Cleonice*.

1793 James Thomson, *The Seasons* [see under Singleton]. 1 vig. s. Stothard, the 7 others probably by him, eng. Audinet.

1793–4 [William Hayley], *A Philosophical . . . Essay on Old Maids, . . . with additions*. 3 fronts. 1 pl.

1793 Robert Pollard, *The Peerage of Great Britain and Ireland*. 4to. 6 pls.

1793–5 David Hume, *Parson's Genuine Pocket edition of Hume's History . . . with a continuation by Dr. T. Smollett, and . . . J. Barlow, embellished with Historical Engravings and Portraits, . . . Habited in the Respective Dresses of their Time*. 22 vols. Sm. 8vo. 2 pls.

1794 J. F. Marmontel, *Belisarius*. 12mo. Vernor and Hood. 6 pls.

1794 John Langhorne, *Fables of Flora*. 12mo. 'For Harding.' 11 pls.

1794 *The Book of Common Prayer*. 4to. 'By Millar Ritchie.' Pls. eng. Bartolozzi and Schiavonetti.

1794 Samuel Rogers, *Pleasures of Memory*. 8vo 'For T. Cadell.' 2 pls., woodcuts by Luke Clennell.

1794 Bryan Edwards, *The history, civil and commercial of the British Colonies in the West Indies*. 2 vols. 4to. 'For John Stockdale, Piccadilly.' Vol. II pl.: The Voyage of the Sable Venus from Angola to the West Indies [the design

is based on Raphael's *Galatea*], 'T. Stothard pinxt W. Grainger sculp.' 2nd ed.

1795 William Falconer, *The Shipwreck*. 8vo. 'For T. Cadell.' 4 pls.

1795 James Macpherson, *The Poems of Ossian*. 2 vols. 8vo. Perth. 7 pls.

1796 *The Royal Engagement Pocket Atlas*. This is an annual containing information about the Royal Family, lists of M.P.s etc. Each month has 2 blank pages, each headed by a picture and also 1, or sometimes 2, full-page illustrations. Each year illustrates some particular work: Stothard illustrated Hayley's *Triumphs of Temper* (1796), Thomson's *Seasons* (1797), Hawksworth's *Telemachus* (1798), Goldsmith's *Deserted Village* (1799), *Gil Blas* (1800) and continued providing designs till 1826. The books were 12mo, the headpieces measure $2\frac{3}{8} \times 1$ in., and the full-page designs $4\frac{1}{8} \times 2\frac{1}{4}$ in.

1796 Thomas Townshend, *Poems*. 8vo. 'For Harding.' Fronts. and 14 pls.

1796 Alexander Pope, *Essay on Man*. 8vo. 'For T. Cadell Jun. and W. Davies.' Front. and 3 pls.

1797 Salomon Gessner, *The Death of Abel in Five Books, attempted from the German of Mr. Gessner*. 8vo. 'For T. Heptinstall, Fleet St.' Front. and 5 pls. eng. Blackberd. Another ed. of the same year has two additional pls.

1797 William Collins, *Poetical Works*. 8vo. 'For T. Cadell and W. Davies.' Fronts. and 3 pls.

1797 S. de la Mothe-Fénelon, *Adventures of Telemachus. From the French . . . By John Hawkesworth*. 4to. 1 pl.

1798 Alexander Pope, *The Rape of the Lock* [see under Fuseli]. 3 pls. eng. Bromley, Neale, Anker Smith.

1798 Lawrence Sterne, *Complete Works*. 10 vols. 8vo. 'For Johnson, Cadell' et al. 9 pls.

1798 Edward Young, *Night Thoughts*. 8vo. 'By C. Whittingham for T. Heptinstall, No. 304 Holborn.' 8 pls. by various engravers.

1799 L. Ariosto, *Orlando Furioso . . . translated . . . by John Hoole*. 5 vols. 8vo. 'For Verrnor and Hood.' 2 pls.

1798–1800 Shakespeare, *Plays* [see under Thurston]. 'For E. Harding.' 8 pls.

Sir Robert STRANGE, 1721–92

Born in Orkney, and apprenticed to an Edinburgh

engraver, Richard Cooper. He worked in Edinburgh, and is said to have fought on the Jacobite side at Culloden: he escaped to Paris, returning to London in 1751. His refusal to engrave Ramsay's portraits of George III and Lord Bute gave new offence, and he withdrew to Rome, where his engravings of the Old Masters won him great repute and membership of various continental academies. In 1766 he was back in London and a member of the Incorporated Society of Artists, but was soon involved in bitter attacks on the Academy. He did not regain royal favour till 1787, when he was knighted. Probably the best known internationally of all English engravers of the time, his work was on single plates and very rarely for the book publishers.

1747 Thomas Ruddiman, *An Answer to the Rev. G. Logan's late Treatise on Government*. 8vo. 'Edinburgh, by W. and T. Ruddiman.' Front.: figure of blind-fold Justice, des. and eng. R. Strange.
Walter Ruddiman, the Edinburgh publisher and son of Thomas, is called by Scott in *Redgauntlet* 'the learned Ruddiman'.

Joseph STRUTT, 1749–1802

He was apprenticed to W. Wynne Ryland and in 1770 won the Royal Academy Gold Medal. His interests were mainly antiquarian, and he published from 1773 onwards a series of books on medieval English manners and customs, written and illustrated by himself, mainly from coins, seals and illuminations, but with some imaginary scenes. A typical example is *The Chronicle of England; or a Compleat History, Civil, Military and Ecclesiastical, of the Ancient Britons and Saxons*, 4to, 1779, 'For T. Evans in Pater-Noster-Row and Robert Faulder, No. 42 New-Bond-Street'. His most valuable work is the *Biographical Dictionary of Engravers*, 2 vols. 1786. Its frontispiece is a copy of Raimondi's *Adam and Eve*.

William STUKELEY, 1687–1765

A distinguished antiquarian, he was secretary of the Society of Antiquaries and played a large part in its revival in 1717. He himself was a draughtsman, and drew an allegorical frontispiece to the Minutes of the Society, 1717 (Ants. MS. 265). He particularly encouraged drawings of antiquities, and in one of his minutes states: 'Without drawing and designing the Study of Antiquities or any other Science is lame and imperfect'; and again in his preface to the *Itinerarium*: ''Tis evident how proper engravings are to preserve the memory of things and how much better an idea they convey to the mind than written descriptions.'
See Joan Evans, *A History of the Society of Antiquaries*, Oxford, 1956.

1724 William Stukeley, *Itinerarium curiosum; or, an Account of the Antiquitys and remarkable curiositys in nature or art, observ'd in travels thro' Great Brittan . . . Illustrated with copper prints*. 2 vols. Folio. 'For the Author.' Fronts. and 141 pls. 'Stukeley delin.', eng. J. Pine, J. Harris, J. van der Gucht, E. Kirkall, G. Faithorne, Thornton, Parker, Toms.

1740 William Stukeley, *Stonehenge, a temple restor'd to the British Druids*. Folio. 'For W. Innys and R. Manby at the West End of St. Pauls.'
The plates are mainly plans and details of the building, but some are general views with figures, and the first plate is an imaginary picture of a Druid, 'Stukeley delineavit. G. V. Gucht sculpsit.'

John STURT, 1658–1730

A pupil of Robert White, he was best known for his skill in designing initial letters and small headpieces. He engraved an elaborate Book of Common Prayer (1717, large 8vo) printed from plates with borders, initials and small histories at the top, and worked in a similar small scale in his edition of Samuel Wesley's versifications of the Bible (Old Testament 1704, New Testament 1715).

1707 Andrea Pozzo, *Rules and Examples of Perspective proper for painters and architects . . . engraved in 105 ample folio plates, . . . adorn'd with 200 initial letters . . . by John Sturt—Done into English from the original printed at Rome, 1693, in Latin and Italian. By J. James*. Folio 'Printed by Benjamin Motte, sold by John Sturt in Golden Lion Court in Aldersgate Street.'
Among the subscribers were Sir Chr. Wren, J. Vanbrugh, Thomas Highmore.

1727 J. Hamond, D.D., *An Historical Narration of the Whole Bible . . . curiously adorned with proper cuts engraved by Mr. J. Sturt*. 8vo. 'For R. Ware.' 44 pls. eng. and probably some des. by Sturt.

c.1730 *The Historical Part of the Holy Bible, or The Old and New Testament exquisitely and accurately described in near three hundred*

historys. Engraven by John Sturt, from designs of the greatest masters. Folio. 'Richard Ware, at the Bible and Sun on Ludgate Hill.'

The 'designs of the greatest masters' are very freely interpreted into Sturt's own style; the pls. are based on those in the Wesley vols., but enlarged: they were used by Thomas Baskett for his Bibles of 1721, 1723 and 1751. In some of these there is a title-page: 'Printed and sold by Richard Ware . . . to bind up with all sorts of House Bibles.' This practice of publishing prints for insertion was common at the time. James Cole did another set of 200 'Biblical Historys curiously engraved' for Richard Ware.

1728 John Bunyan, *The Pilgrim's Progress: from this world, to that which is to come . . . with twenty-two copper plates, engraven by J. Sturt.* Large 8vo. J. Clarke and J. Brotherton. 22nd ed.

(1732) Sébastien Le Clerc, *A Treatise of Architecture, with remarks and observations. For Young People (Engraven in CLXXXI copperplates by John Sturt. Translated by Mr. Chambers.)* 'Printed and sold by Richard Ware.' Front. eng. M. le Clerc.

Charles TAYLOR, 1756–1829

He was articled to his father Isaac as an engraver, and visited Paris in 1777 to study French engraving. He was employed as an engraver, rather than a designer. In 1780 his house was burned down during the Gordon riots.

Isaac TAYLOR the Elder, 1730–1807

Of the 'library engravers' at work in London in ever increasing numbers during the 1760s and 1770s, Isaac Taylor was one of the most charming and certainly the most successful. Readers had by then come to expect their books to be 'embellished with copperplates', and the number and variety of publications for which Taylor and others were asked to supply a frontispiece or at least a small vignette for the title-page give point to the assertion of a contemporary critic who spoke of the 'indispensable necessity to adorn with engravings any work of whatever description that is offered to the public'. That all the designs made for this purpose soared to the heights of great art it would be pointless to expect or to contend; rather, like the designers and makers of the period's fine furniture or table silver, the engravers of book-illustrations were artisans highly skilled in their particular craft, with an eye unspoilt by mass-production and reproduction, and with a real love for their job.

Certainly Isaac Taylor was such a craftsman both by background and training. Unlike etching, which can be practised by amateurs and was still an occasional pastime for Victorian ladies and gentlemen, headed by Queen Victoria and Prince Albert, the technique of line engraving can only be acquired by long years of apprenticeship and practice. When he came to London, walking beside the stage wagon all the way from his native Worcester, Isaac Taylor already possessed a solid grounding in his trade. His father, William Taylor, a brass-founder by profession, was a versatile man who undertook all sorts of engraver's work and even wielded an occasional pencil or brush, not without a certain naïve skill, as is shown by his large painting of the house and gardens at Stanway in Gloucestershire which is still preserved there. In their father's business Isaac and his brother James (who subsequently worked for a time as a china painter in the Worcester Porcelain Manufactory) learnt to engrave playing cards, book plates and elaborate trade cards, and above all to decorate silver-plate with the coats-of-arms of the gentry, an exacting task in which many an eighteenth-century artist, Hogarth included, gained his first acquaintance with the graver.

To this experience, reinforced as it was by several years' apprentice work in London with the well-known publisher of maps and topographical works, Thomas Jeffreys, geographer to George III, Taylor undoubtedly owed the neat finish and excellent workmanship which from the outset distinguished the engravings he made for the booksellers.[1] His plates had the reputation of 'wearing better' than those of his colleagues, a vital factor when it is recollected that, until the introduction in the nineteenth century of steel-facing which gave almost unlimited life to the engraved plates, only a very restricted number of satisfactory impressions (between 500 and 800) could be taken from copperplates without re-working. Taylor liked to fill every part of his plates, but every corner was finished with equal care and it is hardly too

[1] Taylor married Jeffreys' niece in 1754, and continued his interest in cartography throughout his life. He engraved six large-scale county maps, for which he himself made the surveys. See Richard Gough, *Topography*, 1780, pp. 317, 418–19.

much to say that from his time dates the gradual ascendancy of English engravers over their French masters which towards the end of the century and well into the next gave them an international reputation second to none. Though no proof impressions have survived to bear this out, it appears to have been Taylor's usual practice, in accordance with the technique which Le Bas passed on to a whole generation of pupils both French and English, to etch lightly an outline of his backgrounds before finishing his plates with the graver. It is, however, the straight line, only occasionally broken up into fine dots, which prevails in the general effect, and indeed the strictly formal quality of line engraving seems well fitted for representation of the stately postures and ceremonious occasions of the Georgian era from which Taylor by preference took his subjects when he came to design his own illustrations, instead of working after the drawings of others such as Hayman and Wale.

As a draughtsman and designer, Taylor was entirely self-taught. There is a story that in his early days at Worcester he saw and studied drawings by Marcellus Laroon, and even personally met this amusing, self-willed painter, but no reason whatever to think that he was instructed or influenced by him. The demand for representations of scenes from fashionable life which arose inevitably out of his dependence on booksellers' and publishers' commissions unfortunately gave him little opportunity for exercising what now looks like having been his finest gift, landscape drawing. There is preserved, at Colchester Museum, the only known copy of a little volume of drawing lessons produced and published by Taylor which is entirely devoted to studies of various trees, drawn with great charm and freedom. In the books of the period illustrated by Taylor there is only one plate which can be described as pure landscape, an enchanting pastoral scene of a mill overshadowed by a spreading tree, with cattle fording the stream and a bridge leading to thatched cottages beyond. This frontispiece to Cunningham's Poems, Chiefly Pastoral—'a foretaste', Mr Iolo Williams has called it, 'of what was to be painted at Flatford Mill'— so pleased Thomas Bewick that he described it as 'the best thing that ever was done'.

Surprisingly this plate, which today seems to stand out as Taylor's masterpiece, was not among the three or four dozen engravings exhibited between 1765 and 1780 at the annual shows of the Incorporated Society of Artists, of which he eventually became Secretary. Its superiority to the somewhat stilted figures of many of his narrative pictures, with their occasional trend towards the lachrymose or melodramatic which is noticeable, for instance, in the seven frontispieces to Sir Charles Grandison, justifies Bewick's regret that his friend Taylor, whom he had come to regard as an incorrigible townsman, 'attended too much to fashions and the change of mode'. It is indeed true that, if Taylor was ever sensitive to the less pleasant aspects of eighteenth-century city life, to the evil abuses which aroused Hogarth's cruel satire, he never allowed a hint of it to enter his illustrative work. True to the spirit of the novels and the poems which he was usually set to embellish, he did not look far beneath the surface of the embroidered coats and elegant manners of Georgian society; he accepted with perfect equanimity the conventions of his day and hardly allowed himself a smile whatever the absurdities of fashion which, in the seventies, reached almost unprecedented heights.

Yet this unsophisticated acceptance of his own age and his faithful attention to every detail of dress and posture, furniture and setting is a gain in so far as it gives authenticity to his picture of the manners of a bygone age in his illustrations for Brooke's Fool of Quality, Richardson's Grandison, Renwick's Genuine Distresses or McKenzie's Man of Feeling, and in the series of frontispieces which he did for Bickerstaffe's operas and musical entertainments. It is, moreover, a life, if remote, by no means unreal, and his figures, too, have substance and stand firmly on their feet.

The fact that they were taken directly from the contemporary stage gives special importance to the engravings which Taylor did for the collection of modern plays assembled under the title The New English Theatre in 1776–7. Some of these plates, which show leading actors of the time in their parts, are expressly signed 'I. Taylor ad vivum delineavit'. If they are not always reliable as representations of stage decor, because more often than not the background seems to have been added as an afterthought as the fancy took the draughtsman, there is no doubt that costume and pose of the actors are exactly represented as they were seen on the stage.

Of Taylor's small title-vignettes and fleurons, which became for a time so regular a feature of the title-page of quarto editions of poems, it is less easy

to speak with enthusiasm. Their allegorical figures and allusions can easily appear repetitive and only vaguely relevant. Even these plates, however, whether done from his own designs or after drawings by Samuel Wale, W. Hamilton and others, are distinguished by technical excellence, for Taylor was at his very best working on a small scale, and at least one of his engraved title-pages, for *Daphne and Amintor*, with its cherubs surrounded by a festoon of roses, belongs to the prettiest things of the kind done in the rococo style in this country.

Another of Taylor's activities was the production of books of architectural ornaments, with the architect, N. Wallis.[1] These were published by I. Taylor in Holborn near Chancery Lane (*Ornaments in the Palmyrene Taste* 1771, *The Carpenters Treasure; A Collection of Designs for Temples . . . in the Chinese Taste*, 1773, etc.). From 1775 J. Taylor's name is sometimes added to that of Isaac, presumably his brother James, though later Isaac's son, Josiah (1761–1834), took up the publishing business.

Constant application to the copperplate may have ruined Taylor's eyesight while he was still a comparatively young man. That theory, in any case, would account for the fact that he did not exhibit any engravings after 1780, the year in which he is supposed to have retired to Edmonton, and that there are no books with original illustrations by him published after 1781. By this time Isaac Taylor the Elder had become a fairly prosperous man, and when he died, more than twenty-five years later, he left besides a small collection of prints and his 'working tools belonging to the business of an engraver' an estate valued for probate at the not inconsiderable sum of £3,500. The engraver's establishment which he had set up in Holborn was carried on, for a while, by his brother James, his sons and other pupils trained by him. According to an obituarist in the *Literary Panorama* of 1808, Taylor's reputation as a book illustrator stood very high and his influence was still felt at the time of his death, for, says the chronicler, 'no less than five artists of this family have been and are engravers, and there are others rising up to continue the profession, with no diminution of skill and reputation.' Some of Isaac Taylor's

descendants, especially his sons Charles and Isaac the Younger, better known as Taylor of Ongar (whose work is often confused with his, as in the *DNB*), deserve in their own right a place among the leading illustrators of their time.

H. A. Hammelmann, *Book Collector*, I. 1952, pp. 14–27; and *CL*, CXII, 1950, p. 1877. The *Literary Panorama*, Jan. 1808, has an article 'Recollection of circumstances connected with the art of engraving, chiefly that branch of it which is directed to the embellishment of books', which gives considerable biographical information about Taylor.

1764 Morell, *The Tales of the Genii* [see under Walker]. 2 pls.

1764 [John Langhorne], *The Letters that passed between Theodosius and Constantia.* 8vo. 'T. Becket and P. A. De Hondt.' Front. 2nd ed. Frequently reprinted.

1765 [John Langhorne], *The Correspondence of Theodosius and Constantia.* 12mo. 'T. Becket.' Front. Frequently reprinted.

1765 O. Goldsmith, *Essays.* 12mo. 'For W. Griffin.' Title-vig. 2nd ed. 1766.

1766 *The Chimney-Piece-Maker's Daily Assistant, or, a Treasury of new designs for chimney-pieces . . . The whole neatly engraved on fifty-four copper-plates, from the original drawings of Thomas Malton, John Crunden and Placido Columbani.* 8vo. 'For Henry Webley.' Front. des. Isaac Taylor, eng. R. Pranker. The first of Taylor's numerous carpentry pattern books.

1765 M. Wentworth, *The Court Miscellany; or, Lady's New Magazine . . . By Matilda Wentworth, of Piccadilly and others.* 8vo. 'For Richardson and Urquhart at the Royal Exchange.' Vol. I front.

1766 John Cunningham, *Poems, chiefly Pastoral.* 8vo. 'Newcastle, by T. Slack for the Author.' Front. (Plate 26.) Occurs also with London imprint.

1766 John Langhorne, *The Poetical Works.* 2 vols. 12mo. 'For T. Becket and de Hondt.' Front.: the poet crowned by the muses.

1766 [Isaac Bickerstaffe], *Daphne and Amintor. A comic opera.* 8vo. 'For Newbery, Griffin' et al. Front. and title-vig. A new ed.

1767 [Isaac Bickerstaffe], *Love in a Village; a comic opera.* 8vo. 'For Newbery' et al. Front. A new ed. Reprinted 1776.

[1] H. M. Colvin, *Biographical Dictionary of English Architects*, 1954, gives no details of Wallis beyond the names of the publications. The Pierpont Morgan Library has eight of these volumes.

1767 [Isaac Bickerstaffe], *The Maid of the Mill; a comic opera*. 8vo. 'For Newbery' et al. Front. and title-vig. A new ed.

n.d. (*c.* 1767) [Isaac Bickerstaffe], *The Padlock; a comic opera*. 8vo. Title-vig. A new ed.

1767 Metastasio, *The Works . . . translated from the Italian by John Hoole*. 2 vols. 12mo. T. Davies. 2 title-pieces and 6 vigs.

n.d. (probably 1768) Hugh Kelly, *False Delicacy: a comedy*. 8vo. 'For R. Baldwin, W. Johnston and T. Harrison.' Front. and title-vig. The 1st ed. 1768 had no illustration; Taylor exhibited the front. at the Society of Artists in 1768.

1769 [John Ogilvie, D.D.], *Paradise; a poem*. 4to. 'For George Pearch, No. 12 Cheapside.' Oblong title-vig.

n.d. (*c.* 1769) [Isaac Bickerstaffe], *Thomas and Sally; or, the Sailor's return. A musical entertainment*. 8vo. 'For Griffin' et al. Title-vig.

1769 *The Rules and Regulations of the Magdalen-Charity*. 12mo. 'By W. Faden for the Charity.' Front. [unsigned but probably by I. Taylor]. 4th ed.

1770 Oliver Goldsmith, *The Deserted Village, a poem*. 4to. 'For W. Griffin, at Garrick's Head, in Catherine-street, Strand.' Title-vig.: 'The sad historian of the pensive plain'. Frequently reprinted.

1770 [Francis Gentleman], *The Dramatic Censor; or Critical Companion*. 2 vols. 8vo. 'Bell and Etherington.' 2 fronts.; that to Vol. I 'O'erstep not the Modesty'.

1770 John Crunden, *Convenient and Ornamental Architecture, consisting of original designs for farmhouse . . . and . . . villa, . . . The whole elegantly engraved on seventy copper-plates by Isaac Taylor*. 4to. 'For the Author and A. Webley.'

1771 [William Mickle], *The Concubine, a poem*. 4to. 'For G. Pearch.' Title-vig. 3rd ed. and again in 4th ed. 1772.

1771 William Renwick, *The Genuine Distresses of Damon and Celia (a novel), in letters*. 2 vols. 12mo. 'Bath, for the author.' Front.

1771 [Kane O'Hara], *Midas, an English Burletta*. 8vo. 'For T. Lowndes' et al. Front. For another ed. in 1767 see under Wale.

1771 H. Pye, *Poems. By a Lady*. 8vo. 'For J. Walker.' Square title-vig.

1771 [Edmund Cartwright], *Armine and Elvira. A legendary tale*. 4to. 'For J. Murray.' Oblong title-vig. Frequently reprinted.

1772 [Daniel Bellamy], *The Economy of Beauty* [see under Wale]. 1 half-page vig.

1772 Arthur Murphy, *The Grecian Daughter*. 8vo. 'For W. Griffin.' Title-vig. A new ed.

1773 Arthur Murphy, *Alzuma; a tragedy*. 8vo. Front. 3rd. ed., not in 1st or 2nd eds.

1773 Thomas Mawe, *Every Man his own Gardener*. 12mo. 'For W. Griffin.' Front.: gardeners at work.
The impression of the pl. with the 6th ed. is very worn, so that it was probably used already for an earlier ed. The B.M. copy of the first ed., 1767, does not contain the front.

1773 [Henry Mackenzie], *The Man of Feeling*. 12mo. 'For Strahan and Cadell.' Front.

1774 *Bell's Edition of Shakespeare's Plays*: [see under Edwards] *Othello*. 1 pl. des. and eng. Taylor. (Plate 27.) Drawing in Huntington Library.

1774 O. Goldsmith, *An History of the Earth and Animated Nature*. 8 vols. 8vo. J. Nourse. Many pls. by I. Taylor and E. Martin.
Elias Martin, *c.* 1740–1804, a Swedish artist resident in England 1769–80.

1774 A. Portal, *Nuptial Elegies*. 4to. Oval title-vig.

1775 Robert Jephson, *Braganza; a tragedy. A new edition corrected by the author*. 8vo. 'For T. Evans' et al. Oblong title-vig.

1775 *The History of Mademoiselle de Beleau; or, the New Roxana, the fortunate mistress: afterwards Countess of Wintselsheim. Published by Mr. Daniel De Foe*. 12mo. 'For the Editor and sold by F. Noble and T. Lowndes.' Front. s. 'I. Taylor f.'

1775 Pearch, *A Collection of Poems in four volumes by several hands*. Half-page pl. to each vol.

1775 *War, an Ode*. 4to. Title-vig. 2nd ed.

1776 Alexander Pope, *Additions to the Works of Alexander Pope, Esq. Together with many original poems and letters of cotemporary [sic] writers, never before published*. 2 vols. 8vo. 'For H. Baldwin' et al. Identical vigs. on each title.

1776 [Mrs. Hannah Cowley], *The Runaway, a comedy*. 8vo. 'For I Dodsley' et al. Oblong title-vig.

1776 *The Holy Bible containing the Old Testament and the New. With notes.* 12mo. 'For J. W. Pasham.' Title-piece s. 'Is. Taylor f.'

1776 *The Guide to Domestic Happiness. In a series of Letters.* Sm. 8vo. 'For J. Buckland.' Title-vig. Another ed. 1777.

1776 H. Brooke, *The Fool of Quality, . . . A new edition, greatly altered and improved.* 4 vols. 12mo. 'For Edward Johnston.' 4 fronts. eng. by I. Taylor, the first 2 after H. Brooke, a nephew of the author, the other 2 from his own designs.

1776/7 *The new English Theatre in eight volumes* [later extended to 12], *containing the most valuable plays which have been acted on the London stage.* 8vo. 'For Rivington' and many others. General front. eng. T. Hall, title-fleuron to Vol. II des. and eng. by I. Taylor and 10 (out of a total of 60) pls. des. by him, 2 of them eng. by himself and 1 by his brother James Taylor; the remainder of the pls. by Dodd, Edwards and others. 2 of Taylor's original drawings for this work, both representing Garrick, are in the B.M.

1777 John Cosens, *The Economy of Beauty; in a series of fables.* 2 books in 1 vol. 4to. 'For J. Walter.' 19 of the 22 vigs. in this vol. are copied from the famous 1719 Paris ed. of La Motte's *Fables*, 10 of them from Gillot's pls. and 9 from his collaborators, newly eng. by G. Bickham, jnr. and W. Faden, but 3 vigs. are new designs by I. Taylor and eng. by himself.

1777 John Ogilvie, *Rona, a poem . . . illustrated with . . . elegant engravings.* 4to. 'For J. Murray.' 7 oval pls. by Isaac Taylor (2), Caldwall after W. Hamilton (4) and 1 s. 'T. Cook sc.'

1777 A. Cowley, *Select Works, Dramatic and Poetical.* 8vo. 'For T. Sherlock' et al. Vol. III. title-vig.

1777–84 Thomas Evans, ed., *Old Ballads, Historical and Narrative . . .* 4 vols. 12mo. 'For T. Evans.' Title-vig. 2nd ed. 1784.

1778 John Langhorne, *Owen of Carron: a poem.* 4to. 'C. & E. Dilley.' Title-vig.

1778–88 E. Chambers, *Cyclopaedia, or an Universal dictionary of arts and sciences . . .* The numerous technical pls. for this big work were executed at I. Taylor's 'establishment' at 306 High Holborn; though all are signed 'I. Taylor sc.', they may have been eng. by his sons and apprentices.

1779 *A collection and selection of English Prologues and epilogues.* 8vo. 'For Fielding and Walker.' Front.

1780 Rev. Henry Bate, *The Flitch of Bacon; a comic opera, in two acts.* 8vo. 'For T. Evans.' Title-vig.: Cupid shooting arrows at an actor's mask. A new ed.

1781 A. B. Portal, *Poems.* 8vo. 'Printed for the Author.' Oval title-vig.

1781 S. Richardson, *The History of Sir Charles Grandison.* 7 vols. 12mo. 'For W. Strahan' and many others. 7 fronts.; these were exhibited at the Society of Artists in 1778. 7th ed. There is another so-called 7th ed. of 1778, which does not contain the pls.

1781 *The Works of the Marchioness de Lambert. A new edition from the French.* 2 vols. 12mo. 'For W. Owen.' 2 oblong title-vigs.

This list contains, with one or two exceptions, only illustrations of which Isaac Taylor the Elder was the designer as well as the engraver. There are quite a number of works for which Taylor engraved after the designs of others, including: Smollett's *Don Quixote*, 4 vols., 12mo, 1761 (reductions from Hayman's plates for the 4to ed. of 1755; apprentice work signed 'G. V. Neist'); Addison's *Miscellaneous Works*, 4 vols., 8vo, 1765 (reductions of Hayman's plates for the Baskerville ed. of 1761); Richardson's *Clarissa Harlowe*, 6th ed., 8 vols., 12mo, 1768, and *The Newgate Calendar*, 5 vols., 1773 (both after Samuel Wale); Rousseau's *Eloisa*, 4 vols., 12mo, 1776 (after Gravelot's plates for the French edition of 1761); and John Howard's *State of the Prisons*, 4to, 1777. In addition, Isaac Taylor the Elder engraved numerous plates for the periodicals of the time, such as the *Gentleman's Magazine*, the *Lady's Magazine* and the *Westminster Magazine*; many of these illustrations were copied from contemporary French books, but there is almost certainly original work by Taylor to be found there. In the publications of the 1780s and 1790s many plates are signed 'Taylor sc.', with no clear indication as to which member of the family was involved.

Isaac TAYLOR the younger, 1759–1829
He was trained in his father Isaac's studio. He was later employed by Boydell. His most independent work was *Specimens of Gothic Ornament from the*

Parish Church of Lavenham in Suffolk, 1796, 4to with forty plates. Later, as the demand for engraving fell during the Napoleonic war, he became a non-conformist pastor, first at Colchester and then at Ongar in Essex. He wrote several educational manuals and books for children, and in the 1820s published a series of popular topographical works, with engravings mainly from his own designs, but aided by his son, another Isaac.

The Taylor family is treated at some length in the *DNB*. In 1895 Henry Taylor of Tunbridge Wells published a very detailed *Pedigree of the Taylors of Ongar*.

James TAYLOR, 1745–97
The younger brother of Isaac, he came to London about 1770 to work for him. Previously he had been employed as a china painter in the porcelain works at Worcester. His son James, who was for a time a singer at Vauxhall Gardens, worked also as an engraver.

1777 William Julius Mickle, *Sir Martyn, a poem, in the manner of Spencer.* 4to. 'For Flexner, Evans and Bew.' Oblong vig.: nymph in a landscape, s. 'J. Taylor del C. Grignion sculpt.'

1775 *Love Tales and Elegies; interspersed with pastorals and other poems, selected from the best authors.* 8vo. 'For J. Wenham.' Oblong title-vig.

1782 L. M. Stretch, *The Beauties of History.* 2 vols. 4to. 'For Dilly.' Front. J. Taylor 'del et sculpsit.' 5th ed.

Sir James THORNHILL, 1676–1734
The celebrated history painter opened a private academy in his own house in 1724, and through his daughter's marriage with Hogarth had some contact with engravers.

1717 *The Holy Bible.* Folio. 'By John Baskett for the University Press.' Front. to Old Testament; headpieces to Genesis, Leviticus and Joshua; tailpiece to Malachi.
 The extra-illustrated 'Kitto Bible' in the Huntington Library, a massive compilation of 60 vols., has 91 pen and wash sketches by Thornhill of New Testament subjects, and 1 from the Apocrypha of Susannah and the Elders. None of these seems to have been engraved. See C. H. Collins Baker, *Huntington Library Quarterly* X, 1946–7.

1720 John Milton, *Poetical Works* [see under

Cheron]. 1 pl. after Thornhill, eng. G. van der Gucht.

1720 Josiah Burchett, *A Complete History of the Most Remarkable Transactions at Sea.* Folio. 'For J. Walthoe.' Allegorical front.: Neptune, eng. G. van der Gucht.

1721 Joseph Addison, *The Works.* 4 vols. 4to. 'For Jacob Tonson.' 7 headpieces eng. G. van der Gucht.

1758 *Plutarch's Lives in six volumes . . . to which is prefixt the life of Plutarch (by John Dryden).* 8vo. 'For J. and R. Tonson.' Front. after a painting by Thornhill, eng. J. Miller.

John THURSTON, 1774–1822
He was trained as a copperplate engraver under James Heath, but later worked in wood-engraving. Much of his best work was done after 1800. His largest commission before 1800 was for E. Harding's *Shakespeare*.

1796 *Cooke's Pocket Edition of English Poets*: [see under Corbould] *Matthew Prior.* 6; *Addison.* 1; *Warton.* 1; *Savage.* 2; *Mickle.* 1; *Somerville.* 1; eng. Armstrong, Raimbach, Rhodes and Warren.

1798–1800 *The Plays of William Shakespeare.* 12 vols. 12mo. 'For E. Harding,' et al. 45 pls.

1798 [E. A. Kendall], *Keeper's Travels in search of his Master.* 12mo. Front. eng. Daudley.

Peter TILLEMANS, 1684–1734
Born at Antwerp, he came to England in 1708, and made his name as a painter of country mansions. He made nearly 500 drawings for Bridge's *History of Northamptonshire*, for which he was paid one guinea a day while residing in Bridge's house and employed on the work.

1729 *Select Collections of Novels* [see under Vanderbank]. 1 pl. eng. G. van der Gucht.

Henry TRESHAM, ?1749–1814
He was born in Dublin and came to London in 1775. He then travelled with Lord Cawdor and the landscape sketches made on his journeys are the most attractive side of his work. These, however, were till comparatively recently in the Cawdor collection and little known. His contemporary repute was as a history painter, and he became A.R.A. in 1791, R.A. in 1799 and Professor of Painting in 1807. He contributed three paintings to the Boydell Gallery.

1792 *Bell's British Theatre*: [see under Fuseli] *The Roman Father*. 1 pl. eng. A. Smith.

John VANDERBANK, 1694–1739

John Vanderbank's contribution to book illustration was not extensive nor has it attracted much attention. This artist has been known until recently almost exclusively as a portrait painter, where his extensive practice spanned the gap between Lely and Kneller on the one hand and Reynolds on the other. Yet, as his numerous drawings show, there was another side to him which, throughout his life, again and again tried to break away from the prevailing fashion for 'face-painting'. Given Vanderbank's uneasy and restless temperament and his early death, it is possible that most of those swift and spirited sketches were never used for full-fledged paintings or the decorative schemes for which they seem intended; certain it is that hardly any historical paintings of his have survived or at least been identified so far. It is in his book illustration that his achievement can best be judged.

There was indeed, until fairly recently, considerable doubt even about the main dates of Vanderbank's life and about his parentage. The writer of the entry in the *DNB*, for instance, following Dallaway and others, considered him the son of the engraver Peter Vanderbank (or Vandrebanc) who came to this country from Paris *c.* 1674 as a fully-trained practitioner and soon established himself as a prolific, if rather dry, portrait engraver.[1] Despite early royal patronage, Peter Vanderbank died in straitened circumstances (in 1697), leaving three sons, James, Charles and William, of whom little is known.[2] It is now established that John, the subject of this article, was born as the elder son of the tapestry weaver of the same name on 9 September 1694,[3] presumably in Great Queen Street where his father carried on business as the head of the Soho Tapestry Manufactory. No link of any kind between the two families has so far been discovered.

John Vanderbank senior, by virtue of his lucrative office of chief tapestry weaver to the Crown, was a prosperous craftsman and deservedly so to

judge by such work of his as can still be identified.[4] When he died in 1717, he was able to leave his three children (a married daughter, Elisabeth, and another son, Moses) £500 each in cash, while his widow, Sarah, was left in very comfortable circumstances with the remainder of the estate which included, besides the freehold of the house and workshop in Great Queen Street, a farm, cottages and land in Hertfordshire.[5] It is from his father that John junior may well have received his early instruction in drawing; from 1711 he is known to have been an original member of Kneller's Academy near by and he may also possibly have been, as Dodd suggests, a pupil of Richardson's. By October 1720, in any case, he seems to have had assurance enough to set up, with Louis Cheron, life classes of his own in St. Martin's Lane which were attended by many of the most promising younger artists of the time, Hogarth, Highmore and Dandridge included. To all appearance Vanderbank, though among the youngest of the group, was its leading member, as well as the wealthiest, for his contribution to the running costs of the school was several times the subscription of two guineas paid by the other participants.[6]

Vanderbank's well-to-do background—a rare thing among professional artists of this time, or indeed almost throughout the century—had an unfortunate effect on him, for it led him from the outset to adopt a style of life more suited to a young gentleman-about-town than to a professional painter with his way still to make. Vertue, who calls him 'of all men born in this nation superior in skill', complains of his extravagance and 'high living' in keeping coaches and horses 'in town and country' and of his style of dress, but even making allowances for Vertue's rather supercilious attitude towards some of his colleagues, the fact remains that John Vanderbank was for most of his life more in debt than out of it. This is all the more surprising since he received commissions freely from the nobility and gentry both English and Scots, and at least from 1719 onwards must have been in successful practice as a portrait painter. His portrait of Isaac Newton, painted within twelve months of the scientist's death, is also the first work of his I have discovered within the covers of a book, the splendid third edition of the

[1] First in Princes Street, near Leicester Fields, then in Dean Street, Soho. In Paris he had been employed on the French edition of Vitruvius along with Scotin, Grignion and others.
[2] Will of James Forester, their uncle, proved 1696; copy in Hertfordshire County Record Office.
[3] Parish Register, St. Giles in the Fields, baptized there ten days later.

[4] W. G. Thomson, *Tapestry Weaving in England*, 1915, pp. 139–47. He also sometimes signed 'Vandrebanc'.
[5] Will dated 21 April 1716; P.C.C. 1717 Whitfield 163.
[6] Vertue, *Notebooks*, VI, 170.

Principia of 1726. It is engraved there by Vertue, although there is in the British Museum an etching of the picture (in two different states) by the painter himself undertaken as an 'essay',[1] his only known attempt to transfer his own work to the copperplate.

Vanderbank's financial situation, even while he was still living in his mother's house, had meanwhile deteriorated to such an extent that he was obliged 'to go out of England to France' in May 1724 to avoid being thrown into a debtors' prison.[2] He returned again within five or six months, married now to a former actress,[3] but with his finances in no way improved, for according to the *Daily Post*[4] he was obliged to avail himself of the privilege of debtors to live outside the prison within the liberties of the Fleet and took the house of the late Dr. Cade (who had been physician to St. Bartholomew's until his death in 1720) in the Old Bailey. In and around the debtors' prison Vanderbank seems to have continued for the next few years, to judge from a report in the *London Gazette* (31.5.1729) that he was thrown this time into the Marshalsea prison for debt, and it was not until the complete disposal of his mother's estate that the crushing burden of debt seems to have been removed from him, at least for the time being.

Mrs. Sarah Vanderbank had died towards the end of 1727 and according to her will dated 25 September 1727[5] had left everything to her son Moses, presumably in order to avoid action by her elder son's creditors. The most valuable part of her estate was her deceased husband's workshop in Great Queen Street and his office of Yeoman Arras Worker to the Wardrobe, from which she had drawn a regular income until her death.[6] This was duly sold in or around 1729 to the painter John Ellys,[7] and there is little doubt that Moses applied the proceeds fairly and helped to discharge his elder brother for, again according to the *Daily Post*, John was at last

able to leave the liberties at the end of that year and move to Holles Street near Cavendish Square, then a new and elegant part of London, adjoining the countryside. Of Moses's subsequent career as an artist little is known except an altar-piece in Yorkshire[8] and the stray and undistinguished book illustration mentioned at the end of the following list of publications. Vertue calls him even more profligate than his brother, and he was in fact declared bankrupt in March 1734.

During the period of his enforced residence within the liberties appeared one of the earliest as well as most interesting and spectacular books with plates from designs by John Vanderbank, the *Twenty Five Actions of the Manage Horse*, a quarto volume dealing with the training of horses engraved and sold by Josephus Sympson. Sympson senior, who has received some attention of late as the originator of certain spurious Hogarth prints,[9] had attended, together with his son, Vanderbank's Academy;[10] it is therefore quite possible that, in addition to being engraver and part-publisher of the plates, he also composed from personal knowledge the highly laudatory introduction to the volume. There, after a reference to the inadequacy of earlier figures in treatises on horsemanship which fell short either with regard to the action of the horse or to the design, it is said: 'These of the celebrated Artist Mr. J. Vanderbanck, seem to partake of both; who, the better to execute his Ideas, was himself a Disciple in our Riding-Schools, and purchased a fine Horse as a Model for his Pencil: And tho' done in his younger Years, before he arriv'd to his present Perfection, yet they discover his Genius; having both such Justness of Design, and true Grace and Spirit in the Expression, that shews that he can, if he pleases, excel all that have attempted such Performances.'

Sympson's rather crude engravings in the volume do little to justify this eulogy, but comparison with the one original drawing for the work so far available, a rather rapid sketch with pen and grey wash which the engraver did not, apparently, bother to follow very carefully, gives a more favourable impression of Vanderbank's skill in this field. This drawing is in turn related to an oil-painting of the same subject,[11] and indeed there is evidence that, even after the appearance of the

[1] P 8.218, inscribed (possibly by Vanderbank himself) 'Stilograph'; and 1927–10–8–367.
[2] Vertue, III, 20. Perhaps he had been hit, like Kneller, by the collapse of the South Sea Bubble.
[3] In the Bellingham Smith sale (Sotheby, 13.7.1927) there was a black and red chalk drawing (no. 116) described as 'the artist's wife'; a possibly related painting, dated 1731, appeared in the Burton sale (Christie, 4.5.1951, No. 28).
[4] 12 November 1724, in Buckley MSS (V. & A. Library).
[5] P.C.C. 1727 Farrant 310.
[6] cp. also Marillier, *English Tapestries of the 18th Century*, 1930, xvii.
[7] Vertue, III, 38, Ellys (1700/1–c. 1757) was for a time a pupil of Vanderbank the painter.

[8] Croft-Murray, *Decorative Painting in England*, II, p. 260.
[9] Paulson, *Hogarth's Graphic Works*, I, 309ff.
[10] Vertue, VI, 170.
[11] Both in the collection of Mr. Ralph Edwards.

volume, horsemanship and horsemen engaged the artist on a number of occasions.[1]

Horses also figure prominently in one of the eleven illustrations which Vanderbank contributed to the second edition of Croxall's *Select Collection of Novels* which appeared in the same year, 1729. These six volumes are important not only for containing the first publication in English of a number of major novels from the French, Italian and Spanish, but also for the fact that they include, among the thirty-six scenes illustrated, work by Highmore, Monamy, Cheron and Tillemans. Vanderbank's contribution is not perhaps particularly distinguished, but it is interesting to note that several of his designs were for the shorter tales and novels of Cervantes which the editor in his preface describes as 'the richest Jewel' of his collection.

It is a sign of the remarkable vogue which Cervantes enjoyed in England in the early half of the eighteenth century that he is introduced, too, into Highmore's frontispiece to Croxall's *Collection*, where a kneeling knight presents Apollo with a book clearly inscribed 'Don Quixote'. It is therefore not altogether surprising that this work should have been the first novel to appear in a richly illustrated and truly sumptuous edition in London, though one would hardly expect it to have done so in the original Spanish. Not all aspects of this great enterprise, which marks a significant point in the development of book illustration in this country, are yet completely clear, but it is said to have originated with Queen Caroline, presumably while still Princess of Wales, complaining to Lord Carteret that she could find no edition of the work worthy of her library. Carteret (later first Earl Granville, 1690–1763) was not only a classical scholar, but distinguished also as a linguist and close to the royal family on account of his knowledge of German. In 1725, we find a cheap London publication of *Don Quixote* in monthly parts, which gives the Spanish and English text in parallel columns and is dedicated to Carteret, then Lord Lieutenant of Ireland, as 'so exact a Critick in the Elegancy of the Spanish Language . . . few Spaniards can so well account for their own Tongue'. This modest venture may never have been completed, but there is reason to think that by this time Carteret and the publisher Tonson had already resolved upon the new big edition, although it did not reach publication until 1738.

Early in the 1720s, Jacob Tonson, having completed his splendid series of large illustrated editions of the classics, began to bring out a number of foreign works in the original language, most notably a *Racine* (with illustrations by Louis Cheron, 1723) and Tasso's *Gerusalemme Liberata* (with the original illustrations of 1590 re-engraved, 1724), each finely printed in two quarto volumes. It seems natural to assume that the vernacular edition of *Don Quixote* was planned around the same time as the Spanish counterpart to these famous French and Italian works, and this appears to be borne out by the fact that the very first illustration to the novel proper, which represents Don Quixote in his library, is clearly signed by the engraver George Vertue '1723'.[2]

What delayed publication of the work for so many years is not entirely clear. One important reason must have been Carteret's wish to add a full life of the author, which was not available at that time in any language. This was eventually obtained, possibly through the good offices of Count Montijo, Spanish Minister in London from 1732 to 1735, from the Librarian to the King of Spain, Don Gregorio Mayans y Siscar.[3] A portrait of Cervantes proved altogether impossible to find, though an imaginary likeness designed by William Kent was in the end inserted. Another possible reason for delay was the retirement of Jacob Tonson Senior around 1730, and yet another change in the firm upon the death of his nephew in 1735, for Lord Carteret, though patron of the enterprise, was not of course alone responsible for the cost of the four large volumes.[4] As editor he did, however, assume responsibility not only for the text, but also for the numerous illustrations which were to embellish the work. There were eventually no fewer than sixty-eight full-page plates, but although in the published version all are designed by

[1] E.g. drawings in Witt collection 1547 and BM 1856-8-15-80-85, both dated 1730.

[2] The date is also found on the preliminary wash drawing by Vanderbank which recently turned up in London under the surprising title 'King Charles I in his study'. Another, more finished version in the Witt collection (3118), differing in detail, is also dated 1723.

[3] Carteret's letters of 26.3.37 and 24.8.37 (O.S.) in *Private Correspondence of Sir Benjamin Keene*, (ed. Lodge), Cambridge 1933.

[4] Carteret himself writes, in another letter to Keene of 20 April 1738, (*Correspondence*, p. 11) that the outlay to Tonson had been 'above £1200 sterling, but as he has a great estate, he can undertake expensive work, and run the hazard of the sale, which no other publisher would have done . . .' The cost of engraving Vanderbank's designs is presumably included in this figure.

Vanderbank and engraved, with a few exceptions, by Gerard van der Gucht, originally William Hogarth also was to have had a share in the enterprise. He executed, in fact, six (undated) drawings and even engraved them, but 'his performances', say Nichols and Steevens[1] 'gave so little satisfaction to his noble employers, that they were paid for and laid aside in favour of Vanderbank's designs'. However that may have been, it can hardly have been the choice of subject for the individual prints which settled the issue, since this does not appear to have been left to the sole discretion of the artists. Hogarth, in fact, drew (with one exception) the same scenes as Vanderbank and this fits in with what is said in the 'Advertisement concerning the Prints' by Dr. John Oldfield, which discusses the scenes most suitable for illustration and defends those chosen for inclusion.[2]

Oldfield's essay, which covers eight closely printed pages and was reprinted in subsequent English editions containing Vanderbank's designs, is altogether a significant document for eighteenth-century illustration and, since he writes in the plural, may well be the result of discussion with the artists:

'Though prints to books are generally considered as mere embellishments, and are, for the most part, so ordered as to appear of little more consequence than the other ornaments of binding and gilding . . ., they are however capable of answering a higher purpose, by representing and illustrating many things which cannot be so perfectly expressed by words . . . For this reason, an incident that is in itself of no great consequence, and that makes no great figure in the book, by giving occasion for some serious and entertaining expression, may better deserve to be taken notice of in this way, than many of the more material and formal occurrences, which do not so well admit of being drawn or, if they do, yield little or no additional pleasure to that of the written account . . .'

Coypel's famous French series is criticized as offending against this principle; and in fact neither Vanderbank's nor Hogarth's designs owe anything much to the French prints, well known though these must have been in this country.[3] In his sixty-

eight designs, Vanderbank did indeed succeed in producing, with his few, rather large figures, often in rural, somewhat English settings, vigorous human beings who fulfilled the demand for interesting, varied and life-like characterization—so much so indeed that his plates at once came in for grave criticism from a Dutch editor, J. C. Weyerman, for representing 'nothing but English attitudes and customs instead of Spanish ones'.[4] In this country Vanderbank's designs must have been highly successful; they served for at least five subsequent editions of Cervantes's novel in the translation of Charles Jarvis and were by no means superseded even by Hayman's more 'modern' effort some twenty-five years later.

Since not all book illustrations derived from John Vanderbank's drawings or paintings are signed, the list of works so far identified is certainly incomplete. Thus it is only due to the recent rediscovery, in a private collection, of the ten important paintings depicting the life of Charles I (by Cheron, Angelis, Parrocel and others) that his (admittedly minor) share in one of the earliest series of subjects from English history painted and engraved in this country has been confirmed. There is reason to think that Vanderbank was laid under contribution for several of the attractive headpieces in Bickham's *Musical Entertainer* 1737/38; certain of his drawings, like the one from Windsor[5] and others for biblical subjects,[6] also look as if they might have been intended for illustration. Even so, it is unlikely that the list of books with illustrations by him is ever going to be very extensive. With the exception of his *Don Quixote* subjects, which he exploited in various ways to satisfy creditors,[7] this kind of work for the

[1] *Genuine Works of William Hogarth*, 1810, II pp. 302–4.
[2] Dr. John Oldfield (1690–1748) was an M.D. of both Leyden and Cambridge, and one of the first physicians to be appointed to Guy's Hospital.
[3] Thomas Skelton's translation of 1620, *The History of the Valorous and Witty Knight Errant Don Quixote*, was

reprinted in 1731 for J. Walthoe and others in 4to, 'with a Curious Sett of New Cutts, from the French of Coypel'. Vanderbank also did a set of small oil panels (16 × 11⅝″) based on his Don Quixote designs. Some are now in public collections: Tate Gallery (1), Iveagh Bequest, Marble Hill, Twickenham (2), Huntington Library (2), City Art Gallery, Manchester (1), York Art Gallery (1). See *York Art Gallery Quarterly*, XXI, 1968, pp. 763–7, and M. Butlin in *The Tate Gallery 1967–8*.

[4] Preface to the quarto edition in French, The Hague 1746, p. viii.
[5] A. P. Oppé, *British Drawings . . . at Windsor*, p. 618.
[6] E.g. in the National Gallery of Scotland RSA 385 and 433, and British Museum Fawkener 5213–13.
[7] Vertue notes (III, 98) that his landlord 'let him paint anything—what he would . . . (storys of Don Quixote) for wch he not only had house Rent, but the furniture of all goods necessary'.

booksellers, poorly paid as it generally was, can hardly have been sufficiently rewarding for an artist who enjoyed such success as a portrait painter. This success, despite the extravagance of his ways in which his wife appears to have encouraged him, increased if anything in the later part of his life, though it may in the end have suffered from the meteoric rise to popularity of Van Loo after his arrival in London in December 1737.

Not long before, Sir Thomas Prendergast had written to the Duke of Richmond '. . . I think there is no other in London who comes *so near* deserving the name of a painter'[1] as Vanderbank. The full-length portrait of Queen Caroline, which he was commissioned to paint for the Duke[2] a year before her death, proves that, when he was killed by consumption, the painter's powers had as yet by no means exhausted themselves; what seems to have been principally lacking was application. His 'loose morals', says Vertue,[3] 'blasted his reputation, yet still his superior merit in drawing, greatness in pencilling, spirit and composition, kept up to the last, in spite of the blemishes of his vanities.' As late as 1737 he had taken on, at the high premium of 150 guineas,[4] John Robinson,[5] his most gifted pupil next to Arthur Pond. Robinson, who himself died at the age of 30, appears as witness to Vanderbank's will dated 13 December 1739[6] by which the childless artist left all his possessions to his wife Anne. Everything that was found in his studio after his death ten days later is said to have been seized by his landlord in satisfaction of unpaid rent.[7]

H. A. Hammelmann, *Book Collector*, Autumn 1968, pp. 285–94. See also Hammelmann, *Master Drawings*, VII 1, 1969, pp. 3–15; *JWCI*, XXXI, 1968, pp. 448–9; *CL*, CXLI, 1967, pp. 32–3.

1729 *Twenty five actions of the Manage Horse, engraved by J. Sympson from original drawings of Mr. J[ohn] V[anderbank]; to which are added, two of the English Hunter; with the figure of a fine horse measured from the life . . . as also a draught of the true shape of the branch: with short remarks on some parts of Horsemanship.* 4to. 'Printed for and sold by J. Sympson at

the Dove in Russel-Court in Drury-Lane, and Andrew Johnston Engraver in Peter's-Court in St. Martin's-Lane.' The last 2 plates in the book are markedly inferior and Vanderbank had no hand in them. Pl. 1: 'A Spanish Horse' is s. 'J. Vanderbank pinx.' and Sympson must therefore have engraved it from a prior painting; the remaining pls. are s. 'J. VdB del [ineavit]'. An original drawing for pl. 22 is in the collection of Mr. Ralph Edwards, but the engraver has omitted a figure on the left of the drawing. The same collection contains a related oil-painting by Vanderbank. Yet another drawing related to the book may have been the 'étude d'un cavalier, vue de droit, le cheval allant au pas' in the Bellingham Smith sale, Amsterdam 1927, item 214, unsigned and there attributed to Gravelot. Its purchaser and present whereabouts are unknown.

1729 *A Select Collection of Novels and Histories, in six volumes, written by the most celebrated authors in several languages. Many of which never appear'd in English before. All new translated from the originals, by several eminent hands. The second edition, with additions. Adorn'd with cutts.* 6 vols. 12mo. 'Printed for John Watts, at the Printing Office in Wild-Court near Lincoln's-Inn-Fields.' 2 allegorical fronts. by J. Highmore, eng. G. van der Gucht, both twice repeated, and 36 pls. des. by J. VdB. (11), Highmore (10), Louis Cheron (4), G. van der Gucht (4), J. Goupy (2) and 1 each by Du Guernier, Monamy and Tillemans, as well as 2 unsigned by designer, the whole engraved by Gerard van der Gucht except 2, which are by the hand of his younger brother Jan. The first edition, 1720, contained no illustrations.

In his Preface to the second edition, the editor, S[amuel] C[roxall] writes: 'That no Embellishment suitable to a Work of this kind might be wanting, and to render it in every way agreeable to our fair Readers, the Editor has been at the Expence of a Frontispiece to Every History and Novel, taken from some remarkable Incident in each Story; which, we promise ourselves, will confirm the high Opinion the Publick so justly entertains of the Masterly Hands that performed them.'

1729–31 *The Musical Miscellany; being a Collection*

1 The Earl of March, *The Duke and his Friends*, Oxford 1911, p. 308.
2 Waterhouse, *Painting in England* (2nd ed., 1962, p. 125 and plate); still at Goodwood.
3 Vertue, III, 98.
4 Reynolds paid Hudson only £120 a few years later.
5 Genealogical Society 15/74/1737.
6 P.C.C. 1740 Browne 188. 7 Vertue, III, 98.

of Choice Songs, set to the Violin and Flute, by the most Eminent Masters.
After volume 3:
The Musical Miscellany; being a Collection of Choice Songs, and Lyrick Poems; with the Basses to each Tune, and Transpos'd for the Flute. By the most Eminent Masters. 6 vols. 8vo. 'By and for John Watts.' 2 fronts. by John Vanderbank, 1 appearing twice, the other repeated 3 times; the first engraved by Jan, the second by Gerard van der Gucht. Both designs are rather similar, showing the muse with harp and 3 other figures, of which only the angel holding up a book is substantially changed. Among the composers represented are Handel, D. and H. Purcell, Greene, Pepusch, Leveridge, Geminiani and others. The music is printed in the text and not engraved.

1729 Sir John Vanbrugh and Colley Cibber, *The Provok'd Husband; or, a Journey to London. A comedy. As it is acted at the Theatre Royal, by His Majesty's Servants.* 8vo. 'For John Watts.' Front. eng. by G. van der Gucht. 2nd ed. The 1st ed., published also in 1728, contained no illustrations. The frontispiece occurs again, obviously printed from the same pl., in 12mo eds. of 1732, 1734, 1735 (the last being part of the collected edition of Vanbrugh's plays, published with general titles in 2 vols. with the imprint of J. Tonson and J. Watts). The original drawing for this frontispiece is in the B.M.; it is unsigned and used to be attributed (largely on the strength of an obscure inscription on the back)[1] to Hogarth

1731 George Lillo, *The London Merchant: or, the history of George Barnwell.* According to the *Craftsman* of 20 Nov. 1731, a frontispiece by Vanderbank, eng. G. van der Gucht, was published with this play. It is not in any copy of the 1st or 2nd ed. (1731).

1733 *Memoirs of the Life of Barton Booth, Esq.* [the actor], *with his Character. Published by an intimate acquaintance . . . by consent of his widow.* 8vo. 'For John Watts.'
Harvard Catalogue of Engraved Portraits I. 131: portrait within oval frame on pedestal, by G. van der Gucht after John Vanderbank. Not in copy in B.M. or Bodley.

1734 John Banks, *The Albion Queens, or, The*

[1] The inscription reads: 'Mr. Hogarth will be caref[ul]'.

Death of Mary Queen of Scotland. Small 8vo. 'For W. Feales, A. Bettesworth' et al. Front. eng. G. van der Gucht.

1735 John Banks, *The Unhappy Favourite: or, the Earl of Essex. A Tragedy.* 12mo. 'For W. Feales [and 5 others].' Front.: Elizabeth on her throne rejects a petition, eng. G. van der Gucht.

1736 *Letters of Abelard and Heloise. To which is prefix'd a Particular Account of their Lives, Amours and Misfortunes: Extracted chiefly from Monsieur Bayle. Translated from the French, By the late John Hughes, Esq.; the Sixth Edition, corrected.* 12mo. 'For J. Watts; and sold by J. Osborn at the Golden Ball in Pater-Noster Row.' Front.: Abelard giving a lesson to Heloise, eng. Gerard van der Gucht. This print may have appeared already in the 5th ed.; it is still found in the '10th ed.' 1765.

1737 [William Havard], *King Charles the First: an historical tragedy. Written in imitation of shakespeare.* 8vo. 'For J. Watts.' Unsigned front.: Charles I taking leave of his family with caption, 'At this sad scene who can from tears refrain?' possibly drawn by Vanderbank, but based on the Angelis painting in the Charles I series (below). The pl., very worn, is still found in the 3rd ed., 'for T. Lowndes', 1765; again (reduced) with an ed. for W. Lowndes, 1781.

1738 Jacob Hooper, *An impartial history of the rebellion and civil wars in England during the reign of King Charles I; with the precedent passages and actions that contributed thereto and the happy end and conclusion thereof by the restoration of King Charles II.* Small folio. 'Printed and sold by all the booksellers in Town and Country.'
Equestrian portrait front. of Charles I, (poorly) eng. by James Smith after Vandyke, and 18 spirited pls. of battles and incidents in the life of the King, eng. by J. Smith, John Lightbody, Hullett and Charles Mosley, after various unnamed hands, except 1 battle-piece which is signed by Mosley as designer. The plates include rather crudely engraved, reproductions of 9 (out of the full set of 10) engravings illustrating the story of King Charles I after paintings by Louis Cheron, Charles Parrocel, Peter Tillemans, Baston,

Peter Angelis, Jean Roux and Vanderbank executed in the 1720s (Vertue VI, 191). Vanderbank's contribution is '(10) Death [or Apotheosis] of the King', adapted from the original (larger) engraving by B. Baron (at Windsor Castle), printed and sold by Thomas and John Bowles, c.1728.

1738 M. Cervantes Saavedra, *Vida y Hechos del Ingenioso Hidalgo Don Quixote de La Mancha.* 4 vols. 4to. 'En Londres, por J. y R. Tonson.' Portrait of the author, eng. Vertue after William Kent, allegorical front. and 67 pls., all des. by John Vanderbank and eng. Gerard van der Gucht, with the exception of pl. 1 (eng. Vertue), 3 (no designer's or engraver's name), 15 (Bernard Baron), 39, 43, 49 (Claude du Bosc); as well as an engraved tailpiece (Vol. I p. 62) by P[aul] F)ourdrinier] after Vanderbank. All the pls. contain volume and page numbers.

Pl. 3, 'The First Sally in Quest of Adventure', being the only unsigned 1 in the 4 vols., used to be attributed by Lowndes (p. 401) and Ashbee (*Iconography* p. 20) to Hogarth on the strength of J. Ireland (*Hogarth Illustrated* III, 301), but any possibility of his authorship of the design is completely ruled out by its presence among the original Vanderbank drawings in the B.M. For the subsequent fate of Hogarth's 6 rejected illustrations see Paulson, I, 176; they are occasionally found inserted in quarto editions of the novel, but form no part of any of them. 64 of the finished drawings, which are very close to the engraved versions and all dated 1729, are bound into a copy of a Don Quixote edition of 1818 in the Pierpoint Morgan Library (information kindly supplied by Mr. Martin Butlin). An album in the B.M. Print Room (197*d14) contains another 88 original drawings by Vanderbank for Don Quixote of which 62 are in ink and brown wash and another 24 belong to a larger set in pencil with brown and red washes and occasionally heightened with white. Most of these drawings bear dates between 1726 and 1730; the 2 sets differ substantially from each other and from the engravings in detail, but are concerned with the same scenes and moments in the narrative. The number of copies printed of this Spanish edition cannot have been large, since the same copperplates,

without apparent sign of wear, were used again in:

1742 M. Cervantes Saavedra, *The Life and Exploits o' the Ingenious Gentleman Don Quixote de La Mancha. Translated from the original Spanish . . . by Charles Jarvis.* 2 vols. 4to. 'For J. and R. Tonson in the Strand, and R. Dodsley in Pall-Mall.'

This is the 1st ed. of Jarvis's translation, with a lengthy Translator's Preface. Some (but perhaps not all) copies contain a 'Supplement to the Translator's Preface communicated by a learned writer, well known in the Literary World' who is identified (by Lowndes p. 401) as Bishop Warburton. It is inserted between sheet b and c and is marked b (4 leaves). There seem to be 2 issues of this ed., the blank m2 after *The Life* being filled with a half title, and the word *Finis* added on m1 verso. This edition contains all the 68 pls. by Vanderbank, as well as Kent's front., only vol. and page numbers being scratched out and adjusted; the tailpiece is not present. Vanderbank's illustrations were used for several further eds. of Jarvis's translation. 'Second edition carefully revised and corrected', 2 vols, 8vo, 1749, 'For J. and R. Tonson, S. Draper and R. Dodsley [badly printed]'. Contains 24 of the pls., carefully reduced by G. van der Gucht; 3 of them are reversed. 'Third edition': 2 vols. 4to, 1756, 'for J. and R. Tonson, S. Draper, R. and J. Dodsley,' contains front. and all the 69 pls. in original size. Page numbers again adjusted. 'Fourth edition': 4 vols. 12mo, 'for J. and R. Tonson, and J. Dodsley,' 1776; pls. poorly reduced. 31 (numbered) pls., including front., unsigned. 'Firth edition': 4 vols. 12mo, 'for J. Dodsley', 1788, the same as in previous eds., more worn. There was also at least 1 Irish ed. with Vanderbank's illustrations, 4 vols. 12mo, Dublin, 1747, 'for Peter Wilson'. Front.: Don Quixote in his Study, and 12 pls., eng. Philip Simms and T. Chambers. (Plate 13, 14.)

n.d. (1731) Eustace Budgell, *A Letter to Cleomenes King of Sparta . . . being an answer to his Spartan Majesty's epistle published some time since in the Daily Courant. With some account of the manners and government of the antient Greeks and Romans, and political reflections*

thereon. [A political satire.] 8vo. 'For A. Moore and sold by the Booksellers.' Allegorical front. s. 'M[oses] Vanderbank', eng. G. van der Gucht. Appears again with 2nd ed. 1731.

Michael van der GUCHT, 1660–1725

Jan van der GUCHT, 1697–?1732

Gerard van der GUCHT, 1697–1776

There are many variations in their signatures: van der Gucht, vander Gucht, Vdr, Vd.

Michael van der Gucht was born at Antwerp in 1660. He came to England in the 1690s. 'In London about 1700', Vertue writes in his note-books (III, 7), 'the state of engraving on copper was at a low ebb. Indeed Mr. Robert White was still living, and did live three years after, but was declining much, and I think beside him could be found any Master, as one might call so, because none of the other had any talent in drawing. Mr. Griblin [Simon Gribelin, 1661–1733?], Mr. Sturt [John Sturt 1658–1730] excellent for writing-graveing, Mr. Mich. Van der Gucht esteemed as the chief for the neatness of his burin; others hardly worth naming.'

In the circumstances, Van der Gucht had no difficulty in obtaining employment. He is said to have worked for a few years with another immigrant, David Loggan of Danzig, and, upon the death of the latter, made himself independent. The earliest signed engravings of his are dated 1693, but there may well be earlier ones, and they may not have been worked in England, for Vertue (*Notebooks* I, 145) writes that pictures for engraving were often sent to Holland 'to be done by Van Gunst'. A considerable portion of Michael van der Gucht's output for the booksellers consisted of small portraits designed to serve as frontispieces. Thomas Dodd, in the notes for his never completed *Connoisseurs Repertory*, 1824, gives an immense list of such portraits of contemporary figures engraved by Van der Gucht and adds that 'many individuals are represented only by him'. Although Vertue, who was to be a far better practitioner in this sort of thing, is scathing about their execution and says that 'they made a poor figure to the curious', the portraits like that of Defoe (after an unknown draughtsman) prefixed to his *Jure Divino* (1706), of Betterton the actor, Josiah Child the banker and many others are of evident historical value.

There is no reason to think that all of the ubiquitous portrait frontispieces engraved by Michael van der Gucht at the end of the seventeenth and during the first quarter of the eighteenth century were based on *ad vivum* drawings of his own; the usual signature 'M. v. d. Gucht sculp [sit]' can almost certainly be taken at its face value as indicating that he engraved them after portraits or designs of other artists. The same assumption cannot be made when one comes to consider his subject engravings for book-illustration, in spite of the fact that he rarely claimed them as his own by words such as 'invenit' or 'delineavit'. Few drawings from his hand have been identified, but if the engaging design for Purcell's *Judgement of Paris* (1702) in the collection of Mr. Edward Croft-Murray (reproduced in *The Library*, June, 1963) can be taken as a fair sample, he was capable of attractive work in a well-established classical tradition. Whether he was 'burinating' from his own designs or copying those of others, Michael van der Gucht's engravings often strike one as rather stiff and mechanical, but he was certainly a more careful craftsman than most other engravers working for the booksellers in his time, and his prints, when found in good impressions, are less smudgy.

Van der Gucht made his name as an illustrator with the appearance of Tonson's ambitious folio edition of *Virgil* in Dryden's translation, 1697, for which he re-engraved the 101 plates originally designed for Ogilby's edition of 1654 by Hollar, Faithorne and Lombart. Jacob Tonson, perhaps encouraged by the success of the *Virgil*, published early in the eighteenth century a whole series of classical texts in splendid folio and quarto volumes, including the famous *Caesar* of 1712, which must have done much to kindle in this country the taste for fine books. In most of these books, Michael van der Gucht was associated with two Frenchmen, Louis du Guernier and Louis Cheron, and the only Englishman regularly in Tonson's employ, Elisha Kirkall, and was sometimes employed merely as an engraver, sometimes also as designer and some of the magnificent head- and tailpieces, initial letters, and full-page illustrations. His manner can perhaps be seen at its best, or at least at its most grandiose, in the two big 'sculptures' he contributed to Tonson's luxury edition of Ovid's *Metamorphoses* in 1717, 'The Story of Phaeton' and 'The Transformation of Scylla'.

M. van der Gucht's exact share in the designs for the first illustrated edition of Shakespeare, with

which he has often been credited, is doubtful. The only signed plate in the seven volumes published by Tonson in 1709-10, the general frontispiece which is found in each, indeed bears his signature 'M: V dr Gucht sculp.' It has been pointed out, however, that this plate is in fact a mere adaptation of a design by A. Paillet first used for the folio edition of Corneille's *Theatre* published in Rouen and Paris in 1633 (see T. S. R. Boase in *JWCI*, X, 1948, p. 86). Many of the plates, though unsigned, are almost certainly designed by François Boitard. Michael van der Gucht's share in them must at present be regarded as entirely conjectural. Certainly no confirmation can be gained from the two signed plates of his for *Venus and Adonis* and *Tarquin and Lucrece* which are found in Volume IX of Rowe's second edition in 12mo, published in 1714 with re-fashioned or new illustrations; Van der Gucht's reclining Lucrece strikes one indeed as a far more elegant and competent production than any of the play-scenes in either of the two editions discussed.

When Michael van der Gucht died on October 16, 1725, at his home in Bloomsbury, 'of the gout' we are told, he left an established reputation and a number of competent pupils to carry on his work as illustrator. They included George Vertue, the best-known English engraver of his time, and Van der Gucht's two sons whose output is sometimes confused with his own. Jan, the younger, is said to have received instruction in drawing from Louis Cheron, but most of his known work was in reproductive engraving for the booksellers. He was 'carried off by a violent fever in a small time' and at an early age, but hardly as early as 1728, as is suggested in most reference works, including the *DNB*, since much of his work, such as the anatomical plates for William Cheselden's *Osteographia* (1733) and the illustrations he engraved after Hogarth, Dandridge and others for the English edition of Molière's *Select Comedies*, 1732 (eight volumes), appears to have been done several years later.

Jan's brother, Gerard van der Gucht (1696-1776) was an even more prolific book illustrator than his father, though hardly as careful a craftsman. He engraved two of the rare frontispieces designed by Sir James Thornhill, an elaborate allegory for Burchett's *Complete History of the most remarkable Transactions at Sea* (folio, 1720), and a plate for Young's play *Busiris* (1719), where the artist has brought a pyramid, palm-trees, camels,

and even elephants onto the scene to make the settings truly Egyptian. Gerard, known familiarly as 'Gutch', was associated with Hogarth in the Petition which led to the Copyright Act of 1735; he engraved most of the master's book-illustration, though in a manner scarcely superior to the hackwork done by the great man himself in his youth. He, even more than his father, reaped the benefit of the growing taste for copperplate 'cuts' among English readers. The number of books which he 'adorned' with engravings from his own designs or those of others is almost beyond computation. They range from song-books like *The Merry Musician or a Cure for the Spleen* and Croxall's *Select Collection of Novels* (second edition, 1729, 6 vols.), which includes illustrations after Highmore and Vanderbank, to the stately *Racine* of 1723 and the *Dramatick Works* of Dryden, Lee, Steele and many others, not to forget yet another edition of Shakespeare (Theobald's second edition 1740, 8 vols. 12mo), this time engraved from designs by Hubert Gravelot which are remarkable for their wholly un-Elizabethan air of refinement and elegance. His last work appears to be the splendid quarto edition of *Don Quixote* (1742), for which he engraved the plates after Vanderbank. Although he lived to be eighty, he was ousted by the new school of French-trained engravers such as Grignion and Baron, and seems to have concentrated in his later life on his business as a supplier of artist's materials and as a successful dealer in pictures.

Of Gerard van der Gucht's children, who are reputed to have numbered no fewer than thirty-five, only one, Benjamin, succeeded in the profession of artist which was now almost traditional in the family. He exhibited portraits at the Free Society of Artists from an early age and was a regular exhibitor at the Royal Academy between 1771 and 1787, one of his exhibits for 1779 being 'A Head of the late Mr. Garrick, being the last picture he sat for'. In time he became increasingly absorbed in picture cleaning and restoring, and in the trade in Old Master paintings on a large, even an international, scale. By 1796, when he was drowned in a boating accident on the Thames, 'leaving', as the newspapers announced, 'an amiable widow and eleven children to lament their great loss', he was a man of standing and substance. Many of his descendants made distinguished careers for themselves in the British public service. Ten years before his death, Benjamin demonstrated his sound taste by commissioning two

portraits from the foremost English painters of the age. It is to this order that we owe two pictures which are among the most charming of their time: the well-known portrait of the 'amiable' Mrs. van der Gucht (Miss Sophia Eagles) by Romney, and Sir Joshua Reynolds's 'Van der Gucht Children', the group better known perhaps as the 'Babes in the Wood'. A daughter of Gerard married Robert Pranker the engraver.

H. A. Hammelmann, 'A Family of Book Illustrators', *Times Literary Supplement*, 26 July 1957.

M. VAN DER GUCHT

1708 [J. Philips], *Cyder: a poem.* 8vo. 'For J. Tonson within Grays-Inn Gate next Grays-Inn Lane.' Front. 'M Van der Gucht Scul.' possibly also des. by him. (Plate 2.)

1714 *Works of Shakespeare.* 8vo. 'For J. Tonson.' Vol. IX. 2 pls., *Venus and Adonis* and *Lucrece.* s. 'scul.' but possibly des. by him.

G. VAN DER GUCHT

1720 John Hughes, *The Siege of Damascus.* 8vo. 'For J. Ward sold by Samuel Chapman at the Angel and Crown in Pall-Mall.' 1 pl. 'G VderGucht Inv et Sculp.'

1724-5 Sir Philip Sidney *Works* [see under Cheron]. 1 pl. G. van der Gucht 'delin et sc.'

1728 [W. R. Chetwood], *The Voyages and Adventures of Captain Robert Boyle . . . Intermixed with the story of Mrs. Villars . . . to which is added, the Voyage, Shipwreck, and Miraculous Preservation, of Richard Castelman, Gent.* 8vo. 'By Andrew Millar. Front. 'Vd Gucht fecit.' 2nd ed.

1729 *A Select Collection of Novels* [see under Vanderbank]. 2 pls. eng. G. Van der Gucht.

1732 *Select Comedies of Mr. de Molière* [see under Dandridge]. 2 pls. des. and eng. G. van der Gucht and 3 others, probably designed by him, though only s. 'fec' or 'sculp.'

1733 Claudius Quillet, *Callipaedia: or, the Art of getting beautiful children. A Poem in two books . . . Made English by Nicholas Rowe.* 12mo. 'For W. Feales.' 4 pls. 3rd ed.

1735 John Hughes, *Poems on several occasions.* 2 vols. 12mo. 'J. Tonson and J. Watts.' 2 pls. des. and eng. G. van der Gucht.

1735 William Congreve, *Plays.* 12mo. 'For J. Tonson in the Strand.' 5 pls. 'G. Vander Gucht inv. et scul.'

1735 J. Addison, *The Drummer; or, the Haunted-House.* 12mo. 'For J. Tonson in the Strand.' 1 pl. 'G. Vdr Gucht inv et sculp.' (Plate 6.)

1735 Philip Frowde, *Philotas; a tragedy.* 12mo. Pl. 'G. Vandr Gucht in et scu.'
These plays were reissued in 1765 in *The English Theatre, containing the most Valuable Plays which have been acted on the English Stage,* by T. Lowndes.

1736 Voltaire, *The Tragedy of Zara . . . As it is acted at the Theatre-Royal in Drury Lane.* 8vo. 'For J. Watts.' Fronts. Again in 3rd ed. 1752.

1736 Joseph Addison, *Works of Petronius Arbiter in prose and verse.* 12mo. 'For J. Watts.' Front. G. van der Gucht 'inv. et scul.'

1737 [Colley Cibber], *Damon and Phillida. A ballad opera of one act.* 8vo. 'For J. and R. Tonson and J. Watts.' Front. 3 earlier eds. without pls.

1738 [J. Miller], *Art and Nature, a comedy as it is acted at the Theatre-Royal in Drury Lane.* 8vo. 'For J. Watts.' Front.

1760 [W. R. Chetwood], *The Voyages, Travels, and Adventures of William Owen Gwin Vaughan, Esq.; With the history of his Brother, Jonathan Vaughan, six years a slave in Tunis. The second edition.* [1st ed. 1736 not illustrated.] 12mo. 'For T. Lownds [sic] at his Circulating Library in Fleet Street.' Front. G. van der Gucht 'fecit.'

John VARDY, d. 1765

He was an architect and pupil of Kent. Many of his architectural plates were engraved. He published (1744) *Some Designs of Mr. Inigo Jones and Mr. William Kent,* and drew (after Kent) and engraved the title-page.

George VERTUE, 1684-1756

He was trained by Michael van der Gucht and at Kneller's Academy in Great Queen Street, Lincoln's Inn Fields. He became the chief engraver of portraits of his time and is said to have engraved above 500. Much of his work was used as portrait frontispieces for books. He only seldom, however, provided his own designs for book illustration. In his notebooks (*The Walpole Society*, vols XVIII, XX, XXII, XXIV, XXVI, XXX, 1930-55), used by Horace Walpole for his *Anecdotes of Painting,* he left invaluable information about contemporary and earlier artists and their works.

1742 *A Catalogue of the Collection of the Rt. Hon. Edward Earl of Orford deceased . . . which will be sold by Auction by Mr. Cock at his house in the Great Piazza, Covent Garden, on Monday 8th March 1741 and the five following days.* 4to. Elaborate front. 'Vertue in.'

Samuel WALE, ?1721–86

The list of books illustrated by Samuel Wale (?1721–86) which is printed below covers more than a hundred different publications, containing almost a thousand individual illustrations; further search, not to speak of the identification of unsigned engravings, might well in the end double these figures. Such productivity was probably unequalled by any English illustrator until the time of Stothard; there can indeed be few students and collectors of eighteenth-century books who have not on occasion come across frontispieces bearing Wale's name or those oval vignettes on the title-page of the quarto poems of the period which catch so well the special charm of eighteenth-century occasional verse.

Of the life of Samuel Wale, at least of his early career, not much is known and even his birth date and place remain to be ascertained, being variously given as London (by Strutt, Edwards, Bryan and Thieme-Becker) or Yarmouth (by William Sandby and *DNB*). There is in fact an entry in the Parish Register of St. Nicholas, Yarmouth (which has fortunately survived the bombing of the church) which records the birth of one Samuel Wale (or Wade) on 25 April 1721 to Samuel and Margaret Wale, who were married in 1718. A Samuel, son of Samuel Wale, is entered on the Yarmouth Freemen's Roll of 1738. Nor are the Vertue Notebooks entirely free in this instance from ambiguity, for Vertue, never quite reliable for Christian names, speaks (III, 160) of one W. Wale, 'he was prentice to Boldby engraver in London who keeps a print shop—and says for three years of his prenticeship he paid for his study in the accadamy, by which means he has made such progress in drawing that he is most esteemed for his designs and inventions and is much employed in this way.'[1]

The 'accadamy' here referred to was of course the Life School established by Hogarth and others in Peter's Court, St. Martin's Lane, where Wale appears to have worked, at least for a time, with

[1] List of Apprentices at Genealogical Soc. (14/70) gives 1735 'Wale Samuel [son of] Sam. of Yarmouth to Wm. Goldley cit. and gldmth. £21.'

or under Francis Hayman. It was the St. Martin's Lane Academy which eventually paved the way for the creation of the Royal Academy, and Wale is known to have taken from the outset a very active part in the movement directed towards this end. Together with his life-long close friend John Gwynn, the architect of Magdalen Bridge, Oxford, he produced as early as 1749 *Proposals for Erecting a Public Academy . . . for Drawing and the Several Arts* and this was followed, in 1755, by a second essay urging immediate action. In that year, a committee of artists of which both Wale and Gwynn were members was in fact set up with Francis Hayman as chairman, but this first attempt proved abortive and it was not until thirteen years later that the Royal Academy came into being.

In the meantime we find Samuel Wale among the exhibitors at the first exhibition of the Society of Artists in Spring Gardens, which gave the public at large one of its earliest opportunities of seeing a collection of contemporary pictures painted in this country. Wale's contribution was a historical piece of which little is known except the charitable comment of a correspondent in the contemporary *Imperial Magazine*: 'We shall say little of this, he may do better next time.' More successful were the three small circular paintings which the artist presented to the newly established Foundling Hospital, but Wale did not often repeat his attempt in oils; at an early stage, after trying his hand at monumental sign-painting and occasionally in decorative as well as large topographical drawings, he came to specialize more and more in the design of bookplates and, above all, of book-illustrations.

Unlike his contemporaries Anthony Walker and Isaac Taylor, who were designer-engravers in the traditional sense, Wale (though probably trained to engraving) invariably handed his designs to a professional engraver for transfer onto the copperplate. It is with the multiplication and gradual mechanization of processes in the nineteenth century that one is inclined to associate the cleavage between executant and designer in book illustration. In fact the separation of functions is obviously of earlier origin. Very few of the leading French illustrators under Louis XV and Louis XVI undertook the lengthy and troublesome task of engraving their own plates; and in this country, though exceptions were rather more numerous, a parallel distinction unfortunately developed between the draughtsmen as 'original artists' and

the engravers, the 'servile copiers' who were not at first thought worthy a place in the Royal Academy.

Some such division of labour may have seemed perfectly natural to men who, trained with the graver themselves and capable of handling it most competently (like Gravelot, for instance), found themselves overwhelmed with commissions as a result of the vast demand for illustrations which arose in the middle of the eighteenth century. Nor need such a partnership have produced, inevitably, inferior work, provided that the draughtsman understood the medium and remained in close touch with his engraver. Wale, unfortunately, was often ill-served by his engravers, and from this fact his reputation has suffered. One has only to compare prints from the copperplates with their hard and dead cross-hatching, with his original drawings; these are full of movement, especially some of the rapid, flowing sketches which he made before fully working out his designs. In spite of certain mannerisms which he had inherited from Gravelot and his teacher Hayman, Wale was certainly a very able draughtsman. If his designs have none of the directness and immediacy of Hayman's scenes with their full-blooded, self-possessed figures, nor the naïve, provincial charm of Isaac Taylor's, it is often difficult not to consider them superior as illustrations. Not merely do they catch a significant incident and tell its story plainly, but, at their best, as in those chronicles of male-factors, the *Newgate Calendar* and the *Tyburn Chronicle*, they add something significant to our understanding of the text; the authentic flavour of the age, with its surprising mixture of love and cynicism, of vicious cruelty and alluring elegance.

It is probably true to say that indirectly the separation of draughtsman and engraver had another unhappy effect in the case of Wale: it forced him to produce illustrations in such profusion that he gave way, on occasion, to the temptation of turning out repetitive designs. Not a great deal of information has hitherto come to light about the remuneration received by eighteenth-century illustrators from their publishers, but it is clear that the lion's share went to the engravers who were paid according to the time actually or likely to be required for the preparation of a sound copperplate, while payment for the designer, if he was not himself the engraver, was extremely slender. Hayman, who was in a specially strong position, usually obtained two guineas for an ordinary octavo illustration; other designers seem rarely to have charged more than one, though Lowndes, the publisher, is said to have given Wale, for his designs for *Clarissa Harlowe*, 'half-a-crown extra, by which act of liberality the artist pocketed nine guineas for eight designs'.

It is unlikely that Wale was very much concerned over the unsatisfactory financial returns of his illustrative work; he had no family and for most of his life shared a frugal bachelor establishment—in Castle Street, Leicester Fields—with his friend Gwynn. Even so he must have welcomed the appointment, which he received as an original member of the Royal Academy at its foundation in 1768, to the first Chair of Perspective there. In this office the new Professor was enjoined 'to illustrate fully and clearly all the useful propositions of Geometry, together with the principle of Lineal and Aerial perspective, and also the projection of shadows', and particularly 'to confine himself to the quickest, easiest and most exact methods of operation'; which sounds more formidable than it can have been, given the fact that only six annual lectures were provided for.

The list of Samuel Wale's work contains no entries for the last eight years of his life, but this is explained by an entry in the Council Minutes of the Royal Academy, which records a grant to him in 1778 (and repeated every year until his death) of the sum of £20, owing to his being 'rendered incapable of exercising his profession by a Paralytick stroke'. In 1778, while still holding his Professorship, Wale was elected Librarian R.A., but this was probably regarded as a sinecure for a man too ill to carry out any functions, and a deputy had to be appointed at the same time. After several years of illness, Wale died on 6 February 1786 and was buried in St. Martin's-in-the-Fields. By his will he left 'to John Gwynn Esquire my part of all the copperplates and prints likewise all my pictures drawings, all the furniture belonging to me and whatsoever is my property'; but a year or two before his death he had added a pleasant codicil which made over half of his belongings to a 'Mrs. Mary Gurpin for the great care and trouble she has had in nursing me Samuel Wale. Perhaps it is permissible to think that to any exaggerated panegyric of his work, this attractive minor artist would have preferred the tribute paid by one of his colleagues who knew him well. 'He was a man of excellent character,' says Edward Edwards, A.R.A., in his *Anecdotes of Painters* (1808),

'ever ready to assist those who sought his aid or instruction.'
H. A. Hammelmann, *Book Collector*, Autumn 1952.

1744–7 Rapin de Thoyras, *The History of England* [see under Gravelot]. Tailpiece in Vol. V eng. Grignion.

1745–7 *Collection of Voyages and Travels* [see under Gravelot]. Vols. III and IV fronts. eng. N. Parr.

1748 *Geographia Magnae Brittaniae, or, Correct Maps of all the Counties in England, Scotland and Wales.* 8vo. 'For T. Osborne and others.' Double-page title, s. 'S. Wale inv. et fec.'

1748 John Rocque, Surveyor, *A New and Accurate Survey of the Cities of London and Westminster . . .* [title in English and French]. Atlas folio. 'Printed by W. Edwards.' Allegorical title-vig. eng. Truchy, and 24 double-page sectional maps by Parr after Rocque. The vig. does not appear in the 1746 ed.

1749 [John Gwynn], *An Essay on Design; including proposals for erecting a public Academy.* 8vo. 'Brindley,' et al. 1 head- and 1 tailpiece eng. J. Bonneau and 1 fine headpiece by E. Rooker after J. Gwynn.

1750 [Francis Wise, Fellow of Trinity College], *Nummorum antiquorum scriniis Bodleianis reconditorum catalogus.* Folio. 'Oxonii, e theatro Sheldoniano.' Front.: allegorical figures with Sheldonian in background [unusually the full title is inscribed on hanging drapery], eng. Jas. Green.

c.1750 B. Cole, *Select Tales and Fables . . . equally Instructive and Entertaining for the use of both Sexes . . . The whole embellished with Three-score Original Designs . . . neatly engraved on Copper Plates . . . by B. Cole, Engraver.* 2 vols. [usually in 1]. 12mo. 'For F. Wingrave.' 2 title-pages and 60 illustrations, 2 to a page.

1751 Alexander Pope, *The Works* [see Hayman and Walker]. 14 pls. eng. J. S. Müller (2) and Charles Mosley (2).

1753 [Jonas Hanway], *An historical Account of the British Trade over the Caspian Sea . . .* [see Hayman and Walker]. 6 headpieces S. Wale eng. Scotin, 3 of them unsigned.

1752–3 *The Universal Traveller* [see under Gravelot]. Pl. eng. N. Parr.

1755 C. M. de la Condamine, *A Discourse on Inoculation read before the Royal Academy of Sciences at Paris.* 8vo. 'For P. Vaillant.' Title-vig. after Wale, eng. T. Major.

c.1755 *The Life and Opinions of Bertram Montfichet, Esq.; written by himself.* 2 vols. 12mo. 'For C. G. Seyffert in Pall Mall.' 2 fronts.: Vol. I s. only 'Miller sc.', Vol. II Wale eng. Grignion.

1755 [J. G. Cooper] *Letters concerning Taste.* 8vo. 'For R. and J. Dodsley.' Front. eng. Grignion. Again in 2nd and 3rd ed. of 1755, 1757.

1755 *The Oxford Almanack for 1755.* Large folio sheet. Headpiece: 'Science leading man from Ignorance and Vice', eng. J. Green after S.W. Wale also designed headpieces for the Oxford Almanacks of 1757, 1758, 1760, 1761, 1762 and 1766.

1755 *The Universal Magazine of Knowledge and Pleasure.* 8vo. John Hinton. Vol. XVII, fine front. unsigned, but certainly by Wale. Other vols. of this magazine probably contain work by Wale.

1755 [E. Haywood], *Epistles for the Ladies.* 2 vols. 12mo. 'For T. Gardner.' 2 fronts. eng. J. Mynde. 2nd ed. Not in 1st ed. of 1749–50.

1755 [Edward Young], *The Centaur not Fabulous.* 8vo. 'For Andrew Millar.' Front. unsigned but according to 2nd ed. by Wale.

c.1755 *A Catalogue of Pictures belonging to Sir Sampson Gideon, Bart., at Belvedere in . . . Kent.* 4to. No imprint. Pl.: Belvedere House, eng. Green.

1755 *The Liturgy of the Church of England; illustrated with Fifty Nine Historical and Explanatory Sculptures, Engrav'd by Messrs. Ravenett, Grignion, Scotin, Canott, Walker and W. Ryland* [all after designs by S. Wale, some of them excellent in every way] *published . . . May 1st 1755.* 8vo. 'Printed and sold by the Proprietor, Edward Ryland.' Some of the pls. re-used in other editions of Book of Common Prayer.

1756 Thomas Hale, *A Compleat Body of Husbandry . . . illustrated with a great number of plates . . . engraved from original drawings.* Folio. 'For T. Osborne' et al. Front. eng. B. Cole; numerous others pls. after Wale eng. Boyce.

1756 John Hill, M.D., *The British Herbal.* Folio. 'For T. Osborne et al.' Front. eng. H.

Roberts. Title-vig. eng. Grignion. The flower pls. are occasionally s. 'Darby' or 'Edwards fecit,' eng. Boyce, Roberts and A. Smith; many not signed.

1757 [Jonas Hanway], *Motives for the Establishment of the Marine Society. By a Merchant.* 4to. Full page front., 'S. Wale del., T. Major sculpt.' each adds 'donovit'. Repeated in 'the Account of the Marine Society 1759 [reproduced *History Today*, XXIII, 1973, p. 434]. Later editions of the Account and the Regulations of the Marine Society have a plate by Wale eng. Grignion.

1757 [J. G. Cooper], *Epistles to the Great, from Aristippus in retirement.* 4to. 'R. and J. Dodsley.' Large title-vig. eng. Grignion. Re-used in Cooper's *Poems on Various Subjects*, 12mo. for Dodsley, 1764.

1757 Jonas Hanway, *A Letter from a Member of the Marine Society.* 8vo. 'For J. Waugh, Say and Fenner.' Front. S. Wale eng. T. Major, and again donated. Found again in *Three Letters* of 1758.

1757 [Jonas Hanway], *A Journal of eight days journey from Portsmouth, to Kingston.* 2 vols. 8vo. 'H. Woodfall and C. Henderson.' 2 fronts. eng. T. Major. 2nd ed.

1757 Samuel Boyce, *Poems on Several Occasions.* 8vo. 'For Dodsley, Newbery and Reeve.' Front.: 'Fortune obstructing the Genius of Poetry', eng. Boyce.
Wale and Gwynn were among the subscribers to this book.

1757 *Eden, or a Compleat Body of Gardening.* Folio 'For T. Osborne'. Front. eng. Grignion.

1758 [John Hill, M.D.], *The Gardener's new Kalendar, . . . exhibiting . . . the . . . Laying out a Garden in the Modern Taste; with a Copper Plate Figure, elegantly engraved from a drawing of Mr. Wale.* 8vo. 'For T. Osborne' et al. Unsigned folding pl. of a garden.

1758 *Thoughts on the Plan for a Magdalen House for Repentant Prostitutes.* 4to. 'By James Waugh.' Front. S. Wale eng. T. Major. Found also, slightly altered, in 8vo.

1759 *A new universal history of arts and sciences . . . Decyphered in fifty two copper-plates.* 2 vols. 4to. 'For J. Coote.' 2 fronts. eng. B. Cole. The other pls. are all technical.

1759 John Ogilvie, *The Day of Judgement. A Poem in two books.* 8vo. 'For G. Keith.' Front. S. Wale 'inv. et delin', eng. Ryland. 3rd ed.

1759 Philip Miller, *The Gardener's Dictionary.* 4to. 'For the Author.' Front.: 'What Nature sparing gives . . .' eng. E. Rooker. 7th ed. This front. may be already in the 6th ed. of 1752; it was reprinted with the 8th ed., 1768, 2 vols., folio.

1759 J. B. L. Gresset, *Ver-Vert: or, the Nunnery parrot. An heroic poem . . . translated from the French.* 4to. 'R. and J. Dodsley.' Title-vig. s.: 'J. G. C. invenit, S. Wale del., C. Grignion sc.'

1759–62 Benjamin Martin, *The Young Gentlemen's and Ladies' Philosophy . . .* 2 vols. 8vo. 'W. Owen for the Author.' Front. to Vol. II eng. Grignion. Again in 2nd ed. 1772 and 3rd ed. 1781.

1760 Isaac Walton and Charles Cotton, *The Complete Angler; . . . in two parts . . . illustrated with . . . views of the principal scenes described in the book.* 8vo. 'For Thomas Hope.' Front. and 8 pls. eng. Ryland, 2 pp. of eng. music, 3 of equipment; another pl. by Ryland after J. Smith. There appear to be 2 distinct issues of this, Hawkins's 1st ed. Wale's designs were used for many subsequent editions until 1797, when the plates 'had become so worn as to be no longer an ornament to the work'. New plates from the same designs were engraved by Audinet for Bagster's edition of 1808, and used again for Major's editions.

1760 James Scott, *Four Elegies: descriptive and moral.* 4to. 'For J. Buckland.' Title-vig. and tailpiece eng. Grignion.

1761 [Samuel Wale], *London and its Environs Described, containing an account of whatever is most remarkable for grandeur, elegance, curiosity or use . . . decorated and illustrated with a great number of views in perspective, engraved from original drawings taken on purpose for this work.* 6 vols. 8vo. 'For R. and J. Dodsley.'

1761 F. Fawkes, *Original poems and translations.* 8vo. 'For the Author and sold by Dodsley' et al. Title-vig. eng. Grignion.

1761 [Robert Dodsley], *Select Fables of Esop and other fabulists.* 8vo. 'Birminghan, Baskerville for Dodsley.' Front. and title-vig. unsigned

but certainly by Wale; 3 headpieces and 3 tailpieces eng. Grignion after Wale. Reprinted 1764.

1761 *A Catalogue of the Pictures, Sculptures, Models, Drawings, Prints etc. exhibited by the Society of Artists of Great Britain . . . May 1761.* 4to. Title-vig.: 'The Genius of Painting, Sculpture and Architecture relieving the distressed', eng. Grignion; and 2 designs by Hogarth. The catalogue of the Spring Gardens Exhibition of 1762 has a frontispiece by Grignion after Wale: 'Aurea si Tuleris Minora Feres'. The engraved title-page of 1761 was used for several years running.

1761 James Penn, *A Latin Grammar for the use of Christ's Hospital.* 12mo. 'By Thomas Hope.' Pictorial title-page and fronts.

1762 *The British Phoenix: or, The Gentleman and Lady's Polite Literary Entertainer, consisting of a great Variety of . . . Literary Amusements, as have . . . long since been buried in oblivion.* 8vo. 'For H. Serjeant at the Star, without Temple Bar.' Front.: Genius and Science presenting the 'Imperial Magazine' to Apollo, [so that it is possible that this is a reused front.] eng. Adam Smith.

1762 *The Muse's Recreation, in four poems.* 4to. 'For J. Johnson.' Title-vig.: Three cherubs throwing roses into the lap of the muse, eng. Grignion.

1762 James Thomson, *The Works.* 2 vols. 4to. 'For A. Millar.' 2 fronts. portraits by Basire after Aikman and Paton, engraving of Newton's monument after W. Kent and 13 pls.: 4 by Tardieu after Kent for 'The Seasons', 5 designed and engraved by J. Miller, 1 designed and engraved by G. V. Neist and 3 engraved by G. V. Neist after Samuel Wale for 'Britannia', 'Castle of Indolence' and 'Agamemmon'.

1762 *The Matrons; six short histories* [edited and partly translated by Thomas Percy]. 12mo. 'For R. and J. Dodsley.' Front.: 'Ecce sine luce facem', s. 'G.P. inv., S. Wale del., Ch. Grignion sc.' The original drawing is in the possession of Messrs. Elkin Mathews Ltd.

1762 James Macpherson, *Fingal; an ancient Epic poem.* 4to. 'For Becket and de Hondt.' Oblong title-vig. eng. Isaac Taylor. See H. Okun, 'Ossian in Painting', *JWCI,*

XXX, 1967, pp. 331, 339. This was the first illustration to *Ossian's Poems.*

1762 Horace, *Opera.* 12mo. 'Birminghamiae, Baskerville.' Front. title-vig. and 1 escutcheon eng. Grignion. The front. appears again, eng. Spilsbury, in an ed. published by him in 1799.

1762 [T. Leland], *Longsword, Earl of Salisbury. An historical romance.* 2 vols. 12mo. 'Johnson.' Front. Grignion.

1763 Rowland Rugeley, *Miscellaneous Poems.* 8vo. Cambridge. Front.: Greenwich Hospital, eng. T. Simpson.

1763–4 *A New and Complete Dictionary of Arts and Sciences . . . by a Society of Gentlemen.* 8 vols. 8vo. Front. S. Wale 'inv. et delin.', eng. Grignion. 2nd ed.

1764 [Kane O'Hara], *Midas, an english burletta.* 8vo. 'Kearsley' et al. Front. eng. Goldar. Reprinted 1769.

1764 William Mason, *Poems.* 8vo. 'For Robert Horsfield.' Allegorical title-vig. eng. J. Basire, and unsigned escutcheon.

1764–6 *A New History of England from the earliest accounts of Britain to . . . the Peace of . . . 1763, humbly inscribed to the Queen by Mr. Mortimer.* 3 vols. Folio. 'For J. Wilson and J. Fell. Front. 'T. Mortimer inv., S. Wale delin., C. Grignion sc.' 22 pls. of historic scenes, all by Wale, except 3 unsigned. 32 portraits in arabesque borders. Amongst the subscribers are Mr. Gainsborough and Mr. Wale.

c.1765 *The Complete Family Bible . . . with Notes- Historical by Samuel Newton, D.D. Rector of Clifton.* Folio. 'For the Author by T. Brewman.' Full-page pls. and headpieces by Wale, and others unsigned. For Wale's other biblical illustrations see T. S. R. Boase in *JWCI,* XXVI, 1963, pp. 161–2, and under Fuseli 1772.

1765 *Mumbo Chumbo, a tale, written in ancient manner. Recommended to modern devotees.* 4to. 'For T. Becket and P. A. de Hondt, near Surry-Street, Strand.' Title-vig. eng. Grignion.

1765 [T. Percy], *Reliques of Ancient English Poetry.* 3 vols. 8vo. 'For J. Dodsley.' Front. eng. Grignion. 9 headpieces and 1 tailpiece, unsigned, but certainly after Wale.

Bishop Percy's directions to Wale about the headpieces are among the Percy MSS. in Harvard University Library. They include details such as 'Don't forget to place on a conspicuous part of the table *a boar's head* for one of the dishes.'

1765 Christopher Smart, *A Poetical Translation of the Fables of Phaedrus*. 12mo. 'For J. Dodsley.' Allegorical front. eng. Grignion.

1765–6 *An Abridgment of Scripture History . . . Old Testament and New Testament . . . adorned with head-pieces expressive of the Subject of each Narrative curiously* [and rather crudely] *engraved on 60 copperplates*. 2 vols. Sq. 12mo. 60 half-page vigs. to each vol. 2 fronts. eng. Grignion.

1766 Thomas Collins Overton, *The Temple Builder's Companion; being fifty entire new original designs for pleasure and recreation . . . in the Greek, Roman and Gothic taste*. 8vo. 'For Henry Webley, in Holborn, New Chancery Lane.' Front.: statues of Palladio and Inigo Jones in front of temples 'S. Wale inv. et del., R. Pranker sculp.'; the plans and elevations eng. Pranker after Overton.

1767 N. Cotton, *Visions in Verse*. 12mo. J. Dodsley. Front. eng. Grignion. 7th ed. Reprinted 1782.

1767 R. Jago, *Edge-Hill; or, the Rural Prospect . . . A Poem*. 4to. J. Dodsley. 4 landscape headpieces eng. Grignion (3) and E. Rooker (1); unsigned tailpiece, probably also by Wale. Reprinted with Jago's *Poems, moral and descriptive*. 8vo. 1784.

1767 [Christopher Anstey], *The New Bath Guide . . . in a series of Poetical Epistles*. 8vo. J. Dodsley. Front. eng. Grignion. 5th ed. Frequently reprinted; the front. is not in any of the earlier eds.

1767/70 D. Bellamy, *Ethic Amusements*. 4to. 'For the Author.' Of the 29 headpieces, 7 are s. Samuel Wale and eng. Grignion and several others may also have been drawn by him.

1768 E. C. Drake, *A new universal collection of authentic and entertaining Voyages and Travels . . . illustrated with maps from the latest improvements and beautiful plates, by Grignion, and other celebrated masters*. Folio. 'For J. Cooke.' Front. eng. Grignion. Numerous other pls. by various engravers, but probably not des. Wale.

1768 G. P. Tousey, *Flights to Helicon*. 8vo. 'For the Author.' Front. eng. I. Taylor.

1768 *The Adventures of Telemachus . . . transl. from the French of . . . Fenelon . . . by John Hawkesworth*. 4to. 'For the Author.' 24 vigs. and 24 tailpieces eng. Grignion.

1768 William Wilkie, D.D., *Fables*. 8vo. 'For E. and C. Dilly.' Front. and 17 pls. eng. T. Simpson, the last unsigned. (Plate 29.)

1768 J. Byron, *The Narrative of the Honourable John Byron . . . containing an account of the great distresses suffered . . . on the coast of Patagonia . . . written by himself*. 8vo. 'For Baker, Leigh and Davies.' Front.: shipwreck eng. Grignion. Again in 2nd ed. of same year.

1768 Samuel Richardson, *Clarissa Harlowe*. 8 vols. 12mo. Front. to each vol. eng. Charles Grignion and Isaac Taylor. 6th ed. Earlier eds. were not illustrated.

c. 1768 *The Tyburn Chronicle*. 4 vols. 8vo. 'For J. Cooke.' Numerous pls. by Wale.
Original drawings for this work are at the B.M., the Nottingham Castle Museum and in several private collections.

1769 O. Ruffhead, *Life of Alexander Pope*. 8vo. 'Bathurst' et al. Front.: Pope's Monument, eng. Ravenet.

1769/70 *A New and Compleat History and Survey of the Cities of London and Westminster . . . by a Society of Gentlemen. Revised, corrected, and improved by H. Chamberlain*. Folio. J. Cooke. Numerous full-page pls.

1769 *The Complete Farmer: or, a General dictionary of husbandry . . . By a Society of Gentlemen*. 4to. 'For R. Baldwin et al.' Front.: Numa Pompilius calling the Roman husbandmen before him, eng. J. Hall.

1770–1 Rev. William Hanbury, *A complete body of planting and gardening*. 2 vols. Folio. 'Printed for the Author and sold by E. and C. Dilly.' Front. eng. Isaac Taylor; unsigned front. to Vol. II, probably by Wale.

1770 Plutarch, *Lives, translated from the original Greek, with notes . . . by J[ohn] Langhorne*. 6 vols. 8vo. 'For E. and C. Dilly.' 6 fronts. eng. T. Simpson [in the 1774 ed. reduced by S. Caldwell].

1770 Oliver Goldsmith, *The Traveller, a Poem*. 4to. 'For T. Carnan and F. Newbery Junr.'

Title-vig.: traveller enjoying a rural prospect, eng. Grignion.

1770 John Belfour, *A New History of Scotland.* 12mo. 'For E. and C. Dilly in the Poultry.' Front. and 7 pls. including p. 94, The King's Favourites seized and hung, p. 126, Wishart at the Stake, p. 148, Murder of Rizio, eng. T. Simpson.

1770 Dr. Th. Parnell, *Poems on several occasions . . . to which is prefixed, the Life . . . by Dr. Goldsmith.* 8vo. 'For T. Davies.' 2 pls. eng. Grignion. Reprinted 1773.

1771 [Thomas Percy], *The Hermit of Warkworth.* 4to. 'For Davies and Leacroft.' Title-vig. eng. I. Taylor, again in 2nd ed. of the same year.

n.d. (1771/2) W. H. Mountague, *A new and universal History of England . . . illustrated with a great number [110] of curious copper-plates, from original drawings made on purpose for this work by the celebrated Wale, and engraved by those eminent artists Grignion and Walker.* 2 vols. Folio. 'For J. Cooke.'

1771 [E. Haywood], *The Female Spectator.* 3 vols. 12mo. H. Gardner. [originally published by T. Gardner, 1744–48. Vol. IV, 1748, has front. signed 'Bonneau fec'. The 3rd. ed. was published in Dublin by A. Ewing with 2 fronts. 'D. Malone f.'] Vol. I front. 'Bonneau fec.' after S. Wale. Vols. II and III 'Bonneau fec', adaptations of Dublin designs.

1772 The Hon. and Rev. Francis Willoughby, *A Practical Bible* [see under Fuseli]. Front. eng. Grignion; several full-page pls. after Wale.

1772 [Daniel Bellamy], *The Economy of Beauty in a Series of Fables: addressed to the Ladies.* 4to. 'For J. Wilkie and F. Newbery.' Front. eng. Grignion. Title-vigs. by Gravelot, and half-page vigs. some signed Bickham, obviously from some earlier ed.

1772 Adam Fitz-Adam [Edward Moore], *The World.* 4 vols. 12mo. 'For J. Dodsley.' Title-vig. [identical in each vol.]: the author drawing the veil off the globe, eng. Grignion.

1772 [J. H. Wynne], *Choice Emblems, natural, historical, fabulous, moral and divine.* 12mo. E. Newbery [again in 8vo, 1788]. Front. eng. Ovenden; 47 oval woodcuts, unsigned.

1772 Thomas Brerewood, *Galfred and Juetta; or the Road of nature. A Tale* [in verse]. 4to. 'For the

Proprietor.' Title-vig.: A scene in the farmer's parlour, eng. C. Towes.

n.d. (1773) *The Newgate Calendar or Malefactor's Bloody Register.* 5 vols. 8vo. 'For J. Cooke.' 50 pls. [only 1 s.]; some of them eng. James Taylor. (Plate 30) Original drawings for this work are in the B.M., the V. and A., the Nottingham Castle Museum and in several private collections in London: see H. A. Hammelmann in *Picture Post*, 24 March 1951.

1773 John Lockman, *A New Roman History, by Question and Answer . . . designed principally for schools.* 8vo. 'For J. Rivington' et al. Allegorical front. and 15 pls. eng. T. Bonnor and J. June.

1773 *The Tablet of Memory.* 12mo. 'For T. Evans, No. 54 Paternoster Row.' Front. eng. J. Collier [3rd ed. 'For J. Bew'; front. used till 6th ed. 1787].

c. 1773 O. Goldsmith, *Dr. Goldsmith's Roman History. Abridged by himself.* 12mo. S. Baker and G. Leigh. 4 pls.

1774 Richard Graves, *The Spiritual Quixote.* 3 vols. 8vo. J. Dodsley. 3 fronts. eng. Grignion and identical title-vig. to each vol. 2nd ed. Reprinted 1783; the 1st ed. of 1773 has only the title-vig.

1774 *The History of the Renowned Don Quixote . . . Translated from the original Spanish . . . by Charles Henry Wilmot.* 2 vols. 8vo. 'For J. Cooke.' 2 fronts. and 19 pls. eng. Ryder and Rennoldson.

1775 [George Wright], *Walking Amusements for Chearful Christians.* 8vo. 'For J. Buckland' et al. Front. Wale, eng. G. Burder.

1776 M. M. Robinson, *Elegiac Verses to a Young Lady, on the death of her brother, who was slain in the late engagement at Boston.* 4to. 'For J. Johnson.' Title-vig. eng. W. Walker.

c. 1775 Charles Theodore Middleton, *A New and Complete System of Geography.* 2 vols. Folio, 'For J. Cooke.' 120 pls. des. Wale et al., eng. C. Grignion, Taylor, White et al.

1776 Jonas Hanway, *The Soldier's faithful friend: being moral and religious advice to soldiers.* 8vo. Front. eng. Grignion.

1775–6 Walter Harrison, *A New and Universal History, description and survey of the Cities of*

London and Westminster . . . Enriched with upwards of One hundred elegant copper-plate Engravings [unsigned but many of them by Samuel Wale]. Folio. 'For J. Cooke.'

1776 [Thomas Cogan], *John Buncle, Junior, Gentleman.* 2 vols. 12mo. 'For J. Johnson.' Identical title-vig. to each vol. eng. 'Fronti Nulla Fides'.

1777–8 Flavius Josephus, *The Works . . . translated by Ebenezer Thompson and W. C. Price.* 2 vols. 4to. 'For Fielding and Walker.' Front. and 1 pl. out of 60 pls. eng. Richards. Of the other pls., 2 are by Dodd, the others after Luyken [Jan Luyken, d. 1712].

1777 Dr. Cosens, *The Economy of Beauty; in a series of fables.* 4to. 'For J. Walter.' Front. eng. Grignion and 22 vigs. by various hands.

1777 William Augustus Russel, *A new and authentic History of England . . . Illustrated with upwards of one hundred curious Copper plates, engraved from the drawings of the celebrated Mr. Wale and other eminent artists, by Grignion, Walker, Taylor, White, Delroche and other Capital Masters.* Folio. 'For J. Cooke.' Some of the plates are identical with those for Mountague's *History* of 1771.

1778 Beaumont and Fletcher, *Dramatick Works* [see M. A. Rooker]. 2 pls.

1778 *The Indian Scalp, or, Canadian tale; a poem.* 4to. 'For the Author and sold by M. Folingsly.' Front. eng. G. V. Neist.

1778 John Mason, *Self-Knowledge. A treatise.* 8vo. 'For J. Buckland and E. C. Dilly.' Front. eng. B. Cole. 10th ed.

1778 Reverend Henry Southwell, D.D., *The Universal Family Bible or Christian's Divine Library . . . Embellished with upwards of One Hundred Elegant Copper-Plates, finely executed from original Drawings, Designs and Paintings, by Grignion, Walker, Rennoldson, Taylor etc.* 'For J. Cooke.' Many pls.

1784 *The New . . . Survey of the Cities of London and Westminster* [see under Hamilton]. Numerous pls., some after Wale.

1785 *A new history of England from earliest period to the present time on a plan recommended by the Earl of Chesterfield, embellished with copper plates elegantly engraved from the designs of Mr. Wale, by the Rev. Mr. Cooper.* 8vo. 'For E.

Newbery, the corner of St. Paul's Churchyard.'

n.d. (*c.* 1786) George Raymond, *A New, Universal, and Impartial History of England . . . Embellished with upwards of 120 beautiful Copper-Plate Engravings, taken from the original Drawings of Messrs. Metz, Stothard, and Samuel Wale Esq.* Folio. 'For Charles Cooke.' Large numbers of pls. by Wale.

The distinction between 'Messrs.' and 'Esq.' is presumably a tribute to Wale's seniority; possibly his plates were posthumously published.

See T. S. R. Boase *JWCI*, XXVI, 1963, p. 172.

?1790 Edward Barnard, *A New, Comprehensive, Impartial and Complete History of England.* Folio. 'For Alexander Hogg.' Many pls., largely re-used from earlier histories.

Anthony WALKER, 1726–65

Not many among the numerous professional engravers who worked in England in the mid-eighteenth century have today any claim to consideration as original artists. Undoubtedly one of the most gifted of these was Anthony Walker, a Yorkshireman who, as likely as not, had never seen a picture of importance before he set foot in the metropolis. Although he did not reach the age of forty and spent the greater part of his professional life in reproductive engraving—after paintings of Old Masters or, at the behest of booksellers, from drawings by contemporaries such as Francis Hayman—and even gave his time to transferring to copperplates topographical views and antiquarian or technical sketches, Walker proved himself in his book illustrations a draughtsman of remarkable skill with a real sense of decorative design. Unfortunately his opportunities for producing original work were not many, and the list printed below of the illustrations which Walker designed, and usually engraved himself, though spread over a fairly large number of books, covers hardly more than five dozen individual designs, including small casual title-vignettes.

According to the local church register, Anthony Walker was baptized at Thirsk in Yorkshire on 19 March 1725 (OS), and, since at that time baptism was generally carried out within eight days of birth, his birthday may be put on or about 15 March 1726 according to the modern calendar. His father appears in the register as 'John Walker,

exciseman' (not 'tailor' as mistakenly stated in the *DNB*); and a second son, William, later a pupil and fellow engraver of his elder brother, was born late in November or early in December 1729. Very little is known of Anthony Walker's life apart from his work, and the reason for his choice of profession as well as the date of his arrival in London, where he worked throughout his life, remains to be ascertained. Strutt, in his manuscript notes preserved in the British Museum, appears to be the earliest authority for the fact that young Anthony was bound apprentice (perhaps in 1741–2) to John Tinney, a printseller and engraver whose establishment was situated 'at the Golden Lion near the Globe Tavern in Fleet Street'. Tinney himself enjoys no great reputation for the line-engravings, etchings and mezzotint portraits which he produced in his own name, but he cannot have been an altogether incompetent master, for besides Anthony Walker he trained two other notable eighteenth-century engravers, William Woollett who was Walker's junior by some nine years, and John Browne, the Essex engraver who became his apprentice in 1755.[1]

Although Walker's time with Tinney cannot have overlapped for long with Woollett's, the two engravers must have known each other well; they were to collaborate later at an important stage in Woollett's career. More significant, however, is another link between Tinney's three pupils Browne, Woollett and Walker, namely certain common characteristics of technique. Woollett has long been credited with an important development in English line engraving in that he made extensive use of preliminary etching and often rebit his plates in the acid bath several times before finishing his work with the graver. Now it is striking that the same manner distinguishes not only the plates executed by John Browne—reputedly a much better etcher than Woollett—but also those done earlier by Anthony Walker and by his brother William. Walker's method was much more involved than that used to produce the plain line engravings of most of his contemporaries; there is in fact often much more etching in his plates than engraving and this he himself emphasized when he signed his prints, apparently without distinction, either 'Anthony Walker fecit' ('aqua forti' generally understood), or 'sculpsit'. This technique certainly helped to give Walker's engravings greater movement and flexibility than pure line engraving, but for book-illustration, usually on a small scale, it had grave disadvantages: the partly etched plates, worked in great and sometimes very delicate detail, failed to give fresh impressions in sufficient numbers even for one edition, a defect which was aggravated by his habit of laying dark lines so close together that they tended to produce indistinctness and confusion.

The earliest signed work of Anthony Walker's is a fine engraved title-page for Kitchin's small *English Atlas* published in 1749; and from then onwards until his death hardly a year passed without publication of a book bearing at least a frontispiece or title-vignette engraved by him from a design of his own. Walker's engravings large and small after the designs of other artists, however, vastly outnumber his original work.

Walker was among the 154 painters, sculptors, architects, engravers and cognoscenti who were present on 5 November 1757 at the annual Dilletante Virtuosi Feast at the Foundling Hospital, but it is not recorded that he played any prominent part in the counsels of the artists of his time or that he was present at the important meeting two years later which led to the organization of the Spring Gardens Exhibition of the Society of Artists in 1760. In that year Walker was associated with Woollett in the engraving of Richard Wilson's *Niobe* and is said to have executed the figures on this copperplate, the first major line engraving to be commissioned by Boydell. For the rest of his life, Walker was to work regularly for Boydell; the last picture which he engraved for him, Rembrandt's *The Angel departing from the House of Tobit*, was published on 1 May 1765, within only a week of his death.

It would appear that Walker regarded his work as an engraver, for which Boydell is known to have paid generously, as a far more important achievement than his original designs for book-illustration, for at the exhibitions of the Society of Artists in which he took part between 1760 and 1765, his own exhibits were chiefly prints from great masters: in 1763 two after Ostade and one after Pietro da Cortona; in 1764 *The Country Attorney and His Client* from a painting then attributed to Hans Holbein; and in 1765 Rembrandt's *Tobit*. Walker's only other reported exhibit, the 'Scenes from Shakespeare' which he showed at the opening exhibition in 1760, present something of a problem.

[1] Browne (1741–1801) made his repute as an engraver of landscapes, many of them for Boydell, but does not seem to have been employed by the book trade.

The Folger Library has five prints for *Romeo and Juliet* signed 'Anty Walker Invt del et Sculp$^{t'}$ (Plates 23, 24.) Four drawings for these plates are in the Huntington Library along with ten other Shakespearian subjects (five each for *King John* and *Henry IV Pt. 1*). All these drawings, except one for *King John*, are accompanied by prints, some of which are trimmed, others have the publishing date January 15, 1795 by Mno. Bovi, No 207 Piccadilly. Only the *Romeo and Juliet* prints have Walker's name, but the others can safely be attributed to him. There is no indication that any of these prints were published before 1795, or incorporated in any edition of Shakespeare's works. The characters are dressed in vaguely medieval costume, but the Capulet ball is an eighteenth-century *route* in a Palladian setting.[1]

That Walker should have regarded himself primarily as an engraver rather than as a draughtsman is understandable, for commercially there was little if any demand for drawings, while 'burrinating' was not merely an old and highly respected craft but becoming, by the middle of the eighteenth century, an employment profitable to executants. Yet, as a matter of fact, Walker's technique of doing a great deal of preliminary etching before finishing his plates with the graver and his almost invariable habit of filling every part of the pictorial surface make his engravings, especially the small ones, not altogether satisfactory to the eye. Despite the encomium that was bestowed by Horace Walpole on Walker's work,[2] there is certainly some force in the criticism of a near-contemporary colleague, Strutt, who remarked that his prints 'would have appeared to more advantage, if they had been executed in a clear determined style; but the manner which he adopted is so heavy, and confused, that it is often difficult to distinguish one figure from another.'

As a designer and draughtsman, on the other hand, Anthony Walker, at his best, need not fear comparison with his English contemporaries. His ability as a designer is seen to great advantage in the illustrations he did for Warburton's edition of Pope's *Works*, published early in his career in 1751, a task which brought him into direct competition

with some of the principal illustrators of the time: Francis Hayman, Samuel Wale, and Nicholas Blakey. The two designs from Walker's hand, the frontispieces for *The Temple of Fame* and *The Rape of the Lock*, with their delicacy of composition and lightness of movement are by far the most attractive in these volumes, and easily outclass Hayman's rather clumsy efforts and the typically slip-shod performances by Wale. But the opportunity to produce a whole series of plates in illustration of a major work of literature unfortunately never came to Walker. What he could do, and what he might have done with a congenial subject, can perhaps be seen from the eight successful plates which he did in illustration of Somerville's poems *The Chace* and *Hobbinol*, and for Philip's *Cyder* and *The Splendid Shilling*, though here again it is difficult to find copies of the books containing even reasonably adequate impressions of the plates.

Designs by Walker intended for general decorative purposes are found in at least two Drawing Books of the period, the *Ladies' Amusement* (first published *c.* 1760) and the *Complete Drawing Book* (1762). The only engraving of this kind which is so far known to have been used for transfer printing on china is a scene of two lovers seated on a mound beside a dovecot, found on a mug in the Thoms collection and reproduced by Mr. Cyril Cook in his *Life and Work of Robert Hancock*, item 62.

The original drawings by Anthony Walker so far identified with certainty, on which his reputation as an artist must primarily rest, are designs for book-illustrations in an elegant, somewhat French convention. This makes it tempting to attribute to Walker two other drawings, interiors with elaborate and highly decorative furnishings and accessories very much in the French style, one of which, signed 'A.W.', is in the B.M. In the absence, however, of any positive evidence connecting Walker with France or any artist of the rococo school it would perhaps be rash to attribute these highly accomplished drawings more than tentatively to him.

In 1764 Walker's address is given as 'At the Daffy's, Elixir Warehouse, Clerkenwell'. A year later, on 9 May 1765, he died suddenly at Kensington, aged thirty-nine. The cause of his death is not known and he left no will. 'Administration of the Goods, Chattels and Credits of Anthony Walker, late of the Parish of St. Dunstan in the West London but at Kensington in the County of

[1] H. A. Hammelmann, *Connoisseur*, CLXVII, 1968, pp. 167–174; R. R. Wark, *Drawings from the Turner Shakespeare*, p. 49.

[2] *Correspondence*, (ed Lewis), XV, New Haven and London 1951, p. 97. Walpole writing to Dalrymple in 1764 said that when he pressed Walker to consider his reputation he replied 'that he had got fame enough'.

Middlesex, deceased' was granted to 'Mary Walker widow the relict of the said deceased' on 22 November 1765. He was survived by more than a quarter of a century by his younger brother William (grandfather of the Victorian painter, Fred Walker), who became a well-known and successful reproductive engraver, but appears to have done little original work.

H. A. Hammelmann, *Book Collector*, 1954, pp. 3–12.

1749 [T. Kitchin], *The small English Atlas being A New and Accurate Sett of Maps of all the Counties in England and Wales*. Sm. 4to. Kitchin and Jeffreys. Fine eng. title.

1750–53 *The London Magazine; or, Gentleman's monthly intelligencer*. 8vo. 'Printed for Baldwin.' Fronts. to Vols. XX and XXIII; explanation of the subjects is given at the end of the Preface. Other vols. of this magazine probably contained work by Walker.

1751 Alexander Pope, *The Works . . . In nine volumes complete . . . with the commentaries and notes of Mr. Warburton*. 8vo. 'For Knapton, Lintot, Tonson and Draper.' Front. and 2 pls. Also, poorly reduced, in the 12mo ed., 1757, in 10 vols.

1751–5 *The Universal Dictionary of Trade and Commerce, translated from the French . . . of the celebrated Monsieur Savary . . . by M[alachy] Postlethwayt*. 2 vols. Folio. 'For John and Paul Knapton.' Front.: bearing beneath a quotation from Gay's *Fables*: 'O Britain chosen port of Trade', etc., eng. C. Mosley. There is also a title-vig. s. 'J. Basire sc.' which is probably not by Walker. The original drawing for the front. is in the B.M.; it is s. and dated 1755. The print does not bear his signature.

1753 Jonas Hanway, *An historical Account of the British Trade over the Caspian Sea . . . in four volumes*. 4to. 'Dodsley, Nourse and others.' This work contains, besides engravings after Hayman, Blakey and Wale, 4 portraits eng. Walker, 4 headpieces embodying heraldic devices des. and eng. by him for the dedications in each vol. as well as 2 other headpieces by him. All these pls. (in rather worn state) reappear in the 2nd ed., 2 vols. 4to, 1754, for T. Osborne et al.

1754 Alexander Drummond, *Travels through different cities of Germany, Italy, Greece and several parts of Asia*. Folio. 'By W. Strahan for the Author.' Large folding front. 'J.S.M[üller] sc.', almost certainly from a drawing by Walker. Numerous views etc. eng. Müller.

c. 1755 Tom Brown's *Complete Jester*, 4th ed. Front.

1755 Sir James Marriott, *Two Poems presented to his Grace the Duke of Newcastle . . . upon his Grace's revisiting* [Cambridge]. 4to. London, [no publ. but probably R. and J. Dodsley]. Medallion title-vig. and tailpiece: the Senate House, s. 'I. Marriott figuras del. et inv., A. Walker sculpsit.'

1756 [Jonathan Richardson], *The Paths of Virtue delineated; or, the history in miniature of the celebrated Pamela, Clarissa Harlowe, and Sir Charles Grandison. Familiarised and adapted to the capacities of youth.* 12mo. 'For R. Baldwin.' Front.

1756 Christopher Smart, *Hymn to the Supreme Being*. 4to. 'For J. Newbery.' Oval title-vig.

1756 John Duncombe, *Poems*. 4to. 'R. and J. Dodsley.' Title-vig. and tailpiece identical with those for Marriott's *Two Poems*.

1757 William Somerville, *The Chace. A poem*. 8vo. 'For G. Hawkins.' Front. by Gravelot [reduced (in reverse) by Walker from the 1st ed., 4to, 1735], and 7 pls. des. and eng. Walker. 4th ed. Frequently reprinted, 5th ed. 1767; again Birmingham 1767, and [with *Hobbinol*] 1737.

1757 *A Treatise Composed by Tho. Foubert, Author of Several Curious Performances of Mechanism*. 4to. Eng. title.

1757–72 *A Collection of the Dresses of Different Nations, Antient and Modern* [titles in English and French on opposite pages]. 4 vols. 4to. 'Published by Thos. Jeffreys.' Title-vig. eng. Grignion for Vols. I and II [identical].

c. 1757 *The Bull-Finch, a collection of Songs*. 12mo. n.d. Front.

1758 Jonas Hanway, *Three letters on the subject of the Marine Society*. 4to. 'For Dodsley, Vaillant and Waugh.' Front. to Letter III s. 'F. Hayman delint et donavit Ant. Walker Sculpt et donavit.'

1758 *Atlas Minimus or New Set of Pocket Maps of the several Empires, Kingdoms and States of the World . . . drawn and engraved by J. Gibson, revised . . . by Eman Bowen, geographer to His Majesty*. 16mo. 'Publ. according to Act of

Parliament and sold by J. Newbery.' Front. unsigned but probably by Walker.

1758 Thomas Foubert, *The Litherary* [sic] *Cards, being a new invention to learn to read . . . embellished with Forty-eight Heads of Illustrious Personages and other ornamental Engravings, curiously done on Copper-Plates.* Folio. 'London, printed for the Author and sold in his lodgings at Mr. Slade's Grocer, in Castle Street near Oxford Market.' Front. 'A. Walker del et sculp', also a fine pl. eng. Walker after Lancret.

1759 Jonas Hanway, *Reasons for an augmentation of . . . mariners to be employed in the Merchant's Service.* 4to. 'For R. and J. Dodsley.' Half-page headpiece,

1759 *The Youth's Pocket Companion or Universal Preceptor.* 12mo. 'For J. Coote.' Allegorical front.: 'Behold Minerva, See her crown the boy'. 2nd ed.

1759–62 Benjamin Martin, *The Young Gentlemen's and Ladies' Philosophy.* 2 vols. 8vo. 'For W. Owen.' Front. Vol. I. (Plate 25). A 2nd ed. with Walker's front. appeared in 1772.
 The work forms part of Martin's *General Magazine of Arts and Sciences,* 14 vols., 1755–65. Walker's original drawing was in the collection of the late Mr. A. P. Oppé; it was reproduced in *The Library* (1936), 4th series vol. xvii, facing p. 20.

1760 Sir James Marriott, *Poems, written chiefly at the University of Cambridge, together with a Latin oration.* 8vo. 'Printed by James Bettenham.' Walker's 2 illustrations for Marriott's *Two Poems,* 1755, reappear here: the Senate House as full-page front., the medallion vig. as tailpiece. 5 other tailpieces are added; these were all des. by Marriott and probably all eng. T. Major, though only 2 are so signed.

1760 *A New and Complete Collection of Voyages and Travels: comprising whatever is valuable of this kind in the most celebrated English, Dutch, French . . . Writers . . . The whole being a general survey of Europe . . . Illustrated with fifty-two elegant copper-plates.* 4to. 'For J. Coote, 1760.' Front. s. 'A. Walker del. et sculp.' The other pls. eng. Adam Smith, H. Roberts, James Roberts, T. Kitchin, Proud after unsigned topographical designs.

1760 [Arthur Murphy], *The Desert Island, a dramatic*

poem. 8vo. 'For Paul Vaillant, Southampton Street, in the Strand.' Front.

1760 Samuel Foote, *The Minor, a comedy.* 8vo. 'By J. Coote' et al. Front. 'A. Walker inv. and sculp'. Repeated up to 6th ed. 1764, with signature almost worn away.

1760–1 [Mrs. Charlotte Lennox], *The Lady's Museum. By the Author of The Female Quixote.* 2 vols. 8vo. 'For J. Newbery, J. Coote' et al. Front.

1760–7 *The British Magazine; or Monthly Repository for Gentlemen and Ladies.* 8 vols. 8vo. 'For H. Payne.' The first 2 vols. contain the first appearance of Smollett's *Launcelot Greaves* with illustrations by A. Walker. These were the first known magazine illustrations of a serialized novel.

1760 [Arthur Murphy], *The Way to Keep Him, a comedy in five Acts.* 8vo. 'For P. Vaillant.' Fronts. Again in 2nd ed. of same year, but not in subsequent ones.

1762 John Ogilvie, *Poems on several subjects.* 4to. 'For G. Keith.' Title-vig.

1762 John Philips, *Poems attempted in the style of Milton.* Sm. 8vo. 'Tonson and Lowndes [sic].' Front. portrait unsigned. 2 pls. for *The Splendid Shilling* and *Cyder.*

1762 [J. Newbery], *The Art of Poetry on a new Plan.* 2 vols. 12mo. 'J. Newbery.' Front.

1763 *A Description of Millennium Hall and the country adjacent . . . By a Gentleman on his travels.* 12mo. 'For J. Newbery.' Front.

1763 Thomas Gordon, *A Cordial for Low Spirits: being a collection of curious Tracts.* 3 vols. 12mo. 'For Wilson and Fell.' Front.

1763 [Jonas Hanway], *Christian Knowledge made easy: . . . To which are added, The Seaman's faithful Companion . . . The whole calculated for the use of young Persons: And this particular Book, adorned with Engravings, to render it more acceptable to* [blank], *to whom it is presented.* 8vo. Front.

1764/5 *Museum Rusticum et Commerciale; or, select papers on agriculture, commerce, arts and manufactures . . . Revised and digested by several members of the Society for the Encouragement of Arts, Manufactures, and Commerce.* 3 vols. 8vo. 'For R. Davis, J. Newbery et al.' Front. to

Vol. I unsigned but probably by A. Walker; other technical pls. by M. Darley et al.

1764 John Ogilvie, *Providence. An allegorical poem.* 4to. Title-page and 3 pls.

1764 D. Fenning, *The Young Man's Book of Knowledge.* 8vo. 'For S. Crowder and B. Collins.' Front. Same front. in 3rd ed. of 1774.

1764 [James Ridley], *The Tales of the Genii; or the Delightful lessons of Horam . . . by Sir Charles Morell.* 2 vols. 8vo. 'For J. Wilkie.' 12 pls., 1 eng. I. Taylor and 2 des. and eng. Taylor. The 3rd ed., 1766, contains 2 additional pls. by Walker, 1 for each vol. Some of Walker's pls. show clear signs of re-working.

1764 John Ogilvie, *Poems on several subjects.* 8vo. 'For G. Keith.' Title-vig. identical with that for the *Poems* of 1762, 2 pls. for 'The Day of Judgment' and headpieces for 'Odes'.

1767 *A collection of the most esteemed pieces of poetry . . . With a variety of originals by the late M[oses] Mendez.* 8vo. 'For Richardson and Urquhart.' Headpiece eng. Isaac Taylor. 2nd ed. 1770.

1767 Torquato Tasso, *Jerusalem Delivered: An Heroic Poem translated from the Italian . . . by John Hoole.* 2 vols. 12mo. 'For T. Davies and J. Dodsley.' 2 title-vigs.

1769 John Ogilvie, *Poems on Several Subjects.* 2 vols. Sm. 8vo. 'By T. and J. W. Pasham for George Pearch.' Title-vig. from *Poems* 1762, reduced by Isaac Taylor.

1775 *The Kentish Songster, or the Ladies and Gentlemen's Miscellany.* 12mo. 'Canterbury, by Simmons and Kirby', also 'London by J. Johnson.' Title-vig. eng. I. Taylor.

1776 Thomas Gray, *Poems . . . A new edition.* 12mo. 'For J. Murray and C. Elliott, Edinburgh.' The same title-vig. as in Ogilvie's *Poems.*

1782 *Scriptores Romani; sive selecta ex M. T. Cicerone, Tit. Livio, Editio altera.* 12mo. 'Etonae, Excudit Jos. Pott.' Title-vig., probably occurs in earlier editions of this school-book.

William WALKER, 1729–93
Brother of Anthony, Redgrave describes him as 'one of a family of 10 children, all of whom were remarkable for their love of drawing'. He was employed by Boydell. 'Early in life he discovered the valuable art of rebiting, and Woollett, who occasionally used the process, when successful was wont to exclaim, "Thank you, William Walker".' (Redgrave)

1771 J. H. Wynne, *The Prostitute, a Poem.* 4to. 'For J. Wheble.' Large oblong title-vig.

1772 *Sanitas, Daughter of Aesculapius. To David Garrick, Esq. A poem.* 4to. 'For G. Kearsley' et al. Large oval title-vig.

1780 *The Novelist's Magazine*: [see Dodd] Goldsmith, *The Vicar of Wakefield.* 'Ill.'

1791 Shakespeare's *Plays* [see under Corbould]. 1 pl.

John WALL, 1708–83
He was a practising physician at Worcester, but painted and designed as an amateur.

1751 R. O. Cambridge, *The Scribbleriad* [see under Gravelot]. Front. 'J. Wall inv.' eng. Boitard.

Benjamin WEST, 1738–1820
West and his son Raphael (1769–1850) both painted for Boydell's Shakespeare Gallery, but not surprisingly the President of the Royal Academy was not much engaged in book illustration. Bryan Edwards's *History of the British Colonies in the West Indies,* 1794 (see under Stothard) has a front. to Vol. I: an Indian Cacique addressing Columbus, 'B. West delint, F. Bartolozzi sculpt.'

Richard WESTALL, 1765–1836
He studied in the Academy Schools and became A.R.A. in 1792, R.A. in 1794. For a time he shared a house with Lawrence in Soho Square. His 'Christ crowned with Thorns' is still the altarpiece at All Souls, Langham Place, and is an example of his historical style. He painted five subjects for Boydell's Shakespeare Gallery, and one each for Bowyer's History Gallery and Macklin's *Bible.* He was much employed as a book illustrator, but the larger part of his output is after 1800.

1794 Samuel Rogers, *Pleasures of Memory* [see under Stothard]. 2 pls., woodcuts by Luke Clennell.

1794-7 John Milton, *The Poetical Works.* 3 vols. Folio. 'Printed by W. Bulmer for J. and J. Boydell.' All pls. by Westall. See M. Pointon, *Milton and English Art,* pp. 119-21.

1791-7 *Bell's British Theatre*: [see under Fuseli] *Philaster (as altered from Beaumont and Fletcher).* 1 pl. eng. Bartolozzi.

Robert WHITE, 1645–1704

He was mainly employed in drawing and engraving portraits. His son George (1671–*c*.1734) was also an engraver. The book listed below may be from a re-used plate by Robert.

1739 [John Hildrop], *An Essay for the better regulation and development of Freethinking.* 8vo. 'For R. Minors.' Front. des. and eng. R. White.

W. WHOLEY

1799 *Cooke's Sacred Classics*: [see under Corbould] O. Goldsmith, *Essays.* 2 pls. eng. Warren,

1799 *Cooke's Select Classics*: *Adventurer.* 6 pls. eng. Hawkins; *Rambler.* 7 pls. eng. Woodman and Waite; *Idler.* 4 pls. painted by W. Wholey, ornamented by R. W. Satchwell, eng. Woodman.

John WOOTON, d. 1765

He is best known as a painter of animals, generally working on a large scale. His 29 illustrations to Gay's *Fables* in 1727 (see under Kent) were engraved by Fourdrinier, G. and J. van der Gucht, Baron and Motte, and were re-adapted by Blake and others for the edition of 1793.

Thomas WORLIDGE, 1700–66

He was born in Peterborough and taught by an Italian painter, Grimaldi, working in the English provinces, whose daughter he married. He was chiefly known for his etchings after antiques, particularly gems, and the style he developed was known as the 'scritch-scratch manner'. He did copies of the Old Masters, particularly Rembrandt, and miniatures on ivory. Etching being a method that produced less durable plates than copper engraving, he was not much employed by the publishers, but his etching 'The Mowers' for Smart's *Poems* is a pleasant piece.

See H. A. Hammelmann, *CL*, CXLIV, 1969, pp. 414–15.

1755 W. Toldervy, *Select Epitaphs.* 12mo. 'For W. Owen and sold by R. and J. Dodsley et al.' Vol. I front. eng. Boitard.

1752 Christopher Smart, *Poems on Several Occasions* [see under Hayman]. Pl. des. and etched Thomas Worlidge.

George WRIGHT

1775 George Wright, *Solitary Walks: to which are added the Consolations of Religion.* 16mo. 'For W. Otridge.' Front. des. G. Wright, eng. G. Burder. 3rd ed.

J. WRIGHT

c. 1772 [Mrs. Anne Penny], *Poems, with a dramatic entertainment.* 4to. 'For J. Dodsley' et al. Title-vig. and 4 headpieces eng. I. Ross and J. Caldwell.

1780 [Mrs. Anne Penny], *Poems.* 4to. 'For J. Dodsley and P. Elmsley.' Title-vig. eng. I. Ross.

PLATES UNSIGNED BY THE DESIGNERS

A catalogue of eighteenth-century illustrated books where the designer is unnamed would run to great lengths, and would include much work of mediocre quality. The following very brief list is only intended as some indication of the range of this material.

c. 1708 [Dr. King], *The Art of Cookery In Imitation of Horace's Art of Poetry . . . By the Author of The Journey to London. Humbly inscrib'd to the Honourable Beef Steak Club.* 8vo. 'For Bernard Lintott.' Front.: scene of ancient cookery, eng. M. van der Gucht. 2nd ed. 1st ed. had no front.

1712 [A. Pope], *Miscellaneous Poems and Translations by Several Hands.* 8vo. 'For Bernard Lintott.' Front. eng. E. Kirkall.

1718 Shakespeare, *The Tragical History of King Richard the Third. Revised with alterations by Mr. Cibber.* 8vo. 'For W. Mears, at the Lamb et al.' Front.: the Crown being offered to Henry Tudor on the battlefield, eng. E. Kirkall.

1724 *Tamerlaine an Opera Compos'd by Mr. Handel and Corrected and Figur'd by his own hand.* 4to. 'Engraved, printed and sold by J. Cluer.' Front.: Handel harping, with the Muse flying above.
Other of Handel's operas were published by Cluer with engraved frontispieces; that of *Rodelinda* is the same as *Tamerlaine*. The publication of Handel's scores and librettos is a large and complex subject.

1737 *Bacchus and Venus: or, a Select Collection of near 200 . . . Songs and Catches in Love and Gallantry, many of which never appeared in print before.* 12mo. 'For R. Montague.' Woodcut front., 'W. Pennock sculp.' [One of the very rare good woodcuts of the period.]

1739 [Henry St. John, Viscount Bolingbroke], *A Dissertation upon Parties; in several letters to Caleb d'Anvers Esq.* 8vo. 'For R. Franklin.' Front.: Walpole surrounded by allegorical figures. 5th ed.

1749 [John Cleland], *Memoirs of a Woman of Pleasure.* 2 vols. Large 12mo. 'Printed for

G. Fenton in the Strand.' 9 mezzotint pls, all unsigned. 3rd ed.
The only copy of this edition seems to be that in the Royal Library in Copenhagen. It is one of the earliest examples of erotic book illustration produced in England. It was later to be better known under the name of its heroine, Fanny Hill. Information from Dr. P. Steen Larsen.
See D. Foxon, *Libertine Literature in England 1660–1745*, New York 1965.

1757 F. L. Norden, F.R.S., *Travels in Egypt and Nubia.* 2 vols. Folio. 'For Lockyer Davis and Charles Reymers, Printers to the Royal Society.'
The editor, Dr. Peter Templeman draws attention to the problem of 'engraving so large a number of plates and the improbability, to say the least, of getting the execution anything comparable to the original'.

1760 Alexander Pope, *The Iliad of Homer.* 8vo. 'By Charles Rivington for Osborne et al.' Portrait front. and 28 headpieces of narrative scenes, all unsigned.

1770 Philip Thicknesse, *The Valetudinarians Bath Guide; or, the Means of obtaining long life and health.* 4to. 'For J. Dodsley et al. Sold by Wood opposite the Pump Room.' Front.: The Genius of Nature in Contemplation of the Universe.

1780 *Novellettes, selected for the use of Young Ladies and Gentlemen, written by Dr. Goldsmith, Mrs. Griffiths etc. and illustrated by elegant engravings.* 8vo. 'Printed for Fielding and Waker, Paternoster-row.' Portrait front.: Mrs. Griffith [described in the preface as 'the ornament and pride of her country, she has strove to open the flood-gate of Literature to her sex, and purifying the stream from the filth with which it was impregnated, to make it glide with meandering Invitation through the vallies.'] The 4 pls. are unsigned, but of good quality, possibly based on French designs.

1781 William Hayley, *Ode, inscribed to John Howard,* 4to. 'For J. Dodsley.' Front.: Howard visiting a prisoner, eng. Bartolozzi. 2nd ed.

INDEX OF AUTHORS AND TITLES

Titles are listed only of anonymous works.

GENERAL INDEX

The words (engraver) and (publisher) after surname-only entries are used loosely as a general guide.

ILLUSTRATIONS

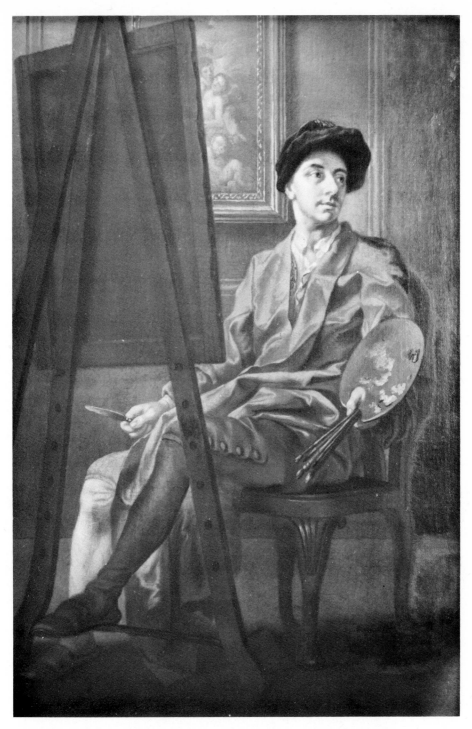

1. Francis Hayman: *Self-portrait*; Royal Albert Memorial Museum, Exeter.

2. *Cyder. A Poem*; frontispiece engraved and probably designed by M. van der Gucht, 1708.

3. (below, left) F. Boitard: scene from *Hamlet*; Tonson's edition, 1709; engraved E. Kirkall.

4. (below, right) Scene from *The Tragical History of King Richard III* (Shakespeare adapted by Colley Cibber); engraved and probably designed by Elijah Kirkall, 1718.

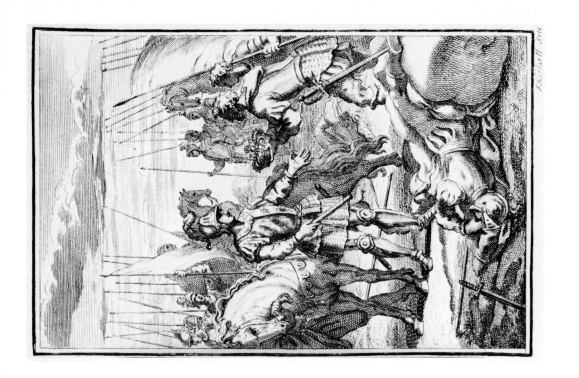

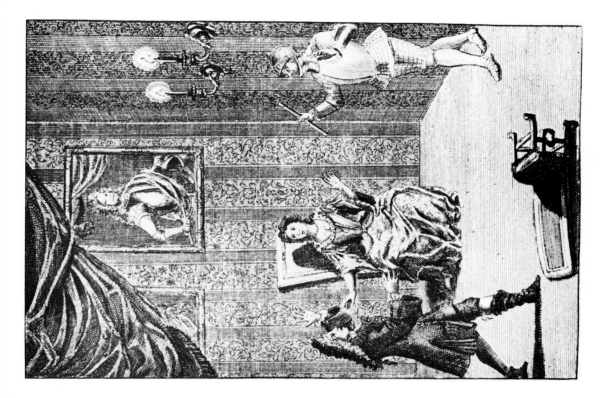

6. G. van der Gucht, designed and engraved: scene from *The Drummer* or *The Haunted House* by Joseph Addison, 1735.

5. Louis du Guernier, designed and engraved: scene from *Rosamond* by Joseph Addison, 1725.

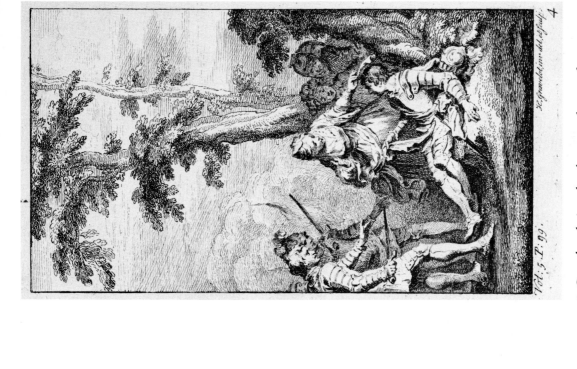

Vol: 5. P. 99.

H. Gravelot inv. del. et sculp.

4

8. Gravelot, designed and engraved: scene from
Henry VI, iii; Lintot's edition, 1740.

7. Gravelot: scene from *Henry VI*, iii; drawing,
Albertina.

10. Gravelot: scene from *Macbeth*; Lintot's
edition, 1740; engraved G. van der Gucht.

9. Gravelot: scene from *Macbeth*; drawing,
Albertina.

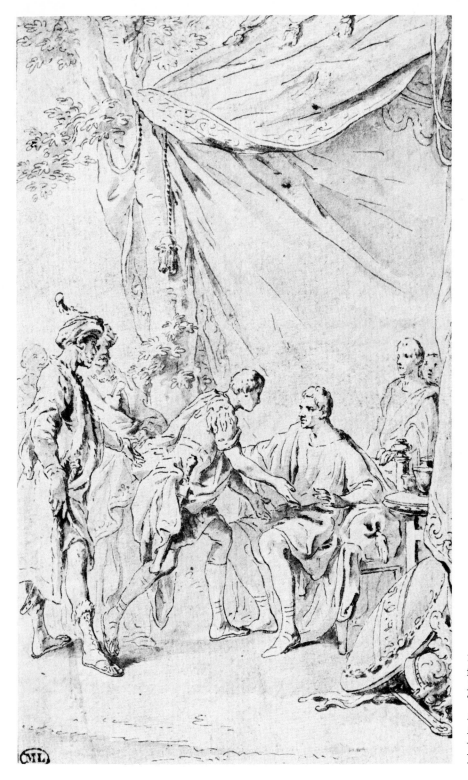

11. Gravelot: drawing
for Rollin's *Roman
History*, Vol. VII 1742,
'The Ambassadors of
Antiochus sent to Scipio
Africanus with his son,
without ransom';
Louvre.

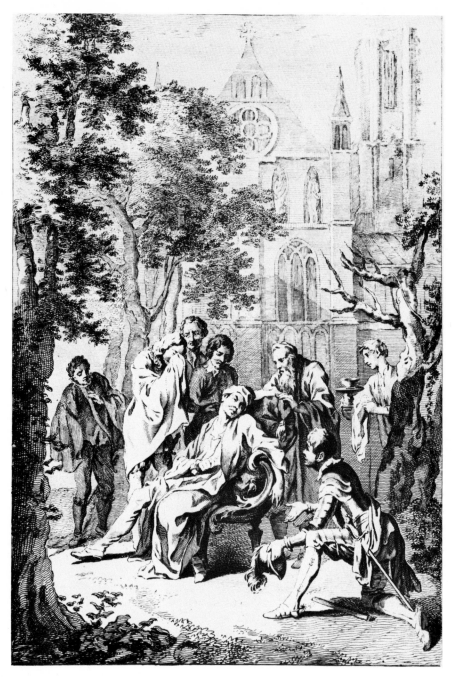

12. Hayman: scene from *King John*; Hanmer's edition of 1744; engraved Gravelot.

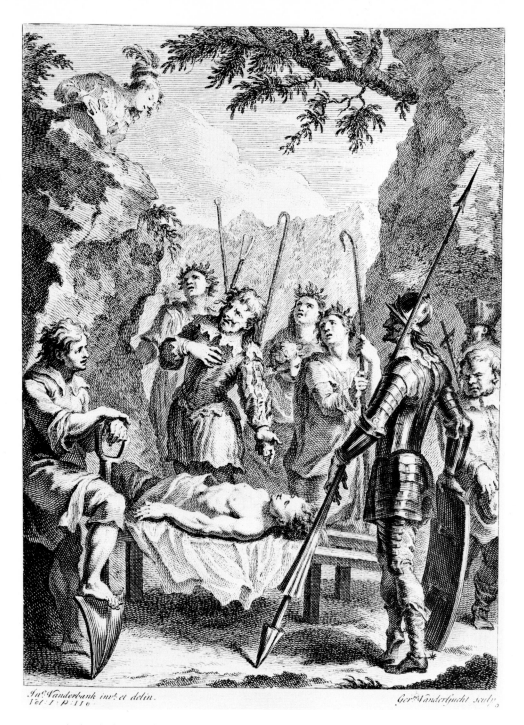

An.ᵉVanderbank inv.ᵗ et delin.
Vol. I. P. 110.

Ger.ᵈVanderGucht sculp.

13. Vanderbank: 'Funeral of Chrysostom' from *Don Quixote*, 1738; engraved G. van der Gucht.

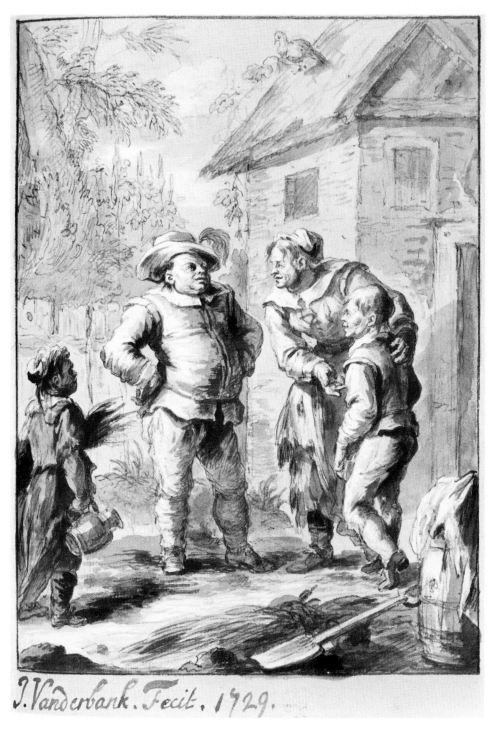

J. Vanderbank. Fecit. 1729.

14. Vanderbank: 'Sancho Panza and his Family'; drawing, Pierpont Morgan Library.

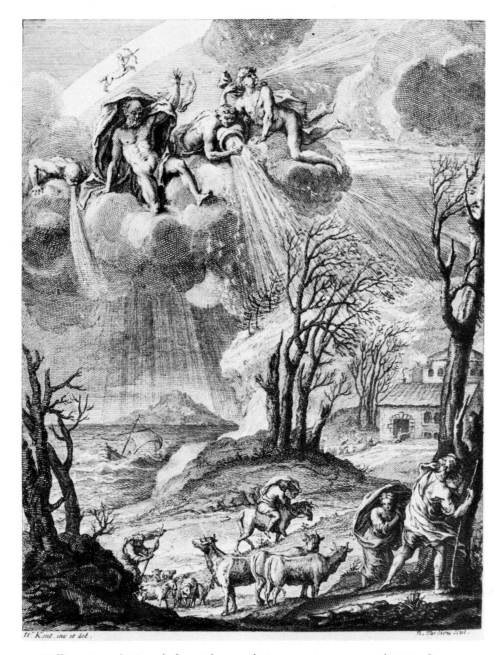

15. William Kent: 'Winter'; from Thomson's *Seasons*, 1730; engraved N. Tardieu.

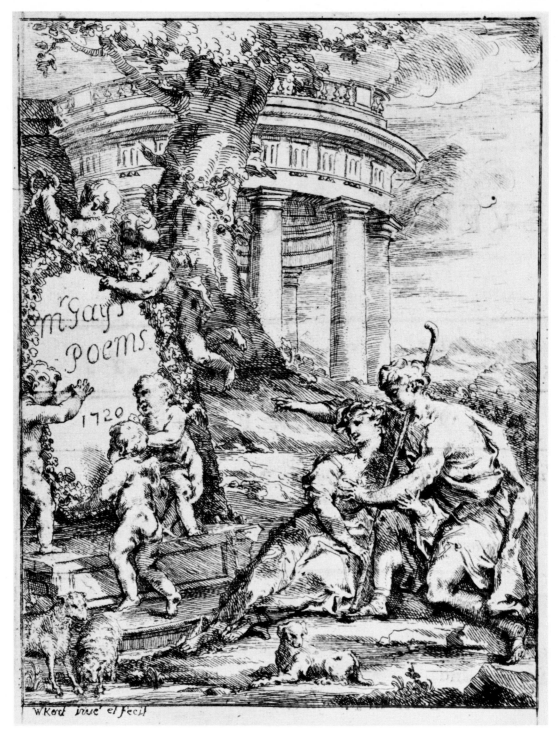

Mr Gay's
Poems.

1720

W Kent inve' et fecit

16. William Kent: drawing for title-page of Gay's *Poems*, 1720; British Museum.

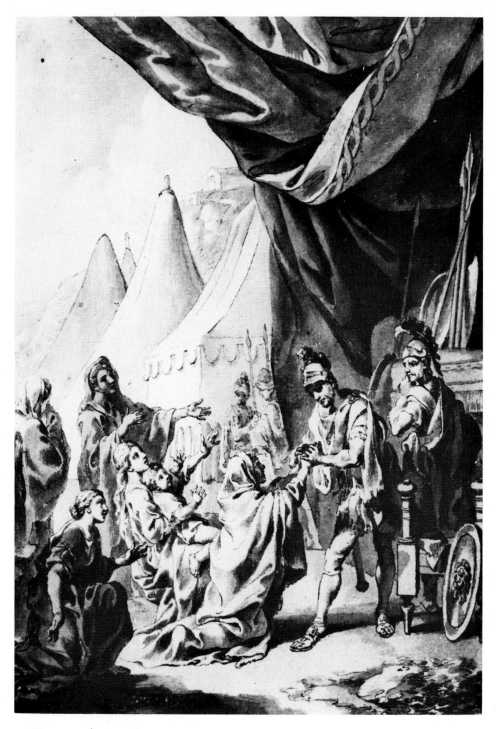

17. Hayman: drawing for *Coriolanus*; Folger Shakespeare Library.

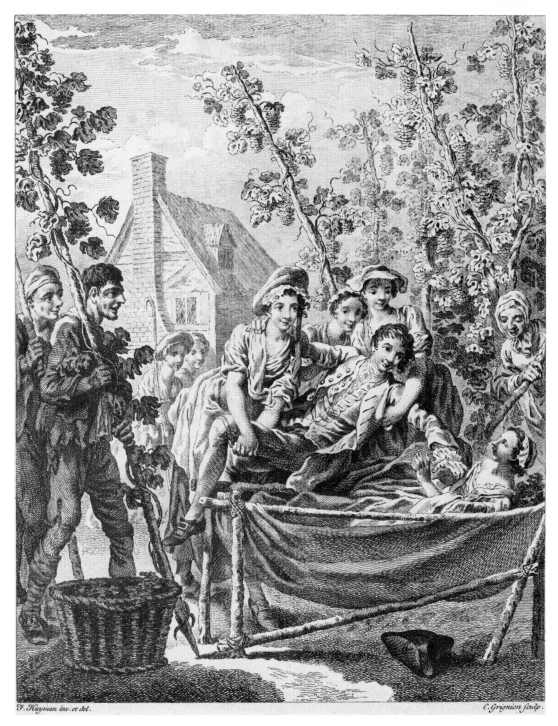

F. Hayman inv. et del.

C. Grignion sculp.

18. Hayman: 'The Hop Garden' from Christopher Smart, *Poems on Several Occasions*, 1752; engraved
C. Grignion.

19. Hayman: drawing for *Fables for the Female Sex*; engraved C. Grignion in edition of 1744; Waddesdon Manor (National Trust).

20. Hayman: drawing for *Fables for the Female Sex*; engraved C. Grignion in edition of 1744; Waddesdon Manor (National Trust).

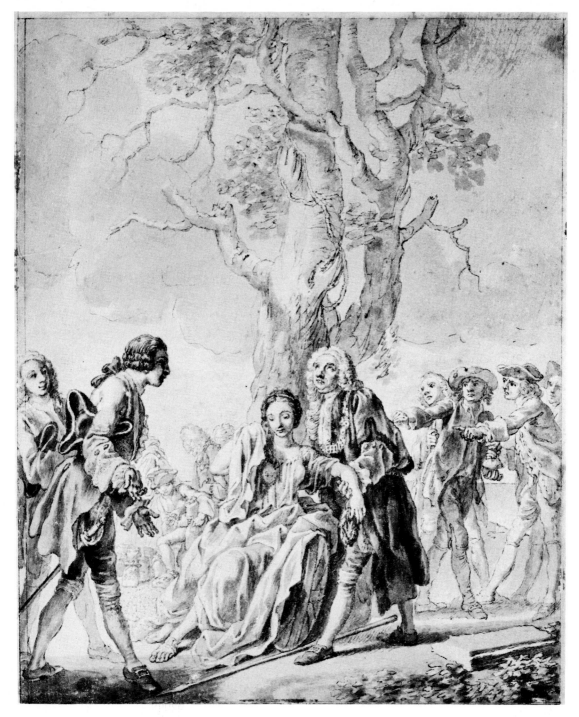

21. Hayman: drawing for Hanway, *Trade over the Caspian Sea*, Vol. II; emblematical Description of the State of Britain with regard to her debts; engraved C. Grignion in edition of 1753; Huntington Library.

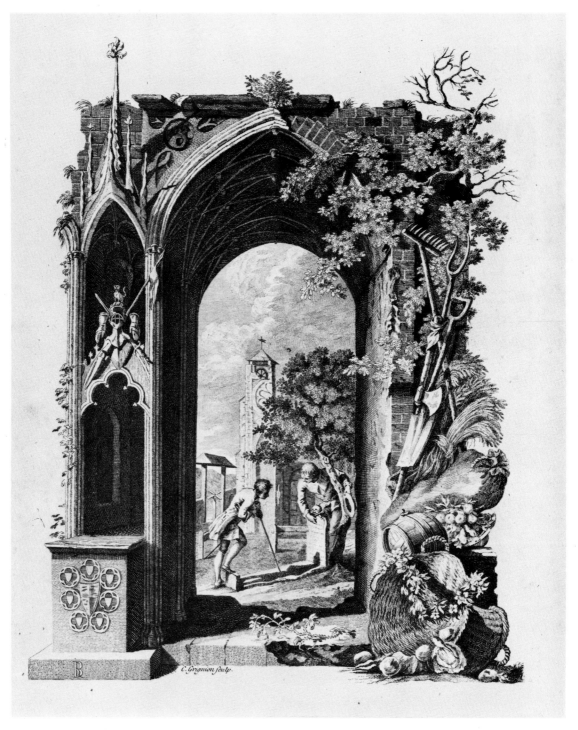

C. Grignion sculp.

22. *Designs by Mr. R. Bentley for Six Poems by Mr. T. Gray*: 'Elegy in a Country Churchyard'; engraved
C. Grignion, 1753.

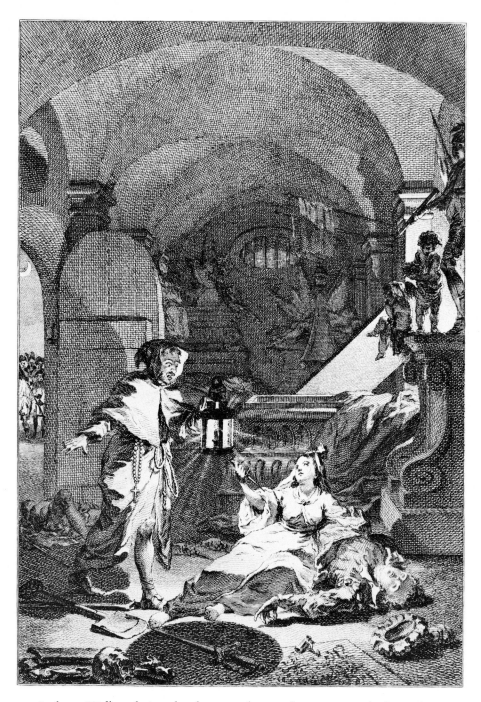

23. Anthony Walker, designed and engraved: scene from *Romeo and Juliet*; Folger Shakespeare Library.

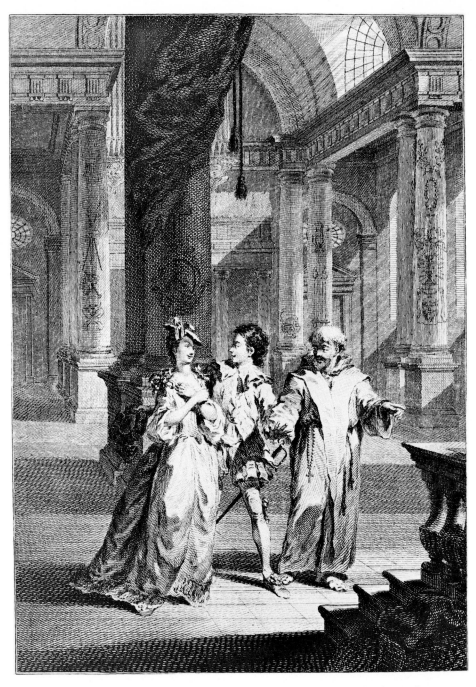

24. Anthony Walker, designed and engraved: scene from *Romeo and Juliet*; Folger Shakespeare Library.

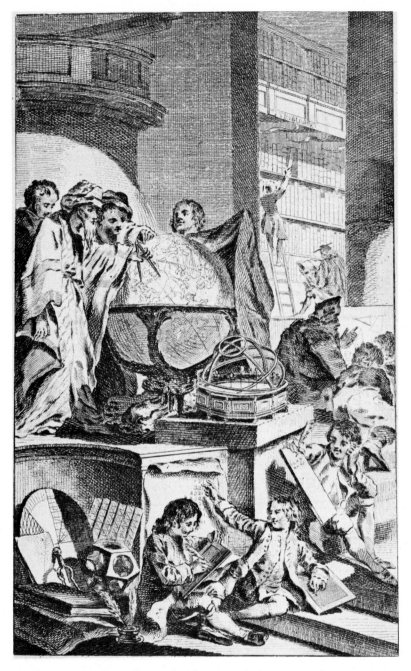

25. Anthony Walker, designed and engraved: frontispiece for Benjamin
Martin, *The Young Gentleman's and Lady's Philosophy*, Vol. I, 1759.

26. Isaac Taylor, designed and engraved: frontispiece for John Cunningham, *Poems chiefly Pastoral*, 1766.

28. Edward Edwards: *Hamlet*; John Bell's edition, 1774, engraved J. Hall.

27. Isaac Taylor, designed and engraved: scene from *Othello*; John Bell's edition, 1774.

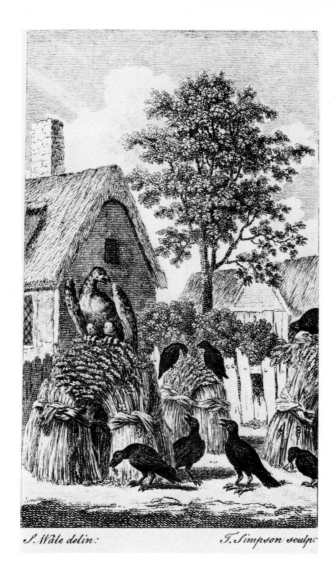

S. Wale delin: T. Simpson sculp:

29. Samuel Wale: William Wilkie, *Fables*, 1768; engraved
T. Simpson.

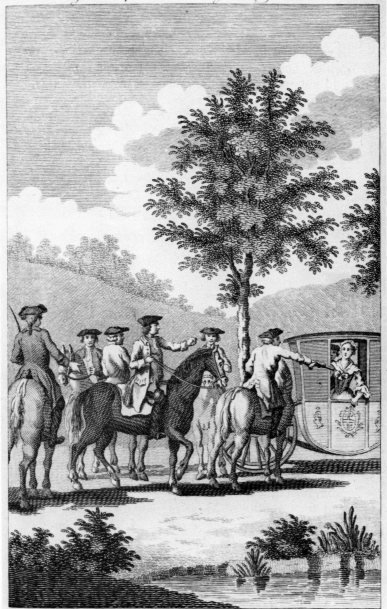

JOHN McNAUGHTON EsqR *in company with his accomplices, going to shoot* MISS KNOX, *near Lifford in Ireland.*

30. Samuel Wale: 'Attack on Miss Knox by John McNaughton'; *Newgate Calendar*, Vol. V, 1773.

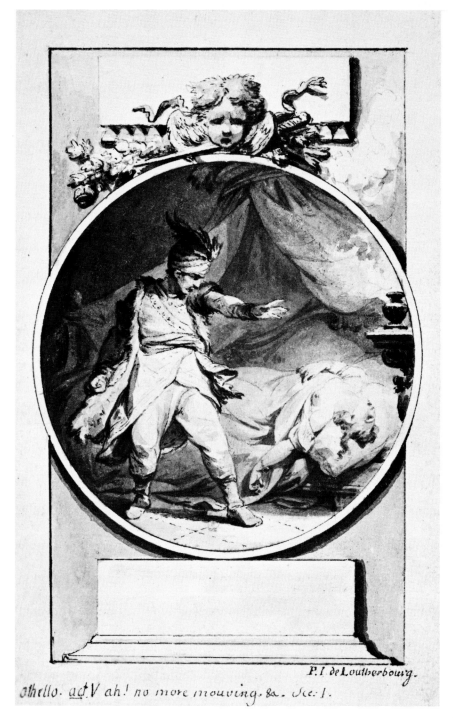

P. I de Loutherbourg.

Othello. act V ah! no more mouving. &c. Sce: 1.

31. De Loutherbourg: drawing for scene from *Othello*, for Bell's *Shakespeare*, 1784–8; Huntington Library.

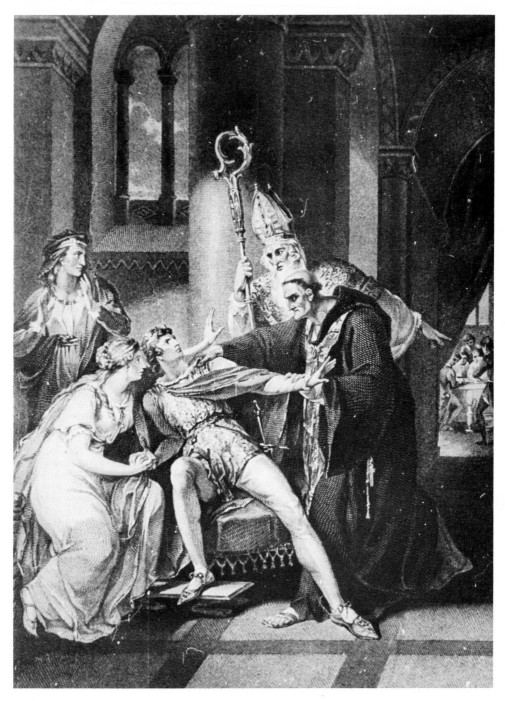

32. William Hamilton: 'Edwy and Elgiva' from Bowyer's *History*.

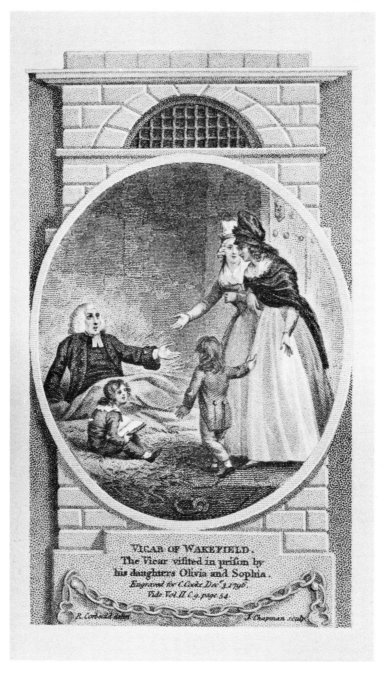

VICAR OF WAKEFIELD.
The Vicar visited in prison by
his daughters Olivia and Sophia.
Engraved for C.Cooke Dec.r 4 1796.
Vide Vol.II Cg page 54.

R.Corbould delin. J.Chapman sculp

33. Richard Corbould: 'The Vicar in Prison', *The Vicar of Wakefield,
Cooke's Select Novels* 1797–9; engraved Chapman.

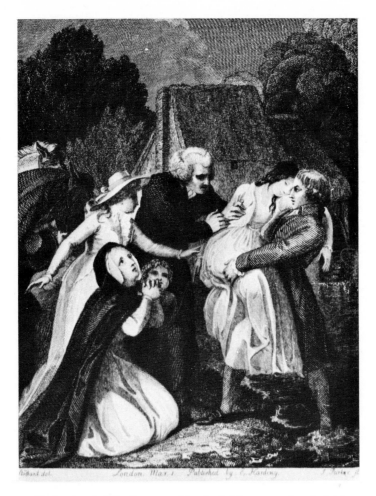

34. T. Stothard: 'The Rescue of Sophia', *The Vicar of Wakefield*;
engraved J. Parker, 1792.

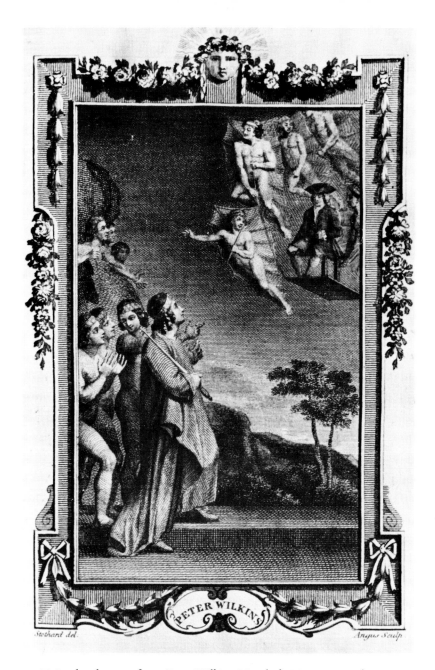

PETER WILKINS

Stothard del. Angus Sculp.

35. T. Stothard: scene from *Peter Wilkins, Novelist's Magazine*, Vol. XII;
engraved Angus, 1780–86.

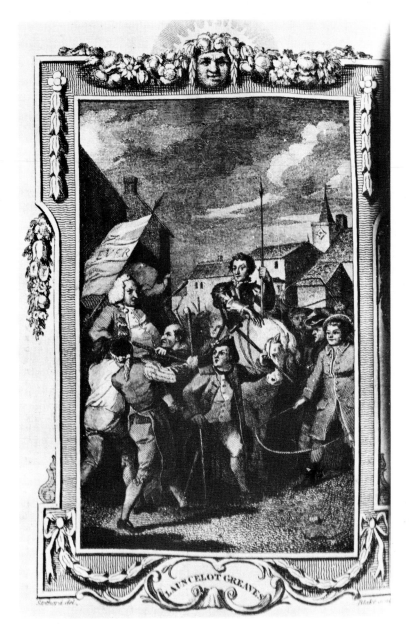

36. T. Stothard: scene from *Sir Launcelot Greaves, Novelist's Magazine,*
Vol. IX; engraved Blake, 1780–86.

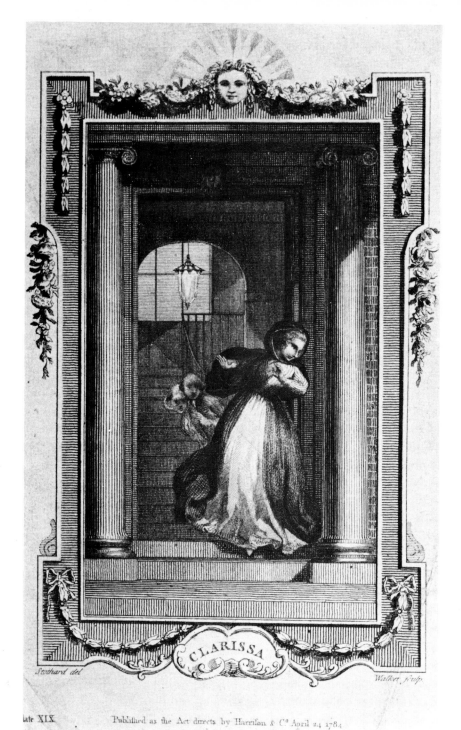

late XIX. Published as the Act directs by Harrison & Cᵒ April 24 1784

37. T. Stothard: scene from *Clarissa, Novelist's Magazine*, Vol. XIV, 1784.

38. E. F. Burney: drawing for scene from Mrs. Sheridan's *Memoirs of Miss Sidney Bidulph*, for the *Novelist's Magazine*, Vol. XXII; 1787; Victoria and Albert Museum.

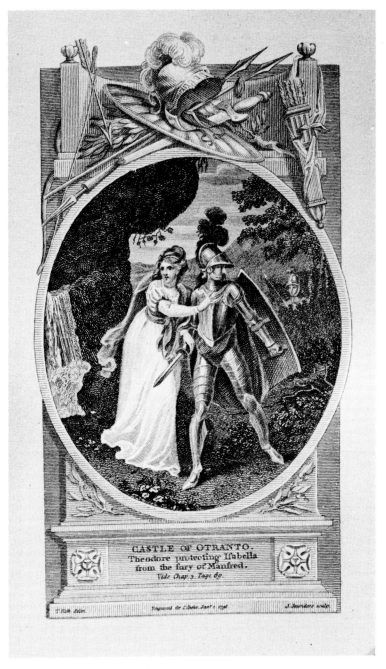

CASTLE OF OTRANTO.
Theodore protecting Isabella
from the fury of Manfred.
Vide Chap 3. Page 69.

39. T. Kirk: scene from *The Castle of Otranto, Cooke's Select British Classics*, 1793–6.

DRYDEN's POEMS.
He, like a patient angler, ere he strook,
Would let him play awhile upon the hook.
Vide Astraea Redux, vol. I. Page 3, line 17.

40. Richard Corbould: illustration to Dryden's *Astraea Redux*,
Cooke's Classic Poets; engraved Hawkins, 1798.

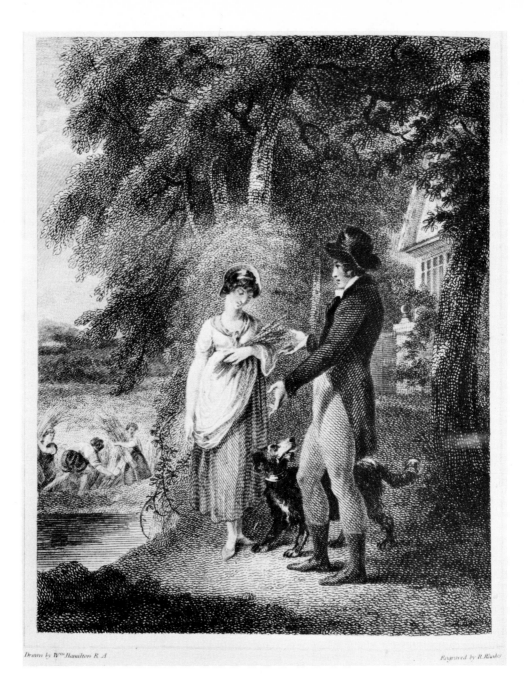

Drawn by Wm Hamilton R.A. Engraved by R. Rhodes

41. William Hamilton: 'Palemon and Lavinia' from Thomson's *Seasons*, 1802; engraved R. Rhodes.

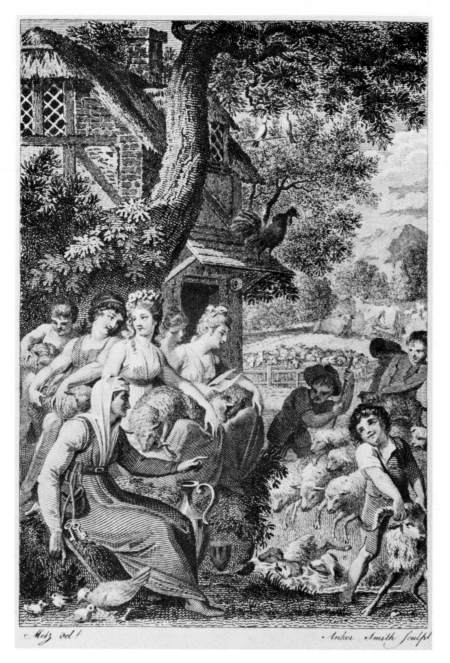

42. Conrad Metz: 'Summer' from Thomson's *Seasons*, 1793; engraved Anker Smith.

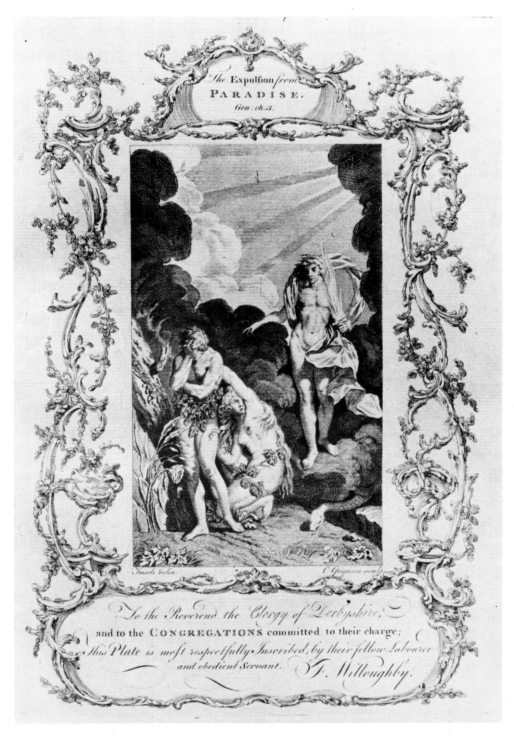

43. Fuseli: 'The Expulsion from Paradise' from Willoughby's *Practical Family Bible*, 1772; engraved C. Grignion.

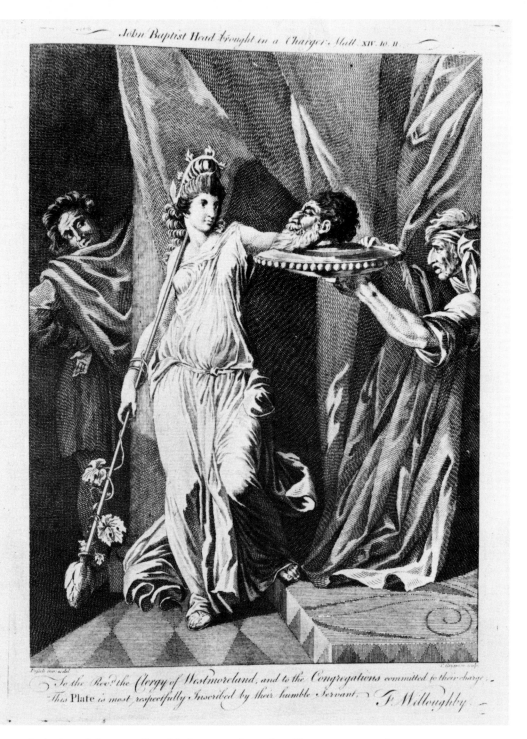

To the Rev.ᵈ the Clergy of Westmoreland, and to the Congregations committed to their charge.
This Plate is most respectfully Inscribed by their humble Servant, F. Willoughby.

44. Fuseli: 'Salome', from Willoughby's *Practical Family Bible*, 1772; engraved C. Grignion.

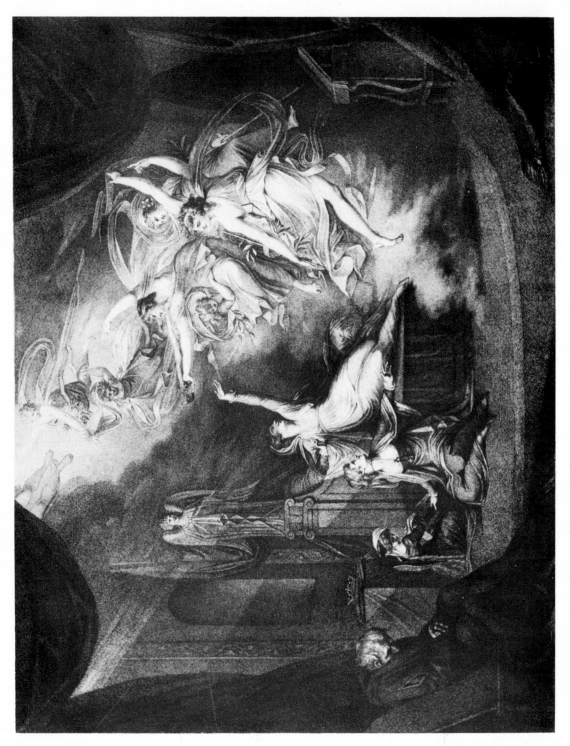

45. Fuseli: 'Queen Katherine's Vision' for *Macklin's Poets*, 1788; engraved Bartolozzi.

G5